KU-141-886

WRITING THE PRE-RAPHAELITES

Writing the Pre-Raphaelites

Text, Context, Subtext

Edited by Michaela Giebelhausen and Tim Barringer

UNIVERSITY OF WINCHESTER
LIBRARY

ASHGATE

© The editors and contributors 2009

All rights reserved. No part of this publication may be reproduced, stored in a retrieval system or transmitted in any form or by any means, electronic, mechanical, photocopying, recording or otherwise without the prior permission of the publisher.

Michaela Giebelhausen and Tim Barringer have asserted their right under the Copyright, Designs and Patents Act, 1988, to be identified as the editors of this work.

Published by
Ashgate Publishing Limited
Wey Court East
Union Road
Farnham
Surrey, GU9 7PT
England

Ashgate Publishing Company
Suite 420
101 Cherry Street
Burlington, VT 05401-4405
USA

www.ashgate.com

British Library Cataloguing in Publication Data
Writing the Pre-Raphaelites : text, context, subtext.
 1. Pre-Raphaelitism. 2. Art criticism--History--19th
 century. 3. Artists' writings--History and criticism.
 I. Barringer, T. J. II. Giebelhausen, Michaela.
 759.2'09034-dc22

Library of Congress Cataloging-in-Publication Data
Giebelhausen, Michaela.
 Writing the Pre-Raphaelites : text, context, subtext / Michaela Giebelhausen
 and Tim Barringer.
 p. cm.
 Includes bibliographical references.
 ISBN 978-0-7546-5717-0 (hardcover : alk. paper)
 1. Pre-Raphaelitism. I. Barringer, T. J. II. Title.

ND467.5.P7G54 2009
759.2--dc22

2009007667

ISBN 978 0 7546 5717 0

UNIVERSITY OF WINCHESTER

03581004 | 759.2
G1E

Mixed Sources
Product group from well-managed forests and other controlled sources
www.fsc.org Cert no. SGS-COC-2482
© 1996 Forest Stewardship Council
FSC

Printed and bound in Great Britain by
TJ International Ltd, Padstow, Cornwall

Contents

List of illustrations

List of contributors

TIM BARRINGER is Paul Mellon Professor in the Department of the History of Art at Yale University. He is the author of *Reading the Pre-Raphaelites* (1999) and *Men at Work: Art and Labour in Victorian Britain* (2005). He co-edited *Frederic Leighton: Antiquity, Renaissance, Modernity* (with Elizabeth Prettejohn) (1999) and *Art and the British Empire* (with Geoff Quilley and Douglas Fordham, 2007). He has co-curated a number of exhibitions, including *American Sublime* (2002) and *Art and Emancipation in Jamaica* (2007).

DEBORAH CHERRY is Professor of Modern and Contemporary Art at the University of Amsterdam. She has written extensively on nineteenth- and twentieth-century art, and her publications include *Painting Women: Victorian Women Artists* (1993) and *Beyond the Frame: Feminism and Visual Culture, Britain 1850–1900* (2000). She has also edited and co-edited a number of books including *Art: History: Visual: Culture* (2005), *About Stephen Bann* (2006), *Local/Global: Women Artists in the Nineteenth Century* (2006), *Location* (with Fintan Cullen, 2007) and *Spectacle and Display* (with Fintan Cullen, 2008), in addition to contributing to the exhibition catalogue for *Waking Dreams: The Art of the Pre-Raphaelites from the Delaware Art Museum* (2004).

JULIE F. CODELL is Professor of Art History at Arizona State University. She wrote *The Victorian Artist* (2003); edited *Imperial Co-Histories* (2003), *Genre, Gender, Race, and World Cinema* (2007), and *The Political Economy of Art* (2008); and co-edited *Encounters in the Victorian Press* (2004) and *Orientalism Transposed* (1998; translated into Japanese, 2008). She is currently editing *Photography and the Coronation Durbars of British India* (2009) and preparing a study of Pre-Raphaelitism and material culture.

DAVID PETERS CORBETT is Professor of Art History at the University of York and editor of the journal *Art History*. He has written and edited a number of

books on British art, including *The Modernity of British Art, 1914–30* (1997), *English Art 1860–1914* (2000), and *The World in Paint* (2004).

COLIN CRUISE is Research Lecturer at the School of Art, the University of Aberystwyth, Wales. He has written widely on nineteenth-century art, particularly on its relationship with gender, religion, and literature, publishing essays on Rossetti, Solomon, and Beardsley, among others. He was guest curator and editor of the catalogue for the touring exhibition *Love Revealed: Simeon Solomon and the Pre-Raphaelites* (2005). He is currently researching the role of drawing in the development of Pre-Raphaelitism.

MICHAELA GIEBELHAUSEN is Senior Lecturer in Art History and Theory at the University of Essex. She has published widely on prison architecture, museum architecture, and on the Pre-Raphaelites. She is editor of *The Architecture of the Museum: Symbolic Structures, Urban Contexts* (2003) and author of *Painting the Bible: Representation and Belief in Mid-Victorian Britain* (2006). She is currently researching aspects of urban ruination and preparing a monograph on the city in ruins since 1750.

JULIE L'ENFANT is Professor and Chair of the Liberal Arts Department at the College of Visual Arts in Saint Paul, Minnesota. In addition to *William Michael Rossetti's Art Criticism* (1999), she has written on Edith Wharton, Virginia Woolf, Dora Maar, and other writers and artists. Her book *The Gag Family: German-Bohemian Artists in America* was published in 2002 by Afton Historical Society Press.

MATTHEW PLAMPIN received his PhD from the Courtauld Institute of Art and was subsequently a postdoctoral fellow of the Paul Mellon Centre for Studies in British Art. He has taught overseas courses for the University of Chicago and currently teaches in Skidmore College's London programme.

JASON ROSENFELD is Associate Professor of Art History at Marymount Manhattan College, New York City. He was the co-curator of the John Everett Millais exhibition that travelled from Tate Britain in London to the Van Gogh Museum in Amsterdam and to two venues in Japan in 2007–08. He has published widely on Victorian and contemporary art and is preparing a monograph on Millais for Phaidon Press Ltd. He received his PhD from the Institute of Fine Arts, New York University.

WILLIAM VAUGHAN is Professor Emeritus in History of Art at Birkbeck College, University of London. He has published several books on Romanticism and British and German art of the nineteenth century. He

organized the exhibition on Samuel Palmer held at the British Museum, London and the Metropolitan Museum of Art, New York in 2005–06. He is currently completing a study of Palmer's work and career.

MALCOLM WARNER is Deputy Director of the Kimbell Art Museum, Fort Worth, Texas. Previously he was Senior Curator of Paintings and Sculpture at the Yale Center for British Art. His doctoral dissertation at the Courtauld Institute was on John Everett Millais, and he contributed the entries on Millais to the catalogue of the great Pre-Raphaelites exhibition at the Tate Gallery in 1984. He has since curated a number of exhibitions on eighteenth- to twentieth-century British art, including *The Victorians: British Painting 1837–1901* (1997) and *Millais: Portraits* (1999).

Acknowledgements

The editors would like to thank their patient contributors, and the editorial and production staff at Ashgate for stoically enduring some lengthy delays. We are heavily indebted to Dr Rachel Oberter, Mellon Postdoctoral Fellow at Haverford College, for her invaluable contribution to the editorial process.

Owing to the high cost of reproduction, only works which are not readily obtainable in print or via internet resources have been reproduced in this volume.

Introduction: Pre-Raphaelite mythologies

Michaela Giebelhausen and Tim Barringer

The ideology of the inexhaustible work of art, or of 'reading' as re-creation masks—through the quasi-exposure which is often seen in matters of faith—the fact that the work is indeed made not twice, but a hundred times, by all those who are interested in it, who find a material or symbolic profit in reading it, classifying it, deciphering it, commenting on it, combating it, knowing it, possessing it. Enrichment accompanies ageing when the work manages to enter the game, when it becomes a stake in the game and so incorporates some of the energy produced in the struggle of which it is the object. The struggle, which sends the work into the past, is also what ensures it a form of survival; lifting it from the state of a dead letter, a mere thing subject to the ordinary laws of ageing, the struggle at least ensures it has the sad eternity of academic debate.

<div style="text-align:right">

Pierre Bourdieu, 'The Production of Belief: Contribution to an Economy of Symbolic Goods,' in *The Field of Cultural Production: Essays on Art and Literature*, Cambridge: Polity Press 1993, p. 111

</div>

The work of the Pre-Raphaelites, in image and text, has certainly entered the 'game,' in Pierre Bourdieu's sceptical term, and continues to fascinate and perplex a global viewing, reading, and writing public more than a century and a half after the foundation of the Pre-Raphaelite Brotherhood (PRB) in September 1848. Constantly written about, read, re-read, revised, and re-written, the Pre-Raphaelites are established without question as the most important grouping in the history of nineteenth-century British art. In an inaugural act of writing the Pre-Raphaelites, his letter to *The Times* of May 13, 1851, John Ruskin offered a brilliant—though only partly accurate—account of the group's objectives:

These pre-Raphaelites (I cannot compliment them on common sense in their choice of a *nom-de-guerre*) do *not* desire or pretend in any way to imitate antique painting as such ... They intend to return to early days in this one point only—that, as far as in them lies, they will either draw what they see, or what they suppose might have been the actual facts of the scene they

desire to represent, irrespective of any conventional rules of picture-making; and they have chosen their unfortunate though not inaccurate name because all artists did this before Raphael's time, and after Raphael's time did *not* this, but sought to paint fair pictures, rather than represent stern facts.[1]

At a stroke, Ruskin tendentiously claimed for the Brotherhood the status of a realist rather than a revivalist movement, opening up a debate about the nature of Pre-Raphaelitism that continues to this day—a battle fought out in prose as much as in paint on canvas. Ruskin's was one of many attempts to marshal the unruly production of the Pre-Raphaelites under the banner of a single idea. Despite the critic's hostility to it as a *nom-de-guerre*, the term 'Pre-Raphaelite' has proved to be a masterpiece of branding (as Matthew Plampin terms it in this collection), and has remained in popular and scholarly currency ever since. Its meaning, however, has remained unstable, a term variously of affection and of abuse: writers have appropriated it to badge the group as both radical and conservative, ultra-modern and arch-reactionary. The Pre-Raphaelites remain vulnerable to the act of writing as much as to the process of reading.

Bourdieu gives the name 'reading' to the ponderous and unending process of re-creation by which works of art and literature are perpetuated, constantly reborn. By paying close attention to the making and unmaking of reputations and value judgements, the authors of the essays collected here address interdependencies that constitute the warp and weft of the cultural field's rich tapestry. We are interested in the ways in which the Pre-Raphaelites were written into prominence, the ways in which texts and textual strategies have affected the definition and reputation of the Pre-Raphaelites as a group, as a movement, and as individual artists. We argue that the 'reading' of artworks proposed by Bourdieu, and the 'game' of long-term survival of those works in the canon, are significantly shaped and even determined by an ever-growing body of texts—reviews and biographies produced by contemporaries; letters, diaries, notebooks, and autobiographical writings by the artists themselves; and, finally, the products of art history: the scholarly article, the monograph, the exhibition catalogue, the catalogue raisonné, and even collections of essays such as this. We focus on the way in which artistic identities were constructed— shifted, manipulated, fixed, and re-formed—through the medium of the word. We 'know' Dante Gabriel Rossetti, William Holman Hunt, and John Everett Millais not only through their visual production, but also through hundreds of thousands of words; barely fewer have been spilled on Ford Madox Brown or Edward Burne-Jones, and it would take many years to track down and devour every word written about even 'minor' Pre-Raphaelite brothers such as James Collinson, and followers of the movement such as Simeon Solomon, or to read the complete output of Pre-Raphaelite writers such as William Michael Rossetti or F.G. Stephens. Of interest to us are artistic identities and the machinations of position-seeking in the field; we are concerned with reputations and with

assessments of merit, individual and collective, a process in which we participate even as we attempt to analyze it. In doing so, we aim to unravel the complex implications of Pre-Raphaelite myth-making in the past and in the present, of what it meant and continues to mean to be writing the Pre-Raphaelites.

Complexities and complicities of art historical practice

To write about the history of art, literature or culture is to be implicated in the act of writing history itself. However Rankean we would like to be in telling the past just as it happened, we are not able to do so. The truth, plain and simple, cannot be written: every telling of history is a story in which raw data is edited, left out or embellished. This, of course, is not only true of our own scholarly practices but is also inherent in the source materials with which we constantly deal.

As art historians we have long—longer perhaps than practitioners in other disciplines—acted on the belief that these historical records offered up unadulterated truths which could be read at face value and mobilized to validate and authenticate interpretations in the most straightforward ways. In the field of Pre-Raphaelite studies, it took a literary scholar to draw attention to the fact that sources were not simply transparent, showing things as they had really happened. As recently as 1989, Laura Marcus introduced the notion of literary genre, the conventions and dictates of literary form and norm.[2] In her perceptive analysis of William Holman Hunt's autobiography, *Pre-Raphaelitism and the Pre-Raphaelite Brotherhood*, Marcus revealed the intricate constructions through which Hunt had achieved the seamless semblance of veracity, an achievement every bit as complex as the deceptively transparent realism of his art. As we have become more self-reflexive in our approach to, and interpretation of, the sources, we have also shifted our attention from the work of art to the networks of production, reception, and consumption that make up the field of cultural production.

In writing the Pre-Raphaelites, questions of terminology and definition invariably come to the fore. They have accompanied the movement from the start. It is relatively easy to determine the original membership of the Pre-Raphaelite Brotherhood, but it is more difficult to reconstruct their shared artistic vision, which spanned the practices of painting, sculpture, literature, poetry, and criticism. Theirs was a truly interdisciplinary project given coherence only by the vaguest of *post factum* manifestos, advocating the rejection of convention, the inspiration of nature, and the practitioner's heartfelt sincerity. From the start there were hangers-on, sympathizers, and contributors to the early Pre-Raphaelite periodical *The Germ* who were not members of the Brotherhood. As time went on, matters diversified even further: the Brotherhood years were followed by the flowering of a 'second

generation,' producing a more diffuse but momentous sense that a movement existed with the name 'Pre-Raphaelitism.' The battle over terminology is nowhere more evident than in the awkward title of William Holman Hunt's autobiography, *Pre-Raphaelitism and the Pre-Raphaelite Brotherhood*, which oscillates between personal memoir and definitive Pre-Raphaelite history.

In his bibliocritical study of Pre-Raphaelitism published in 1965, the literary scholar William E. Fredeman acknowledged the complexities of definition and proposed a tripartite classification: the Pre-Raphaelite Brotherhood, the Pre-Raphaelite Movement, and Pre-Raphaelitism. He claimed that these were 'not mutually exclusive but sequential terms descriptive of a continuous, if not a unified, aesthetic force.'[3] Pre-Raphaelitism was not a monolithic entity with a tightly focused aesthetic agenda; it was different things at different times in its long history that spanned more than half a century, from the founding of the Brotherhood in 1848 to the death of William Michael Rossetti—founder member, diarist of the Brotherhood, art critic, indefatigable chronicler, and keeper of the Rossetti legacy—in 1919. If it seems hard to pin down exactly what the term 'Pre-Raphaelite' encompassed during the second half of the nineteenth century, the recent proliferation of writings about all things Pre-Raphaelite has not made matters any easier. This collection is premised on a broad and inclusive definition of 'Pre-Raphaelitism.' Eschewing attempts to delimit the movement, the authors gathered here investigate specific, telling moments of myth-making that accompanied and complicated the writing of the Pre-Raphaelites.

From obscurity to ubiquity

In 1965 Fredeman reached the pessimistic conclusion that 'Pre-Raphaelitism remains today little removed from the obscurity and misunderstanding that has haunted it throughout the past century and a decade.'[4] By the mid-1990s, however, Fredeman found it increasingly difficult to monitor the field of Pre-Raphaelite studies 'as interest in the Pre-Raphaelites has accelerated around the world at an alarming pace.'[5] His terminology made it sound like some kind of global warming. A keyword search in the British Library catalogue throws up over 190 entries containing 'Pre-Raphaelite' in the title, from dream and vision to twilight and tragedy, via illustration, painting, camera, women, marriage, and passion. Pre-Raphaelites can be found at home and abroad; in fact, anywhere between heaven and hell. In the past 40 years, interest in the Pre-Raphaelites has spawned a huge literature. They are now ubiquitous in print, in color reproduction, and digitally they loom large on the internet. Pre-Raphaelitism is far from obscure.

By 1965 Fredeman identified a surge in *serious* interest in the Pre-Raphaelites, which gradually shifted from the journalistic, historical, and biographical to

the scholarly and critical.[6] He also pointed out that scholarship was impeded by the lack of standard tools such as 'editions, letters, biographies, iconographies, collections of reproductions, objective criticism.'[7] The emphasis was on the apparatus of literary scholarship rather than art history; conspicuously absent from his list of desiderata are catalogues raisonné for the movement's key artists and catalogues of major Pre-Raphaelite holdings in public collections. In some ways, this may reflect Fredeman's opinion that Pre-Raphaelitism had fared worst at the hands of artists and art historians.[8] The movement is more often condemned out of hand as an insignificant (sometimes even pernicious or perverse) episode in the history of English painting, irrelevant to the larger history of European art: a derailing, as it were, of the train of artistic progress or a branch line leading nowhere. This chilling assessment, however, no longer holds sway. The past 40 years have seen an encouraging (rather than 'alarming') burgeoning of interest in the Pre-Raphaelites from art historians and literary scholars.

Important primary source material has been made available. There have been some notable editions of letters, or specific bodies of correspondence such as that between William Holman Hunt and John Lucas Tupper.[9] But it is Dante Gabriel Rossetti whose epistolary legacy continues to be singled out for special treatment. Some 30 years after the fraught four-volume edition by Doughty and Wahl, Fredeman embarked on a new and definitive edition of Rossetti's letters.[10] It is the poet-painter who profits from the scholarly habitus of English Literature. Other Pre-Raphaelite documents have also received attention. Amongst the most important are Fredeman's edition of *The P.R.B. Journal* and the facsimile reprint of *The Germ*;[11] Virginia Surtees's edition of Ford Madox Brown's diary and Odette Bornand's of William Michael Rossetti's diary for 1870 to 1873;[12] and, more recently, the impressive and useful four-volume collection, *The Pre-Raphaelites: Writings and Sources*, edited by Inga Bryden, which brings together poetry, criticism, and various forms of life writing, as well as Caroline Hares-Stryker's introductory anthology.[13]

In the discipline of art history, the serious study of the Pre-Raphaelites has moved forward in leaps and bounds. A series of exhibitions held during the late 1960s and early 1970s triggered an ongoing reassessment of their art. The triad of shows curated by Mary Bennett at the Walker Art Gallery in Liverpool— dedicated to leading Pre-Raphaelite artists, John Everett Millais (1967) and William Holman Hunt (1969), and previously to Ford Madox Brown (1964), at once a significant sympathizer and role model—were foremost in focusing scholarly attention on the Pre-Raphaelites. Other exhibitions such as Dante Gabriel Rossetti (Royal Academy, London and Museum and Art Gallery, Birmingham, 1973) and Edward Burne-Jones (The Arts Council, 1975–76) soon followed.[14] In most instances the accompanying catalogues offered the first serious scholarly engagement with these artists since exhibitions held at the end of the nineteenth century. They have proved invaluable to generations

of scholars, since catalogues raisonné of most major Pre-Raphaelite artists are yet to be published. Unsurprisingly perhaps, the celebrated and charismatic Dante Gabriel Rossetti was the first of the Pre-Raphaelites whose *oeuvre* was subjected to the rigors of the catalogue raisonné. Virginia Surtees's two-volume catalogue of Rossetti's paintings, watercolors and drawings, published in 1973, signalled that this once maligned and neglected artistic movement would receive its scholarly due.[15] It remained a solitary beacon, however, until the publication of Judith Bronkhurst's monumental two volumes on William Holman Hunt in 2006.[16] Whilst Surtees's catalogue was accompanied by black and white images, in Bronkhurst's all the oil paintings glow with Pre-Raphaelite intensity, finally laying to rest Fredeman's complaint about the lack of good color reproductions. Mary Bennett's long-awaited catalogue of Ford Madox Brown's work is in press, and when Malcolm Warner's *magnum opus* is published, it will provide the same service for Millais.

In addition, several significant public collections of Pre-Raphaelite work have been catalogued, at least in part, among them Mary Bennett's excellent catalogue of first-generation Pre-Raphaelite work in the Merseyside galleries (1988) and the exhibition and accompanying catalogue of the British Museum's holdings in Pre-Raphaelite drawings (1994), masterminded by John Gere, a pioneer of Pre-Raphaelite scholarship active since the 1940s.[17] A major show devoted to the substantial collection of Pre-Raphaelite art in the Birmingham Museums and Art Gallery toured a generous selection of key works to several venues in the United States. A similar transatlantic exchange took place at Nottingham Castle Museum in 2005 where the Bancroft collection, now housed at the Delaware Art Museum, made its only UK stop. In 2003, the Royal Academy hosted *Pre-Raphaelite and Other Masters* from the Andrew Lloyd Webber collection, affording a rare opportunity to see works hitherto withheld from public view. All three exhibitions were accompanied by scholarly catalogues which were lavishly illustrated.[18] We are now also witnessing a second wave of single-artist shows. Burne-Jones was celebrated on the centenary of his death, in 1998, with an exhibition that toured from his home city of Birmingham to the Musée d'Orsay in Paris and the Metropolitan Museum in New York.[19] In 2003–04, the Walker Art Gallery staged an impressive Dante Gabriel Rossetti show with an important catalogue.[20] This was followed by a triumphant and long overdue retrospective of John Everett Millais's work at Tate Britain in 2007, the successor to a small but significant show marking the centenary of his death, held in Southampton in 1996.[21]

Exhibitions also provide focal points around which shifts in scholarship manifest themselves. Hunt has since followed suit with an exhibition organised by the Art Gallery of Ontario which opened at the Manchester City Art Gallery in the autumn of 2008.[22] This was most significantly the case with the large retrospective, *The Pre-Raphaelites*, held at the Tate Gallery (now Tate Britain) in 1984.[23] It was the first Pre-Raphaelite blockbuster, which shaped the taste of a

generation. The catalogue, with a weak introduction by Alan Bowness but with detailed and scholarly catalogue entries by a team including Mary Bennett, Judith Bronkhurst, and Malcolm Warner, was devoted to empirical scholarship, which kept close to written source material, treating it as irrefutable evidence rather than exposing it to critical study. An accompanying volume of essays, *Pre-Raphaelite Papers*, added new material but few new lines of interpretation.[24] Key scholars instantly seized on this lack of critical perspective as old-fashioned. Deborah Cherry and Griselda Pollock's review of the exhibition heralded a clarion call in Pre-Raphaelite studies.[25] Published in the five-year-old periodical *Art History*, the house journal of the 'new art history' in Britain, this followed hot on the heels of their pioneering essay on Siddall as sign in which feminist and semiotic approaches were deployed to disrupt the standard biographical account of Siddall as model and muse, foil to Rossetti's genius.[26] In 1989 the impact of this exhibition in the academic field found oblique acknowledgement in a collection of essays, *Pre-Raphaelites Re-viewed*, edited by Marcia Pointon.[27] The authors advocated a re-viewing, a fresh scrutiny of the Pre-Raphaelites, with the help of rigorously applied theoretical models mostly drawn from psychoanalysis and literary theory. Pointon's slim but sharply focused collection intensified the exchange between art historians and literary scholars. Art history's slow awakening to the use and abuse of theoretical positions already familiar and widely used in literary studies revealed a rich field in the intricacies of Pre-Raphaelite art which was positioned in the interstices between the visual and the verbal. Pointon's own essay on Hunt also drew the Pre-Raphaelites into the debates about Orientalism which had been ignited by the publication of Edward Said's groundbreaking study in 1978.[28]

During the 1970s and early 1980s, important studies of Pre-Raphaelite art were undertaken mostly by literary scholars whose interest in the writings of John Ruskin and Victorian notions of typology regularly included a serious engagement with the Pre-Raphaelites. Publications by Herbert Sussman, George P. Landow, and Chris Brooks made compelling and compulsory reading for art historians trying to come to grips with the complexities of Pre-Raphaelite symbolic realism.[29]

Academic art history's embrace of the Pre-Raphaelites coincided with an overall shift in the discipline, during which the established canon was challenged by ventures into less established fields of study. Moreover the inception of a 'social history of art' fostered attention on issues of race, class, and gender hitherto notable for their absence from art-historical discourse. The move to a focus on social and political problematics and the inception of feminist approaches revealed overlooked riches in Pre-Raphaelite studies as a roll call of women artists was rediscovered, their works re-evaluated, and their biographies written into Pre-Raphaelite histories.[30] Elizabeth Siddall now functioned as a sign not of male creativity, as Pollock and Cherry had previously argued, but as an emblem of the burgeoning interest in women

as artists. Suddenly the object of exhibition, catalogue, and biography, she figured as Pre-Raphaelite artist, legend, and supermodel.[31] Finally, she was recontextualized as part of a larger—though amorphous—group of Pre-Raphaelite women artists and as a distinctive and significant figure among the Pre-Raphaelites themselves.

Recent years have yielded an impressive harvest of scholarly monographs and essay collections on the key artists and founding members of the PRB.[32] If engagement with the Pre-Raphaelites has gradually shifted from the impressionistic, historical, and biographical to the scholarly and critical, as Fredeman claimed, scholarly and critical perspectives have mostly remained focused on individual personalities. Perhaps the wealth of personal material in the form of diaries, letters, biographies, and autobiographies has favored the biographical approach over the thematic. Scholarly monographs still tend to focus on one artist rather than on a theme. Notable exceptions include Allen Staley's pioneering *The Pre-Raphaelite Landscape* (1973) as well as recent studies on realism and religious painting.[33] Within the past decade, surveys of the Pre-Raphaelites have moved away from mere chronology to adopt various thematic approaches to suit their intended audiences.[34] For example, in *The Art of the Pre-Raphaelites*, Elizabeth Prettejohn has inserted a chapter on the Pre-Raphaelite sisterhood between those on the Brotherhood and on Pre-Raphaelitism; a gesture that significantly contributes to the ongoing feminist rewriting of the histories of Pre-Raphaelite art.[35] Alongside issues such as gender or intellectual contexts, expected of the 'new art history,' Prettejohn also devotes a whole chapter to the crucial, but often overlooked, question of Pre-Raphaelite technique, a topic that has since been the focus of a major new study.[36] At last questions of technique are being pushed beyond the usual token reference to the application of paint on a 'wet white' ground, which turns out to be one more powerful myth. The meaning and materiality of Pre-Raphaelite painting is also central to Carol Jacobi's monograph on William Holman Hunt, subtitled 'Painter, Painting, Paint.' The detailed study of the artwork's materiality adds an important and long-neglected facet to Pre-Raphaelite studies, while it continues the revaluation of Pre-Raphaelite art begun during the 1960s that reclaimed the work through exhibition. As Bourdieu's 'inexhaustible work of art' is made 'a hundred times,' Pre-Raphaelite art, too, is constantly made and remade, read and reread, written and rewritten.

Writing the Pre-Raphaelites: text, context, subtext

Given Fredeman's alarm at the acceleration of all matters Pre-Raphaelite, any new item should come with a sound justification for its existence. *Writing the Pre-Raphaelites* is the first collection of essays to shift the emphasis away from the artwork itself and on to the diverse strands of the written record which

surrounded and shaped Pre-Raphaelite practices. Art historians have used writings by members of the Pre-Raphaelite circle and other texts by critics, novelists, journalists, and even churchmen interested in Pre-Raphaelitism as if they were straightforward primary source material—raw data. Yet these documents have rarely been analyzed as significant cultural texts in their own right. Deborah Cherry and Griselda Pollock drew attention to this absence of critical purchase back in 1984 when they wrote: 'it is this literature of partisan apologies and self-justification which is now mistreated by modern art historians as if it were merely an historical archive.'[37] Several scholars have since treated the textual record with more discernment. Julie F. Codell's recent monograph focuses on 'the artist as text;' it scrutinizes the motivations for writing the Victorian artist and outlines the intricacies of a publishing industry devoted to biography.[38]

There is no such thing as a 'merely' historical archive: to ignore its formation, inherent logic, and diverse intentionalities results in naïve scholarship. The archive, complex and contradictory, is none the less deliberately constructed. The anecdote of how Fredeman discovered the so-called Penkill papers, the correspondence of Alice Boyd and William Bell Scott, in the rambling castle's forgotten attic is symptomatic. Amongst the papers was a bundle of letters, neatly tied up and marked 'To be destroyed.'[39] Someone forgot to execute the command. But the inscription bears witness to the intentional policing of the record. How many Pre-Raphaelite documents have been thrown into blazing Victorian fireplaces—how many candid artists' confessions consigned to oblivion by worthy hagiographers—we will never know. The extensive mutilation of the PRB Journal—some 20 pages brutally torn out, several more defaced[40]—and the lines of black ink drawn through much of William Holman Hunt's correspondence—one suspects by his second wife Edith purging the documents for posterity—demonstrate that the extant Pre-Raphaelite record underwent extensive physical manipulation.

The Pre-Raphaelite project was both visual and verbal. Pre-Raphaelite artists produced poems and short stories, literary reviews and essays as well as paintings, drawings, engravings, and sculpture. From the beginning, the Pre-Raphaelites were aware of the significance and power of the written word in accomplishing their artistic programme. Of the seven members of the Pre-Raphaelite Brotherhood, one—Dante Gabriel Rossetti—was regarded as highly for his poetry and translations as for his graphic and pictorial work, and two others—William Michael Rossetti and F.G. Stephens—soon abandoned visual production, becoming instead influential art critics and official chroniclers of the movement.

Theirs was a shared artistic project born out of opposition to established pictorial conventions which manifested themselves in the teaching of the Royal Academy (RA) around 1850. The exacting technique of early Pre-Raphaelite work, at once aesthetic hallmark and defiant gesture, resulted in a

very small initial output which was mostly exposed to the vagaries of display and reception manifest in the Royal Academy annual exhibition, not an arena to guarantee recognition or widespread comprehension of a new and original artistic project. Although the Pre-Raphaelite Brotherhood may have lacked a clear manifesto, it established a group identity that depended on ritualistic practices: seven members, regular meetings, a portfolio of drawings passed around for mutual critique, a diary that chronicled the group's activities, and a literary magazine. The only outward sign of this secret society was the initials 'PRB:' they glowed bright red in the bottom right hand corner of Rossetti's *The Girlhood of Mary Virgin* (1848–49, Tate, London) and were carved into the bench the doomed lovers occupy in Millais's *Isabella* (1848–49, Walker Art Gallery, Liverpool). This subtle emblem signaled a quiet revolution; too quiet, perhaps. When both paintings were exhibited in 1849, critics altogether failed to register the existence of the cryptic initials. Although early Pre-Raphaelite works display a shared aesthetic—recognized by the RA's Hanging Committee which often put the paintings of Hunt and Millais in close proximity of each other—the sense of a collective artistic identity was formed through the group activities that defined the PRB.

In 1850 the meaning of the initials PRB leaked out, William Michael Rossetti started writing for *The Critic*, and *The Germ* was launched. The short-lived journal—well received in the press—contained poems, literary essays, and reviews, which were often anonymous or signed pseudonymously, as well as original art works. It acknowledged that it was difficult to know 'where to find the ideas of an Artist except in his pictures.'[41] In professing to present 'the thoughts of Artists, upon Nature as evolved in Art, in another language besides their *own proper* one,' the journal aimed to establish a discourse that ran parallel to the visual. Once the existence of the Pre-Raphaelite Brotherhood had been made public, their paintings met with vitriolic attacks from the periodical press, which have attained legendary status through their endless recycling in writings about the Pre-Raphaelites. Hence William Michael Rossetti welcomed the opportunity to write for *The Critic* as this would enable him to offer critical support for the Pre-Raphaelite Brothers— writing back 'at a time when every man's hand was against them, and the abuse of their performances had reached a singular excess of virulence.'[42] In 1851, while vitriol was still being hurtled at the Pre-Raphaelites, John Ruskin spoke out in their defense. His eloquent intervention, in a nationally prominent site—the letters column of *The Times*—did more to turn the critical tide than all of William Michael Rossetti's moderate and fair reviews in *The Critic*.

The Pre-Raphaelites succeeded in establishing or intervening in various discourses that complemented and bolstered the effectiveness of their visual output. From the start, their history is punctuated with textual acts such as *The Germ*, regular literary and art reviews for the periodical press, and catalogues

to accompany exhibitions of their works, most notably the display of Hunt's *The Finding of the Saviour in the Temple* (1854–55, Birmingham Museum and Art Gallery) in 1860 and Ford Madox Brown's one-man show in 1865.[43] Their activities generated wide press coverage and, from the 1880s onward, a welter of biographical and revisionist literature that offered conflicting accounts of the movement, written by family members, art critics, and professional hacks. In addition to these public writings there is a substantial body of private writings, such as letters and diaries, which often formed the basis of biographical or autobiographical narratives. It is this wealth of extant literature—fragmented, idiosyncratic, conflicting, and often biased—that determines how we see the Pre-Raphaelites. As scholars, therefore, we need to subject these texts to an intense level of scrutiny in order to gain a deeper understanding of how the Pre-Raphaelites were written by themselves and by others.

* * * * *

The present essay collection addresses some key issues raised by the Pre-Raphaelite archive. The essays are arranged in four parts, each grouped around a theme: historiographies; artistic identities; languages of criticism; and spreading the word.

The two essays in the collection's opening section, 'Historiographies,' chart the bewildering mutations of the term 'Pre-Raphaelite.' Deborah Cherry—herself both a contributor to the catalogue and a key critic of the exhibition—takes the seminal 1984 Tate Gallery show, *The Pre-Raphaelites*, as her starting point from which to explore the changes in Pre-Raphaelite appreciation and scholarship. She demonstrates the significance of archetypes of artistic identity for the functioning of art history. The stable identity of the artist generates a signature *oeuvre* that is recognizable and hence marketable. Art history is implicated in creating that authenticity to which it contributes through established forms of scholarship such as the artist biography and the catalogue raisonné, which determine questions of provenance, artistic genealogies, and art historical 'isms.' Cherry demonstrates how our understanding of Pre-Raphaelite art has been shaped by the complex interrelationships between art historical scholarship and the art market, and between archival gatekeepers and the strictures of interpretation.

Turning to an earlier, but no less significant, juncture in the history of the reception of the Pre-Raphaelites, Julie Codell offers a strikingly original overview of less familiar international sources and charts the transformation of the Pre-Raphaelites from rebels to 'old masters.' She too shows the inherent fluidity of the term 'Pre-Raphaelite' which could be made to signify 'manliness or effeminacy, Britishness or cosmopolitanism, tradition or modernity.' The term 'Pre-Raphaelite' was indeed an arbitrary sign. Given this potentially anarchic multiplicity of meaning, the contributors to

this volume insist on examining the term's significance in historically and geographically specific contexts.

The second part of the collection turns more specifically to the construction of artistic identities. In the opening essay of this section, David Peters Corbett offers a subtle reading of Dante Gabriel Rossetti's artistic practice through a pairing of somewhat neglected texts: his short story 'Hand and Soul,' which appeared in the second issue of *The Germ*, and the later 'St Agnes of Intercession.' Corbett's interpretation encompasses Rossetti's work as poet and painter to elucidate the artist's lifelong concerns with representation and modernity. He demonstrates the complexities—but also the potential rewards—of relating the textual contributions in *The Germ* to the pictorial practices of the Brotherhood. Despite their convoluted story lines and early Italian Renaissance settings, Rossetti's two stories analyzed here reveal truly modern concerns. The format of Rossetti's engagement with questions of representation and modernity, in a literary contribution to a group-edited journal, shows signs of an avant-garde habitus *avant la lettre*.

A different kind of clarification of the Pre-Raphaelites' artistic mission was sought by the artist's brother, William Michael Rossetti, who became the first art critic in the Brotherhood when accepting a commission from the magazine, *The Critic*, in 1850. Julie L'Enfant charts William Michael Rossetti's development as an art critic, noting both his intellectual persuasions and his endeavors to promote and defend the work of his Pre-Raphaelite brethren. Rossetti's was a moderate and insightful voice amid the critical cacophony unleashed against the Pre-Raphaelites in the periodical press. Together with figures such as the far more influential John Ruskin, Rossetti toiled to bring about a gradual understanding and appreciation of the Pre-Raphaelite aesthetic.

In addition to evaluating William Michael Rossetti's contributions to Victorian art criticism, L'Enfant's essay also discloses the pervasive ways in which the Pre-Raphaelites sought to influence the critical reception of their work. This practice is maybe best illustrated by William Holman Hunt's deliberate exercises in self-fashioning for which he enlisted the help of fellow Pre-Raphaelite and art critic, F.G. Stephens. In close collaboration with Hunt, Stephens was the author of the catalogue of the artist's work to accompany the exhibition of *The Finding of the Saviour in the Temple* in 1860, an extensive pamphlet which approaches the status of a biography.

In her contribution to the collection, Michaela Giebelhausen investigates Hunt's deliberate self-fashioning as the century's foremost painter of Christ and the ways in which the artist aimed to promote his artistic persona as a sagacious Victorian professional who—in the words of F.G. Stephens—is a 'poet and thinker' rather than the simple recipient of divine inspiration. William Vaughan investigates the artist's astute and relentless jockeying for position to claim dominance of the Pre-Raphaelite movement. This entailed the 'writing out' of Ford Madox Brown as a defining influence on Dante

Gabriel Rossetti and on Hunt himself. Brown's role is transformed from that of a major precursor to a mere follower. By focusing on the liminal figure of Ford Madox Brown, member of the Pre-Raphaelite circle but not of the Brotherhood itself, Vaughan illuminates the different narratives of artistic ownership and originality that struggle for supremacy in the accounts of the PRB's formative years. Whether Brown, himself the subject of a superbly crafted biography by his grandson, Ford Madox Hueffer (later known as Ford Madox Ford), was the movement's John the Baptist or merely a belated apostle (as Hunt would have us believe) will continue to be an issue in years to come as he is the subject of new work. Hunt's written accounts also implicity dispute the widely held view that Rossetti had been the leader of the movement, a perception which itself owed much to publications by Rossetti's younger brother William Michael. Hunt used his autobiographical writings as a space in which to set the record straight and to formulate a narrative in which he and, to a lesser extent, Millais were the driving forces behind the artistic innovations of the Pre-Raphaelite Brotherhood. This interpretation of events stood in marked contrast to the hagiography that had surrounded Dante Gabriel Rossetti since his untimely death in 1882. Hunt's reminiscences were an act of machination as well as of memory.

Jason Rosenfeld and Colin Cruise focus on the critical languages developed to characterize Pre-Raphaelite art. In his innovative analysis of the reception of early Pre-Raphaelite landscape painting, Rosenfeld reveals how criticism was increasingly freeing itself from established references to describe an art that so clearly lay outside traditional norms. While Rosenfeld charts the subtle transformation in critical language and value, Cruise deals with the deliberate vilification of 'poetic' painting in general and the case of Simeon Solomon in particular. He shows how the language of criticism is colored with concerns about morality and notably by anxieties about deviance that expand the purview of art criticism to that of social critique.

The collection's final section considers forms of dissemination, especially display and reproduction. Matthew Plampin focuses on the ways Pre-Raphaelite art has been displayed and viewed outside the Royal Academy, both nationally and internationally. Pre-Raphaelite display practices emerge from Plampin's account as sophisticated and original: the artists self-consciously endeavored to reach out to or create an audience for their work and to exert control over the display environment. Plampin focuses attention on a hitherto neglected aspect of Pre-Raphaelite art and discusses a wide array of display methods conceived as serious alternatives to the vagaries of the RA's annual exhibition, which could make or break an artist's career. Malcolm Warner draws attention to another key aspect of Pre-Raphaelite modernity: the importance of reproduction and its different media, which proliferated in the Victorian period. In fact, most Victorians would have known their Pre-Raphaelites in reproduction: opportunities to see the originals were limited to

occasions such as the RA's annual exhibition, regional exhibitions in Liverpool and elsewhere, international events such as the Paris *Exposition Universelle* (1855) and the Manchester Art Treasures Exhibition of 1857, and from the 1860s onward to a smattering of commercial galleries such as the Dudley and the Grosvenor. By focusing on Millais, whose art was most closely connected to the popular market, Warner traces his work's dependency on reproduction to generate income and fully repay the artistic investment in the original.

The extensive—though far from complete—bibliography of Pre-Raphaelite writings, historical and contemporary, which concludes this volume attests that writing the Pre-Raphaelites has been a compulsion for generations of scholars across the world, as well as, before about 1918, a professional and perhaps a psychological necessity for the movement's protagonists and hangers-on. It is to be hoped that, as a historiographic intervention, this volume initiates a more thoroughgoing reassessment of early Pre-Raphaelite texts, their role in constructing the Pre-Raphaelite project, and their continuing influence on our view of Pre-Raphaelitism today. Such a perspective emphasizes both the perils and the rewards of any attempt to write, or re-write, the Pre-Raphaelites.

Notes

1. 'To the Editor of the "Times",' May 13, 1851, in *The Works of John Ruskin*, eds E.T. Cook and Alexander Wedderburn, 39 vols, London: George Allen and Sons and New York: Longmans, Green & Co., 1903–12, vol. 12, pp. 321–2.

2. Laura Marcus, 'Brothers in their anecdotage,' in Marcia Pointon (ed.), *Pre-Raphaelites Re-Viewed*, Manchester and New York: Manchester University Press, 1989, pp. 11–21.

3. William E. Fredeman, *Pre-Raphaelitism: A Bibliocritical Study*, Cambridge, MA: Harvard University Press, 1965, p. 1.

4. *Ibid.*, p. 38.

5. William E. Fredeman, 'The great Pre-Raphaelite paper chase,' in David Latham (ed.), *Haunted Texts: Studies in Pre-Raphaelitism in Honour of William E. Fredeman*, Toronto, Buffalo, London: University of Toronto Press, 2003, pp. 211–35, p. 232.

6. Fredeman, *Pre-Raphaelitism*, p. 28.

7. *Ibid.*, p. 38.

8. *Ibid.*, p. 33.

9. James H. Coombs, Anne M. Scott, George P. Landow and Arnold A. Sanders (eds), *A Pre-Raphaelite Friendship: The Correspondence of William Holman Hunt and John Lucas Tupper*, Ann Arbor, Michigan: UMI Research Press, 1986.

10. Dante Gabriel Rossetti, *The Correspondence of Dante Gabriel Rossetti*, ed. William E. Fredeman, 6 vols, Cambridge: D.S. Brewer, 2002–06.

11. William Michael Rossetti, *The P.R.B. Journal: William Michael Rossetti's Diary of the Pre-Raphaelite Brotherhood, 1849–1853*, ed. W.E. Fredeman, Oxford: Clarendon Press, 1975; *The Germ: The Literary Magazine of the Pre-Raphaelites*, preface by Andrea Rose, 1979, rpt, Oxford: Ashmolean Museum, 1992.

12. Ford Madox Brown, *The Diary of Ford Madox Brown*, ed. Virginia Surtees, New Haven and London: Published for the Paul Mellon Centre for Studies in British Art by Yale University Press, 1981; William Michael Rossetti, *The Diary of W.M. Rossetti 1870–1873*, ed. Odette Bornand, Oxford: Clarendon Press, 1977.

13. Inga Bryden (ed.), *The Pre-Raphaelites: Writings and Sources*, 4 vols, London: Routledge/Thoemmes Press, 1998; Carolyn Hares-Stryker (ed.), *An Anthology of Pre-Raphaelite Writings*, Sheffield: Sheffield Academic Press, 1997.

14. *Ford Madox Brown 1821–1893*, exh. cat., Liverpool: Walker Art Gallery, 1964; *Millais*, exh. cat., Liverpool: Walker Art Gallery and London: Royal Academy of Arts, 1967; *William Holman Hunt*, exh. cat., Liverpool: Walker Art Gallery, 1969; *Dante Gabriel Rossetti, Painter and Poet*, exh. cat., London: Royal Academy of Arts, 1973; *Burne-Jones: The Paintings, Graphic and Decorative Work of Sir Edward Burne-Jones, 1833–98*, exh. cat., London: Hayward Art Gallery in association with the Arts Council of Great Britain, 1975.

15. Virginia Surtees, *The Paintings and Drawings of Dante Gabriel Rossetti (1828–1882): A Catalogue Raisonné*, 2 vols, Oxford: Clarendon Press, 1971.

16. Judith Bronkhurst, *William Holman Hunt: A Catalogue Raisonné*, 2 vols, New Haven, CT and London: Yale University Press, 2006.

17. Mary Bennett, *Artists of the Pre-Raphaelite Circle: The First Generation: Catalogue of Works in the Walker Art Gallery, Lady Lever Art Gallery and Sudley Art Gallery*, London: Published for the National Museums and Galleries on Merseyside by Lund Humphries, 1988; J.A. Gere, *Pre-Raphaelite Drawings in the British Museum*, London: British Museum Press, 1994.

18. *Visions of Love and Life: Pre-Raphaelite Art from the Birmingham Collection, England*, exh. cat., ed. Stephen Wildman, Alexandria, VA: Art Services International, 1995; *Waking Dreams: The Art of the Pre-Raphaelites from the Delaware Art Museum*, exh. cat., ed. Stephen Wildman, Alexandria, VA: Art Services International, 2004; *Pre-Raphaelite and Other Masters: The Andrew Lloyd Webber Collection*, exh. cat., London: Royal Academy of Arts, 2003.

19. *Edward Burne-Jones: Victorian Artist-Dreamer*, exh. cat., eds Stephen Wildman and John Christian, New York: Metropolitan Museum of Art, 1998.

20. *Dante Gabriel Rossetti*, exh. cat., eds Julian Treuherz, Elizabeth Prettejohn, and Edwin Becker, London: Thames and Hudson, 2003.

21. *John Everett Millais, 1829–1896: A Centenary Exhibition*, exh. cat., eds Claire Donovan and Joanne Bushnell, Southampton: Southampton Institute, 1996; *Millais*, exh. cat., eds Jason Rosenfeld and Alison Smith, London: Tate Publishing, 2007.

22. *Holman Hunt and the Pre-Raphaelite Vision*, exh. cat., eds Katharine Lochnan and Carol Jacobi, Toronto: The Art Gallery of Ontario, in association with Manchester Art Gallery, Manchester, 2008.

23. *The Pre-Raphaelites*, exh. cat., ed. Leslie Parris, London: The Tate Gallery in association with Allen Lane and Penguin, 1984.

24. Leslie Parris (ed.), *Pre-Raphaelite Papers*, London: Tate Gallery, 1984.

25. Deborah Cherry and Griselda Pollock, 'Patriarchal power and the Pre-Raphaelites,' *Art History*, 7 (4), December 1984, 480–95.

26. Deborah Cherry and Griselda Pollock, 'Woman as sign in Pre-Raphaelite literature: a study of the representation of Elizabeth Siddall,' *Art History*, 7 (2), June 1984, 206–27.

27. Marcia Pointon (ed.), *Pre-Raphaelites Re-Viewed*, Manchester and New York: Manchester University Press, 1989.

28. Marcia Pointon, 'The artist as ethnographer: Holman Hunt in the Holy Land,' in Pointon (ed.), *Pre-Raphaelites Re-Viewed*, pp. 22–44. See Edward Said, *Orientalism*, New York: Pantheon Books, 1978.

29. Herbert L. Sussman, *Fact into Figure: Typology in Carlyle, Ruskin, and the Pre-Raphaelite Brotherhood*, Columbus: Ohio State University Press, 1979; George P. Landow, *William Holman Hunt and Typological Symbolism*, New Haven: Published for the Paul Mellon Centre for Studies in British Art by Yale University Press, 1979; George P. Landow, *Victorian Types, Victorian Shadows: Biblical Typology in Victorian Literature, Art and Thought*, Boston and London: Routledge & Kegan Paul, 1980; Chris Brooks, *Signs for the Times: Symbolic Realism in the Mid-Victorian World*, London and Boston: Allen & Unwin, 1984.

30. Jan Marsh, *The Pre-Raphaelite Sisterhood*, London: Quartet Books and New York: St Martin's Press, 1985; *Pre-Raphaelite Women Artists*, exh. cat., eds Jan Marsh and Pamela Gerrish Nunn, London and New York: Thames and Hudson, 1998; originally published Manchester: Manchester City Art Galleries, 1997; Clarissa Campbell Orr (ed.), *Women in the Victorian Art World*, Manchester and New York: Manchester University Press, 1996.

31. *Elizabeth Siddal: Pre-Raphaelite Artist, 1829–1862:*, exh. cat., ed. Jan Marsh, Sheffield: The Ruskin Gallery, Collection of the Guild of St George, 1991; Jan Marsh, *The Legend of Elizabeth Siddall*, London: Quartet Books, 1989; Lucinda Hawksley, *Lizzie Siddal: Tragedy of a Pre-Raphaelite Supermodel*, London: André Deutsch, 2004.

32. Alicia Craig Faxon, *Dante Gabriel Rossetti*, New York: Abbeville Press, 1989; Raymond Watkinson and Tessa Newton, *Ford Madox Brown and the Pre-Raphaelite Circle*, London: Chatto & Windus, 1991; Kenneth Bendiner, *The Art of Ford Madox Brown*, University Park, PA: Pennsylvania State University Press, 1998; Julie L'Enfant, *William Rossetti's Art Criticism: The Search for Truth in Victorian Art*, Lanham, MD and Oxford: University Press of America, 1999; Paul Barlow, *Time Present and Time Past: The Art of John Everett Millais*, Aldershot, England and Burlington, VT: Ashgate, 2005; Carol Jacobi, *William Holman Hunt: Painter, Painting, Paint*, Manchester and New York: Manchester University Press, 2006.

33. Allen Staley, *The Pre-Raphaelite Landscape*, 1973, 2nd edn, New Haven and London: Yale University Press, 2001; Marcia Werner, *Pre-Raphaelite Painting and Nineteenth-Century Realism*, Cambridge and New York: Cambridge University Press, 2005; Michaela Giebelhausen, *Painting the Bible: Representation and Belief in Mid-Victorian Britain*, Aldershot, England and Burlington, VT: Ashgate Publishing, 2006.

34. See Tim Barringer, *The Pre-Raphaelites: Reading the Image*, London, Weidenfeld and Nicolson, 1998; published in the US as *Reading the Pre-Raphaelites*, New Haven: Yale University Press, 1999.

35. Elizabeth Prettejohn, *The Art of the Pre-Raphaelites*, London: Tate Publishing and Princeton, NJ: Princeton University Press, 2000.

36. Joyce H. Townsend, Jacqueline Ridge, and Stephen Hackney (eds), *Pre-Raphaelite Painting Techniques, 1848–56*, London: Tate Publishing, 2004.

37. Cherry and Pollock, 'Patriarchal power and the Pre-Raphaelites,' 484.

38. Julie F. Codell, *The Victorian Artist: Artists' Lifewritings in Britain, ca. 1870–1910*, Cambridge and New York: Cambridge University Press, 2003.

39. Fredeman, 'The great Pre-Raphaelite paper chase,' p. 221.

40. Fredeman, 'Introduction,' in William Michael Rossetti, *P.R.B. Journal*, pp. xx–xxi.

41. *The Germ*, p. 193.

42. William Michael Rossetti, *Some Reminiscences of William Michael Rossetti*, 2 vols, London: Brown, Langham & Co. and New York: Charles Scribner's Sons, 1906, rpt, New York: AMS Press, 1970, vol. 1, p. 93.

43. [F.G. Stephens], *William Holman Hunt and His Works: A Memoir of the Artist's Life, with Description of His Pictures*, London: James Nisbet & Co., 1860; Ford Madox Brown, *The Exhibition of Work, and Other Paintings, by Ford Madox Brown*, London: McCorquodale and Co., 1865.

1

In a word: Pre-Raphaelite, Pre-Raphaelites, Pre-Raphaelitism

Deborah Cherry

In the spring and early summer of 1984, the Tate Gallery at Millbank in London (now Tate Britain) staged a highly successful exhibition entitled *The Pre-Raphaelites* (Figure 1.1); it was so popular that when 100,000 people had visited, the Tate introduced late-night opening on Tuesdays. With its substantial, well-illustrated catalogue, the event signaled that the Pre-Raphaelites, already widely popular in consumer culture, had become the subject of academic art history. The director of the Tate, Alan Bowness, established the rationale for the project: 'In recent years there have been excellent one-man exhibitions of major Pre-Raphaelite artists, but no really comprehensive exhibition has ever been devoted to Pre-Raphaelite painting as such.'[1]

In explaining the selection process, Bowness elaborated the key aims: to 'bring together as many as possible of the essential works of the movement so as to give a more complete account than has been possible in the past;' to 'examine the changing affiliations and divisions between the protagonists of Pre-Raphaelitism;' and, as demonstrated in Figure 1.1, to 'reunite paintings by different artists which were first shown together in the exhibitions of the time.' The first and over-riding emphasis was unhesitatingly placed on artists; coherence was to be achieved through temporal sequence and, despite the claim to comprehensiveness, fine art preferred to design. Why was this? And how did the exhibition and its accompanying publications participate in a series of major debates about writing the Pre-Raphaelites? This essay sets out to find some answers.

The state of the Tate

The Pre-Raphaelites prioritized fine art. The exhibition rooms, like the catalogue, were dominated by paintings which comprised 147 out of the 250

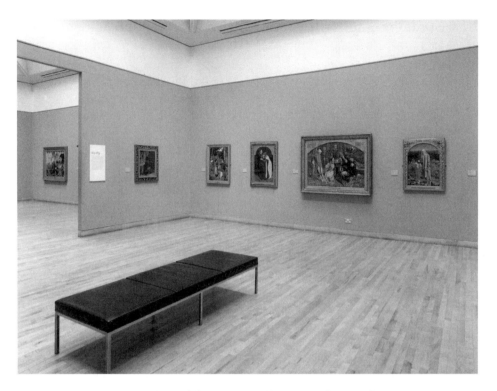

1.1 *The Pre-Raphaelites* exhibition, Tate Gallery, 1984, showing the section 1851–54 and a suite of pictures exhibited at the Royal Academy in 1851, Tate Library and Archive

works selected. Ninety-four works on paper were on show in specially lit galleries where the focus was on Pre-Raphaelite drawings and watercolors as independent art forms, as preparatory studies were by and large excluded (Figure 1.2). Nine sculptures were included though they were rarely integrated into the exhibition's narratives and displays (Figures 1.2 and 1.3). Although the catalogue entries occasionally acknowledged artistic work in other media,[2] Pre-Raphaelite design, which ranged from furniture to textiles, wallpaper, tiles, stained glass, and the diverse output of Morris, Marshall, Faulkner and Company ('the firm'), was decisively omitted. Bowness freely admitted that 'no attempt has been made to represent the multifarious decorative arts of the movement.' Also absent was any mention of the literature which drew attention to what Ray Watkinson, in a pioneering study published in 1970, called *Pre-Raphaelite Art and Design*.[3] The paintings were generously spaced, and the hanging had no truck with displays which exhibited the fine and decorative arts side by side, as in the small but dazzling array of paintings, watercolors, drawings (including cartoons), textiles, and painted furniture imaginatively presented with panels hung with replica Morris wallpaper at

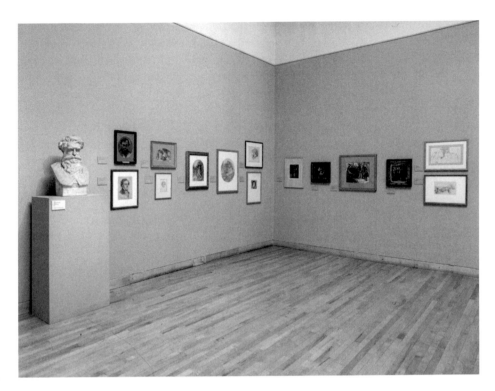

1.2 *The Pre-Raphaelites* exhibition, Tate Gallery, 1984, showing a selection of drawings from the 1850s, Tate Library and Archive

the University of Kansas in 1958.[4] A growing field of study was chronicling another history, emphasizing the interaction and reciprocities of artistic work in different media and across varying genres. A full-length study of Edward Burne-Jones issued in 1973 included painted furniture, magazine and book illustration, as well as a plethora of designs for tiles, jewellery, tapestry, and stained glass with some panels photographed in situ. In a chapter on 'the firm' and throughout, comment was offered on Burne-Jones's design philosophy, his reuse of designs between media, the impact of the firm on his art, and the collaborative processes of design. The volume itself was a shared project: the main text, contributed by Bill Waters, was accompanied by a 'select list of stained glass windows,' provided by Martin Harrison, who was also responsible for much of the photography, plates, and layout.[5]

Despite the oversights of *The Pre-Raphaelites*, where William Morris was represented by his only painting, *La Belle Iseult*, also known as *Guinevere* (1858, Tate, London), there has been an enduring interest in William Morris—although his recognition as a major designer has often demanded that his activism be played down. Morris's politics have always been contested, becoming a

touchstone for debates about the relations between art, culture and society in the post-war democratic settlement and beyond. A spate of biographies, new editions and studies released in the 1970s and 1980s considered Morris's links to Marxism, Socialism and Anarchism; his independence of thought; and the connections between his political ideas and his literary and artistic achievements.[6] *William Morris Today*, an exhibition staged at the Institute of Contemporary Arts in London in the spring of 1984, just before *The Pre-Raphaelites*, considered Morris's interests in a wide platform of social reform, with a supporting program of seminars given by prominent left-wing thinkers. The inventive and unorthodox design for the exhibition and catalogue focused attention on Morris's relevance for contemporary campaigning, a point not lost on the reviewer for *The Times Literary Supplement*: 'a rediscovery of Morris, it is suggested, could bring about the intellectual revival for which Socialism in this country is searching so desperately' five years after the landslide election of the Conservative government in 1979 under the leadership of Margaret Thatcher.[7] The aims of *William Morris Today* could not have been more different to those of the Tate: 'to show his ideas as they developed in his lifetime,' 'to suggest parallels between Victorian society and our own,' and 'to link Morris with our current dilemmas by letting him "comment" on particular aspects of life today.'[8] Although the show found it hard to make sense of Morris's design work, relying on Peter Fuller to reflect on what he called Morris's 'radical aesthetic conservatism,' it left viewers and readers in no doubt that Morris was a political and politicized figure.[9]

The genesis of *The Pre-Raphaelites* was attributed to a stream of solo exhibitions in the 1960s and 1970s which showcased selections of pictures and drawings by Ford Madox Brown, Dante Gabriel Rossetti, John Everett Millais, William Holman Hunt, and Edward Burne-Jones.[10] This new research converged with a flourishing art market for Pre-Raphaelite work in the two decades before the 1984 exhibition, which reversed the slump in prices and critical fortunes initiated at the beginning of the twentieth century. With the prospect of *The Pre-Raphaelites* on the horizon, Millais's *The Proscribed Royalist, 1651* (1852–53, Lloyd-Webber Collection) sold in November 1983 for a record sum of £780,000. The Maas Gallery opened in 1961, specializing in Victorian and Pre-Raphaelite art. With trade expanding and prices rising, Sotheby's dedicated its new Belgravia auction house to a full-scale Pre-Raphaelite revival.[11] With the exception of the *Burne-Jones* show of 1975, the raft of solo exhibitions coinciding with the commercial resurgence of Pre-Raphaelite art presented their protagonists almost exclusively as painters, subordinating design activity to narratives about making pictures and exhibiting them.[12] This approach has conspicuously shaped many introductory publications such as Tim Hilton's *The Pre-Raphaelites* and John Nicoll's *The Pre-Raphaelites*, both issued in 1970, as well as Christopher Wood's *The Pre-Raphaelites* and Andrea Rose's, *The Pre-Raphaelites* of 1981.[13]

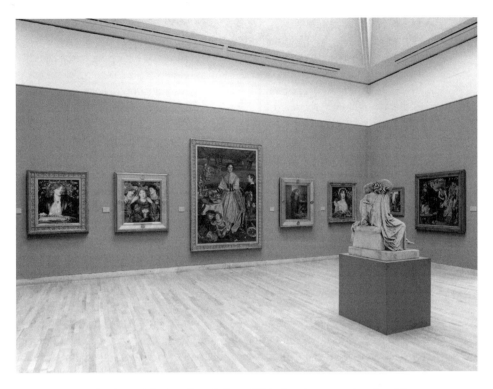

1.3 *The Pre-Raphaelites* exhibition, Tate Gallery, 1984, showing part of section VI, with paintings after 1860, Tate Library and Archive

What then did the figure of the artist as painter offer, and why was it so compelling for the Tate exhibition? Whereas accounts of design spoke about co-operative activity and production processes, a focus on fine artists reinforced narratives of individual genius, solitary creativity, and art as self-expression. In writing a history of design it can be difficult to attribute authorship; designs by one artist can be realized by another, and their re-use, time and again, troubles concepts of the singular and unique work of art. Design objects may interrupt, distract or demand another kind of looking; they suggest connections to social life which unravel formalist and stylistic appropriations of painting and disengage the viewing experience as 'visual epiphany.' Most of all they fail to generate the iconic function of the picture: to stand in for and to make manifest a movement and, most of all, to represent the artist. In the 'sacramental' and sealed spaces of the late modernist art gallery, as Brian O'Doherty has so eloquently explained, works of art are placed on the wall, singly and one by one.[14] Cell-like units with pristine white walls, even light, and pared-down surfaces seal the artwork in an environment of mythic quietude, visual sensation, and sensory depletion (Figures 1.1, 1.2 and 1.3). The wall becomes the scene of the drama as pictures,

symmetrically arranged, are accompanied by minimal labeling and brief interpretation. The repetitious placement of pictures hung on the line allows a seemingly uninterrupted encounter with art while the grouping, only roughly chronological, emphasizes the artist, and thus encourages a perception of art as self-expression. The two portraits introducing the selection of early watercolors and drawings neatly signaled the presence of the artist, as did the pairings of related studies by Ford Madox Brown and the suite of Rossetti watercolors (Figure 1.2). Rossetti's predilection for watercolors and studio showings made him an awkward candidate for an exhibition aiming 'to reunite paintings … which were first shown together in the exhibitions of the time.' Hailed as the movement's key figure, he was well-represented in specially lit rooms dedicated to works on paper and/or vellum and by 15 paintings 'after 1860' (Figure 1.3). While the Tate, in contrast to the University of Kansas 1958 exhibition, eschewed encounters between fine art and design, its modernist aesthetic departed from the theatrical staging favored by the Birmingham City Art Gallery and Museum at the turn of the century. Here Pre-Raphaelite acquisitions were included on walls crowded by double hanging, overhung and framed by swags of fabric mimicking curtains.

The Tate's aim to 'examine the changing affiliations and divisions between the protagonists of Pre-Raphaelitism' was not easily fulfilled. The tension between an art historical concern to arrange the history of art into movements and a stress on the history of art as the history of artists—the individual *The Pre-Raphaelites* of the title—was resolved by two complementary strategies: authorship and chronology. Through the first, the movement was proposed as the sum of the artistic expression of each of its leading protagonists. Temporal order was imposed, in the exhibition as in the catalogue, through a sequence of segmented time periods united by an overall division of the movement into two major phases.[15] While the notion of two phases was by then well established, *The Pre-Raphaelites* affirmed what has become the major narrative that structures virtually all studies of the movement.

The catalogue recounted an already well-known story of the trials and tribulations, successes and achievements of a group of young men who set out to revolutionize a moribund art world, tracking the moves from the foundation of the confraternity to its first demise and later reformation as a major art movement which would attain international pre-eminence. Bowness's introduction opened with the already familiar tale of boyish enthusiasm and innovation:

The Pre-Raphaelite Brotherhood was founded in September 1848 in
the Millais house, just around the corner from the British Museum.
There were seven founder members, of which only three really count.
They were William Holman Hunt, aged twenty-one, Dante Gabriel
Rossetti, aged twenty and John Everett Millais, aged nineteen.[16]

From the fraternity of the Pre-Raphaelite Brotherhood (PRB) a triumvirate of three reigning geniuses was identified:

The Brotherhood of seven, when it was founded in 1848, contained three
great individuals who happened to be personal friends, but whose ideas and
temperaments were vastly different. At the beginning they benefited from
each other's company, and learnt much, and were stimulated by competition,
but very quickly their individual paths opened up before them.[17]

Each character is given his own distinctive personality: Hunt is said to be 'ambitious, arrogant, obstinate, unlikable,' a man of 'little natural talent' and 'great determination.' Millais, by contrast, is identified as having 'wonderful natural talents, and a charming, winning manner,' whereas Rossetti, from a 'classless, cosmopolitan background,' is defined as a man whose strength as much as his weakness was a disinclination to concentrate on either painting or poetry.[18] The plot told how youthful energy and enthusiasm—'it is easy to overlook the extreme youth of the PRB'—combined with common purpose to 'forge a new and common style.' But the works on show were disparate in appearance, subject matter, media, and technique. The desire for unity, for 'a new and common style' which could satisfactorily be identified as 'Pre-Raphaelite,' ran counter to the visual material on the walls. Faced with disparities and discontinuities, the writer finally admitted that the term 'Pre-Raphaelite' could be meaningless. Repudiating it, he concluded: 'Perhaps we should think in terms of Huntian, Millaisian and Rossettian painting rather than Pre-Raphaelite painting.'[19] Abandoning a stylistic classification, the Tate enterprise settled for individual diversity: the great thing about great individuals is that they are just that, distinctive, different, unique. Changes of artistic direction, inconsistencies in approach, and alterations of style can be attributed to each artist's character, making the account of these larger-than-life figures all the more fascinating and intriguing.

A few years after its founding, the Brotherhood is said to be 'disintegrating' as the protagonists set out on their separate pathways.[20] With Hunt in Palestine, by 1855–56 Millais and a growing band of Pre-Raphaelite followers come to the fore,[21] only to be displaced by 'the second Rossetti-inspired phase of Pre-Raphaelitism.'[22] By this date, Hunt has dedicated himself to religious art, Millais has established himself in society portraiture, and both have slipped 'away into an unproductive later career.'[23] By leaving the story, they make way for Rossetti to emerge as 'the most influential figure' after 1860, by which date 'Pre-Raphaelitism had largely lost its original meaning' and gained a 'completely new lease of life.'[24] Rossetti then passes the torch on to Burne-Jones, 'who effectively took over Rossetti's role as leader in the second phase of Pre-Raphaelitism by this time quite unrecognizable in terms of the art of 1848 but closely aligned both to the Aesthetic Movement and to Symbolism.'[25] The status of these artistic colossi was enhanced by the selection of exhibits

and the minimal number from 'minor' artists. This tried and tested narrative has been widely repeated in monographs as well as in over-views: indeed, it has proved difficult to write the Pre-Raphaelites without invoking it. It is a story about origins and founding fathers, genealogies and legacies.[26] In its attempts to fit British art into existing maps of modern art, it works something like Alfred Barr's flow chart in *Cubism and Abstract Art* of 1936.[27]

The Tate validated the Pre-Raphaelites as exemplars of the modern. Firstly, they were hailed as iconoclastic rebels determined to overturn the conventions of contemporary art: 'Essentially, here were three enterprising and variously (but hugely) gifted young men, feeling that English art was at a low ebb and that they had a unique opportunity of doing something about it. Painting had been in the doldrums since the accession of the young Queen.'[28] Raiding *Dante Gabriel Rossetti: His Family-Letters with a Memoir by William Michael Rossetti* of 1895 for a quotation from *The Germ* of 1850 enabled Bowness to equip the brothers with a manifesto, a necessary declaration for any modernist movement.[29] Never mind that it was written two years after the Brotherhood was formed and published in a year of intense public controversy. In accordance with modernist accounts of modern art, the Pre-Raphaelites are hailed as 'avant-garde,' and set in opposition to something positioned as 'old guard,' vaguely explained as the 'dull and uninspiring' summer exhibitions of the Royal Academy.[30] The Introduction then tracks, for a third of its length, the emergence of a 'new beginning,' 'a new and common style,' 'a distinct and completely new style,' and 'new pictorial symbolism.'[31] The second strategy, however, is even more audacious. The Pre-Raphaelites, initially celebrated for rescuing British art from the insularity and parochialism which disqualify it from accounts of modern art, are hailed as comprising an art movement which is the equal of its European counterparts. It is here that the catalogue triumphantly speaks of 'Pre-Raphaelitism' as a movement to stand with others in the modernist progression: 'this second wave was to bring Pre-Raphaelite painting international fame, and a major role in the European symbolist movement.'[32]

The significance of the exclusion of English art from the modernist canon can be measured by its longevity. For most of the last century, art in Britain was deemed inferior to the great achievements of the Italian Renaissance, French modernism or American Abstract Art. Clive Bell included a chapter on the Pre-Raphaelites in *Landmarks in Nineteenth Century Painting* of 1927, only to dismiss them as of 'utter insignificance to the history of European culture.'[33] Charles Harrison has more recently assigned art in England to an outer space well beyond the criteria for modernism.[34] The Tate's celebration of the Pre-Raphaelites as 'avant-garde,' modern, and of international consequence was a significant move in the early 1980s, having a profound impact in the literature. In part these tactics may be attributed to Bowness's own interests in asserting the modernity of English art in publications which have promoted

Barbara Hepworth, Henry Moore, and movements towards abstraction.[35] With its advocacy of modernity, the Tate catalogue marked a new emphasis in writing the Pre-Raphaelites, dismissed in the previous decade for being 'unashamedly "literary painters".'[36] But the terms of modernity and of art's relation to the modern have changed profoundly in the last three decades. Claims for Pre-Raphaelite 'modernity' now rest on the criteria for French art: an engagement with the modern world of urban culture, visual spectacle, modern social relations, and questions of difference. It is this approach which underwrites Elizabeth Prettejohn's thoughtful comparisons between the Pre-Raphaelites and the French Impressionists in an account which decisively unsettles the conventions for writing the Pre-Raphaelites.[37]

Markets, memoirs, masters

The Pre-Raphaelites, like the solo shows of the 1960s and 1970s, consciously looked back to the later nineteenth century. Bowness's celebration of artistic originality and youthful exuberance, for example, recycled a story set in place in the 1880s. Henry Virtue Tebbs, who had known Dante Gabriel Rossetti in later life, went into print soon after the artist's death to claim that 'Rossetti's mind and temperament were too original to admit of his following in the footsteps of any master.' He 'soon attracted round himself a band of young and ardent comrades' with whom he formed the Pre-Raphaelite Brotherhood. Too individual 'to remain long in a common band,' the confrères soon 'went their separate ways.'[38] Tim Hilton had linked his overview, published in 1970, to Percy Bate's *The English Pre-Raphaelite Painters, Their Associates and Successors* of 1899.[39] Time and again, publications are justified by past example. The catalogue of the Millais exhibition (1967) reminded its readers that 'the last major exhibition' was held at the Royal Academy in the winter of 1898, two years after the artist's death.[40] The catalogue of *Burne-Jones* (1975–76) claimed to be 'the most comprehensive exhibition ... since 235 of his paintings, drawings and decorative works were shown at the New Gallery in the winter following his death in June 1898.'[41] Recent studies have been framed by past concerns, whether in (re-)writing the artist or explaining present enthusiasms. Thus Rossetti is ever the bohemian, and Burne-Jones the perennial visionary and dreamer, a perception buttressed by an uncritical recourse to the documentary archive for his enduring artistic credo: 'I mean by a picture a beautiful romantic dream of something that never was, never will be—in a light better than any light that ever shone—in a land no one can define or remember, only desire,—and the forms divinely beautiful—and then I wake up, with the waking of Brynhild.'[42] And Rachel Barnes, meditating on the group in the mid-1990s, gives a similar romantic gloss: 'What were the Pre-Raphaelite painters and poets escaping?' She arrives, however, at a conclusion shaped

by more recent concerns: 'It is essential to set their work in the context of a deeply materialistic, industrial age. Art often had little place in a competitive, class-ridden society where the work ethic ruled. If this sounds not unlike the Thatcher years, it may go some way to explaining the huge revival of interest … during the last decade.'[43]

There is more here than legitimating precedent: twentieth-century perceptions of the Pre-Raphaelites as creative individuals with distinct artistic trajectories were based on, and indeed revived, nineteenth-century strategies at work in markets, exhibitions, museums, and memoirs which fashioned artistic activity as individual enterprise, the strategy depending on those long-standing ideologies of bourgeois individualism which produced the sovereign subject of western imperialism.[44] For well over a hundred years from the 1880s, 'Pre-Raphaelitism' has been dispersed into, and understood as, the separate endeavors of individual Pre-Raphaelites.

The closing decades of the nineteenth century witnessed a cascade of Pre-Raphaelite 'retrospectives:' Millais at the Grosvenor Gallery and Hunt at the Fine Art Society in 1886; Burne-Jones at the New Gallery in 1892 with his studies and drawings curated by Julia Cartwright at the Fine Art Society in 1896, the same year in which *A Pre-Raphaelite Collection* showcased Leathart's holdings at the Goupil Gallery. The London auction house Christie's hosted a series of collector and studio sales which brought works into view and released them into the market, giving added exposure and, in many cases, boosting value. The studio sale of Burne-Jones's works in July 1898 preceded a second New Gallery exhibition by a few months. Paralleling scholarly interest in old master drawings, considerable emphasis was placed on drawings, not only at the New Gallery but also in the collection of drawings displayed at the Burlington Fine Arts Club in 1899.[45] In April 1901 the Fine Art Society presented Millais's 'pictures, drawings and studies for pictures,' noting that although 'few examples of his black and white work' had previously been shown, Lady Millais had 'collected and collated' the artist's drawings, so that the show 'embraces with few exceptions, practically all the best … now in existence.'[46] Accompanied by catalogues and reviews, these exhibitions were occasionally partnered by full-length publications: M.H. Spielmann's study of Millais was published to coincide with the major retrospective at the Royal Academy in 1898. Dealers and auction houses, especially in London, played a central role in this making of the artist by presenting solo shows, studio sales, and select collections, as well as by brokering acquisitions for the new public institutions.[47]

These exhibitions put in place a key element of art historical endeavor: the definitive catalogue of the *oeuvre*. The catalogue of a major exhibition of Hunt's works in 1907 traced the history of each of its exhibits from the Fine Art Society show of 1886, to the Leicester Gallery in 1906, Manchester later that year, and finally the Walker Art Gallery in Liverpool. Publications

accompanying exhibitions, like those of the permanent collections of regional museums, installed the artist as the source of meaning and increasingly attempted to establish and catalogue the complete work. The 1898 show of Burne-Jones was typical in its claim to present 'a complete series of the artist's easel pictures' disposed in chronological order.[48] A template catalogue entry was quickly established: a description, perhaps with quotation from the artist's papers; a record of the signature, medium, support, size, and current owner; the demarcation of replicas and versions and some mention of literature and exhibition history. The Rossetti exhibition of 1883, for instance, drew on William Sharp's *Dante Gabriel Rossetti: A Record and a Study* to establish S. numbers (since superseded by Surtees) to establish its authority. The hallmark of each artist was personal vision: as Cosmo Monkhouse wrote of Burne-Jones, although his imagination 'developed under external influences ... it always remained essentially personal and original.'[49]

The undoubted first retrospective was that which was devoted to Rossetti at the Royal Academy in the winter of 1882–83, not long after the artist's death in April 1882.[50] It was followed by and overlapped with another major retrospective, *Pictures, Drawings, Designs and Studies by the Late Dante Gabriel Rossetti*, which opened at the Burlington Fine Arts Club in January 1883.[51] These two events brought into the public arena many works which, given Rossetti's predilection for studio showings, had not been exhibited before. The uneven assimilation of Rossetti into an emerging canon of British art was indicated by the debate over the space at Burlington House. *The Times* strongly supported the case for Rossetti as a grand Old Master of British Art and, following a complaint by the newspaper's reviewer about the Academy's 'glaring misapprehension' of the artist's importance, two galleries were made available.[52] This same writer enthused over the exhibition at the Burlington Fine Arts Club in which visitors could 'trace the painter's career through its various phases.' What was in the making was a corpus of work which could, with all its disparities, be unified around the artist.

Rossetti's reputation had been adversely effected by William Buchanan's censure of 'the fleshy school' and critical condemnation of a morbid and enervated female beauty deemed 'unwholesome' and 'unhealthy.'[53] His supporters countered these attacks with an argument that was to return time and again, that any sensuality was mitigated by deeply spiritual qualities. For Tebbs 'the mystic and spiritual elements' were present in Rossetti's portrayal of a type of beauty steeped in 'mystic intensity, sorrowful, and as if filled with thoughts of a faraway land.'[54] *The Times*'s critic, however, advanced Rossetti as a new kind of artist: solitary, powerfully creative yet reclusive, removed from public life and the marketplace, yet decisively influential.

Rossetti is, perhaps, among modern artists, the one in whom genius, properly so-called, manifested itself in the most striking manner. As a painter and poet

he was distinctively creative, and the influence of his powerful individuality made itself felt in circles where, perhaps owing to his retired mode of life, even his name had never penetrated. Now creative genius of the higher order is not as a rule, an Academic virtue…. Rossetti at any rate stood alone.[55]

The terms of this discussion settle firstly around the Romantic mythology of the artist as a solitary yet towering 'genius' who is hailed as *par excellence* the 'modern' artist, and whose avant-gardism is pitched against the older order of the Academy, and secondly, around a corpus of work which is recognized as the artist's personal and unique expression. The task of these retrospective exhibitions was, then, not only to bring together works by a single artist from a number of scattered collections and thus to collate the *oeuvre*, but also to make sense of this heterogeneous assembly of items by plotting it in terms of an artistic development and personal style. It was a formative moment in the discipline of art history.

In the making of an extensive literature on the Pre-Raphaelite artists, key players rapidly emerged, notably those with familial and/or friendship connections and those with an already established reputation for authoritative writing in art criticism and history. M.H. Spielmann, editor of the *Magazine of Art*, compiled *Millais and His Works*.[56] William Michael Rossetti's authority as the major writer on his brother was not only founded in the family but also based on his established status as a published art writer whose signature was securely in place in art journalism: his writings on Dante Gabriel Rossetti and Pre-Raphaelitism came after some 30 years of writing reviews and critical pieces.[57] F.G. Stephens was also a widely published writer as the art critic for *The Critic, London Review, Macmillan's Magazine*, and *The Crayon*, and a columnist for *The Athenaeum*.[58] A dedicated writer of artists' memoirs and the biographer of Mulready and Landseer, he wrote the first Pre-Raphaelite monograph, *William Holman Hunt and His Works: A Memoir of the Artist's Life, with Description of His Pictures*, issued in 1860 in conjunction with Ernest Gambart's exhibition of *The Finding of the Saviour in the Temple*. For many years the only critic granted access to Rossetti's studio, his features on the artist provided the springboard for his study *Dante Gabriel Rossetti* published in 1894.[59] William Michael Rossetti and F.G. Stephens had been members of the Brotherhood; they as much as their subjects were veritable Pre-Raphaelites.

Other signatures relied on patrilineage and inheritance: *Ford Madox Brown: A Record of His Life and Work* (1896), was written by the artist's grandson, the novelist Ford Madox Ford.[60] *The Life and Letters of Sir John Everett Millais* (1899) was assembled by the artist's son, who also provided the introductory note to the catalogue of the Fine Art Society exhibition of April 1901.[61] *Memorials of Edward Burne-Jones* (1904) was composed by Georgiana Burne-Jones, the artist's wife.[62] In a pioneering study of the gendered relations of art writing, Meaghan Clarke shows how women writers like Julia Cartwright, author

of a special issue of the *Art Annual* on Burne-Jones (1894) and curator of the 1892 exhibition of his drawings at the Fine Art Society, relied on friendship rather than familial connections as well as an established critical reputation.[63] Like William Michael Rossetti, F.G. Stephens, and M.H. Spielmann, Julia Cartwright dedicated her career to the study of art, and indeed to the study of art as the study of artists.

The authority of their publications rested on the recognized status of their signatures. In analyzing the workings of a text, the French philosopher Jacques Derrida has drawn attention to its framing devices—the title, the author-name or signature, and the corpus within which it appears, all of which act as borders to it, shaping readers' expectations and encounters with it.[64] Reflecting further on the workings of the signature, Derrida argues that although it implies the absence of the writer, the fact that he or she is not there, 'it also marks and retains his [sic] having-been-present,' that is, that he or she was there. The signature thus testifies to the presence of the author in and for the text which is issued in his or her name. And he goes on to explain that the signature, although singular, must be capable of repetition: 'In order to function, that is, in order to be legible, a signature must have a repeatable, iterable, imitable form; it must be able to detach itself from the present and singular intention of its production.'[65] Derrida's analysis draws attention to the signature's constant citation, its reappearance time and again as it authorizes and re-authorizes the texts which it borders. With its legitimating powers, the signature was vitally important for a growing contingent of professional art writers who, through their writings, created art history and criticism as a specialized form of cultural knowledge. The late nineteenth-century literature on the Pre-Raphaelite artists demonstrates the close connections between the move from anonymity to established author names, and the emergence of 'scientific forms' of attribution and authentication for works of art: both were essential to establishing the artist's *oeuvre*.

The professionalization of art writing/history was accompanied by the development of distinctive styles characterized by a cool, detached tone, distanced observation (alongside the admission of special access), and the use of documentary evidence. While Rossetti, Stephens, Spielmann, and Cartwright relied on, even traded on, an intimate knowledge born of friendship or kinship, they validated their accounts with the methods of the new life-sciences. William Michael Rossetti's accounts of his brother were carefully crafted to strike a judicious equilibrium between intimate revelation and objective judgment, between the partiality of a brother, the balanced assessment of a critic, and the painstaking care of an archivist. As his brother's executor and as a participant in the movement, William Michael Rossetti had amassed a substantial archive of papers, not only by or from his brother, but also relating to the Pre-Raphaelite artists more generally,

and he drew on and edited these papers for his many publications. Whether explicitly on Dante Gabriel or purporting to be about the movement, his writings—published between 1889 and 1911—all ascribe priority to his brother as progenitor and chief protagonist of the movement.[66]

William Michael claimed authority on the basis of several interlocking claims: his proximity to events, his status as a trustworthy eye-witness, and his personal knowledge. In writing of 'my brother,' he assures his readers that he has a deep, detailed, and comprehensive knowledge of that brother's private, affective, and creative life. Yet in presenting his accounts, he is careful not to leave them open to accusations of imaginative or fictional elaboration. Events and encounters are all painstakingly documented, the evidence of letters and diaries supporting the author's claims and recollections. At the opening of his first lengthy study, *Dante Gabriel Rossetti as Designer and Writer* of 1889, he states his 'endeavour to compile with care and fullness and to present the results with precision and perspicuity.'[67] And a decade later he reiterates this purpose: 'My object in the present volume [*Pre-Raphaelite Diaries and Letters* of 1900] ... is not to give any continuous narrative or dissertation of my own, but to set forth original documents, with such introductory or annotating matter as may make them plain.'[68] He frequently drew attention to the basis of his accounts in the manuscripts in his care, offering copious excerpts and transcripts. At the outset of *Dante Gabriel Rossetti: His Family-Letters* he remarks, 'The letters such as they are, shall be left to speak for themselves.' He does, however, add the qualifier, that 'I have told what I choose to tell, and left untold what I do not choose to tell; if you want more be pleased to consult some other informant.'[69] This suggestion that there is more to tell not only fueled enthusiasm for the later volumes, but also was part of a strategy of revelation within the highly controlled contexts of authorized publications.

Paralleling the stories of Sherlock Holmes and his biographer, Dr Watson, William Michael Rossetti's accounts stage an effective contrast between the rational raconteur and the irrational genius who is his subject. His numerous volumes revealed a life full of sudden deaths, unusual occurrences, obsessive pursuits, drug-taking, erratic business practices, strange dwellings, and special languages, coteries and friendships, to figure a new kind of modern artist, with a character which not only set him apart from most sober-minded middle-class readers, but also from others in the artistic fraternity. While the archive compiled by William Michael Rossetti still defines the biographical subject, that archive is, as Michel Foucault has demonstrated, always a fissured monument to the past, partial and fragmentary in its composition, in which what is absent, destroyed or altered is as significant as what remains.[70] Particularly conspicuous in the Pre-Raphaelite memorialists is a strategic approach to the archive, in which the constitution of a particular order of knowledge is secured through the preservation of particular documents and

their presentation to the public in highly regulated contexts. Although this approach is characteristic of nineteenth-century preoccupations with archives and documents, it has been imported wholesale into the twentieth century. Scholarly projects to produce complete editions of the letters of famous men such as Dickens, Carlyle, and more recently Dante Gabriel Rossetti similarly insist that letters offer immediate and transparent access to the subject.[71] Lytton Strachey's scepticism about the 'great ocean of material' poured forth and accumulated by the Victorians remains, by and large, unheeded.

The 'life and letters,' a form of art literature which emerged in the later nineteenth century, wrote the story of art and life with copious quotation. These lavish publications, profusely illustrated and often in two volumes, participated in an increasing emphasis on the individual artist, marked by the issuing of photographs of art works and photographic cartes-de-visite, the 'retrospective' exhibitions and the solo shows, and, in response to new ideas about exhibition display, a shift in the writing of critical reviews to focus on the exhibiting artists one by one, rather than provide the walk-round-the-gallery itinerary of the 1850s. Interviews with and features on artists were commonplace by the 1880s. Solo shows, monographs, authored pieces, essays, and special issues all contributed to the production of the artist as 'author' in a double sense: as the subject of writing and as subject to writing.[72]

William Holman Hunt's *Pre-Raphaelitism and the Pre-Raphaelite Brotherhood* of 1905 offered a form of art writing which differentiated it from the accounts delivered by the professional writers.[73] Written by an author-artist, Hunt's two volumes simultaneously narrate the development of an artist and the emergence and significance of the movement, see-sawing uncomfortably for some 1,000 pages between 'Pre-Raphaelitism' and 'Pre-Raphaelite,' used both as a classificatory adjective and as a noun to denote Hunt himself. Like the professional writers, Hunt makes a claim for veracity, writing of 'the duties of a historian.'[74] As an *auto*biography, however, *Pre-Raphaelitism and the Pre-Raphaelite Brotherhood* gives special prominence to voice and speech. Hunt positions himself as a participant who can still hear, and so recreate, conversations that took place decades ago. Although he publishes some rare archival material, Hunt legitimates his account with memory and imagination. In contrast to the memorialists' differentiation of biographer and subject, Hunt maps an artistic and authorial self. In *Pre-Raphaelitism and the Pre-Raphaelite Brotherhood*, author and artist are one, sutured by the voice.

Reflecting on the difference between speech and writing, Jacques Derrida has highlighted the role of the voice in western culture, pointing out a long philosophical tradition in which the voice is linked to and perceived as expressive of consciousness. Derrida contends that there is a widely held understanding that the voice is an intimate and personal expression of the

self, and that there is an 'absolute proximity of voice and being.'[75] While Hunt's strategy of the voice does position him as an outsider and a prophet in the tradition of Victorian sage writing,[76] the distinctive voice offers another way of telling about the past which speaks of partiality, inclination, and preference.

Hunt's autobiography drew on John Henry Newman's *Apologia Pro Vita Sua*, published in 1864. Newman's account of his crisis of faith, tortured spiritual journey, and embattled quest for truth, as well as his modeling of the maturation of the self through distinct phases of spiritual development, provided a powerful example. Though an Evangelical, Hunt's delineation of his spiritual and artistic development comes close to Newman's. In the *Apologia* the private is inseparable from the public: inner development is linked to external circumstance and the life work set on the national stage.[77] This indivisibility, which allowed all sorts of exclusions, was influential elsewhere in the writing of Pre-Raphaelite memoirs and in creating figures of national significance; the biographers of Millais and Rossetti silhouetted the maturation of an artistic self against the mutability of external forces, whether the vacillations of public opinion or the vagaries of the weather.[78]

Hunt's volumes were a first, in being an autobiography, and at the same time one of the last examples of this kind of Pre-Raphaelite literature. By the time the second edition was issued in 1913, three years after Hunt's death, the gorgeous art biographies of the 1880s and 1890s were on the wane, interest in the Victorians was evaporating, and *The Times Literary Supplement* regretted that 'a book which might have had permanent value as the record of an interesting movement in the history of British Art should contain so many pages about personal squabbles which have no historical or artistic importance.'[79]

Hunt's autobiographical writings, begun in the mid 1880s with a series of essays on his artistic practice, initiated a flurry of publications and exhibitions as those still alive, their supporters, and their descendants entered print to make claim and counter-claim. These often bitter contentions were about origin and precedence, about who came first and who could be a 'Pre-Raphaelite.' And while these altercations were largely conducted in print, they were not unconnected to the movements of the art markets in the late nineteenth century.

In 1886 and 1887 the *Contemporary Review* published lengthy articles by Hunt. An account of the painting of *The Scapegoat* (1854–55, Lady Lever Art Gallery, Port Sunlight, Merseyside) accompanied three substantive essays entitled 'The Pre-Raphaelite Brotherhood: a fight for art' in which he narrated his place and role in the movement and put forward his artistic credo.[80] What prompted Hunt to write these essays is open to speculation. The essays coincided with a retrospective at the Fine Art Society which included the painting now at the Lady Lever Art Gallery; the sale of the smaller

version (1854–55, City of Manchester Art Galleries) at Christie's on April 2, 1886; and the Thomas Fairbairn sale in May 1887 where *The Awakening Conscience* (1853–54, Tate, London) and the larger *Scapegoat* were bought in. At stake here were not only the sale prices of earlier works but also the rising incomes accruing from the sale of rights as well as pictures and the celebrity which stellar prices—in the studio and the auction room—attracted. Hunt was acutely aware of the need to protect the value of his paintings in an unpredictable market which generated low as well as extraordinarily high prices. While publications and exhibitions were central to the making of individual *oeuvres* and reputations, equally significant was the development and capitalization of the art market in the closing decades of the century, the status of dealer-galleries, the strength of established private collectors, and the founding of regional and national collections.

In the 1880s and 1890s, Pre-Raphaelite paintings were on the move. Economic as well as aesthetic value was highly volatile. Sales attracted high levels of publicity, indexing the rise or fall of an artist's status. Museums enhanced their holdings with careful, though by no means numerous, purchases. A handful of works entered the National Gallery of British Art (later the Tate Gallery), including Millais's *Ophelia* (1851–52) and *The North-West Passage* (1874), both presented by Henry Tate in 1894; Rossetti's *Ecce Ancilla Domini* (1849–50) was bought at the Graham sale where, it is said, Agnew raised his hat when the picture was acquired for £840, and his *Beata Beatrix* (1864–70) was presented in 1889.[81] A proactive policy at Manchester prompted the acquisition of Ford Madox Brown's *Work* (1852–65) in 1885, Burne-Jones's *Sybilla Delphica* (1868) in 1886, Rossetti's *Astarte Syriaca* (1875–77) in 1891, Millais's *Autumn Leaves* (1855–56) from James Leathart in 1892, and Hunt's *The Hireling Shepherd* from his executors in 1896. Hunt's *The Shadow of Death* (1870–73) was presented by Thomas and William Agnew in 1883. The nearby Walker Art Gallery in Liverpool bought Rossetti's *Dante's Dream at the Time of the Death of Beatrice* (1871–81) in 1881, a few months before the artist's death in 1882, and Hunt's *The Triumph of the Innocents* (1876–87) from the artist for £3,750. The City Museum and Art Gallery in Birmingham established itself as a major institution for Pre-Raphaelite paintings and drawings. By the early twentieth century, Millais's *The Blind Girl* (1854–56) and *The Widow's Mite* (1870), Dante Gabriel Rossetti's *Beata Beatrix* (a replica with predella, painted for Graham, 1877) and *The Boat of Love* (1881), as well as Burne-Jones's *The Star of Bethlehem* (1887–91) had entered the museum, along with an unrivalled collection of drawings. Hunt's *Valentine Rescuing Sylvia from Proteus* of 1851 was acquired in 1887 from the Fairbairn sale for just over £1,000. *The Finding of the Saviour in the Temple* (1854–60) was donated in 1896, the picture having appeared in the C.P. Matthews sale of June 6, 1891, where it had been bought by Agnew for 3,400 guineas. Entering by purchase or gift,

these works enhanced the cultural standing of regional centers, and their collections and retrospective exhibitions increasingly highlighted their significance as major lenders. When the substantive display of works by Hunt was organized by the Walker Art Gallery in 1907, the claim for 'the important part played by Liverpool in the encouragement of his [Hunt's] genius during the early years of struggle against the conservatism of mid-Victorian art' referred not only to the annual exhibitions, but also to the art collection accumulated by the city. The regional art galleries also offered local worthies an appropriate stage for cultural benefaction; on numerous occasions acquisitions were facilitated by aldermen and councillors who were themselves art collectors. Alderman William Kenrick, active in the administration of the Birmingham museum, donated *The Blind Girl* and facilitated the acquisition of Pre-Raphaelite drawings.[82]

Although Hunt's *The Triumph of the Innocents* secured a substantial sum in 1883 and *The Shadow of Death* sold to Agnew in 1874 for the record-breaking amount of £11,000, prices for Hunt's paintings were outpaced by those for Millais's later works, with *Over the Hills and Far Away* of 1876 reaching £5,250 in 1887 and *The North West Passage* of 1874, £4,200. His early Pre-Raphaelite pictures sold well in these years, *The Order of Release* (1852–53, Tate, London) rocketing from £2,835 in 1879 to £5,250 in 1898. Gerald Reitlinger has pointed to William Graham's sale in 1886 as a turning point in the re-appraisal of Rossetti and Burne-Jones.[83] Whereas prices at Rossetti's executor sale were generally low, with tariffs for individual works remaining under £2,000, at the sale of Joseph Ruston's collection in 1898, *Dante's Dream at the Time of the Death of Beatrice* (1880, Dundee Art Gallery) and *La Ghirlandata* (1873, Guildhall Art Gallery, London) together realized £6,300. Although there is some evidence that Burne-Jones had difficulties selling his late works,[84] prices in the sale rooms during the artist's lifetime matched those of Millais and Leighton, with *Laus Veneris* (1873–78, Laing Art Gallery, Newcastle-upon-Tyne) and *Le Chant d'Amour* (c. 1868–77, Metropolitan Museum of Art, New York) securing £2,677.10s and £3307.10s respectively at the Graham sale, while at the Ruston sale *The Mirror of Venus* (1877, Gulbenkian Foundation, Lisbon) realized £5,727 and *Love and the Pilgrim* (1896–97, Tate, London), which had failed to sell when the artist exhibited it at the New Gallery the year before, secured £5,775. Reflecting on the difficulties of acquiring a Burne-Jones for the Art Gallery of South Australia, Harry Gill, Principal of the School of Design in Adelaide, acutely remarked, 'I do not think it is in any way possible to obtain one of his works. The greatest thing in the life of the art of 1898 has been the wonderful rise in his prices—being dead [and] no longer a producer.'[85]

Equally important in the making of an *oeuvre* and intimately linked to the retrospective exhibition was the distribution of reproductions. Alicia Craig Faxon's research testifies to 'the widespread interest and commerce

in photographs of works of art.'[86] Noting Rossetti's dispatch of photographs of his works to friends and patrons, she also demonstrates the role that photography played in the making of the artist's posthumous reputation in the UK, Europe, and the United States. When William Michael Rossetti inherited a large number of images and negatives, he hired the photographer Hedderly (who had worked for his brother) to provide photographs which he astutely released from the estate by running a series of advertisements in the *Athenaeum*; so successful was this as a marketing strategy that within three months he had amassed orders worth £120.[87] Photographs of Dante Gabriel Rossetti's works were included in the 1883 Burlington Fine Arts Club exhibition, sold at the Rossetti Gallery run by Fanny Cornforth Schott and her husband nearby at 1A Old Bond Street, and on display at the New Gallery in 1898. Art works hung side by side with photographic reproductions. While photographs, especially when authorized by an artist's estate, specialist exhibitions or reputable galleries, catered to a new niche market, they also played an important role in collating the *oeuvre* and in documenting the presence and appearance of lost or repainted works.[88] In *Dante Gabriel Rossetti* (1899), H.C. Marillier, for example, utilized photography to demonstrate the earlier version of *Lucretia Borgia* (1860–61) which had disappeared in a later repainting (1868, Tate, London); and it is to the Marillier illustration to which Virginia Surtees refers in her catalogue raisonné when establishing the distinct versions of this subject.[89]

The individual artist and his life—whether presented as exhibition display, extended at length in the life story, or offered in shorter fragments in essay form—was, I have suggested, the prevailing form for writing the Pre-Raphaelites at the turn of the twentieth century. It was through the monographic impulses of the period 1880–1911 that 'Pre-Raphaelitism' came to be defined in terms of the singular 'Pre-Raphaelites.' This jostling between aged participants, whom Laura Marcus wittily calls 'Brothers in their anecdotage,' is well known.[90] One question remains, however: why was the memoir the arena in which this took place? To ask this question is to shift the ground away from contentions of origin which worry about auto/biography's debts to Victorian novels, earlier *Vitae* or nineteenth-century historical writing with the invariable citation of Carlyle. It is to consider less the form or origin of the genre and more its discursivity, proliferation, and pre-eminence. A number of recent scholars have drawn attention to the role that the artist's biography played in the making of a distinctively 'English' school of art.[91] The opening of the Tate Gallery in 1897, the founding of the National Art Collections Fund in 1903, the establishment of municipal museums, and the rise of international exhibitions all assisted the articulation of national identity in the arena of high culture. There was, however, a notable disparity between the literature promoting the Pre-Raphaelite artists as distinctively 'English'[92] and the failure of their works to enter national and regional collections in

any substantive number. Pictures by Rossetti, Burne-Jones, and Hunt were not purchased for the Chantrey Bequest and, despite the preferences of Birmingham, Manchester, and Liverpool, relatively few entered the new museums. These fissures demonstrate some of the tensions in the making of 'English' art, and they complicate the alliance between the formations of national identity and the fabrication of the artist subject.

The putting of the artistic self into the text of biography textualized the western sovereign subject as white and masculine. As such it relied on, indeed demanded, a doubling of alterity in the racialization and sexualization of difference. The 'life and letters' format did not, indeed could not, textualize the life of a woman artist. Increasingly numerous in the later nineteenth century and the subject of a growing literature, women artists were the focus of numerous profiles, articles, and interviews in journals and magazines and occasionally included in biographical dictionaries such as Ellen Clayton's English Female Artists of 1876. But few were honored with a full-length memoir, the nearest admission coming with an account of husband and wife. Furthermore, the genre of female auto/biography, which generally bypassed women artists until the 1920s, eschewed a narrative of centered self in favor of a tactics of diffusion.[93] Although nineteenth-century feminist discourse enabled the mapping of feminine artistic subjectivity by appropriating the writing of a masculine self, women writers, as Meaghan Clarke has demonstrated, tended to focus their attention on 'great men,' although an avowed campaigner like Florence Fenwick Miller supported Henrietta Rae's bid for success in academic circles.[94]

Pre-Raphaelite memoirs were engaged in the production of 'civility,' a concept proposed by Homi Bhabha to delineate a specific form of nineteenth-century (masculine) imperialist subjectivity. For Bhabha, the inception of western modernity was characterized by the emergence of 'civility,' a term whose meaning slips from the signification of a code of polite behavior to the governance of civil society and colonial territory. Bhabha explains:

[A]t the same time as the question of cultural difference emerged in the colonial text, discourses of civility were defining the doubling moment of the emergence of western modernity. Thus the political and theoretical genealogy of modernity lies not only in the origins of the idea of civility, but in this history of the colonial moment.[95]

The production of an imperialized masculine self in Hunt's diaries and memoirs has been astutely analyzed by Julie Codell's attention to their participation in 'a nationalistic discourse in which cultural identity was characterized as "[v]igorous, manly and English",' a conclusion which builds on discussions by Marcia Pointon, as well as Cherry and Pollock.[96] Pre-Raphaelite biographers struggled with the terms of 'Englishness,' by no means a stable or self-evident category in the 1880s and 1890s. The complexities of an intervention into a politics of population shaped in and by discourses on national identity,

morality, health, and sexuality[97] are signaled in H.V. Tebbs's skilful declaration in 1883 of 'Rossetti's birthright as an Englishman,' who 'inherited to the full the passionate fervour and ardent temperament of the South.'[98] Intimately part of colonialism's cultures, these biographies participated in a complex texturing of the difference of race, gender, and sexuality. As Englishness was uncertain and Pre-Raphaelite masculinities contested, this vast biographical texting worked to produce the Pre-Raphaelite artist-subject as a white 'civilizing subject,'[99] drawing the lines between white, 'not quite/not white,'[100] and mapping gradations and differentiations within the global cartographies of late nineteenth-century empire.

Pre-Raphaelite memoirs participated in the making of an imperial identity elaborated in the arena of high culture. Reviewing the two Rossetti retrospectives held in 1882 and 1883, *The Times* concluded that they have 'thrown new light on the origin of a movement which has played an important part in the development of English art.'[101] Significant here was inclusion of Pre-Raphaelite artists in the making of 'the British School.' Rossetti's Royal Academy retrospective coincided with the winter exhibition at the RA of the 'works of the Old Masters and Deceased Masters of the British school,' establishing a linkage which was to be made time and again in the 1880s as well as in the 1980s. In the second half of the twentieth century, writing the Pre-Raphaelites once again became entangled in discussions of national identity. Drawing together the threads of an argument at the end of his introduction to *The Pre-Raphaelites*, Alan Bowness enthusiastically proclaimed, 'what group of English painters can match them?'

The politics of knowledge

Like many major exhibitions, *The Pre-Raphaelites* drew on the intellectual resources of a number of scholars. The proceedings were overseen by a 'Committee of Honour'—Quentin Bell, John Gere, Diana Holman Hunt, Mary Lutyens, Rosalie Lady Mander, and Virginia Surtees—designated by Bowness as a group of 'distinguished scholars.'[102] But the catalogue's list of publications mentions only Surtees's catalogue raisonné of Dante Gabriel Rossetti, Gere's co-authored study of Pre-Raphaelite paintings (1948), and Mary Lutyens's studies of Millais.[103] The 'Committee of Honour' was as much about the putting in place of a particular kind of approach to the Pre-Raphaelites as it was about affiliation. In the making of 'cultural capital,' as Pierre Bourdieu has elaborated, the production of knowledge is entwined with social connection.[104] Two of the group had professional credentials. Bell, who had been Slade Professor at Oxford, and Professor of the History of Art at the University of Hull and the University of Sussex, was best known for his writing on Bloomsbury and a two-volume biography of his aunt, Virginia

Woolf. Following his studies on Ruskin, *The Schools of Design* (both 1963) and *Victorian Artists* (1967), he wrote an introduction to the Pre-Raphaelites in his retirement.[105] John Gere, a curator at the British Museum who had been an influential supporter in the immediate post-war years, wrote the introductions for the Whitechapel show, *The Pre-Raphaelites*, in May/June 1972 and the Rossetti exhibition at the Royal Academy in the following year. The others were positioned by kinship and/or their connections to the social elite. A biographer of Rossetti, Rosalie Glynn Grylls became Lady Mander by marriage and thus the custodian of Wightwick Manor with its collection of Pre-Raphaelite pictures and drawings, printed books, and Morris furnishings.[106] Virginia Surtees, the great-granddaughter of Ruth Herbert and the sister-in-law of a British ambassador to Rome, compiled the definitive catalogue of Rossetti's work, edited the diaries of George Price Boyce and of Ford Madox Brown, and wrote on various nineteenth-century subjects.[107] Descended from William Holman Hunt, Diana Holman Hunt had written her recollections of her grandfather.[108] Mary Lutyens's *Millais and the Ruskins*, published to coincide with the Millais exhibition of 1967, strengthened the biographical interpretation characteristic of this second wave of Pre-Raphaelite memorialists.[109]

Many of the group owned or had privileged access to extensive private holdings of documents and were influential gatekeepers to other archives. Together with the well-connected owners of pictures, they formed a network of sociability through which admission to private houses and private collections was granted.[110] Jeremy Maas has acknowledged that entrée to this powerful circle was vitally important for a successful dealer, and, it might be added, for any aspirant researcher.[111] Kinship and friendship remained as important in the two decades before 1984 as they had been in the later nineteenth century. As Noel Annan astutely analyzed, the 'intellectual aristocracy' which dominated politics, public service, and education in Britain from c. 1880 to 1950 and after—and to which Quentin Bell was related—was cemented by associations of family and familiarity.[112] Pre-Raphaelite circles operated on similar principles. Yet, it was in the 1960s and 1970s that many families dispersed their collections, putting their pictures on the market and shipping boxes of archival materials to North American libraries. The massive appreciation in value of Pre-Raphaelite pictures as commodities on the art market was matched by a tumultuous traffic in documents. The acquisition by the Library at the University of British Columbia of the vast archives of papers and memorabilia which had been owned by William Michael's descendants, Helen Angeli and Imogen Dennis, and the Leathart papers, previously in the care of Gilbert Leathart, the descendant of one of Pre-Raphaelitism's most famous patrons, are but two examples of this transatlantic transfer.[113] Since the archive has to a large extent determined the subject of writing, the demise of family holdings and the slackening of the grip of a powerful elite

over the materials of Pre-Raphaelitism have had profound effects in writing the Pre-Raphaelites and on the kinds of scholarly endeavors which can be undertaken.

The Pre-Raphaelites took place at a critical moment in the development of art history, and perhaps unsurprisingly the project became embroiled in the major upheavals that were reshaping the discipline's concerns, subjects, and procedures.[114] While attention to design was shifting the ground, a number of studies considered the historical contexts of paintings and drawings. In *Pre-Raphaelite Paintings from the Manchester City Art Gallery* (1980), Julian Treuherz meditated on the relationship between works of art and 'contemporary political and religious movements;' mentioning the significance of Chartism, Socialism, and religious controversy, he argued that 'such commitment gave their paintings on modern themes an extra vividness.'[115] More radical moves were underway with the inception of 'the social history of art' and the interventions of feminism. Although certain tensions were apparent in the catalogue of *The Pre-Raphaelites*, with some of the entries departing from the approach taken by the institution, the Tate firmly repudiated feminist re-writing and the social history of art. But as nineteenth-century art in Britain and France has increasingly proved productive ground for some of the most innovative studies of the formations of class, gender and sexuality, imperialism and Orientalism, the scholarship represented at the Tate, particularly in the *Pre-Raphaelite Papers*, has tended not to come to fruition. Although three contributors have become the distinguished curators of the next generation, much has changed since 1984: the Pre-Raphaelites and their literature have been completely overhauled in major new accounts which emphasize consumption, class, and the visual representation of sexuality, gender, and race.[116]

Whereas the term 'Pre-Raphaelite' was contested for most of the second half of the nineteenth century, subject to both acclaim and vilification, this is hardly the case in the present. Rather, the infinite expansiveness and elasticity of the term has been accompanied by a far-reaching dissemination in popular culture from the 1960s onwards. Over the past 40 years, there has been huge growth in the influence of Pre-Raphaelitism on the decorative arts and visual culture, including the diffusion of Pre-Raphaelite inspiration into advertising, fashion, and even hairstyling, alongside the abundance of coffee-table books, calendars, posters, and greetings cards. In a decade that saw a widespread reproduction of William Morris prints, critics pointed to the appeal of Pre-Raphaelite art, Bryan Robertson writing in 1975 of 'the popular decorative art spiralling across record sleeves, paperbacks and fabrics for a society starved of decoration.'[117] Tastes have changed, and as Elizabeth Prettejohn so nicely points out, the current artists of the poster trade—Rossetti, Burne-Jones, and Waterhouse—are not necessarily those of the original Brotherhood.[118]

The adjective 'Pre-Raphaelite' has become remarkably flexible, equally applicable to art works, clients, models, and artists. In speaking of 'Pre-Raphaelite patrons' or 'Pre-Raphaelite women collectors,' the reference is to those who acquired certain kinds of imagery,[119] whereas in *Pre-Raphaelite Women Artists* it points to a particular kind of maker.[120] 'Pre-Raphaelite' has been mostly employed as a very elastic term to designate a style of art and design, whether in Robin Ironside and John Gere's *The Pre-Raphaelite Painters* of 1948, Allen Staley's *The Pre-Raphaelite Landscape*, first issued in 1973, or innumerable museum catalogues. The term has heralded an expansion of the field with studies such as *The Pre-Raphaelite Camera* or *Pre-Raphaelite Sculpture*. In the past decade it has announced new areas of design history with Charlotte Gere and Geoffrey C. Munn's *Pre-Raphaelite to Arts and Crafts Jewelry* and has acquired international resonance with *Pre-Raphaelite Art in its European Context*.[121] Since it necessitates some sort of definition, 'Pre-Raphaelitism' has been generally avoided, and the *portmanteau* term 'Pre-Raphaelites' remains the favored title. Variations on this theme promote location, offering glimpses of *The Pre-Raphaelites in Oxford*, Birmingham, Manchester, the North East of England or Merseyside.[122]

The continued production of individuating monographs, surveys, and catalogues testifies to the longevity of the discursive strategy which disperses Pre-Raphaelitism into the Pre-Raphaelites. Narratives of individual achievement comprised a prominent strand in the post-war development of art history as an independent academic discipline and the fostering through art publishing of close links to middle-class, middlebrow consumerism. Ernst Gombrich's *The Story of Art* announced in the mid-1950s that the story of art was no more and no less than the story of artists. Although Rachel Barnes attributed an enthusiasm for the Pre-Raphaelites to a desire for escapism from the competitive materialism of the Thatcher years,[123] the fashioning of the artist in terms of singular creativity and self-expression played into the appropriation of 'Victorian values' of self-help and individual endeavor espoused by Margaret Thatcher and her government in the early 1980s. Margaret Thatcher was the guest of honor at the dinner held at the Tate on March 28, 1984 to inaugurate the exhibition (Figure 1.4). Her presence manifested the increasing entanglement of public culture and corporate enterprise on a global scale. *The Pre-Raphaelites* was sponsored by a multinational corporation, Pearson, whose extensive holdings included manufacturers, mining companies, and merchant bankers, a raft of heritage and entertainment concerns, as well as publishers.[124]

If recent studies have been shaped by late romantic concepts of the personal quest and self-expression of the artist, recently reborn in the mythologies of the YBAs, or young British artists, they have equally been informed by twentieth-century ideas about sexuality.[125] The life and letters as much as the 'new' art history have been challenged by the life and loves. A tension

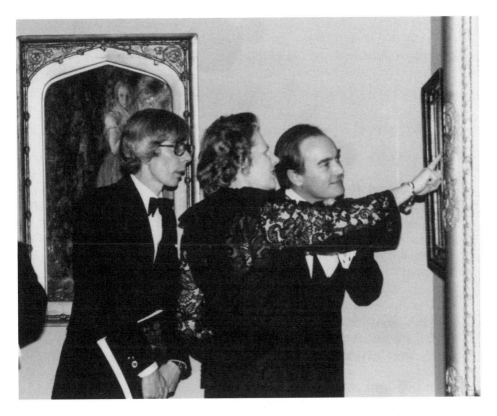

1.4 *The Pre-Raphaelites* exhibition Tate Gallery, 1984, showing Margaret Thatcher
visiting the exhibition accompanied by Leslie Parris and Peter Palumbo

between the stories of life and love and a more serious engagement with the
historical circumstances of production and consumption was written into
The Pre-Raphaelites. Bowness's introduction attributed the dissolution of the
artistic fraternity, so necessary to the story of great individuals, to the fact
that '[g]irls had now entered the Pre-Raphaelite circle, and the close group
of young men was breaking up.' He chronicled Rossetti's 'growing passion'
for Elizabeth Siddall and his 'sexual attraction' to her, speculated at length
on the relations between Rossetti, Morris, and Jane Burden, and dwelt on
Rossetti's discovery of 'the pleasures of the company of a different kind of
woman [who] enter[s] his art and life.' In contrast to Bowness's perception
of *The Hireling Shepherd* as a record of a 'sexual temptation for Hunt
personally, perhaps even his own seduction by or of the girl and his loss of
sexual virginity,' Judith Bronkhurst, in a lengthy entry, locates the painting
within the debates about Catholicism.[126] It has, nevertheless, become almost
impossible to write about the Pre-Raphaelites without some reference to

love affairs, preferably those doomed by circumstance, as is evidenced by a lengthy entry on Burne-Jones's *Perseus and Andromeda* (1876), published in 1994. A serious account of the commission and history of the picture is suddenly interrupted:

In 1869 Burne-Jones's lover Mary Zambaco became very distressed at the state of their relationship and attempted to kill herself first by laudanum and then by drowning. It has been suggested Andromeda's features are similar to those of Mary Zambaco and that the scene on the left hand side of the painting is an allusion to Zambaco's plight and subsequent attempt at rescue by Burne-Jones.[127]

In these neo-romantic narratives of the artist, personal anguish generates great art. And in their tales of masculine creativity, women become tragic figures, sick or suicidal or both, as in the stories about Elizabeth Siddall. No longer recognized as practising artists, these women become model, muse, and mistress. They are transformed into the pervasive sign 'woman,' which signifies not the woman herself or her active practice as an artist but masculine creativity.[128] The literature on Elizabeth Siddall, and dissention over the spelling of her name, acutely demonstrates the conflicts over women's role in Pre-Raphaelitism. In 1991 Jan Marsh's exhibition and catalogue situated Elizabeth Siddall's art within a largely biographical framework, while *Rossetti's Portraits of Elizabeth Siddal[l]* by Virginia Surtees presented, with a bare minimum of text, a selection of Rossetti's drawings of the artist. Screening out images by the many other painters for whom she had modeled, and those which portrayed her as other than languid, reclining or inert, the collection produced Siddall as neither a practising artist nor an active agent, but as a screen for masculine fantasy and desire, a sign of masculine creativity, the catalyst for a singular obsession.[129]

Perhaps it is not surprising then that women artists have been robustly omitted in major collections or showings of Pre-Raphaelite art: as Siddall's work was minimized at the Tate in 1984, Evelyn De Morgan's was neglected at the *Symbolism and Britain* exhibition in 1997.[130] If 'Pre-Raphaelite' is an uncontentious term, the issue of who was, or may be defined as, a 'Pre-Raphaelite' is still open to question. These recent curatorial and art historical strategies contrast to those of the 1850s, when a number of Pre-Raphaelite exhibitions brought together an eclectic range of artists in London and the United States. Works by Elizabeth Siddall were displayed at the Pre-Raphaelite exhibition at Russell Place in London in the summer of 1857. The American Exhibition of British Art, selected by William Michael Rossetti, included a substantial number of works by women. As a critic, Rossetti actively intervened in debates about gender and art. A stalwart supporter of women's suffrage, which he advocated on 'the general ground of liberty and justice,' it is perhaps not surprising that in the decade in which discussion of the new phenomenon of the 'female artist' was widespread and sexual

segregation strengthened in the established artists' societies, he should curate an exhibition with an innovative gender balance.[131]

In the reassessment of the Victorians which took place from the 1960s onwards, Rossetti and Burne-Jones became emblematic of the masculine artist whose artistic interests were inextricably linked to his sexual activity, a narrative in which woman figures as a sign of that sexuality and creativity. As the Victorian period was re-evaluated, the Pre-Raphaelites figured in the emergent discourses of libertarianism as great male lovers whose exotic liaisons with beautiful mistresses produced a sexual as well as artistic avant-garde. From Oswald Doughty's revelations in 1964 of the relationship between Rossetti and Jane Morris, Rossetti's life has provided fertile ground for staging masculine mythologies of the artist as a bohemian, wayward genius, forever in pursuit of and inspired by lovely women.[132] Interest in Millais's life, if not his art, has been kindled by the retelling of a romantic and adulterous liaison with Effie Gray.[133] And Pre-Raphaelite images of women became a selling point as much as a subject of scholarly concern. Jeremy Maas presented works for sale on the commercial market under banners such as *Stunners*, a sobriquet inspired by Rossetti's slang.[134] Surveys and overviews have discovered a Pre-Raphaelite 'cult of beauty.' In common with the collection of Rossetti's portraits of Elizabeth Siddall, they emphasized sensuous mood and decorative effect, and conflated the beauty of the work with the beauty of the model.[135]

The reinvigoration of feminist studies in the 1960s and 1970s provoked a sustained critique of Pre-Raphaelite images of women, launching a contested set of interpretations which draw variously on social history, psychoanalysis or biography to focus on female models and the homosocial/heterosexual contexts of production and consumption, reading Pre-Raphaelite representations of women 'against the grain.'[136] Feminism has also generated a raft of studies that have challenged mythic accounts of masculine creativity to reinstate the creative agency of female practitioners. New research recasts Maria Terpsithea Cassavetti Zambaco (1843–1914) as one of many 'Pre-Raphaelite' women artists, a skilled metal worker and sculptor exhibiting in London and Paris whose membership in the Greek community had a significant impact on her art.[137] Recent studies have attended to the massive task of rediscovering lost lives as well as pictures, drawings, and sculptures 'hidden from history,' weaving a neo-Victorian thematic of 'separate spheres' into accounts of women, sisters, artists, and models, and thereby recasting the theatre of the Pre-Raphaelites.[138] Exhibition catalogues and overviews of individual practitioners and collectives have focused attention on little-known artists and their works and filled in the gaps. But as Griselda Pollock has explained, if the canon is only perceived as a system of exclusion, the addition of women artists in a separate category ensures that definitions and boundaries remain relatively consistent.[139] Current accounts favor the telling of the life-story, weaving art and life together. If biography has proved a resilient resource for documenting and re-instating

the lives and works of women artists, it nevertheless relies on that model of individuation which in the nineteenth century so powerfully provided for women's exclusion. Although this approach indicates the historical conditions of production or consumption, it places the art in the frame of the artist. As a counter-weight, the scholarly catalogues and exhibitions dedicated to Evelyn De Morgan, for example, have done much to resituate this artist's work within the cross-currents of late nineteenth-century practice.[140] Innovative studies are now shifting attention to women's participation in the contested regimes of representation and signification, shaped by formations of race and ethnicity as much as sexual difference. In connecting an attention to women as artists with a consideration of woman as image, these approaches recognize that, in practising art, women artists are not only makers of signs but also participants in a 'double session' of representation;[141] negotiating their own image, they worked within and transformed the visual codes of femininity. Although there is an abundance of studies on the 'Pre-Raphaelite' women, it is perhaps here that the terms 'Pre-Raphaelite,' 'Pre-Raphaelites,' and 'Pre-Raphaelitism' face their greatest challenge in rethinking a history of art in which the practice of women and the concerns of difference set the terms of definition.

Notes

I am indebted to the editors of the volume for their judicious editing and to the participants of the conference session at which this paper was first presented. I warmly thank archivists and librarians at Tate for generous assistance in locating materials and photographs. The research was supported by a grant from the Arts and Humanities Research Council.

1. Alan Bowness, 'Foreword,' in *The Pre-Raphaelites*, exh. cat., ed. Leslie Parris, London: The Tate Gallery in association with Allen Lane and Penguin, 1984, p. 7. *The Pre-Raphaelites* was published without an author, and only when it was republished in 1994 was the in-house curator Leslie Parris credited with the project.

2. John Christian's entry for *Le Chant d'Amour* (no. 149) points out that 'the design was conceived as part of the decoration of a small upright piano that the Burne-Joneses were given as a wedding present in 1860,' p. 228. Morris was represented by only one item, *Queen Guinevere*, now titled *La Belle Iseult* (no. 94).

3. Ray Watkinson, *Pre-Raphaelite Art and Design*, London: Studio Vista and Greenwich, CT: New York Graphic Society, 1970.

4. *Dante Gabriel Rossetti and His Circle: A Loan Exhibition of Paintings, Drawings and Decorative Objects by the Pre-Raphaelites and Their Friends*, exh. cat., Lawrence: University of Kansas Museum of Art, 1958. The exhibition also included unpublished manuscripts and printed books from the University library.

5. Martin Harrison and Bill Waters, *Burne-Jones*, London: Barrie and Jenkins, 1973.

6. Paul R. Thompson, *The Work of William Morris*, London: Heinemann, 1967; Philip Henderson, *William Morris: His Life and Friends*, London: Thames and Hudson, 1967; Ray Watkinson, *William Morris as Designer*, London: Studio Vista, 1967; Raymond Williams, *Culture and Society, 1750–1950*, London: Chatto & Windus and New York: Columbia University Press, 1958. E.P. Thompson's revised edition in 1977 of *William Morris: Romantic to Revolutionary*, first published in 1955, charts the changing climate of reception for Morris's ideas in the twentieth century. Socialism is not a subject much countenanced by curators; see *William Morris*, exh. cat., London: Victoria and Albert Museum in association with H.M. Stationery Office, 1958; and *William Morris*, exh. cat., ed. Linda Parry, London: Victoria and Albert Museum in association with Philip Wilson, 1996.

7. Nicholas Shrimpton, *The Times Literary Supplement*, April 13, 1984, 405.

8. *William Morris Today*, exh. cat., London: Institute of Contemporary Arts, 1984, p. 7.

9. Peter Fuller, 'Conserving "joy in labour",' in *ibid.*, p. 93.

10. Mary Bennett, curator at the Walker Art Gallery in Liverpool, organized *Ford Madox Brown* (1964), *John Everett Millais* (1967), and *William Holman Hunt* (1969); John Gere curated *Dante Gabriel Rossetti, Painter and Poet* at the Royal Academy in 1973, and John Christian curated *Burne-Jones: The Paintings, Graphic and Decorative Work of Sir Edward Burne-Jones, 1833–98*, for the Arts Council of Great Britain, 1975.

11. See Jeremy Maas, 'The Pre-Raphaelites: a personal view,' in Leslie Parris (ed.), *Pre-Raphaelite Papers*, London: The Tate Gallery, 1984, pp. 226–34.

12. Mary Bennett, for example, noted briefly Hunt's design for a lantern for *The Light of the World*, then untraced (*William Holman Hunt*, p. 34).

13. Timothy Hilton, *The Pre-Raphaelites*, London: Thames and Hudson, 1970; John Nicoll, *The Pre-Raphaelites*, London: Studio Vista, 1970; Christopher Wood, *The Pre-Raphaelites*, London: Weidenfeld and Nicolson, 1981; Andrea Rose, *The Pre-Raphaelites*, Oxford: Phaidon, 1977, rev. edn, 1981.

14. Brian O'Doherty, *Inside the White Cube: The Ideology of Gallery Space*, 1986, expanded edn, Berkeley: University of California Press, 1999, p. 14.

15. These are: 1845–48, 1849–50, 1851–54, 1855–56, 1857–60, after 1860.

16. *The Pre-Raphaelites*, exh. cat., ed. Leslie Parris, p. 11.

17. *Ibid.*, p. 26.

18. *Ibid.*, pp. 12–13.

19. *Ibid.*, p. 26.

20. *Ibid.*, p. 85.

21. *Ibid.*, p. 129.

22. *Ibid.*, p. 157.

23. *Ibid.*, p. 21.

24. *Ibid.*, p. 23.

25. *Ibid.*, p. 193.

26. While Ford Madox Brown's 'paradoxical position,' as William Vaughan defines it elsewhere in this volume, has had negative effects, the Tate's casting of Brown as the movement's founding father and antecedent elder figure reiterates the all-too-familiar preoccupation with origins and genealogies.

27. Alfred Barr's flow chart on the jacket of the first edition of *Cubism and Abstract Art*, New York: Museum of Modern Art, 1936.

28. *The Pre-Raphaelites*, exh. cat., ed. Leslie Parris, p. 11.

29. William Michael Rossetti (ed.), *Dante Gabriel Rossetti: His Family-Letters with a Memoir by William Michael Rossetti*, 2 vols, London: Ellis and Elvey and Boston: Roberts Brothers, 1895, vol. 1, p. 135.

30. *Ibid.*

31. *Ibid.*, pp. 15–16.

32. *Ibid.*, p. 26. This was to be demonstrated in *The Age of Rossetti, Burne-Jones and Watts: Symbolism in Britain 1860–1910*, exh. cat., eds Andrew Wilton and Robert Upstone, London: The Tate Gallery Publishing and Paris and New York: Flammarion, 1997. Harrison and Waters had discussed Burne-Jones in relation to Symbolism in 1973.

33. Clive Bell, *Landmarks in Nineteenth-Century Painting*, London: Chatto and Windus and New York: Harcourt, Brace, 1927.

34. Charles Harrison, '"Englishness" and "Modernism" revisited,' *Modernism/Modernity*, 6 (1), January 1999, 75–90.

35. Bowness published on Terry Frost, Lynn Chadwick, and Ivon Hitchens in *British Art and the Modern Movement, 1930–1940*, exh. cat., London: Welsh Committee of the Arts Council of Great Britain, 1962; *Modern Sculpture*, London: Studio Vista, 1965; *Henry Moore: The Complete Sculpture*, 6 vols, London: Lund Humphries, 1944–88; and *The Complete Sculpture of Barbara Hepworth, 1960–69*, London: Lund Humphries, 1971.

36. *The Pre-Raphaelites*, exh. cat., ed. J. Gere, London: Whitechapel Art Gallery, 1972.

37. Elizabeth Prettejohn, *The Art of the Pre-Raphaelites*, London: Tate Publishing and Princeton, NJ: Princeton University Press, 2000.

38. *Pictures, Drawings, Designs and Studies by the Late Dante Gabriel Rossetti*, exh. cat., intro. by H.V. Tebbs, London: Burlington Fine Arts Club, 1883, p. 6, p. 10.

39. Percy H. Bate, *The English Pre-Raphaelite Painters, Their Associates and Successors*, London: George Bell and Sons, 1899.

40. *Millais*, exh. cat., Liverpool: Walker Art Gallery and London: Royal Academy of Arts, 1967, p. 3.

41. *Burne-Jones: The Paintings, Graphic, and Decorative Work of Sir Edward Burne-Jones, 1833–98*, exh. cat., London: Hayward Art Gallery in association with the Arts Council of Great Britain, 1975, p. 7.

42. Cosmo Monkhouse, 'Drawings and studies by Sir Edward Burne-Jones,' in *Exhibition of Drawings and Studies by Sir Edward Burne-Jones*, exh. cat., London: Burlington Fine Arts Club, 1899, p. 7. This vision of Burne-Jones as dreamer was one of several competing for attention in the years after his death. Sidney Colvin, writing in the *Catalogue of an Exhibition of Drawings and Studies by Sir Edward Burne-Jones*, exh. cat., London: Leicester Galleries in association with Ernest Brown & Phillips, 1904, p. 5, who also quotes this letter, points to dissension about the artist, concluding that he is universally admired for his 'pre-eminent industry' and as 'an indefatigable worker.' See: *Edward Burne-Jones: Victorian Artist-Dreamer*, exh. cat., eds Stephen Wildman and John Christian, New York: Metropolitan Museum of Art, 1998.

43. R. Barnes, *The Guardian*, December 12, 1994, 4–5.

44. Gayatri Chakravorty Spivak, 'Three women's texts and a critique of imperialism,' *Critical Inquiry*, 12 (1), Autumn 1985, 243–61; Deborah Cherry, *Beyond the Frame: Feminism and Visual Culture, Britain 1850–1900*, London and New York: Routledge, 2000.

45. *Exhibition of the Works of Sir Edward Burne-Jones*, exh. cat., London: New Gallery, 1892 and 1898; *Studies and Drawings by Sir Edward Burne-Jones*, London: Fine Art Society, 1896; *Exhibition of Drawings and Studies by Sir Edward Burne-Jones*, exh. cat., London: Burlington Fine Arts Club, 1899; *Catalogue of an Exhibition of Drawings and Studies by Sir Edward Burne-Jones*, exh. cat., intro. by Sidney Colvin, London: Leicester Galleries in association with Ernest Brown & Phillips, 1904.

46. *Catalogue of an Exhibition of Pictures, Drawings and Studies for Pictures made by the Late Sir J.E. Millais*, exh. cat., intro. by John Guille Millais, London: the Fine Art Society, 1901, n.p.

47. On the legacies of empire in London, see Deborah Cherry, 'Statues in the square, hauntings at the heart of empire,' *Art History*, 29 (4), September 2006, 660–97.

48. *Exhibition of the Works of Sir Edward Burne-Jones*, exh. cat., 1898, n.p.

49. Cosmo Monkhouse, in *Exhibition of Drawings and Studies by Sir Edward Burne-Jones*, pp. ix–x.

50. *Works by the Old Masters and by Deceased Masters of the British School Including a Special Selection from the Works of J. Linnell and Dante Gabriel Rossetti*, exh. cat., London: the Royal Academy of Arts in association with William Clowes and Sons, 1883. Rooms 1 and 2 were dedicated to John Linnell, and rooms 3 and 4 to the Old Masters, with rooms 5 and 6 set aside for Rossetti. The Millais retrospective, by comparison, occupied rooms 1 to 5.

51. *Pictures, Drawings, Designs and Studies by the Late Dante Gabriel Rossetti*, exh. cat., intro. by H.V. Tebbs, London: Burlington Fine Arts Club, 1883.

52. *The Times*, December 30, 1882, 6.

53. Elizabeth Prettejohn, *Rossetti and His Circle*, London: Tate Gallery Publishing and New York: Stewart, Tabori & Chang, 1997, p. 70.

54. Tebbs, 'Introduction,' in *Pictures, Drawings, Designs and Studies*, exh. cat., p. 10.

55. *The Times*, December 30, 1882, 6.

56. M.H. Spielmann, *Millais and His Works*, Edinburgh: Blackwood, 1898.

57. Rossetti worked as a civil servant and this work competed with his writing activities. See *The Diary of W.M. Rossetti, 1870–1873*, ed. Odette Bornand, Oxford: Clarendon Press, 1977; and Julie L'Enfant, *William Rossetti's Art Criticism: The Search for Truth in Victorian Art*, Lanham, MD and Oxford: University Press of America, 1999.

58. Dianne Sachko Macleod, 'F.G. Stephens, Pre-Raphaelite critic and art historian,' *Burlington Magazine*, 128 (999), June 1986, 398–406.

59. F.G. Stephens, *William Holman Hunt and His Works: A Memoir of the Artist's Life, with Descriptions of His Pictures*, London: James Nisbet & Co., 1860; and *Dante Gabriel Rossetti*, London: Seeley & Co. and New York: Macmillan & Co., 1894.

60. Ford Madox Ford [Ford M. Hueffer], *Ford Madox Brown: A Record of His Life and Work*, London and New York: Longmans, Green & Co., 1896.

61. John Guille Millais, *The Life and Letters of Sir John Everett Millais, President of the Royal Academy*, 2 vols, London: Methuen & Co., 1899.

62. Georgiana Burne-Jones, *Memorials of Edward Burne-Jones*, 2 vols, London and New York: Macmillan & Co., 1904.

63. Meaghan Clarke, *Critical Voices: Women and Art Criticism in Britain, 1880–1905*, Aldershot, England and Burlington, VT: Ashgate, 2005, pp. 29–30.

64. Jacques Derrida, 'Living on: border lines' (1979), in Peggy Kamuf (ed.), *A Derrida Reader: Between the Blinds*, London: Harvester Wheatsheaf and New York: Columbia University Press, 1991, pp. 254–68.

65. Jacques Derrida, 'Signature Event Context' (1972), in Derrida, *Margins of Philosophy*, trans. A. Bass, Chicago: University of Chicago Press and Brighton: Harvester Press, 1982, pp. 307–31.

66. William Michael Rossetti, *Dante Gabriel Rossetti as Designer and Writer*, London: Cassell & Co., 1889; *Dante Gabriel Rossetti: His Family-Letters*; *Ruskin, Rossetti, Pre-Raphaelitism: Papers 1854 to 1863*, London: George Allen and New York: Dodd, Mead & Co., 1899; *Pre-Raphaelite Diaries and Letters: Papers 1854 to 1862*, London: Hurst and Blackett, 1900; *Rossetti Papers, 1862–70: A Compilation*, London: Sands & Co., 1903; *Some Reminiscences of William Michael Rossetti*, 2 vols, London: Brown, Langham & Co. and New York: Charles Scribner's Sons, 1906, *The Works of Dante Gabriel Rossetti*, rev. edn, London: Ellis, 1911.

67. William Michael Rossetti, *Dante Gabriel Rossetti as Designer and Writer*, p. 3.

68. William Michael Rossetti, 'Introduction,' in *Pre-Raphaelite Diaries and Letters*, n.p.

69. William Michael Rossetti (ed.), *Dante Gabriel Rossetti: His Family-Letters*, vol. 1, p. xi, p. xii.

70. Michel Foucault, *The Archaeology of Knowledge*, trans. A.M. Sheridan Smith, London: Tavistock Publications and New York: Pantheon, 1972.

71. For example, William Fredeman argues that 'As life documents [Rossetti's letters] provide the most immediate access to an understanding of his life.' Dante Gabriel Rossetti, *The Correspondence of Dante Gabriel Rossetti*, ed. William E. Fredeman, 6 vols, Cambridge: D.S. Brewer, 2002–06, vol. 1, p. xxvi.

72. Michel Foucault, 'What is an author?,' trans. D. Bouchard, *Screen*, 20 (1), Spring 1979, 13–33.

73. Julie F. Codell classifies this text as a bio-history, a project in which the individual is located within a collectivity. She demonstrates how Hunt portrayed himself as originator of the Brotherhood and the linchpin of English art, which was culturally hegemonic in the west. 'The artist colonized: Holman Hunt's "bio-history", masculinity, nationalism and the English school,' in Ellen Harding (ed.), *Re-framing the Pre-Raphaelites: Historical and Theoretical Essays*, Aldershot, England: Scolar Press and Brookfield, VT: Ashgate, 1996, pp. 211–29.

74. William Holman Hunt, *Pre-Raphaelitism and the Pre-Raphaelite Brotherhood*, 2 vols, London: Macmillan & Co., 1905, vol. 1, p. 1, vol. 2, p. 86.

75. Jacques Derrida, *Of Grammatology*, 1967, trans. Gayatri Chakravorty Spivak, Baltimore and London: Johns Hopkins University Press, 1976, pp. 11–12.

76. Thaïs E. Morgan (ed.), *Victorian Sages and Cultural Discourse: Renegotiating Gender and Power*, New Brunswick and London: Rutgers University Press, 1990.

77. See Frank M. Turner, *John Henry Newman: The Challenge to Evangelical Religion*, New Haven and London: Yale University Press, 2002.

78. Codell, 'The artist colonized,' p. 217.

79. *The Times Literary Supplement*, April 16, 1914, 183.

80. William Holman Hunt, 'The Pre-Raphaelite Brotherhood: a fight for art,' *Contemporary Review*, 49, 1886, 471–88, Part II, 737–50, Part III, 820–33; 'Painting *The Scapegoat*,' *Contemporary Review*, 52, 1887, 21–38, 206–20.

81. Gerald Robert Reitlinger, *The Economics of Taste: The Rise and Fall of Picture Prices*, 3 vols, London: Barrie and Rockliff, 1961–70, vol. 1, 1961, p. 167. Reitlinger also notes that rising prices as well as reputation were entangled in the claims and counter-claims about the membership of the movement, citing John Guille Millais's refusal to admit Dante Gabriel Rossetti as a Pre-Raphaelite in his biography of his father, p. 144.

82. William Kenrick, 1831–1919, owned Burne-Jones's *The Feast of Peleus* (1872–81, Birmingham Museums and Art Gallery), acquiring it from Graham's collection.

83. Reitlinger, *The Economics of Taste*, vol. 1, p. 165.

84. In *Burne-Jones*, exh. cat., 1975, p. 65, John Christian notes that *Love and the Pilgrim* was returned unsold from the New Gallery exhibition of 1897.

85. Cited in *Morris and Company: Pre-Raphaelites and the Arts and Crafts Movement in South Australia*, exh. cat., ed. Christopher Menz, Adelaide: Art Gallery Board of South Australia, 1994. p. 67. *Perseus and Andromeda* was acquired in 1902–03.

86. Alicia Craig Faxon, 'Rossetti's reputation: a study of the dissemination of his art through photographs,' in Helene E. Roberts (ed.), *Art History Through the Camera's Lens*, Amsterdam: Gordon and Breach, 1995, p. 321.

87. *Ibid.*, p. 326.

88. The Rossetti exhibition at the Burlington Fine Arts Club in 1883 included a photograph of a crayon drawing of *Rosa Triplex*, c. 1869, 'supposed to be lost.'

89. H.C. Marillier, *Dante Gabriel Rossetti: An Illustrated Memorial of His Art and Life*, London: George Bell and Sons, 1899, p. 105 illustrates the first version. Virginia Surtees, *The Paintings and Drawings of Dante Gabriel Rossetti (1828–1882): A Catalogue Raisonné*, 2 vols, Oxford: Clarendon Press, 1971, vol. 1, p. 77, no. 124.

90. Laura Marcus, 'Brothers in their anecdotage,' in Marcia Pointon (ed.), *Pre-Raphaelites Re-Viewed*, Manchester and New York: Manchester University Press, 1989, p. 13.

91. Laurel Bradley, 'The Englishness of Pre-Raphaelite painting: a critical review,' in Margaretta Frederick Watson (ed.), *Collecting the Pre-Raphaelites: The Anglo-American Enchantment*, Aldershot, England and Brookfield, VT: Ashgate, 1997, pp. 199–208.

92. As in Bate, *The English Pre-Raphaelite Painters*.

93. Valerie Sanders, *The Private Lives of Victorian Women: Autobiography in Nineteenth-Century England*, New York: St Martin's Press, 1989.

94. See Cherry, *Beyond the Frame*, and Clarke, *Critical Voices*.

95. Homi K. Bhabha, *The Location of Culture*, London and New York: Routledge, 1994, p. 32.

96. Codell, 'The artist colonized,' p. 211; Marcia Pointon, 'The artist as ethnographer: Holman Hunt and the Holy Land,' in Pointon (ed.), *Pre-Raphaelites Re-Viewed*, pp. 22–44. Deborah Cherry and Griselda Pollock, 'Patriarchal power and the Pre-Raphaelites,' *Art History*, 7 (4), December 1984, 480–95.

97. Frank Mort, *Dangerous Sexualities: Medico-Moral Politics in England since 1830*, London: Routledge and Kegan Paul, 1987.

98. Tebbs, 'Introduction,' in *Pictures, Drawings, Designs and Studies*, exh. cat., p. 5.

99. On the civilizing subject, see Catherine Hall, *Civilising Subjects: Metropole and Colony in the English Imagination, 1830–67*, Chicago: University of Chicago Press and London: Polity Press, 2002.

100. Homi K. Bhabha, 'Of mimicry and man: the ambivalence of colonial discourse,' in Bhabha, *The Location of Culture*, p. 131.

101. *The Times*, December 30, 1882, 6.

102. *The Pre-Raphaelites*, exh. cat., ed. Leslie Parris, p. 7.

103. *Ibid.*, pp. 44–5.

104. Pierre Bourdieu, *Distinction: A Social Critique of the Judgment of Taste*, 1979, trans. Richard Nice, London: Routledge and Kegan Paul and Cambridge, MA: Harvard University Press, 1984.

105. Quentin Bell, *Ruskin*, Edinburgh: Oliver and Boyd, 1963; *The Schools of Design*, London: Routledge and Kegan Paul, 1963; *Victorian Artists*, London: Routledge and Kegan Paul and Cambridge, MA: Harvard University Press, 1967; *Virginia Woolf: A Biography*, London: Hogarth Press and New York: Harcourt Brace Jovanovich, 1972; and *A New and Noble School: The Pre-Raphaelites*, London: Macdonald, 1982. His reflections on 'The Pre-Raphaelites and their critics' was included in Parris (ed.), *Pre-Raphaelite Papers*, pp. 11–22.

106. Rosalie Glynn Grylls, Lady Mander, wrote *Mary Shelley: A Biography*, London and New York: Oxford University Press, 1938; *Trelawny*, London: Constable, 1950; and *Portrait of Rossetti*, London: Macdonald and Carbondale: Southern Illinois University Press, 1964.

107. Virginia Surtees, *Rossetti Catalogue Raisonné*; *The Diaries of George Price Boyce*, Norwich: Real World Publishers, 1980; and *The Diary of Ford Madox Brown*, New Haven and London: Published for the Paul Mellon Centre for Studies in British Art by Yale University Press, 1981.

108. Diana Holman Hunt, *My Grandfather, His Wives and Loves*, London: Hamilton and New York: Norton, 1969.

109. Mary Lutyens (ed.), *Millais and the Ruskins*, London: John Murray and New York: Vanguard Press, 1967.

110. Leonore Davidoff, *The Best Circles: Society, Etiquette and the Season*, London: Croom Helm, 1973.

111. Maas noted that he 'still number[s] all of them among my friends,' in Parris (ed.), *Pre-Raphaelite Papers*, p. 230.

112. Noel Annan, 'The intellectual aristocracy,' in J.H. Plumb (ed.), *Studies in Social History: A Tribute to G.M. Trevelyan*, London and New York: Longmans, Green & Co., 1955, pp. 243–87.

113. A key player here was W.E. Fredeman, Professor at the University of British Columbia in Vancouver, whose exhaustive bibliography of Pre-Raphaelitism was published in 1965 and whose extensive knowledge of Pre-Raphaelite documentation was consolidated on visits to descendants.

114. See the introduction to Deborah Cherry (ed.), *Art: History: Visual: Culture*, Malden, MA: Blackwell Publishing, 2005.

115. *Pre-Raphaelite Paintings from the Manchester City Art Gallery*, exh. cat., ed. Julian Treuherz, London: Lund Humphries in association with the City of Manchester Art Galleries, 1980, p. 11.

116. Dianne S. Macleod, *Art and the Victorian Middle-Class: Money and the Making of Cultural Identity*, Cambridge and New York: Cambridge University Press, 1996; Tim Barringer, *The Pre-Raphaelites: Reading the Image*, London: Weidenfeld and Nicolson, 1998; Prettejohn, *The Art of the Pre-Raphaelites*.

117. Bryan Robertson, *The Times*, October 26. 1975, n.p. Tate archives.

118. Elizabeth Prettejohn, *Rossetti and His Circle*, p. 6.

119. Dianne S. Macleod, 'The identity of Pre-Raphaelite patrons,' in Harding (ed.), *Re-framing the Pre-Raphaelites*, pp. 7–26; and 'Pre-Raphaelite women collectors and the female gaze,' in Watson, *Collecting the Pre-Raphaelites*, pp. 109–20.

120. *Pre-Raphaelite Women Artists*, exh. cat., eds Jan Marsh and Pamela Gerrish Nunn, London and New York: Thames and Hudson, 1998; originally published Manchester: Manchester City Art Galleries, 1997.

121. Robin Ironside and John Gere, *The Pre-Raphaelite Painters*, London: Phaidon Press, 1948; Allen Staley, *The Pre-Raphaelite Landscape*, Oxford: Clarendon Press, 1973, 2nd edn London and New Haven: Published for the Paul Mellon Centre for Studies in British Art by Yale University Press, 2001; Michael Bartram, *The Pre-Raphaelite Camera: Aspects of Victorian Photography*, London: Weidenfeld and Nicolson and Boston: Little Brown & Co., 1985; Charlotte Gere and Geoffrey C. Munn, *Pre-Raphaelite and Arts and Crafts Jewellery*, Woodbridge: Antique Collectors Club, 1996; Joanna Barnes and Benedict Read, *Pre-Raphaelite Sculpture: Nature and Imagination in British Sculpture 1848–1914*, London: The Henry Moore Foundation in association with Lund Humphries, 1991; Susan P. Casteras and Alicia Craig Faxon (eds), *Pre-Raphaelite Art in Its European Context*, Madison, NJ: Fairleigh Dickinson University Press and London: Associated University Presses, 1995.

122. William E. Fredeman, *Pre-Raphaelitism: A Bibliocritical Study*, Cambridge, MA: Harvard University Press, 1965; James Sambrook (ed.), *Pre-Raphaelitism: A Collection of Critical Essays*, Chicago and London: University of Chicago Press, 1974; Susan P. Casteras, *English Pre-Raphaelitism and Its Reception in America in the Nineteenth Century*, Rutherford, NJ: Fairleigh Dickinson University Press and London: Associated University Presses, 1990; Rachel Barnes, *The Pre-Raphaelites and Their World*, London: Tate Gallery Publishing, 1998; Andrea Rose, *The Pre-Raphaelites*, Oxford: Phaidon, 1977; Prettejohn, *The Art of the Pre-Raphaelites*; Steven Adams, *The Art of the Pre-Raphaelites*, London: Apple Press and Secaucus, NJ: Cartwell Books, 1988; *Pre-Raphaelites: Painters and Patrons in the North East*, exh. cat., Newcastle upon Tyne: Tyne and Wear Museums Service with assistance from the Paul Mellon Centre for Studies in British Art, 1989; *The Pre-Raphaelites in Oxford*, exh. cat., ed. John Christian, Oxford: Ashmolean Museum, 1974; *The Pre-Raphaelites and Their Circle*, exh. cat., ed. Richard Ormond, Birmingham: Birmingham Museum and Art Gallery, 1965; Roy Hartnell, *Pre-Raphaelite Birmingham*, Studley, Warwickshire: Brewin Books, 1996; *The Pre-Raphaelites and Their Associates in the Whitworth Art Gallery*, exh. cat., Manchester, Whitworth Art Gallery, 1972; *The Pre-Raphaelites on Merseyside*, exh. cat., ed. Frank Milner, York: Village, 1985.

123. Rachel Barnes, *The Guardian*, December 12, 1994, 4–5.

124. Pearson's holdings in the 1980s included Doulton and Co. (plastics, ceramics, and engineering), Doulton Glass Industries, Royal Doulton Tableware (Holdings) Ltd, Fairey Holdings Ltd, Fairy Nuclear Ltd, S. Pearson Industries (land and mineral extraction in North and South Americas, Singapore, Cayman Islands, Nigeria), Lazard and Co. (merchant bankers), Madame Tussauds, Chessington Zoo, London Planetarium, Warwick Castle, and the publishing group Pearson Longman which controlled *The Economist, The Financial Times*, the art magazine *Apollo*, Goldcrest Films, and Longman Penguin.

125. Julian Stallabrass, *High Art Lite: British Art in the 1990s*, London: Verso, 1999; and Mandy Merck and Chris Townsend (eds), *The Art of Tracey Emin*, London and New York: Thames and Hudson, 2002.

126. *The Pre-Raphaelites*, exh. cat., ed. Leslie Parris, pp. 18–25, p. 96.

127. *Morris and Company*, exh. cat., p. 67.

128. Deborah Cherry and Griselda Pollock, 'Woman as sign in Pre-Raphaelite literature: a study of the representation of Elizabeth Siddall,' *Art History*, 7 (2), June 1984, 206–27.

129. *Elizabeth Siddal: Pre-Raphaelite Artist 1829–1862*, exh. cat., ed. Jan Marsh, Sheffield: The Ruskin Gallery, Collection of the Guild of St. George, 1991; *Rossetti's Portraits of Elizabeth Siddal: A Catalogue of the Drawings and Watercolours*, exh. cat., ed. Virginia Surtees, Aldershot: Scolar Press in association with the Ashmolean Museum, Oxford, 1991. Deborah Cherry, 'Elizabeth Eleanor Siddall, 1829–62,' in Elizabeth Prettejohn (ed.), *The Cambridge Companion to the Pre-Raphaelites*, Cambridge: Cambridge University Press, forthcoming.

130. *The Age of Rossetti, Burne-Jones and Watts*, exh. cat., eds. Wilton and Upstone.

131. William Michael Rossetti, *The Diary of W.M. Rossetti, 1870–1873*, p. 189; Jennifer Rinalducci, 'The 1857–58 American exhibition of British art: critical reactions in the cultural context of New York,' in *Athanor*, 20, 2002, 77–83.

132. A key biography is Oswald Doughty, *Dante Gabriel Rossetti: A Victorian Romantic*, London: Frederick Muller and New Haven: Yale University Press, 1949; 2nd edn, London: Oxford University Press, 1960.

133. Euphemia Chalmers Gray Millais, *Effie in Venice: Unpublished Letters of Mrs. John Ruskin Written from Venice between 1849–1852*, ed. Mary Lutyens: London: John Murray, 1965; Lutyens, *Millais and the Ruskins*; and *The Ruskins and the Grays*, London: John Murray, 1972.

134. *Stunners: Paintings and Drawings by the Pre-Raphaelites and Others*, exh. cat., London: Maas Gallery, 1974.

135. Surtees, *Rossetti's Portraits of Elizabeth Siddal*.

136. Griselda Pollock, 'Woman as sign: psychoanalytic readings,' in Pollack, *Vision and Difference*, London and New York: Routledge, 1988, new edn, 2003, pp. 166–211. Lynne Pearce, *Woman/Image/Text: Readings in Pre-Raphaelite Art and Literature*, New York and London: Harvester Wheatsheaf, 1991.

137. *Pre-Raphaelite Women Artists*, exh. cat., eds Marsh and Nunn, pp. 136–7. On women artists of the period, see Deborah Cherry, *Painting Women: Victorian Women Artists*, London and New York: Routledge, 1993.

138. Jan Marsh, *Pre-Raphaelite Women: Images of Femininity in Pre-Raphaelite Art*, London, Weidenfeld and Nicolson, 1987; Jan Marsh and Pamela Gerrish Nunn, *Women Artists and the Pre-Raphaelite Movement*, London: Virago, 1989; Jan Marsh, *The Pre-Raphaelite Sisterhood*, London: Quartet and New York: St. Martin's Press, 1985; *Pre-Raphaelite Women Artists*, exh. cat., eds Marsh and Nunn.

139. Griselda Pollock, *Differencing the Canon: Feminist Desire and the Writing of Art's Histories*, London and New York: Routledge, 1999.

140. *Evelyn De Morgan: Oil Paintings*, exh. cat., ed. Catherine Gordon, London: De Morgan Foundation, 1996, one of a number of publications which, like the work of the De Morgan Study Centre in London, promotes research on this artist.

141. Gayatri Chakravorty Spivak, 'The practical politics of the open end,' in *The Post Colonial Critic: Interviews, Strategies, Dialogues*, ed. Sarah Harasym, New York and London: Routledge, 1990, pp. 67–74, explains the double session of representation, *Vertretung* and *Darstellung*. Deborah Cherry, 'Pre-Raphaelite images of women,' in *Waking Dreams: The Art of the Pre-Raphaelites from the Delaware Art Museum*, exh. cat., ed. Stephen Wildman, Alexandria, VA: Art Services International, 2004, pp. 64–73.

UNIVERSITY OF WINCHESTER
LIBRARY

Pre-Raphaelites from rebels to representatives: masculinity, modernity, and national identity in British and Continental art histories, c. 1880–1908

Julie F. Codell

There is no contemporary school of painting, no modern movement in art, that commands even now more profound attention or retains more completely the interest of the public than that splendid and daring rebellion of half a century ago, which has exercised so great an influence on the painting of the world. It was the revolt of naturalism against convention, of sincerity against affectation.

<div style="text-align: right;">

Anon, review of *The English Pre-Raphaelite Painters*, by Percy Bate, *Magazine of Art*, 24, 1900, 125

</div>

By the time the *Magazine of Art* reviewer wrote this panegyric, the Pre-Raphaelites had been thoroughly transformed from 'daring' rebels to icons of Englishness whose revolt, marked by sincerity and naturalism, had been sanitized, domesticated, commodified, and nationalized. Some reputations were salvaged from bohemianism or decadence (Dante Gabriel Rossetti and Edward Burne-Jones), and the early Brotherhood's ideals enlarged into English ideals of domestic order, masculinity, and class hierarchy in myriad essays and biographies. Debates also raged over whether it was, indeed, naturalism or later symbolism that defined Pre-Raphaelite art. In the wake of poststructuralist thinking we might worry less about its definition as realist or symbolist/aesthetic, its two 'generations,' and its lack of monolithic consistency, and we might instead begin to explore the actual uses of 'Pre-Raphaelitism' in its late Victorian life when the term served many functions beyond art historical categorization. Discussions of style often function to disguise underlying issues such as national identity exemplified by the topic of national 'schools,' central to late nineteenth-century European art histories. The meaning of Pre-Raphaelitism had implications for both British and Continental national identities, and for articulating cultural differences within Europe.

'Pre-Raphaelite' and 'Pre-Raphaelitism' were elastic terms embracing the original Brotherhood, the Aesthetic Movement and late, decorative Pre-Raphaelitism, although the major artists and basic chronological story remained roughly the same for most writers. Such elasticity reveals the 'divisive tendencies in Pre-Raphaelitism from the beginning,' its 'fracture lines' radiating through the rest of the century, as James Sambrook and Inga Bryden point out.[1] Victorian art criticism mapped out these fractures by identifying Pre-Raphaelitism with manliness or effeminacy, Britishness or cosmopolitanism, tradition or modernity. The disciplinary force of the then-new field of art history, itself obsessed with artistic influences, genealogies (Bernard Berenson's word), and stylistic morphologies, further inflected Pre-Raphaelitism's meanings and identities. By around 1908, however, the Pre-Raphaelite Brotherhood (PRB) had become an arbitrary sign of a homogeneous myth sanitized to serve the needs of British cultural politics for a national imagined community.

Begun as a 'rebellion' of artists who yet endorsed a 'feudal or communal Englishness,'[2] their rebelliousness—brief, inchoate, disunified and juvenile—was itself mythologized and socialized. The PRB became institutionalized, its originary moment made mythic and its artists heroic, as in the above quote from the sycophantic *Magazine of Art*.[3] The Brotherhood artists were reconstructed as 'normal' like their solid British public. As John Tomlinson notes, representation and imagery help project unified notions of cultural identity and nationalism. National identity 'has a special political and ideological significance' with a 'good deal of deliberate "cultural construction" involved in the making of national identities.'[4] Pre-Raphaelitism was one cultural construction central to Victorian national identity.

My purpose here is to explore the historical indeterminacy of 'Pre-Raphaelitism' that permitted it to be inflected by concepts of masculinity, modernism, and national identity. The period from 1880 to 1908 was a high point of literary self-consciousness in the construction and fashioning of public meanings of Pre-Raphaelitism. These years were marked by increasing attention to Pre-Raphaelite artists in the press, art histories, auctions, and museums. This tendency culminated in the 1908 Franco-British exhibition catalogue where Pre-Raphaelitism was hailed as British, modern, and world class. British and Continental critics, along with Pre-Raphaelites and their families and friends, all contributed purposefully to turn the 'daring rebels' into representatives of Englishness. My focus in this essay will be writings less well known and relatively unexamined by scholars.[5]

This chapter can only touch the tip of a vast literature in which Pre-Raphaelitism represented everything from anxiety over cultural degeneracy to hubris over cultural superiority. I will focus on literature about 'core' Pre-Raphaelites—William Holman Hunt, John Everett Millais, Dante Gabriel Rossetti, Ford Madox Brown, and Edward Burne-Jones, although critics

described many other artists as Pre-Raphaelite (G.F. Watts, Frederic Leighton, Lawrence Alma-Tadema). Debates raged about who started the movement, who strayed from and who stayed within its founding principles, and what those principles were. National and masculine identities often undergirded these debates, as did anxieties about modernity and cultural/racial decline among writers and artists searching for the 'vigorous, manly, and English' after 1880.[6] These issues also dominated Continental writings about the Pre-Raphaelites, but often with different conclusions.

Masculinity and degeneracy

The late nineteenth-century controversy over the mental imbalance of artists, or 'degeneracy,' which undermined masculine behavior was fabricated by Cesare Lombroso, his popular disciple Max Nordau, and their British followers.[7] Nordau's 1895 book *Degeneration* kept a special place for the PRB, and for Burne-Jones above all, in his section on mysticism, a condition of liminal representations due to the artist's inability to apprehend the 'real connecting links between the simplest and most obviously related phenomena.'[8] Nordau described Pre-Raphaelite medievalism as mythic, unhistorical, and 'outside of time and space—a time of dreams and a place of dreams.'[9] In Nordau's view, Ruskin was 'one of the most turbid and fallacious minds ... the Torquemada of aesthetics,' and Pre-Raphaelites followed Ruskin 'blindly.'[10] Nordau attacked Algernon Swinburne and found feint praise for William Morris as 'intellectually far more healthy than Rossetti and Swinburne.'[11] The Pre-Raphaelite influence attracted 'the hysterical and degenerate,' while only Tennyson, 'so sound a poet,' resisted it.[12]

Historian Alfred Egmont Hake anonymously replied to Nordau and vigorously defended the Pre-Raphaelites.[13] He attacked Nordau for failing to admire the sane altruism of religious feeling and for focusing only on hysterical religious behavior.[14] He insisted Pre-Raphaelite art portrayed a healthy mysticism, which people conduct rationally in daily life and in religious belief.[15] A mystical imagination was 'an indispensable attribute to a well-equipped mind. It is the mental faculty which most distinguishes man from the animals—the one on which he could with the greatest appearance of legitimacy base his claim to divine origin.'[16] Hake defended the Pre-Raphaelites as 'emotionalists, mystics, and even symbolists, and they frankly claimed the right to be regarded as such. They considered themselves as having a mission, and the fact that a man throws himself heart and soul into his mission is no sign of degeneration.'[17] They 'expand the scope of pictorial art, to sanctify it, and to make it appeal to the inmost recesses of our emotional nature.'[18] Hake concluded that their influences were far-reaching, beautiful, imaginative, and innovative,[19] evoking 'a feeling of respect and admiration for religion ... the

higher significance of our spiritual being over our bodily,' especially Burne-Jones's female images, 'devoid of ... coquetry, roguishness, animal spirits, and exuberance of health,' but with 'a contemplative mood and a yearning to see the invisible.'[20] Pre-Raphaelitism 'contributed considerably to the elevation of art so far as aims and subjects go.'[21] Hake attacked the inconsistency of Nordau's assessments of Millais's art as revealing degeneracy, but also as displaying a 'sound mind.'[22]

Critics often attacked Burne-Jones as degenerate based on their reading of his figures' lack of energy, placid expression, and lax body language. *Blackwood's Magazine*'s conservative critic J.B. Atkinson feared Burne-Jones's enervating influence on artists, despite his fertile imagination.[23] Harry Quilter decried Burne-Jones's art as effeminate, sensuous, medievalizing, immoral, and un-English: 'little suited is this spirit of sick-sad dreams to the country I love, and the folks who have made England in the old time, and who are making it to-day.'[24] *The Magazine of Art* editor, M.H. Spielmann, in the artist's defense, portrayed him as a 'normal' artist to shake off associations with degeneracy, dreaming, and decadence. He defended Burne-Jones as 'in the best and highest sense a humorist ... a Radical of Radicals ... a Home Ruler, and always disposed to countenance militant independence' who told Spielmann, 'I approve of rebellions.'[25] Burne-Jones's character emitted 'beauty and nobility' here,[26] along with vigorous masculine militancy defused by a sense of humor. The French critic Robert de la Sizeranne insisted that Burne-Jones's figures' 'bodies are healthy, powerful, almost athletic, but their movement is languid, hesitating, weary, ecstatic ... He never sacrificed beauty of form to achieve expression ... he will always be a great master.'[27]

Masculinity was a pliable term, as in John Ruskin's changing views of the PRB.[28] In 1853 Ruskin emphasized the PRB's masculinity and national mission, comparing them with Old Masters and reiterating the word 'men' over and over. By 1878 Pre-Raphaelite masculinity for Ruskin functioned differently, summed up in his examination of three paintings: Rossetti's *Ecce Ancilla Domini* (1849–50, Tate, London), Millais's *The Blind Girl* (1854–56, Birmingham Museum and Art Gallery), and Burne-Jones's *The King's Wedding* (which Ruskin calls *Bridal*) (1870, private collection). In his view, these three paintings privileged domestic order, the everyday, and submission to religious or social hierarchies as natural orders. Rossetti's Virgin was a simple, surprised girl, no heavenly queen, and Millais's blind girl in nature, not in a workhouse, enjoyed sound, smell, and touch, while Burne-Jones's wedding party celebrated without clergy or other signs of institutional religion to bless their union. Ruskin's changing emphasis, from masculinity to domesticity, socialized and tamed the public image of Pre-Raphaelite artists.[29] Ruskin domesticated them through these paintings, yoking Rossetti's bohemianism, Burne-Jones's associations with decadence, and Millais's manly respectability to construct a moderate brew of Pre-Raphaelite masculinity tied to English adherence to social and domestic orders. Yet he insisted that all

three paintings defied conventions of art, social life, and religious institutions, thereby retaining the PRB's original resistance to conventions in art and in life. Ruskin did not feminize these artists of domestic subjects but still described their masculinity as a 'manifestly opponent and agonistic temper' of their original 'Lutheran challenge' to convention through images of the feminine.[30] Ruskin incorporated Burne-Jones into the Pre-Raphaelite rebellion in order to construct continuity from the PRB to later artists. This he achieved through a coordination of their masculinity as domesticated but not cowed, despite their feminine subjects.

Notions of masculinity were also affected by images of the artist that metamorphosed from gentleman to aesthete during this period. The late nineteenth-century association of artists with effeminacy induced A.L. Baldry to insist that Millais 'manfully' withstood criticism and did many things beyond 'the splendid virility of his art:'

Admirable and sincere though he was in his devotion to his profession,
he did not make it his sole interest; but, outside his studio, threw
himself into the occupations and amusements that are dear to every
man of robust vitality, and are expressive of physical inclinations rather
than intellectual gifts. Our concern is with him as a worker, as one
of the greatest painters that the British School has known ... [31]

Attempting to free Millais from any association with degeneracy, Baldry described him not as a genius but as a worker whose national and masculine roles superseded his artistic performance. Readers were assured that Millais spent as much time hunting, fishing, and riding as he spent painting to restore that sapped strength: 'Healthy vitality has taken the place of morbid decrepitude; and in its restored and robust strength, our native school is capable once again of holding its own against any competitors it may chance to meet.'[32] Millais's vigorous manliness, social respectability, and the 'attractiveness of his personality' qualified him to represent 'the awakening of British art' without excessive imagination or 'dreams and fancies,' allusions to Burne-Jones's 'degeneracy.'[33] Citing the high market value of Millais's paintings, Baldry revealed to no one's surprise the close ties among market value, popularity, the Royal Academy, and manly Englishness.[34] Baldry mythologized Millais's early life, exaggerating the difficulties of the Pre-Raphaelites to stress their struggle and persistence.[35] This 'typically English' artist of 'manly wholesomeness' revealed the fitness of 'our race to dominate the world.'[36] The frontispiece of Arthur Fish's 1923 biography of Millais was the 'masculine' *The Yeoman of the Guard* (1876, Tate, London), similarly used in other biographies. Fish insisted on Millais's wide popularity among working men: *Cherry Ripe* (1879, private collection) was beloved by 'Australian miners, Canadian backwoodsmen, South African trekkers and all sorts and conditions of Colonial residents,' making his art universal in its appeal to Britain's most manly descendents.[37]

Although Ernest Radford considered Rossetti a genius with 'desirable masculine traits' of buoyancy, vigor, and candidness,[38] Rossetti's bohemian persona threatened to contaminate his role as a Pre-Raphaelite. In 1904 Arthur Benson confronted stories that 'stimulated public curiosity ... exaggerating all that was morbid, darkening every shadow, ... lapses from conventional standards, and substituting for the brave, genial, robust personality ... an affected, decadent, fantastic figure, posturing in a gloomy *danse macabre*, or wandering in an airless labyrinth of poisonous loveliness.'[39] Benson's Rossetti was sociable and sunny, 'like Ion on the temple platform, with the virginal freshness of the opening day about him, intent upon his holy service ... untainted by passion, unshadowed by the sombre clouds that darken the later life.'[40] So contradictory was Rossetti's reputation that Benson felt obliged to have a separate chapter on his character, un-English in its mysticism and passion for beauty, but not guilty of 'mere sensuous impulse.'[41] Benson separated Rossetti's genius from his character, which was tragic but not degenerate.

In 1902 Wyke Bayliss masculinized art as 'the vibrating of the heart of Aeneas—the manhood of the man himself.'[42] He emphasized 'the relation in which Art stands to the people of the land' and praised Ruskin for defining a modern relationship between art and religion through the character of the artist.[43] The painters Bayliss praised (Millais, Burne-Jones, Hunt, Leighton and Watts) 'have brought a gracious element into the National Life ... [and] led us into the presence chamber of the Creator,' to help Britons 'understand Him—and each other—better,'[44] eliding art's Christian religious purpose with Art as the epitome of 'National Life.'[45]

Hunt's autobiographical account also elides masculinity, Christianity, and Englishness and places the PRB at the nexus of all three values.[46] Curiously, despite recent scholarly attention to Hunt, he was rarely the subject of popular biographical writers, who preferred Rossetti and Millais. Hunt was not interviewed in the press (as Millais often was), perhaps because of his prolonged absences on trips, such as those to the Middle East. Masculinity emerges as a key theme in the pamphlet written to accompany the 1860 exhibition of Hunt's *Finding of the Saviour in the Temple* (1854–60, Birmingham Museum and Art Gallery). Although signed by the critic F.G. Stephens, himself an original member of the PRB, the text represents Hunt's self-fashioning.[47] As Michaela Giebelhausen notes elsewhere in this book, Hunt's two-volume autobiography cum PRB history attempted to overwhelm the massive literature on his cohorts and to assert definitively his status as a manly artist. His autobiography was filled with assertions of his adventurousness, including his notorious account of painting *The Scapegoat* (1854–55, Lady Lever Art Gallery, Port Sunlight, Merseyside) in the Middle East with a gun under his arm to fend off hostile tribesmen.

Modernity

By the end of the nineteenth century, the 'modern' in art became associated variously with earlier art history, non-European cultures or areas deemed irrational—dreams, fantasies, desires, and memory. The topic of modernity became a fundamental part of the discourse of cultural nationalism often in discussions of artistic lineage. In *Giotto*, Quilter considered Millais, Hunt, Rossetti, and Burne-Jones as successors of Giotto's reform 600 years earlier, linking Pre-Raphaelitism with the early Renaissance.[48] Quilter argued, however, that Pre-Raphaelitism was not directly rooted in Renaissance Italian art (foreign and antiquarian, in his view) but linked through its British 'father,' Ford Madox Brown, who perpetuated Renaissance ideals.[49] In the end Quilter considered the PRB a failed promise for 'the most magnificent art of modern times' in England because it could not shake off its early antiquarianism.[50] Robert Ross regarded Hunt as archaic and the least modern of the originators, straying from the PRB's 'new impulse to English art' by painting religious works for mass appeal, while Rossetti was the most modern of the PRB, in his opinion.[51]

Herbert Horne's landmark two-volume *Botticelli* (1908) applied Bernard Berenson's notion of artistic genealogies to attack Pre-Raphaelitism's claims to modernity.[52] He distinguished Botticelli from late Pre-Raphaelites to condemn an art Horne considered derivative, weak, effete, and thus unlike fifteenth-century art. Horne argued that the Pre-Raphaelite obsession with decorative elements was close only to Botticelli's mannered fifteenth-century imitators. Morris and Burne-Jones were 'preoccupied with detached ornament which has no direct relation to architecture, and with detached sentiment which had no direct relation to actual life.'[53] Burne-Jones was 'too merely erotic in temper.'[54] Horne hoped to sever the popular association between Pre-Raphaelitism and Botticelli and correct 'that peculiarly English cult of Botticelli, which now became a distinctive trait of a phase of thought and taste, or of what passed for such, as odd and extravagant.'[55] Burne-Jones and Morris threatened to erase Pre-Raphaelite modernist features (realism, *ut pictura poesis*, and a radical view of the past). Horne's monograph reiterates these revolutionary principles, endorsing the PRB's 'greats'—Blake, Dante, Michelangelo, Giotto, and Botticelli.

Personal intensity was a unique aesthetic principle among the original PRB, and Horne resurrected this virtue as one of Botticelli's stylistic features. Drawing on Pater's concepts of modernity, Horne underscored the originality of Botticelli's intensity and Pater's insights. Burne-Jones and Byam Shaw, by contrast, were mannered and conventional, following the letter of the PRB law but not its true Botticellian spirit.[56] Like early Pre-Raphaelites, Botticelli resisted conventions through 'purely pictorial qualities,' focusing on 'the world around him,' rather than by imitating antiquity. This modernity emerged in

'forms which are not beautiful in themselves, and sometimes even ungainly,' the very criticism hurled at the PRB in 1850.

By the time of the Franco-British Exhibition of 1908, M.H. Spielmann argued in the official catalogue that Pre-Raphaelitism was the foundation of a truly British art, while international in its influence and modern in its nature. Their most characteristic achievement was their original protest, a trait that tied them to other great protesters, such as Hogarth and the Arts and Crafts Movement.[57] The PRB 'was a protest pure and simple—a protest which, short-lived as it was as an organized movement, led to a revulsion of feeling against the uninspired art of the day far beyond the borders of the circle and of the country with which it is identified.'[58] Spielmann insisted that its Ruskinian tenets 'are still the inspiration of some of the phases of the Impressionist school [which Spielmann disliked], and which, when Monet, Manet, and their followers adopted them, were hailed as inventions, or at least as innovations, of the revolted schools of France.'[59] Pre-Raphaelitism's stepfathers were Brown and William Dyce, and Spielmann broadly expands its list of followers.[60] Spielmann described the PRB as 'Radical Revivalists who made the modern school possible for us.'[61]

Modernity was contested in 1908. Roger Marx, a progressive critic on the exhibition committee, insisted that Impressionists and Post-Impressionists be included. The British asserted their own modernism by promoting Pre-Raphaelitism. By 1908 artists themselves had a more international view of art. British artists argued for the inclusion of Impressionism and against the views of the regressive French official Leon Bonnât; some protested Spielmann's selections and catalogue essay.[62] While British artists and progressive critics knew French modernist art, French and British officials of the exhibition tried to exclude French modernism. As Paul Greenhalgh notes, for Spielmann, Pre-Raphaelitism constituted 'a recent, indigenous style with a moral dimension and a reverence of the past' lacking in Impressionism and Post-Impressionism, defined by Spielmann as offshoots of Pre-Raphaelitism.[63]

The question of Pre-Raphaelite modernity dominated Continental art histories. French critic Robert de la Sizeranne believed England lacked modern artists.[64] German critic Richard Muther divided the realism of the early years of Pre-Raphaelitism from Rossetti's and Burne-Jones's later idealism. Muther compared the PRB to Renaissance artists: 'In all studios artists spoke a language which had never been heard there before; all great reputations were overthrown ... A miracle seemed to have taken place in the world.'[65] He considered the Nazarenes mere imitators by comparison with the PRB 'who reared against the yoke of tradition, flung aside all the conventions of form and colour ... the first great champions of the liberty of modern art,' comparable to Courbet, Millet, and Hogarth.[66] He claimed Brown was the PRB's 'mature ally and forerunner,'[67] and 'the English Menzel' whose *The Last of England* (1852–55, Birmingham Museum and Art Gallery) was

'the most remarkable work,' and whose *Work* (1852–65, Manchester City Art Galleries) equalled Courbet's *Stone Breakers* (1849, formerly Gemäldegalerie Neue Meister, Dresden, destroyed 1945), linking Brown with Continental modernism, Muther's touchstone.[68]

Muther placed Rossetti, Burne-Jones, Morris, and Whistler in his third volume under 'The New Idealists.' He considered this group truly modern, stamping art with its own age through images of 'the inner life of the nineteenth century.'[69] England had 'taken the lead' in this modern strain beginning with Blake.[70] Blake inspired 'a kind of Italian Renaissance upon English soil,' both eclectic and highly personal, 'the most remarkable form of art upon which the sun has ever shone,' a radical lineage for British art.[71] Rossetti was a Blakean modern unlike Hunt, Brown or Millais,[72] and Burne-Jones, 'the flower of most potent fragrance in English aestheticism'[73]: 'Burne-Jones stands to Botticelli as Botticelli himself stood to the antique,' modern in transforming the past.[74]

The German writer Julius Meier-Graefe, editor of the avant-garde journal *Pan*, took a contrary view, writing in 1908 that the PRB had destroyed any chance for real modernity in England, their methods being 'less capable of expansion, of a wide, universal artistic development than' French art.[75] He contrasted PRB artists to Courbet, a hero of his book along with Constable, 'the father of modern painting,'[76] whom he commended as a European artist.[77] Constable, like Hogarth, another artist Meier-Graefe admired, 'left little trace in England.'[78] Lacking depth, the English 'are sentimental to the point of insipidity:' 'Hunt's *Light of the World* [1851–53, Keble College, Oxford] is the English Sunday in paint, wearisome to the last degree. Its dramatic qualities are bad theatrical effects.'[79] Meier-Graefe claimed that Italian primitives had been recognized on the Continent before being discovered by the PRB,[80] who did not understand or follow the ancients: 'With the ancients in mind, we are less repelled by a Claude Monet than by a Walter Crane.'[81] Unlike Van Gogh's positive anarchism, Morris and Crane exhibit merely a 'rhetorical anarchism.'[82] The PRB misunderstood the Italians and completely failed to follow their great predecessors, forcing English artists 'to go to the Continent to learn what has become of Turner and Constable.'[83] He blamed the PRB for encouraging successors in a 'vain desire to reap without sowing.'[84]

Meier-Graefe's views were nationalistic—he compared French art with a healthy wife who produces healthy offspring, employing a late nineteenth-century discourse of health to argue that only French art is tied to both antiquity and modernism. The only hope for English art was William Morris and the Arts and Crafts Movement. Meier-Graefe disengaged Morris from Pre-Raphaelitism and linked him to the Gothic tradition of English art and especially architecture, a tradition both English and German. Ideologically Meier-Graefe admired the English communistic Middle Ages rather than the individualism of the PRB, so heralded by British critics. The other hope for English modernism was Whistler, whose greatness was due to the lack of Pre-

Raphaelite influence and to the international inspirations—French, English, Japanese, and Spanish—which made him truly modern.[85]

National identities, nativist origins

Pre-Raphaelitism as a cultural construction was central to Victorian national identity. The end of the nineteenth century was a culminating moment in the creation of national myths, and art was an important part of the mix. National identity was as much the consequence of cultural practices as of political and social practices and changes. Ernest Gellner argues that nationalism depends on the appearance of 'that similarity of culture' needed to form social bonds and political identities. Benedict Anderson also describes nationalism, or 'nation-ness,' as a cultural artifact that was widely diffused 'to a great variety of social terrains' through popular media.[86] The press's role was in promoting a visual language and a social function for artists, as they also had fixed a national, vernacular language.[87] Writers promoted faith in national continuity through the imagined sacred and homogeneous character of high culture.[88] The deployment of art as the embodiment or expression of national identity had earlier appeared in Britain in the nationalizing of Constable,[89] arguments for the existence of a 'British School,'[90] mythologizing of the Norwich School and representations of the eighteenth century as a golden age.[91] Spielmann insisted that the PRB and their followers were truly English, direct heirs of the great eighteenth-century painters.

In comparison with earlier nationalistic claims for art, debates over Pre-Raphaelite national identities constituted a contentious, xenophobic enterprise, anticipated in 1866 by Richard and Samuel Redgrave, who excluded foreigners and women from any role in the formation of the British School.[92] William Sharp in 1886 considered the late nineteenth century an English Renaissance, a national awakening.[93] In 1905, J. Ernest Phythian identified the PRB as the salvation of British art, the medicine that restored British art to the health and vigor of its 'national life and character,' safeguarding it from foreign influences. Pre-Raphaelitism's most British characteristics were individuality and independence from convention.[94]

A major topic of contention was its founders' origins. In English art-historical scholarship, lines of inquiry were devoted to topics of origins, genealogies, canons, and regional or national styles. In many ways art history and nationalism were partners, validating, normalizing, scientizing, and reinforcing each other's authority. Claims for Pre-Raphaelite origins in British art history were mixed, citing Hogarth, Blake, and the Italian Renaissance artists. Individual artists' origins were intimately tied to their constructed roles in Pre-Raphaelite histories and historiographies. For example, Brown could be a foreigner or the PRB's 'father.' Trained on the Continent, he

was a favorite of some French critics, while both hailed and denigrated as Continental by English writers. Percy Bate considered Brown the father of the PRB, and William Michael Rossetti called Brown a 'prime mover.'[95] La Sizeranne claimed Brown as the PRB's 'father' and found his art to be characterized by the intellectuality of the subject, the moral narrative, and the intensity of expression. He identified Brown as the root of 'a great national art in England' by 'bringing English contemporary art over with him to his own country' from the Continent.[96] This 'sower' of new art in England brought 'an aesthetic revolution in his Portfolio.'[97] British art critics often attacked such claims for Brown. An anonymous reviewer of Ford Madox Ford's biography of his grandfather Brown refers to *Work* as 'a much overrated picture' and the frontispiece portrait of Brown as unworthy 'of a manly painter.'[98] Another anonymous reviewer argued that Brown was 'a timid Iconoclast' compared with the PRB.[99] And Hunt dismissed Brown as too close to the German Nazarenes to found a British art movement.[100]

Arthur Fish insisted that 'above all, the movement was entirely a national one, a pure native product, without a trace of any foreign element ... under its influence the Academy schools certainly produced a large percentage of students who, in after life, greatly distinguished themselves.'[101] Millais was 'British through and through ... He had no abstruse ideas on the mission of art, but he held sturdy, common-sense views on what an artist ought to set before him in his work ... believing that each painter ought to work out his own salvation on individual lines.' Fish attacked English painters who paint 'in a broken French accent,'[102] unlike Millais, 'English to the core, honest, and straightforward in his character as in his work.'[103]

But not everyone admired Millais's Englishness. Emilie Barrington, who strenuously promoted her favourites, G.F. Watts and Frederic Leighton, admitted that Millais was a genius and his art 'very national in its character, very English,' like any great work which 'must have in it a national distinctiveness.'[104] The Englishness of Millais's work lay in its expression of feeling, 'pure, transparent, and thoroughly healthy ... straightforwardness ... efficiency,' making him 'though great as a painter,' not really great 'as an artist.'[105] She criticized his popularity as a sign of superficiality, also English: 'We English' are driven by 'preferences and prejudices ... lazy in adapting our intellectual focus to different classes of subject,' fitter for business than for art.[106] Joseph and Elizabeth Pennell were also suspicious of Millais's identity 'as the honoured, the successful, the distinguished man, the brilliant artist, the typical Englishman.'[107] They dismissed critics' praise for his having 'worn a tweed suit, to have painted in a pipe, to have fished in Scotland, and to have made more money with his own hands than anybody else ... to the glory of British art.' The Pennells claimed Millais 'was forced to compromise with patrons' to succeed in the highly commercial art world by painting 'Miss Muffets, Cherry Ripes, and Cinderellas.'[108]

Cosmo Monkhouse in *British Contemporary Artists* (1899) compared Millais to Hogarth, Reynolds, and Turner. Millais was equal to these three because 'he is as thoroughly national and original as any of them, and that in simplicity, sincerity and power, he will hold his own with the best.'[109] Millais's development was 'the growth of four centuries writ small on a single brow,' recapitulating European art history for Britain.[110] His Englishness meant he was 'neither a profound thinker nor a learned scholar,' but 'a man of action' with 'common sense,' a conservative who 'had a great hatred of all innovation,' but was tolerant in art matters.[111]

British critics sometimes tried to anglicize PRB origins and remove foreign influences. Quilter argued for purely English origins—Hunt's art training came through self-study before he ever saw engravings from Italian paintings, and Rossetti read English poetry before he read Dante.[112] Quilter even claimed that the original PRB leaders—Hunt, Millais, and Rossetti—were shrewd businessmen and therefore like other solid Englishmen, thoroughly bourgeois and entrepreneurial.[113] Percy Bate attempted a definitive history of what he insisted was a 'school' and a movement 'so vast and far-reaching … the great artistic crusade' with a 'high aim' and 'the brilliant achievement which has crowned their strenuous endeavours,' laying out ennobling terms and claims for British art, although Bate did not mention Millais in the history of the PRB.[114] Bate considered Brown the father of the movement. Brown and Rossetti produced 'the most momentous results in the world of art.'[115] Bate treated the movement as a synergy, requiring the special gifts of its three founders: Rossetti's imagination, Hunt's self-reliance, and Millais's technical knowledge.[116]

In contrast to Bate, J. Ernest Phythian spent an inordinate amount of prose arguing that Brown was neither a member of the PRB nor a major influence, a subtle means of suggesting that Rossetti, as Brown's protégé, was not the foremost member of the Brotherhood. Phythian sided with Hunt's self-aggrandizing version of Pre-Raphaelite history. Their revolutionary zeal permitted them 'to shake off the surplus weight of tradition.'[117] The PRB 'permeated the whole art of the nation.'[118] Concluding that only Hunt remained true to PRB ideals after the group disbanded, Phythian charged Millais with becoming, in this regard, 'a pervert' yet with the 'point of view of a healthy, simple-minded Englishman!'[119]

Pre-Raphaelitism's originary moment was often recast in conflicting ways—juvenile, inconsistent, sincere, and sacred—but almost always beneficial to national culture. Critics admired the movement's founders while disparaging some of their paintings: Sidney Colvin in 1867 admired their scientific realism which 'revolutionised English painting,' while having its 'share of British narrowness and doggedness.'[120] He ascribed the doggedness and subordination to Hunt and Brown, the loss of 'all earnestness' and lack of invention to Millais, and praised only Rossetti, 'the chief intellectual force …

thoroughly to have combined beauty with passion and intellect,' and Burne-Jones whose modernity Colvin lauded.[121] M.H. Spielmann argued that Rossetti was primarily of 'Italian blood' with 'sensuality' and mysticism not found in the 'Saxon sturdiness of Hunt and the British vigour of the sportsman Millais,' nor even in Burne-Jones's 'wistful rather than voluptuous' art, 'English rather than Italian.'[122] As 'the best-known member' of the PRB, Millais carried out 'a protest of sincerity against the fatuousness of conventional art' and 'owed absolutely nothing but the example of sincerity to foreign or ancient artists of any kind' for his 'magical and revolutionary' art.[123]

There are many overlapping points between these debates and practices of cultural nationalizing: the quest for pure origins, tensions between concepts of modernity and tradition, historical revisionism and obsessions with style as rooted in 'innate' national or racial characteristics. Pre-Raphaelite practitioners' origins were examined through a vocabulary of race, modernity, primitivism, and progress. At a time when the art world was flooded with art from every corner of Europe, Asia, and Africa, and styles and journals claimed to be international (for example, art nouveau, *Studio*), lines were also being more tightly drawn around national 'schools' of art. Borrowing methods from linguistics and archaeology, art historians, seeking pure origins and clear stylistic influences and lineages, separated artists from their followers. Giorgione and Botticelli, for example, were distinguished from their 'schools.' By 1900, Pre-Raphaelite artists were similarly inscribed by the author function, giving the illusion that they were forever a unified group, despite the Brotherhood having been long disbanded.

As these texts indicate, however, the assessments were hardly uniform, but rather were inflected by the critics' nationalism and views on modernism. La Sizeranne claimed that France colonized all Europe, except England, and, like a good colonizer, improved the colonies, so only England remained culturally backward.[124] While European artists sacrificed details to overall composition,[125] the English maintained a myopic attention to details. While Europeans painted atmosphere, the English maintained bright colors. English artists failed to understand and practice facture, a trademark of the French.[126] Britons alone resisted Impressionism. As La Sizeranne's metaphors indicate, a notion of cultural imperialism defined European artistic relations, what Ernest Chesneau termed 'rival nations of art.'[127] Here the rivalry was over who owned modernism in art.

Homi Bhabha's concept of the time-lag which exists at the center of the myth of modernity is useful for analyzing late Victorian cultural tensions that lay beneath critics' conflicts over the meaning and significance of Pre-Raphaelitism. Bhabha's 'time-lag' exists between the 'Great Event' (here the PRB origin) and its circulation as an historical sign of the 'people' or an 'epoch.' Differences through time, as between PRB origins and later public and national images of Pre-Raphaelite artists, are homogenized by being constituted into a collective

memory of a cultural past inscribed by the present narrative obsessions of masculine Englishness and European cultural hegemony. Inscriptions of critics and historians become 'a disposition to cultural communality, a form of social and psychic identification.'[128] Bhabha argues that modernity was re-invented through an imposed historical continuity in the face of conflicting juxtapositions. In the case of the histories and historiographies of Pre-Raphaelitism, discontinuities included those between its 'radical' origins and its sanitized national representations of its artists and of it as a 'movement.' Bhabha defines his time-lag as 'the historically transformative moment,'[129] the moment I consider here as that of writing the past to fit present circumstances, ideals, and purposes. For Bhabha, the distance between an event and its spectators is the event's meaning. I apply this to Pre-Raphaelitism's literary formations read by late nineteenth-century 'spectators' that became meanings of the originary PRB. Pre-Raphaelitism, in this version, is defined as English by virtue of its presumed individualism and sincerity, despite its founders' combined rejection of sentimentality and nationalism and embrace of international cultures across time and space.

The original members of the PRB created their own time-lag, asserting both Italian 'primitive' origins and their historical modernity through applications of archaeology, empirical science, and psychology. The PRB founders defined their movement as primitive and spiritual, claiming a direct, primordial language of emotional intensity in opposition to Enlightenment discourse or bourgeois commercialism represented by academic conventions. But they also defined themselves as modern and scientific. While British critics' master-narratives insisted on the progressiveness and 'health' of the PRB, modern art's story was becoming increasingly aligned with the primitive, unconscious, dreamlike, and intuitive. To claim Pre-Raphaelites for English modernism, some apologists emphasized their realism, their scientific replication of the world as a break with convention (Spielmann), while others advanced them as moderns because of their use of myth and imagination (La Sizeranne). Its rebellion became a cultural protestantism, claiming to be both traditional and modern.

The time-lag meant that the 1848 rebellion had to be tamed and its realism appropriated. After 1880, art writers not only solidified the notion of the Pre-Raphaelites as representatives of national traits, but also re-wrote their early history. Walter Armstrong's 1885 interview of Millais revised and reduced Pre-Raphaelitism's 'radical rebellion' to a mere 'wave of impatience with stereotyped fashion, which swept over the country in the early part of the present reign ... Earnestness was the new watchword,' making the movement evangelically English and part of a widespread 'sweep,' while softening its criticism of the RA, since by 1885 Millais had long been an academician.[130] Armstrong's Millais could thus appear unified and homogeneous from youth to maturity. But fissures remained in Armstrong's interview. Claiming that an

archaeologically inclined public would expect Semitic children in a painting of Christ, Millais asked, 'What children do we care about? Why our own fair English children, of course; not the brown, bead-eyed, simious-looking children of Syria … The public is too critical to bear this kind of thing now.'[131] Armstrong lamented realism as a lost innocence: 'The world—the modern Art-world—is now so old, it knows and demands so much that the naiveté of Vermeer must not be looked for in any of those who paint its pictures.'[132] Realism, a PRB article of modernist faith, became fallen knowledge, what the philistine public expected. Armstrong's representation of Millais was conflicted: Millais's early career depended on its exposition of the 'new' modern realism which later made it impossible for him to recast biblical history with English children.

Armstrong re-inscribed PRB identity, represented by Millais, with a national idealism. This revisionism was underwritten by the identification of Pre-Raphaelite artists with the great geniuses of the British and Italian Renaissance. F.G. Stephens in 1884 likened Millais to Titian, Raphael, and Velasquez, while emphasizing his Englishness in his 'indefatigable industry, the keenest sense of the logic of art, a noble physical presence, perfect *savoir vivre*, fidelity in friendship, and a genial manner that never tires.'[133]

Rossetti and Burne-Jones had first to be domesticated in order to be fully appropriated as national icons. Burne-Jones was always characterized as spiritual, partly because of the authority of his wife Georgiana Burne-Jones's biographical depiction of him as otherworldly. But he was also popularly characterized by critics as degenerate and esoteric. Burne-Jones was presented as self-taught (a common trope of Englishness in artists' biographies) and motivated solely by his love of art. Malcolm Bell misrepresented the artist's dispute with, and resignation from, the Old Water Colour Society over their removing his *Phyllis and Demophoön* (1870, Birmingham Museums and Art Gallery) (with its frontal male nudity) from exhibition. He claimed that Burne-Jones 'retired in 1870, in consequence of a dispute which need not be recalled,'[134] both citing and erasing this 'uncomfortable' event that raised issues of the artist's unconventional use of nudity. Burne-Jones's leaving the Watercolour Society was a protest, not a retirement, but Bell minimized the rebelliousness of the incident.[135]

Debates over Rossetti's role in the PRB raised issues of both national identity and masculinity. William Sharp's 1882 biography, published the year the artist died, was a template for later Rossetti biographies. Sharp separated the artist's works from his life and dispatched the life in the first chapter.[136] He introduced the genius theme, comparing Rossetti to Leonardo as multi-talented. Unlike Rossetti's subsequent biographers who found him essentially Italian (Ernest Radford, Ford Madox Ford),[137] Sharp described him as 'an unmistakable Englishman' with a strong 'Italian element' who thought himself 'wholly English.'[138] By separating life from art, Sharp helped later

writers avoid Rossetti's profligacy in money and sexual relationships. In 1890, Richard and Samuel Redgrave described Rossetti as 'The guiding spirit in the brotherhood as first formed' who 'owed nothing to foreign travel, academic study, or to artists in general.' They compared him to Constable and Hogarth in Englishness and originality. Though 'sensuous' and 'uneven,'[139] Rossetti was fit into their nationalistic master narrative because he never traveled to Italy, despite influences of the Italian Renaissance on his work and his persona. Esther Wood's 1894 book argued that only Rossetti, 'the grafting of an Italian genius upon English stock,' saved England from Constable's dire prediction that British painting was dying.[140] Rossetti represented 'a nation and a century ... the sum of temperaments becomes the spirit of an age; or rather, the nation itself ... as a living, thinking, struggling personality.' Rossetti's struggles were England's. But Ford Madox Ford mentioned Rossetti's lack of a work ethic and inadequate skills. He became Pre-Raphaelitism's prodigal son, always amateur and emotionally impulsive, behaviors not associated with Englishness.[141]

Realism was claimed as a British national and racial virtue. Sharp joined Pre-Raphaelitism to the Oxford Movement and the Gothic Revival, claiming that all three shared interests in medieval art, '*earnestness*,' and a state of 'revolt against whatever was effete, commonplace, or unsatisfactory.'[142] Sharp insisted there was no resemblance between Italian primitives and the PRB except for the principle of going to nature for inspiration and guidance: 'the young brotherhood of contemporary artists were altogether superior to the Italian Preraphaelites in skill of manipulation, power of drawing, and knowledge of effect; as superior in these as they were inferior in grace of design.'[143] Despite the prominence of religious themes in Pre-Raphaelite art, the movement amounted to 'a sceptical revolt'[144] based on scientific investigations and a limited protest: 'A Protestant, a protester, belonging nearly always to an extreme minority, is inevitably disliked ... and though nearly every good law we possess, our individual, our social, our religious, our moral freedom is owing to protest after protest, the theory of the beneficent action of protestation is only admitted *in* theory, as only praiseworthy in the past.'[145]

But idealism could be just as characteristic of Pre-Raphaelite art and Englishness. According to La Sizeranne, the 1889 public success in France of Burne-Jones's *King Cophetua and the Beggar Maid* (1884, Tate, London) 'was a revelation' that British national identity was synonymous with chivalric idealism:

French people gazed with secret sympathy at this enigmatical picture
... we had come on the exhibition of the soul ... the Scorn of Wealth
... a king laying his crown at the feet of a beggar-maid for her beauty's
sake ... It was a dream—but a noble dream ... that an artist should have
depicted the Apotheosis of Poverty. It was the revenge of art on life.[146]

One of La Sizeranne's themes was that English painting was characterized by dreams—Hunt's dream inspired by Ruskin, Watts's myths, and Leighton's

idealism. English artists painted not what they saw but their optimism, hopes, and fears. His hero was the 'Celtic' Burne-Jones.[147] But La Sizeranne considered English painting to be in crisis, also reflected by Burne-Jones's art's 'half-avowed distress of wavering reason, of divided will, or of unconscious feeling.'[148]

The inherent Englishness of Pre-Raphaelite art was substantiated by its popularity with English audiences. Malcolm Bell argued that Burne-Jones's paintings were appreciated and loved by the classes *and* the masses, countering charges that his art was a refined taste appealing only to cognoscenti. Bell satirized critics and anointed the public as ultimate judges, suturing artist and public together, based on their presumed shared taste. Bell constructed a legible, democratic Burne-Jones who 'did not misapply his talents in setting pictorial puzzles or devising undecipherable hieroglyphics of form and colour,' like French modernists. Burne-Jones passed the 'golden test of popularity' and his works did well on the auction block.[149] For Malcolm Bell, Burne-Jones's popularity argued against charges of effeminacy by virtue of the artist's special appeal to working men, 'the lower classes … throng the exhibitions at the Guildhall,' where working men discussed Burne-Jones's *The Wheel of Fortune* (1875–83, Musée d'Orsay, Paris). This provided evidence of a unified and unifying national taste.[150]

Millais's art, however, could be tied to French influences as well. La Sizeranne described Millais as 'aesthetically, the least English of the artists of his country,'[151] the direct *opposite* of British critics' claims for him as quintessentially British. Being 'most nearly to French ideas in art,' Millais 'did not choose subjects specially for their morality' and sacrificed edges of paintings to the center, unlike other Pre-Raphaelite brethren.[152] However, 'in an avowed effort to please the upper classes,' his art went 'straight to the sentimental or amusing'[153]: 'He charms all the superficial side of the English mind, as Burne-Jones will charm all refined minds in France when he is better known there. Therefore another boundary must be found for aesthetic preferences than a frontier line, and another origin than that of atmosphere or soil.'[154]

What raised La Sizeranne's anxiety most was English art's intense nationalism: 'English artists admit that the whole nation expects them to preach and to moralise … art must be both dignified and popular, it must preach philosophy, and to all men'[155] and 'become common property.'[156] With some rare exceptions, the British artists were opposed to all foreign, 'that is to say, all French influence'[157]: 'And there is no doubt among them that English hearts and English skies are inspired by an art superior to all that of all other lands and ages.'[158] La Sizeranne preferred 'fine French qualities of logic, arrangement, harmony, simplicity and proportion,' traits that were Italian, Flemish, Spanish when these countries 'were lands sown in turn by the unknown god who raises artists, or served as a refuge to that vagabond

called genius.' English 'art with a purpose ... crushes art more surely.'[159] La Sizeranne pleaded with French artists to continue French traditions and not follow the English who strayed from beauty's path with their moral intentions and sentimentality.[160]

La Sizeranne even orientalized English art: 'But on reaching the English pictures you feel, on the contrary, that you are no longer amongst fellow-countrymen and it is doubtful even whether they may be your contemporaries. It is like slipping a magic ring on to your finger which transports you to a distant and known shore.'[161] His metaphors were military: 'The assaults of realism and of impressionism are broken on their aestheticism, like the squadrons of Ney on the squares of Wellington. There are German, Hungarian, Belgian, Spanish, Scandinavian painters, but there is an English School of painting,'[162] built from the successes of Burne-Jones, Millais, and Hunt at the Paris Salon of 1889. To the Symbolists, 'the names of Watts and Burne-Jones have been heard with reverence ... as magic words,' and young artists like Tissot and Puvis de Chavannes (called the French Burne-Jones), 'are impregnated with them,'[163] threatening French cultural imperialism.

In other ways, for La Sizeranne, the PRB was typically English: its clubbiness and use of initials after names[164] and its commercial success formed 'a sign of predestination' more pertinent to commercial-minded Britain than to other countries.[165] As if to undercut their heroic idealism, La Sizeranne claimed that 'Millais, Hunt and Rossetti had made, between them, not less than half a million sterling,'[166] while Brown's *The Last of England* (1852–55, Birmingham Museum and Art Gallery) 'touched the heart of the multitude' without gaining such remuneration.[167] By 1857 'the school of Madox Brown was triumphant, and Millais, the head of that school, committed moral suicide. The whole movement of 1850 is comprised in these two facts.'[168] Their principles were 'an apprentice's manual, not a Bible of the ideal; a road, not a goal.'[169] The artists shared a 'longing for a new art, substituting strange, novel, individual gesture, for commonplace generalisations; and fresh, dry, pure colour, brilliant by its juxtapositions'[170] that offered up 'this great aesthetic revolution of the middle of the century, this break in the current of English art,'[171] their discontinuity with the past.

Other French accounts of Pre-Raphaelites' Englishness also insisted on difference and on Pre-Raphaelitism's discontinuity with ancient and Renaissance art. Chesneau's *The English School of Painting* appeared in English in 1885 (1864 in France) with an introduction by Ruskin who feared that 'British schools [note plural here] of painting are now in the contrary danger of losing their national character,' by imitating German, French or 'Asiatic' art.[172] Chesneau dated the rise of English painting to 1851, the year of the Great Exhibition and of continuing attacks on the PRB. After the 1878 Paris Exhibition, English art was no longer insular and became renowned in France.[173] Yet Chesneau denied the existence of an English School with its own national tradition: 'Each painter seems to stand by himself, and is, so to speak,

isolated from his brother artists,' without uniformity of method or teaching, and so 'is free, and on that very account is infinitely varied, full of surprises and unexpected originality.' These traits, however, can represent a nation, he conceded.[174]

Chesneau described the Pre-Raphaelites' studios as impervious, 'closed by a portion of the Great Wall of China ... a continual continental blockade,' making European art 'a sealed book for them.'[175] The PRB's chief aims were 'a distinctly moral purpose ... by representing, in as minute a style as possible, subjects in historical art.'[176] His metaphors for their earnestness were 'military order, an order of knight-templars ... religious and even mystical element.'[177] For Chesneau, *The Light of the World* (1851–53, Keble College, Oxford) was exemplary PRB,[178] and he made sport of Hunt when he asked, 'Does any one remember the singular picture exhibition in 1855 [sic], entitled "The Light of the World"? ... an example of the peculiar manner' of Pre-Raphaelite interpretations of the Bible.[179] Chesneau considered Millais to be 'foremost ... in the English school.'[180] He disliked Brown[181] and adored Burne-Jones, 'the only artist whose high gifts in designing, arranging and colouring are equal to his poetical conceptions.'[182] He characterized Pre-Raphaelite landscape as un-Latin in its focus on details.[183] Chesneau believed British artists 'strayed far from the right path' by trying to convey 'the truth of the spirit through the letter,'[184] resulting in 'unintelligible' paintings,[185] beyond the proper 'rules' of painting as the French and the ancients defined them.[186] This difference put Pre-Raphaelite style in 'diametrical opposition to our own' as it lost sway after 1870 and failed to become modern.[187] The Pre-Raphaelites' Englishness precluded modernity and historical continuity, both of which Chesneau claimed for the French.

Conclusion

> To articulate the past historically does not mean to recognize it 'the way it really was' (Ranke) ... In every era the attempt must be made anew to wrest tradition away from a conformism that is about to overpower it.
>
> Walter Benjamin, *Illuminations*, 1936, trans. H. Zohn and ed.
> H. Arendt, New York: Schocken Books, 1969, p. 255

The cultural situation in England around 1900 was more pluralistic and international than in the 1850s. The act of resisting tradition in 1848 had come to be seen, by the 1890s, as a gesture endorsing the purity of Englishness. The PRB itself became part of a mytho-cultural apparatus.[188] British critics transformed PRB rebelliousness into an invented tradition of secular Protestantism signifying British individualism and realism. Key questions in the debates about Pre-Raphaelitism—the question of Englishness, the diminution of the influence of Italian art, rejections of Brown or Rossetti's

claims as founders—became means of stabilizing the PRB's place in English traditions.

By 1900 critics had domesticated the PRB originators, de-emphasizing their radical, 'primitivist' style and youthful avant-garde self-fashioning, and repositioning them towards the center of cultural hegemony. Now they stood as sages and bearers of dominant cultural values, and protectors of the autonomy of English culture from Continental infiltration. Pre-Raphaelite artists who originally challenged academic conventions and taste had, by the 1908 Franco-British Exhibition, become canonized as 'masters' of a modern 'British School.' Their art was institutionalized, deemed national, traditional, modern, individualistic, and moral. The PRB became central to what Raymond Williams called the illusion of community, disseminated by the power of literature to claim homogeneous and unifying values, a conformism from which Walter Benjamin encouraged us to save history.[189] Fetishized, anglicized and distanced from notions of youthful rebelliousness, the term 'Pre-Raphaelite' had come by 1908 to signify a homogeneous myth.[190] Pre-Raphaelite art was elevated to what Roland Barthes described as 'a sacred merchandise, produced, taught, consumed, and exported in the context of a sublime economy of values,'[191] absorbed into the cultural mechanism that restrains or erases deviance and assures 'purity.' Although by 1908 the PRB had become English Old Masters, critics differed on the meanings of their work. Writings about Pre-Raphaelitism from this period reveal a rich, heterogeneous historical stew of meanings within the late nineteenth century's dominant concerns of nation, gender, and modernity.

Notes

1. James Sambrook (ed.), *Pre-Raphaelitism: A Collection of Critical Essays*, Chicago and London: University of Chicago Press, 1974, p. 3, p. 11. See Inga Bryden, *Pre-Raphaelites: Writings and Sources*, 4 vols, London: Routledge, 1998, vol. 1, pp. 2–3, in which she marks the three stages and argues for the Pre-Raphaelites as 'indefinable.' Bryden maps the term's various meanings in the Pre-Raphaelite writings she selects.

2. Bryden, *Pre-Raphaelites*, vol. 1, p. 8.

3. Pre-Raphaelitism became a dominant trend after 1853 according to William Holman Hunt in *Pre-Raphaelitism and the Pre-Raphaelite Brotherhood*, 2 vols, London and New York: Macmillan & Co., 1905, vol. 1, p. 343, and vol. 2, pp. 391–2. William Bell Scott chose 1852 as the date when Pre-Raphaelite influence was rampant in Britain. See *Autobiographical Notes of the Life of William Bell Scott*, ed. W. Minto, London: Osgood, McIlvaine & Co. and New York: Harper, 1892.

4. John Tomlinson, *Cultural Imperialism*, Baltimore: Johns Hopkins University Press, 1991, p. 69.

5. While I briefly mention John Ruskin, I will not consider his writings on Pre-Raphaelitism, which have been discussed by many scholars, nor others' writings that have been subjected to thorough scholarly investigation, such as those by William Michael Rossetti.

6. Philip Dodd, 'Englishness and the national culture,' in Robert Colls and Philip Dodd (eds), *Englishness: Politics and Culture 1880–1920*, London: Broom Helm, 1986, p. 6.

7. Max Nordau, *Degeneration*, London: William Heinemann and New York: D. Appleton, 1895, attacked the Pre-Raphaelites, pp. 81–6, and Rossetti's poetry, pp. 86–98.

8. *Ibid.*, p. 69.

9. *Ibid.*, p. 70.

10. *Ibid.*, p. 77, p. 83.

11. *Ibid.*, p. 98.

12. *Ibid.*, p. 99.

13. Alfred Hake, *Regeneration: A Reply to Max Nordau*, London: Archibald Constable, 1896; see pp. 30–31. Hake, author of a book on General Gordon's death, was a historian and political writer who wrote on free trade and related topics.

14. *Ibid.*, p. 39.

15. *Ibid.*, p. 49.

16. *Ibid.*, pp. 51–2.

17. *Ibid.*, p. 55.

18. *Ibid.*, p. 61.

19. *Ibid.*, pp. 62–3.

20. *Ibid.*, pp. 68–9.

21. *Ibid.*, p. 71.

22. *Ibid.*, pp. 63–4.

23. Atkinson's comment on Burne-Jones's bad influence is in 'The state of art in England,' *Blackwood's Magazine*, 131, May 1882, 614; his attack on Millais's *Ruling Passion* appears in 'The decline of art: Royal Academy and Grosvenor Gallery,' *Blackwood's Magazine*, 138, July 1885, 6. His remarks on Rossetti appear in 'Contemporary art—poetic and positive: Dante Gabriel Rossetti and Alma-Tadema—Linnell and Lawson,' *Blackwood's Magazine*, 133, March 1883, 400.

24. Harry Quilter, *Preferences in Art, Life and Literature*, London: Swan Sonnenschein, 1892, p. 76.

25. M.H. Spielmann, *Magazine of Art*, 22, 1898, 528.

26. *Ibid.*

27. Robert de la Sizeranne, 'In memoriam: Edward Burne-Jones "Tribute from France",' *Magazine of Art*, 22, 1898, 520.

28. Francis O'Gorman, 'Ruskin and the Pre-Raphaelite imagination in the 1870s,' in Robert Hewison (ed.), *Ruskin's Artists*, Aldershot, England and Brookfield, VT: Ashgate, 2000, pp. 185–203.

29. *Ibid.*, pp. 195–6.

30. John Ruskin, *The Three Colours of Pre-Raphaelitism* (1878), in *The Works of John Ruskin*, eds E.T. Cook and Alexander Wedderburn, 39 vols, London: George Allen and Sons and New York: Longmans, Green & Co., 1903–12, pp. 152-3.

31. Alfred Baldry, *Sir John Everett Millais*, London: George Bell, 1899. The reference to Millais 'manfully' resisting criticism is on p. 29.

32. *Ibid.*, p. 10.

33. *Ibid.*, pp. 13–14.

34. *Ibid.*, p. 111.

35. *Ibid.*, p. 17.

36. *Ibid.*, p. 34.

37. Arthur Fish, *John Everett Millais, 1829–1896*, New York: Funk and Wagnalls, 1923, p. 142.

38. Ernest Radford, *Dante Gabriel Rossetti*, London: George Newnes, 1905, p. vii.

39. Arthur Benson, *Rossetti*, London and New York: Macmillan & Co., 1904, pp. 1–2.

40. *Ibid.*, p. 26.

41. *Ibid.*, pp. 202–4.

42. Wyke Bayliss, *Five Great Painters of the Victorian Era: Leighton, Millais, Burne-Jones, Watts, Holman Hunt*, London: Sampson, Low, Marston, 1902, p. 127.

43. *Ibid.*, p. 128.

44. *Ibid.*, p. 155.

45. *Ibid.*, p. 157.

46. See Julie F. Codell, 'The artist colonized: Holman Hunt's "bio-history", masculinity, nationalism and the English school,' in Ellen Harding (ed.), *Re-framing the Pre-Raphaelites*, Aldershot: Scolar and Brookfield, VT: Ashgate, 1995, pp. 211–29; and Marcia Pointon, 'The artist as ethnographer: Holman Hunt and the Holy Land,' in Marcia Pointon (ed.), *Pre-Raphaelites Re-Viewed*, Manchester and New York: Manchester University Press, 1989.

47. [F.G. Stephens], *William Holman Hunt and His Works: A Memoir of the Artist's Life, with Description of His Pictures*, London: James Nisbet & Co., 1860.

48. Harry Quilter, *Giotto*, London: S. Low, Marston, Searle & Rivington, 1880.

49. *Ibid.*, p. 7.

50. *Ibid.*, p. 6.

51. Robert Ross, 'Mr. Holman Hunt at the Leicester Galleries (an inspection),' *Masques and Phases*, London: A.L. Humphreys, 1909, p. 177.

52. Herbert Horne, *Alessandro Filipepi, Commonly Called Sandro Botticelli, Painter of Florence*, London: George Bell & Sons, 1908.

53. *Ibid.*, pp. xix–xx.

54. Horne disliked Burne-Jones for a morbidity he defined as 'northern, not Italianate,' *Morning Leader*, August 18, 1900, 4.

55. For a survey of the fortunes of Botticelli in the nineteenth century, see Michael Levey, 'Botticelli and nineteenth-century England,' *Journal of the Warburg and Courtauld Institutes*, 23, 1960, 291–306. Sir Charles Eastlake purchased the first Botticelli painting for the National Gallery in 1855. Dante Gabriel Rossetti saw his first Botticelli in the Louvre in 1848. Burne-Jones was an enthusiast of Botticelli's art in the 1860s. Horne's evaluation of Botticelli disagrees on almost every count with J.A. Symonds's assessment of the painter in *The Renaissance in Italy: The Fine Arts*, New York: Henry Holt, 1888, pp. 249–55. For an assessment of Horne's monograph, see Julie F. Codell, 'Horne's *Botticelli*: Pre-Raphaelite modernity, historiography and the aesthetic of intensity,' *Journal of Pre-Raphaelite and Aesthetic Studies*, 2, 1989, 27–41.

56. Horne, *Morning Leader*, April 25, 1900, 7, claimed the PRB made 'strange things seem familiar and familiar things seem strange,' while Byam Shaw 'makes strange things seem commonplace and familiar things, grotesque.'

57. M.H. Spielmann, 'The British Art Section,' in F.G. Dumas (ed.), *Franco-British Exhibition: Illustrated Review*, London: Chatto and Windus, 1908, p. 23. This volume was heavily illustrated with Pre-Raphaelite paintings. These remarks also appeared in Isidore Spielmann (ed.), *Souvenir of the Fine Art Section, Franco-British Exhibition 1908, with Illustrations, and an Essay on the Fine Art Section by M.H. Spielmann*, London: Bembrose and Son, 1909.

58. Spielmann, 'The British Art Section,' pp. 43–6.

59. *Ibid.*, p. 46.

60. Spielmann included as followers Byam Shaw, John Brett, J.F. Lewis, John Linnell, Noel Paton, Frederick Sandys, John Gilbert, G.A. Storey, Eleanor Fortescue-Brickdale, Isobel Gloag, Lindsay Smith, Cayley Robinson, J.M. Strudwick and G.F. Watts.

61. Spielmann essay in *Le Figaro Illustré*, 26, 1908; n.p.

62. Paul Greenhalgh, *Ephemeral Vistas: The Expositions Universelles, Great Exhibitions and World's Fairs, 1851–1939*, Manchester: Manchester University Press, 1988, p. 212. See pp. 218–23 on the modern in the 1908 exhibition.

63. *Ibid.*, p. 213.

64. Robert de la Sizeranne, *English Contemporary Art*, trans. H.M. Poynter, Westminster: A. Constable, 1898, p. ix.

65. Richard Muther, *The History of Modern Painting*, 3 vols, trans. A. Hillier, New York: Macmillan & Co., 1896, vol. 1, p. 560.

66. *Ibid.*, vol. 2, p. 561.

67. *Ibid.*, vol. 2, p. 581.

68. *Ibid.*, vol. 2, pp. 603–4.

69. *Ibid.*, vol. 2, p. 256.

70. *Ibid.*, vol. 3, p. 561.

71. *Ibid.*, vol. 3, pp. 579–80.

72. *Ibid.*, vol. 3, p. 576.

73. *Ibid.*, vol. 2, p. 603.

74. *Ibid.*, vol. 3, p. 613.

75. Julius Meier-Graefe, *Modern Art, Being a Contribution to a New System of Aesthetics*, 2 vols, trans. Florence Simmonds and George W. Chrystal, London: W. Heinemann, 1908, vol. 1, p. 14.

76. *Ibid.*, vol. 1, p. 140.

77. *Ibid.*, vol. 1, p. 136.

78. *Ibid.*, vol. 1, p. 137.

79. *Ibid.*, vol. 2, p. 188.

80. *Ibid.*, vol. 2, p. 189.

81. *Ibid.*, vol. 2, p. 190.

82. *Ibid.*, vol. 1, p. 211.

83. *Ibid.*, vol. 2, p. 232.

84. *Ibid.*, vol. 2, p. 238.

85. *Ibid.*, vol. 2, pp. 198–225 on Whistler. Muther describes Millais as 'one of those men in the history of nineteenth-century painting who are as forcible and healthy as they are many-sided.' Cited in Baldry, *Sir John Everett Millais*, p. 109.

86. Ernest Gellner, *Nationalism*, New York: New York University Press, 1997, pp. 3–4; and Benedict Anderson, *Imagined Communities: Reflections on the Origin and Spread of Nationalism*, rev. edn, London and New York: Verso, 1991, pp. 4–6.

87. Tomlinson, *Cultural Imperialism*, p. 81.

88. Timothy Brennan, 'The national longing for form,' in Homi K. Bhabha (ed.), *Nation and Narration*, London and New York: Routledge, 1990, p. 51.

89. Elizabeth Helsinger, 'Constable: the making of a national painter,' *Critical Inquiry*, 15 (2), Winter 1989, 276–9.

90. Morris Eaves, *The Counter-Arts Conspiracy: Art and Industry in the Age of Blake*, Ithaca: Cornell University Press, 1992; and Shearer West, 'Tom Taylor, William Powell Frith, and the British School of Art,' *Victorian Studies*, 33 (2), Winter 1990, 309–10.

91. Andrew Hemingway, 'Cultural philanthropy and the invention of the Norwich School,' *Oxford Art Journal*, 11 (2), 1988, 34; Laurel Bradley, 'From Eden to empire: John Everett Millais's *Cherry Ripe*,' *Victorian Studies*, 34 (2), Winter 1991, 179–203, on the eighteenth century as a golden age to Victorians.

92. Julie F. Codell, 'Righting the Victorian artist: the Redgraves' *A Century of Painters of the English School* and the serialization of art history,' *Oxford Art Journal*, 23 (2), 2000, 95–119.

93. William Sharp, 'Introduction,' in Allan Cunningham, *Great English Painters. Selected Biographies from Allan Cunningham's 'Lives of Eminent British Painters,'* ed. William Sharp, London: Walter Scott, 1886, p. xiv.

94. J. Ernest Phythian, *The Pre-Raphaelite Brotherhood*, London: G. Newnes, 1905, pp. vii–viii.

95. William Michael Rossetti, 'Critiques on contemporary painters and designers: Madox Brown,' in W.M. Rossetti, *Fine Art, Chiefly Contemporary*, London: Macmillan & Co., 1867, p. 190.

96. La Sizeranne, *English Contemporary Art*, p. 3.

97. *Ibid.*, p. 8.

98. Review of *Ford Madox Brown*, by Ford Madox Ford [Ford Madox Hueffer], *Athenaeum*, February 27, 1897, 284.

99. Review of *Ford Madox Brown*, by Ford Madox Ford [Ford Madox Hueffer], *Athenaeum*, March 13, 1897, 353.

100. Hunt, *Pre-Raphaelitism and the Pre-Raphaelite Brotherhood*, vol. 1, pp. 225–6.

101. Fish, *John Everett Millais*, p. 102.

102. *Ibid.*, pp. 162–3.

103. *Ibid.*, p. 162.

104. Emilie Barrington, 'Why is Mr. Millais our popular painter?' *Fortnightly Review*, 30 o.s., 32 n.s., July 1, 1882, 63.

105. *Ibid.*

106. *Ibid.*, p. 64.

107. Joseph and Elizabeth Pennell, 'John Everett Millais, painter and illustrator,' *Fortnightly Review*, 66 o.s., 60 n.s., 1896, 443.

108. *Ibid.*, p. 444 on Rossetti and Brown, and p. 445 on Millais's 'compromise.'

109. Cosmo Monkhouse, *British Contemporary Artists*, London: William Heinemann and New York: Scribner's, 1899, p. 47.

110. *Ibid.*, p. 49.

111. *Ibid.*, p. 82.

112. Quilter, *Preferences in Art, Life and Literature*, pp. 31–2.

113. *Ibid.*, p. 24.

114. Percy Bate, preface to *The English Pre-Raphaelite Painters, Their Associates and Successors*, London: George Bell and Sons, 1899, p. v.

115. *Ibid.*, p. 2.

116. *Ibid.*, p. 3.

117. Phythian, *The Pre-Raphaelite Brotherhood*, pp. xvii–xviii.

118. *Ibid.*, p. xx.

119. *Ibid.*, p. xix.

120. Sidney Colvin, 'English painters and painting in 1867,' *Fortnightly Review*, 8 o.s., 7 n.s., October 1867, 471.

121. *Ibid.*, p. 474.

122. Spielmann, 'The British Art Section,' pp. 52–3.

123. F.G. Stephens, *Artists at Home*, 2 vols, London: Sampson, Low, Marston, Searle and Rivington, 1884, vol. 1, pp. 16–17.

124. La Sizeranne, *English Contemporary Art*, p. x.

125. *Ibid.*, p. xi.

126. *Ibid.*, p. 286.

127. The phrase is from the title of Ernest Chesneau's *Les nations rivales dans l'art*, Paris: Didier, 1868.

128. Homi K. Bhabha, '"Race", time and the revision of modernity,' *The Oxford Literature Review*, 13 (1–2), 1991, 202.

129. *Ibid.*

130. Walter Armstrong, *Sir J.E. Millais, Bart, RA: His Life and Work*, London: J.S. Virtue and Co., 1885, p. 3.

131. *Ibid.*, p. 25.

132. *Ibid.*, p. 32.

133. Stephens, *Artists at Home*, vol. 1, p. 15.

134. Malcolm Bell, *Sir Edward Burne-Jones*, 1892, rpt, London: George Bell and Sons, 1910, p. 128.

135. This painting is reproduced in *Sir Edward Burne-Jones* facing p. 60, although Bell only comments that it was redone as *The Tree of Forgiveness*.

136. Joseph Knight's 1887 biography of Rossetti also avoided biographical details.

137. Ford Madox Ford [Ford Madox Hueffer], *Rossetti: A Critical Essay on his Art*, London: Duckworth, 1902, p. 37.

138. Sharp, 'Introduction,' *Great English Painters*, p. 37.

139. This appears in their 1890 abbreviated revision of their 1866 text, *A Century of Painters of the English School*, London: Sampson, Low, Marston, 1890, pp. 470–72.

140. Esther Wood, *Dante Rossetti and the Pre-Raphaelite Movement*, London: Sampson Low, Marston, 1894, p. 3.

141. Ford [Hueffer], *Rossetti*, pp. 1–2.

142. Sharp, 'Introduction,' *Great English Painters*, pp. xv–xvi.

143. *Ibid.*, pp. xvi–xvii.

144. *Ibid.*, p. xxxi.

145. *Ibid.*, pp. xxxii–xxxiii.

146. La Sizeranne, *English Contemporary Art*, p. 113. See his similar remarks in 'Sir Edward Burne-Jones, in memoriam,' p. 515.

147. La Sizeranne, *English Contemporary Art*, p. 207.

148. *Ibid.*, p. 258.

149. Bell, *Sir Edward Burne-Jones*, p. 127. See Julie F. Codell, *The Victorian Artist: Artists' Lifewritings in Britain ca. 1870–1910*, Cambridge and New York: Cambridge University Press, 2003, for a survey of Victorian artists' biographies.

150. Bell, *Sir Edward Burne-Jones*, pp. 71–2.

151. La Sizeranne, *English Contemporary Art*, p. 176.

152. *Ibid.*

153. *Ibid.*, pp. 178–9.

154. *Ibid.*, p. 179.

155. *Ibid.*, pp. 307–8.

156. *Ibid.*, pp. 310–11.

157. *Ibid.*, p. 313.

158. *Ibid.*, p. 315.

159. *Ibid.*, p. 323.

160. *Ibid.*, pp. 323–4.

161. *Ibid.*, pp. ix–x.

162. *Ibid.*, p. xi.

163. *Ibid.*, pp. xiii–xiv.

164. *Ibid.*, p. 33.

165. *Ibid.*, p. 42.

166. *Ibid.*, p. 155.

167. *Ibid.*, p. 154.

168. *Ibid.*, p. 56.

169. *Ibid.*, p. 62.

170. *Ibid.*, p. 71.

171. *Ibid.*, p. 83.

172. Ernest Chesneau, *The English School of Painting*, trans. Lucy Etherington, London: Cassell, 1891, pp. ix–x. This went into four editions between 1884 and 1891.

173. *Ibid.*, pp. xli–xliii.

174. *Ibid.*, pp. 1–2.

175. *Ibid.*, p. 169.

176. *Ibid.*, p. 180.

177. *Ibid.*, p. 183.

178. *Ibid.*, p. 183.

179. *Ibid.*, pp. 183–4.

180. *Ibid.*, p. 227.

181. *Ibid.*, pp. 230–31.

182. *Ibid.*, p. 235.

183. *Ibid.*, pp. 245–6.

184. *Ibid.*, p. 187.

185. *Ibid.*, p. 194.

186. *Ibid.*, pp. 196–7.

187. *Ibid.*, p. 204.

188. Tomlinson, *Cultural Imperialism*, p. 86.

189. Raymond Williams, *The Country and the City*, Oxford and New York: Oxford University Press, 1973, pp. 1–3.

190. Benedict Anderson, cited in Homi K. Bhabha, 'DissemiNation: time, narrative, and the margins of the modern nation,' in Bhabha (ed.), *Nation and Narration*, London and New York: Routledge, 1990, pp. 308–9.

191. Roland Barthes, 'Authors and Writers' (1960), in *A Barthes Reader*, ed. S. Sontag, London: Vintage, 1993, p. 189.

'A Soul of the Age:' Rossetti's words and images, 1848–73

David Peters Corbett

Writing in *The Critic* on February 15, 1850, Edward William Cox, its editor, announced a departure 'from our usual plan of noticing the periodicals under one heading' in order to review the first two numbers of *The Germ*, a new monthly magazine subtitled *Thoughts towards Nature in Poetry, Literature, and Art*. Cox endeavored to allay any suspicions his readers might feel on discovering that *The Germ* was 'the production of a party of young persons,' claiming that 'an affected title and an unpromising theme really hides a great deal of genius.' He cited extracts from some of the anonymous contributions (in fact by Dante Gabriel Rossetti, Coventry Patmore, and Christina Rossetti) to demonstrate that 'the contents of *The Germ* are the production of no common minds,' before concluding with a passage that connected the magazine to more general issues:

> *The Germ* has our heartiest wishes for its success; but we scarcely dare
> to *hope* that it may win the popularity it deserves. The truth is that it
> is too good for the time. It is not *material* enough for the age.[1]

In a later review of the two subsequent and, as it proved, final issues of the magazine,[2] Cox glossed what he meant by this, arguing that 'we cannot contemplate this young and rising school in art and literature without the most ardent anticipations of something great to grow from it, something new and worthy of our age:'

> *The Germ* was not wantonly so entitled, for it abounded with the promise
> of a rich harvest ... But we expressed ... our fear lest the very excellence
> of this magazine should be fatal to its success. It was too good—that
> is to say, too refined and of too lofty a class, both in its art and its
> poetry—to be sufficiently popular to pay even the printer's bill.[3]

This is an interesting response to *The Germ* for a number of reasons. Firstly, Cox's assertions signal *The Germ*'s role as the expression of a group

endeavor and a focused intellectual and artistic program, something which other reviewers at the time also felt to be worthy of comment. 'English artists have hitherto worked each one by himself, with too little of common purpose, too little of distinct and steadily pursued intellectual object,' wrote *The Guardian*, welcoming the fact that 'here, at last, we have a school,' and suggesting that its 'success ... would be a national blessing.'[4] It was this sense of group identity which marked out the artists and writers who originated *The Germ* and who called themselves the Pre-Raphaelite Brotherhood (PRB) and which underlay their characteristically modern view of art as a practice in which innovation and revelation played a crucial role.[5] According to one of them, William Michael Rossetti, the artists and writers who made up the PRB had been motivated by dissatisfaction with the capacity of existing conventions of art to deal adequately with the needs of modern life: 'The temper of these striplings, after some years of the current academic training, was the temper of rebels: they meant revolt, and produced revolution.'[6]

Although Rossetti was writing with the benefit of hindsight, his comments usefully clarify the critics' hopes for 'this young and rising school' to be 'something new and worthy of our age.' For the innovative art and literature produced under the aegis of the PRB was intended to revive the culture's deadened systems of representation and to reinvent them as revelatory expressions of a spiritual or human dimension to existence, which was perceived to be absent from contemporary life.[7] Like Carlyle, who in 1843 had written in the opening pages of *Past and Present* of the stunned 'enchantment' and spiritual impoverishment of 'the English Nation' struggling to 'get to know the meaning of *its* strange new Today,' the PRB were questing for 'the eternal inner Facts of this Universe ... Nature's right truth' as an answer to the pressing questions of modern life and its representation.[8] In this sense Cox's comment that *The Germ* was 'not *material* enough' might be understood as a recognition of its repudiation of the materialist basis of judgment in 1850 and an endeavor to achieve a critical view on contemporary experience. Hence, too, the many attempts of the Brotherhood's artists to produce pictures of modern life, from William Holman Hunt's *The Awakening Conscience* (1853–54, Tate, London), to Dante Gabriel Rossetti's long contemplated and finally abandoned *Found* (1854–81, Delaware Art Museum, Wilmington). Theirs was to be an innovative, committed, and vatic art in which the visual would function as the medium through which reality, Carlyle's 'the right Inner True,' would be clarified and revealed to the nation to match Ruskin's 'art in some sort compassionate, exhortant, or communicative, and useful ... as a record of what was done among men in your day.'[9]

Such ambitions raise the central questions which confronted the PRB. If the role of their new art was to provide a new order of visual representation which could deal with modern experience in this revelatory way, then how

was that goal to be achieved? In what sense could the visual arts diagnose, communicate, and reform the lived realities of mid-nineteenth-century life? Exactly how could 'a national school' advance the question of 'the condition of England'? Without an answer to such questions the PRB and artists in general felt themselves to be in danger of becoming the equivalents of the 'dilettanti' 'pasturing' among the 'mutilated black Ruin' of modernity whom Carlyle had anathematized in *Past and Present*.[10]

What seemed the possible answer emerges from the second theme raised by Cox's *Germ* reviews. This is the fascination of the founding Pre-Raphaelites with the material constitution of the medium in which they operated, whether that was words, images, or, as in the case of Dante Gabriel Rossetti, both. Jerome McGann has suggested that we should understand Rossetti through a sense of his 'art of embodied practice,' and has described his 'proper subject' as 'the cognitive nature of immediated sensual perception.'[11] Rossetti himself spoke of Pre-Raphaelitism as a 'materialist' art, and his materialism, in this sense of a close, reflective engagement with the sensual world, is evident from very early in his career.[12] Perhaps it is for this reason that F.G. Stephens's later description of Rossetti's appearance at the Royal Academy Schools in 1847 seems to capture the young artist's embroilment in the physical and material details of the world:

Rather below the middle height and with a slightly rolling gait, Rossetti came forward among his fellows with a jerky step, tossed the falling hair back from his face, and, having both hands in his pockets, faced the student world with an *insouciant* air which savoured of defiance, mental pride and thorough self-reliance. A bare throat, a falling, ill-kept collar, boots not over familiar with brushes, black and well-worn habiliments, including, not the ordinary frock or jacket 'of the period', but a very loose dress-coat which had once been new — these were the outward and visible signs of a mood which cared even less for appearances than the art-student of those days was accustomed to care.[13]

Stephens's final move in this description is to link the materiality of Rossetti's self-presentation to the inward 'mood,' an inner truth which, spurning the materialism of 'appearances' nonetheless finds itself ideally figured through them. At issue here is the mechanism which, connecting the materiality of appearance with the 'inner Facts,' the 'right Inner True' of Carlyle, allows matter, the medium of physical expression in the visual arts, to adequately signify and communicate the eternal realities of experience. In an essay he wrote for the second number of *The Germ*, Stephens set this out as a quasi-official manifesto of the group. In 'The Purpose and Tendency of Early Italian Art' Stephens's understanding of art before Raphael turns on what he takes to be its fundamental realism, its faithful representation of the truths of nature. He draws from this the moral that a painting attending to the reality of what is seen will produce a clear-sighted modern art:

An unprejudiced spectator of the recent progress and main direction of
Art in England will have observed, as a great change in the character of the
productions of the modern school, a marked attempt to lead the taste of the
public into a new channel by producing pure transcripts and faithful studies
from nature, instead of conventionalities and feeble reminiscences from the
Old Masters; an entire seeking after originality in a more humble manner than
has been practised since the decline of Italian Art in the Middle Ages.[14]

Stephens imagines the painter, spiritually honed and refined by 'a firm
attachment to truth in every point of representation,' delineating the reality
of experience, cultivating 'the power of representing an object, that its entire
intention may be visible, its lesson felt.'[15] His model, the same one which
operates subterraneously in his reminiscence of Rossetti as a student, is
therefore one of the penetration of analysis into reality through an inward
purity and innocence of the self. The artist understands and represents the
truth through the burnishing of the mirror of his own identity.

Believe that there is that in the fact of truth, though it be only in the
character of a single leaf earnestly studied, which may do its share in
the great labor of the world: remember that it is by truth alone that the
Arts can ever hold the position for which they were intended.[16]

The key is that, in order to release its yield of significance, the leaf has to be
'earnestly studied,' unlocked through the artist's inner attention.

The circuit Stephens's account of Rossetti posits is one central to the aesthetic
thought of the early PRB. 'The subject was a modern one,' says one of Rossetti's
surrogate narrators of a painting he executes in the short story 'St Agnes of
Intercession' (of which I shall have more to say below): 'and indeed it has
often seemed to me that all work, to be truly worthy, should be wrought out
of the age itself, as well as out of the soul of its producer, which must needs be
a soul of the age.'[17] This resonates with Cox's 'something new and worthy of
our age' as well as with the type of engagement urged by Carlyle and others.[18]
But it differs from them in sharing the mechanism operative in Stephens's
description. For Rossetti's protagonist, expression of the realities of 'the age'
and expression of the artistic self are imagined as identical. The answer which
early Pre-Raphaelitism proposes to the question of how its innovative modern
art could achieve the goal of dealing with modern experience and thus prove
itself worthy of the task of diagnosing and communicating those realities,
is the one Stephens gives: that the artist should look within himself and by
attention to that *necessarily* reflective mirror of the 'soul of the age,' express
the age itself.

In this essay I will be concerned with the way in which these formulations of
the ambitions of the new art impacted on the Pre-Raphaelites' understanding
of the role of the visual arts in representing and assessing modern experience.
I will argue that Rossetti was uneasily aware from an early moment that the

mechanism proposed was conceptually flawed, and that the short stories he conceived for *The Germ* in 1849 and 1850, and subsequently his paintings of the 1860s and 1870s, respond to that scepticism in significant ways. It is to the detail of this reading that I now want to turn.

One of the two early works in oils that Rossetti executed in 1848 when, after leaving the RA Schools, he was briefly a pupil of Ford Madox Brown, is a still-life study of pickle-jars, bottles, and phials, all framed by the repoussoir elements of a large palette and stacked brushes (1848, Delaware Art Museum, Wilmington).[19] It is a conventional subject and, predictably, Rossetti balked at the task. Nevertheless, the effect of the phials, containing paint in the three primary colors, and of the markings on the surface of the palette is suggestively self-reflexive.[20] Alastair Grieve remarks of this painting that Rossetti's 'sudden introduction to colour seems to have led him to question deeply its language,' so that he was able 'to use it in an unconventional way for symbolic and decorative purposes.'[21] And William Bell Scott famously remembered Rossetti working on his first major oil painting, *The Girlhood of Mary Virgin* (1848–49, Tate, London), in an innovative technique: 'He was painting in oils with water-colour brushes, as thinly as in water-colour, on canvas which he had primed with white till the surface was as smooth as cardboard, and every tint remained transparent.'[22] Elizabeth Prettejohn has connected these early works by Rossetti to a broader series of 'experiments with media and techniques' in both paint and drawing which give a 'cohesive look to the early PRB oils.'[23] Prettejohn demonstrates how emphatic the use of the physical trace of the medium, applied 'stroke by individual stroke,' was for the Brotherhood's artists, producing 'a coherent whole not by the imposition of an overall pictorial harmony, but by the accumulation and juxtaposition of numberless equally emphasised touches.'[24]

But if the founding Pre-Raphaelites thought of their project to represent the modern as a visual one, it is also the case that language and literary art featured centrally in Pre-Raphaelite practice and as an equal partner in the reformulation of the arts that the Pre-Raphaelites attempted. Rossetti even persuaded a number of his colleagues who had never previously picked up a pen to create linguistic rather than visual art for *The Germ*, while Rossetti himself was engaged from the first in making his 'double works of art' in both words and images;[25] 'a picture,' he said, 'is a painted poem.'[26] *The Girlhood of Mary Virgin*, the first painting to carry the PRB initials, was exhibited accompanied by two sonnets that present the iconography of the painting and conduct the reader through its symbolic order and theology. In this case, the relationship between text and image appears relatively straightforward, the sonnets glossing a primary visual object, but that simplicity is deceptive, and usefully opens up some of the complexities of word and image relationships for the early Pre-Raphaelites.

The concept of glossing itself raises these issues. Rossetti's poems seem to assume what Michael Baxandall has called an 'ostensive' relationship to the image, that is they point out, explicitly, the important aspects of the painting.[27] Both sonnets begin with this ostensive gesture towards the work: 'This is that blessed Mary;' 'These are the symbols.'[28] The implication of this gesture is that the visual is prior to the linguistic register, which exists in order to explicate it. The spectator is logically prior to the reader because access to the understanding that the work contains inheres in the act of viewing rather than in that of reading text. The image precedes the word.[29] This is perhaps complex enough. But, in Rossetti, the spiral of this relationship does not end there but continues to tighten. For if the visual is prior to the verbal, then on what grounds does it require linguistic explication? What status do the sonnets have if not that of clarification and identification of meanings and significances that are not clear or evident from the visual object itself? And if it *is* the case that the painting requires this exposition, then its priority is irretrievably compromised. The result of this is to complicate the claim that the visual provides access to reality. The ontological complexities of the relationship between language and visual understanding underline how problematic any such claim must be. The visual is not, merely by virtue of its own achievements and without the aid of language, able to conduct the spectator into the inner truths of Pre-Raphaelite ambition.

At the same time as he was working on *The Girlhood of Mary Virgin* and its companion piece, *Ecce Ancilla Domini* (1849–50, Tate, London), Rossetti was writing his short story 'Hand and Soul,' published in the first number of *The Germ* for January 1850.[30] This story, which has received considerable notice as an important statement of Rossetti's Pre-Raphaelite aesthetics, deals with an early Italian painter, Chiaro dell'Erma, and his artistic history.[31] Chiaro's struggles to achieve a satisfactory art are closely connected to Pre-Raphaelite ambitions: 'conceiving art almost … for himself, and loving it deeply, he endeavoured from early boyhood towards the imitation of any objects offered in nature.'[32] Chiaro passes through a series of possibilities, making art that is sensuous, moral, and symbolic by turns, but achieving success with none of his productions. His final attempt is to marry 'cold symbolism and abstract impersonation' to 'the presentment of some moral greatness that should impress the beholder.'[33] But the ambition to attain a direct relationship to contemporary needs which this embodies proves vain. In this style Chiaro paints 'a number of tall, narrow frescos, presenting an allegory of Peace' in the entranceway to a church in Pisa. But, during a feast day, the rival factions of 'the two greatest houses of the feud in Pisa' turn on each other as they leave the church: 'and there was so much blood cast up the walls on a sudden, that it ran in long streams down Chiaro's paintings.'[34] Confronted by this failure of 'the hope that I nourished in this my generation of men,' Chiaro despairs:

I am as one who, through the whole night, holding his way diligently, hath smitten the steel unto the flint, to lead some whom he knew darkling; who hath kept his eyes always on the sparks that himself made, lest they should fail; and who, towards dawn, turning to bid them that he had guided God speed, sees the wet grass untrodden except of his own feet … Am I not as a cloth drawn before the light, that the looker may not be blinded; but which sheweth thereby the grain of its own coarseness; so that the light seems defiled, and men say, 'We will not walk by it'. Wherefore through me they shall be doubly accursed, seeing that through me they reject the light.[35]

This is the climatic moment of the story, when Chiaro's visuality folds into darkness, 'defiling' and 'reject[ing] the light.' Confronted by this failure of his attempt to speak directly and productively to his time, Chiaro experiences a vision in his studio. His soul appears to him in the form of a woman: 'I am an image, Chiaro, of thine own soul within thee.'[36] Her advice is this: 'In all that thou doest, work from thine own heart, simply … set the hand and the soul to serve man with God.'[37]

Despite the importance it has been accorded by William Michael Rossetti and subsequent commentary, 'Hand and Soul' is an unsatisfactory enquiry into the issues it raises. The 'soul,' appearing to Chiaro, reduces the complex question of what contemporary art might be to the interiority of the artist. Since this is an assertion or aspiration rather than a demonstration, the story remains unconvincing as an account of the issue. Rossetti reaffirms the need the Pre-Raphaelites perceived for a spiritual understanding of experience and the modern age, and Chiaro's vision is an exemplification of this, but it leaves unsolved the problem of how such an understanding is to be achieved or disseminated.

Rossetti continued to examine this theme in the second of his short stories, 'St Agnes of Intercession,' which was begun with the idea of inclusion in *The Germ*, although put aside when the periodical failed and only taken up again in 1870 or later.[38] 'St Agnes' deals with a central Rossettian moment, the confrontation with the double, the 'bogie' whose face is eerily identical to the protagonist's own.[39] It is an odd story: it appears to have been extensively revised and completed when it was taken up for the second time, leaving traces of difference in tone, mood, and the nature of the action which are still evident in the existing text.[40] But although William Michael Rossetti felt that 'it does not seem to be intended to bear an equal weight of moral or spiritual significance' as 'Hand and Soul,' it appears to me to have been made over by Rossetti in his later revisions into an important commentary on the early ambitions of the PRB and in fact to amount to a more reflective consideration of the central issues.[41]

Written in a pastiche style derived from Poe's stories and heralded by a coy epigraph purporting to be from *Tristram Shandy*,[42] 'St Agnes of Intercession' tells a first person narrative recounting the disturbing circumstances around

a young artist's discovery of a previous existence. The middle section of the tale describes how he discovers his own face and that of his fiancée, replicated respectively in a self-portrait and a portrait of the mistress of an early Italian painter with whom he has long felt a strange affinity: 'that it *was* my portrait, — that the St. Agnes was the portrait of Mary, — and that both had been painted by myself four hundred years ago, — this now rose up distinctly before me as the one and only solution of so startling a mystery.'[43] The interesting thing for my purposes, however, is not this moment of gothic fantasy, but the development around this core narrative of some of the ideas I have identified in 'Hand and Soul,' which are directly related to the ambitions of the early Pre-Raphaelites.[44] These developments provide in a clarified way a statement of the relationship of art to reality that 'Hand and Soul' offers in a muddled and complex way. Serious doubt is cast on the basis of that clarity, however, by the surrounding tale.

The central events of Rossetti's story are framed by two sections of unequal length which deal with a more familiar, modern, and domestic scene than the supernatural events set in Italy can supply and which are allowed to form a counterpoint to them. The prologue to the Italian section of the story is extended and deals first with the narrator's 'earliest recollections … my father standing before the fire when he came home in the London winter evenings,'[45] then subsequently with his very Rossetti-like education and the circumstances of his first exhibition, showing an equivalent of *The Girlhood of Mary Virgin*.[46] Like Rossetti, the narrator is impatient with the 'toil rigidly exact and dealing often with trifles'[47] of his early art education: 'I cared even too little for what could be taught me by others,' so that 'my original designs greatly outnumbered my school-drawings. 'Struck by one of his sister's friends, Mary Arden, whose 'beauty seemed to grow on my sight by gazing, as the stars do in water,' the youthful art student executes a painting 'with all the energy of which I was capable.'[48] Apart from the fact that Mary sits for the painting, we learn little about it. In one way, however, it differs importantly from *The Girlhood of Mary Virgin*. We gather from the reaction of a self-obsessed and snobbish art critic that the picture conforms to early PRB ambitions, manifesting an 'uncompromising adherence to nature as then present before me, which I had attempted throughout,'[49] and causing it to stand out in the exhibition of conventional paintings which surround it on exhibition at the Royal Academy. But this effect is produced from a striking motif: 'The subject was a modern one, and indeed it has often seemed to me that all work, to be truly worthy, should be wrought out of the age itself, as well as out of the soul of its producer, which must needs be a soul of the age.'[50]

This passage combines the aspirations of Chiaro dell'Erma with an acknowledgement of the essential modernity of aim that inspired them. Chiaro's painting of the soul is here confirmed as the mechanism through which 'the age' itself comes into vision and becomes available for painting.

The self is identical to its age, and its expression is therefore necessarily 'wrought out of the age itself,' something which reflects on the central conceit of the story, with its identities spanning 400 years. This particular aspect of the narrative suggests a desire to dramatize the claim for unity with the spiritually effective art of the past which was more baldly stated in 'Hand and Soul.' Moreover, it is the visual that takes up the burden of revelation and understanding. The narrator's gaze is lively and vivid in the first section of the tale, although often frustrated: 'her beauty seemed to grow on my sight by gazing,'[51] he says of Mary Arden. In the Gallery he fruitlessly seeks his own painting, 'my gaze also passed uneasily, but without encountering the object of its solicitude.'[52] When he does encounter it, it almost slips away:

> As we were shaking hands, a part of the 'line' opposite to where we stood was left bare by a lapse in the crowd. 'There seems to be an odd-looking picture', said my companion. I looked in the same direction: the press was closing again; I caught only a glimpse of the canvas, but that sufficed: it was my own picture, *on the line!*[53]

Sight here, and the visual achievement to which it gravitates, preserves the possibility of revelation. To be hung 'on the line' was to achieve pride of place in the exhibition, available to the spectators' line of sight and not 'skied' out of easy vision.

A much shorter section at the end matches this initial section of the story. The narrator, his health broken by the experience of revelation he has endured during his trip to Italy to see his *Doppelgänger*'s paintings, is slowly nursed back to health in London. The story ends with the ringing of London bells and his first, shaky steps out into the familiar city, a moment which is presented as a return to mental stability after the disequilibrium of his Italian experience. The passage, strikingly truncated in comparison to the leisurely opening, is worth quoting in full:

> I set out hastily in the well-known direction of Mary's house. While I walked through the crowded streets, the sense of reality grew upon me at every step, and for the first time during some months I felt a man among men. Any artist or thoughtful man whatsoever, whose life has passed in a large city, can scarcely fail, in course of time, to have some association connecting each spot continually passed and repassed with the labours of his own mind. In the woods and fields every place has its proper spell and mystery, and needs no consecration from thought; but wherever in the daily walk through the thronged and jarring city, the soul has read some knowledge from life, or laboured towards some birth within its own silence, there abides the glory of that hour, and the cloud rests there before an unseen tabernacle. And thus now, with myself, old trains of thought and the conceptions of former years came back as I passed from one swarming resort to another, and seemed, by contrast, to wake my spirit from its wild and fantastic broodings to a consciousness of something like actual existence; as the mere reflections of objects, sunk in the vague pathless water, appear almost to strengthen it into substance.[54]

UNIVERSITY OF WINCHESTER
LIBRARY

The effect of this passage is to put away the events of the Italian sojourn and return the narrator to the sanity of modern life in the urban environment of his 'earliest recollections.' Like Poe's protagonist in 'The Man of the Crowd,' but to different effect, the narrator returns to the landscape of the city and 'actual existence.'

There are echoes here of earlier statements, and these go some way towards bringing this rather abrupt conclusion into harmony with what has gone before. The final lines recall the narrator's earlier description of Mary (which I have already quoted), whose 'beauty seemed to grow on my sight by gazing, as the stars do in water.' The reference to the cloud before the tabernacle picks up a phrase at the beginning of the story during the account of the narrator's reluctant art training: 'what was then the precise shape of the cloud within my tabernacle, I could scarcely say now; or whether through so thick a veil I could be sure of its presence there at all.'[55] In these rhyming passages Rossetti evokes a number of instances in the Old Testament when God appears to Moses in the form of a 'cloudy pillar … at the tabernacle door' (Exodus 33:9). But whereas the first reference is facetious in its context, the second is very serious in its suggestion of revelation and the bringing into vision of the unseen and mysterious. At the end of the story, Rossetti's narrator offers the modern and urban as a moment of revelation and clarity, which sweeps aside the supernatural and unsettling context of the central sections of the story.

The truncated nature of this final urban epiphany, however, leaves open the possibility that the narrator is mistaken in his apparent clarity and return to health. The two rhyming passages I have cited both evoke images of understanding that are veiled and opaque rather than clear; revelation appears in them as the occult and the unseen. The veil of the tabernacle is the cloth that separated the two rooms within the tent, 'the Holy Place' from 'the Most Holy Place' where the Ark of the Covenant and the inmost mysteries were stored. The veil conceals the moment of revelation, as does God's fiery pillar of cloud. In the concluding passage, the revelation which the narrator hopefully derives from this analysis of 'the thronged and jarring city' remains stubbornly 'unseen,' opaque and indistinct. It is, within the story, inarticulate, in as much as the protagonist informs us that this possibility of reading 'some knowledge from life' resides in perambulation through the city, but we do not see this revelation accomplished. Like the 'mere reflections of objects, sunk in the vague pathless water' which reflect in their turn Mary's 'beauty' that 'seemed to grow on my sight by gazing,' the recovery of truth and experience through attention to the modern is here fluid, but partial and misleading and indeterminate. Like the claims of 'Hand and Soul' it is asserted rather than demonstrated to be so.

From this point of view it is the supernatural events of the story that acquire the greatest meaning because it is they that are the most intense, fully realized, and worked through. It is also these events that present knowledge,

and by implication the knowledge of modernity that the protagonist seeks, as unknowable and inaccessible:

> The tremendous experience of that moment, the like of which has never,
> perhaps, been known to any other man must remain undescribed;
> since the description, read calmly at common leisure, could seem but
> fantastic raving ... After that first incapable pause, during which I stood
> rooted to the spot, I could no longer endure to look on the picture, and
> turning away, fled back through the rooms and into the street.[56]

Whereas in the first section of the story, the narrator's sight is constantly in play, although not necessarily effective, the impact of this encounter, dominated by vision, and in which what is sought is finally actually seen, causes the narrator to shut down his visual sense: 'I drew the blinds before my windows, and covered my face to think;'[57] 'as I again lay back and hid my now burning and fevered face, I repeated ... aloud:—"How unsearchable are Thy judgements, and Thy ways past finding out!";' and (in his dream), 'in the place of my picture, which I could not see, there hung the St Agnes of Perugia.'[58] The dream culminates with an anti-revelation, in which vision and the visual turn out after all to be the agents of non-understanding rather than discovery:

> I was going upstairs to my room at home, where I thought Mary was waiting to
> sit for her portrait. The staircase was quite dark; and as I went up, the voices of
> several persons I knew passed by me, as if they were descending; and sometimes
> my own among them. I had reached the top, and was feeling for the handle of the
> door, when it was opened suddenly by an angel; and looking in, I saw, not Mary,
> but a woman whose face was hidden with white light, and who had a lamb beside
> her that was bleating aloud. She knelt in the middle of the room, and I heard
> her say several times: 'O Lord, it is more than he can bear. Spare him, O Lord,
> for her sake whom he consecrated to me.' After this, music came out of heaven,
> and I thought to have heard speech; but instead, there was silence that woke
> me. This dream must have occurred repeatedly in the course of the night, for I
> remember waking up in perfect darkness, overpowered with fear, and crying out
> in the words which I had heard spoken by the woman; and when I woke in the
> morning, it was from the same dream, and the same words were on my lips.[59]

The emphasis here is on language, the 'words ... on my lips.' The visual is a negative, becoming the blinding light which hides the mysterious woman's face. Words are cried out 'in darkness,' so that neither the light nor the dark carry anything but delusion, incomprehension, and fear.[60]

In 'St Agnes of Intercession' the impossibility of revelation, the Poe-like threat and madness of the crowd are more central than the evocation of the modern cityscape, which therefore appears brutally resistant to the spiritualized understanding proposed by the PRB in 1848–50 as the means through which modernity could be represented and understood. Revising his early text of 1850 in the 1870s, Rossetti seems to have reworked and completed

the tale in order to bring out this meaning, which is about the impossibility of deep interpretation. There is both a franker and more forthright statement of the necessity of confronting and understanding the modern, and scepticism about the capacity of the painter's art to achieve it. The visual, imagined in the project of early Pre-Raphaelitism as capable through innovation of revelation, the understanding of the deep realities of the age, becomes in 'St Agnes of Intercession' the medium of darkness and a bemused incomprehension before the object of its enquiry.

This scepticism about the capacity of the visual to penetrate to the inner meanings of the world, and to carry the perceptions of the spiritualized understanding of experience the Pre-Raphaelites proposed, proved crucial for the subsequent evolution of Rossetti's art. Already when he returned to the manuscript of 'St Agnes of Intercession' in 1870 and made the revisions I have discussed, Rossetti's art had shifted decisively away from the public context of early Pre-Raphaelitism and towards interiority, that perennial opposite pole of modernist practice. The self-reflexivity of the paintings of women who, in the words of F.G. Stephens, are 'amorously, mystically, or moodily lost in dreams, or absorbed by thoughts too deep for words,' which Rossetti began to make in the very late 1850s and 1860s, has been extensively commented upon.[61] *Bocca Baciata* (1859, Museum of Fine Arts, Boston) is widely acknowledged as 'a landmark in the emerging Aestheticism of the post-Pre-Raphaelite era,' because of its preoccupation with the pleasure of the visual, its emphasis on 'sheer visual delight as an end in itself.'[62] More complexly, Elizabeth Prettejohn sees these works as pictures which weave together emphatically modern accounts of femininity with images of self-sufficiency and sexual power to achieve metaphors 'for art's independence from conventional morality.'[63] This turn to interiority and reflection on the status of the art object gave rise to a number of paintings which parallel the scepticism of 'St Agnes of Intercession' in concerning themselves with the occlusion of understanding that the visual carries within it, the veiling and blinding of sight and meaning that arise instead of penetration through the material world to truth.

Lady Lilith (1864–73, Delaware Art Museum, Wilmington), takes as its subject the apocryphal first wife of Adam, in Talmudic tradition a sexual demon.[64] The painting seemed to Rossetti's early commentators to be the apogee of the sensuous evocation of bodily experience for its own sake:[65] 'no painter has ever idealized like this the elemental power of carnal loveliness,' thought H.C. Marillier,[66] and Stephens spoke of 'the ardent languor of triumphant luxury and beauty' in the painting.[67] Stephens went on to associate this sexual glamour with the self-absorption of Lilith's gaze: 'she holds the mirror with negligent grace, and, self-absorbed, trains her bewitching locks.'[68] Rossetti himself called it 'a *Modern Lilith* combing out her abundant golden hair and gazing at herself in the glass with that complete self-absorption by

whose fascination such natures draw others within their circle.'[69] But it was Swinburne, reviewing the Royal Academy exhibition in 1868, who gave the most developed account in this mode:

Her head leans back half sleepily, superb and satiate with its own beauty; the eyes are languid, without love in them or hate; the sweet luxurious mouth has the patience of pleasure fulfilled and complete, the warm repose of passion sure of its delight ... For this serene and sublime sorceress there is no life but of the body; with spirit (if spirit there be) she can dispense ... She is indifferent, equable, magnetic; she charms and draws down the souls of men by pure force of absorption, in no wise wilful or malignant; outside herself she cannot live, she cannot even see: and because of this she attracts and subdues all men at once in body and in spirit. Beyond the mirror she cares not to look, and could not.[70]

It is Lilith's literal superficiality which 'attracts and subdues.' Confined to the surface of the mirror, she is confined as well to the body, to appearance rather than to depth, 'dispens[ing]' 'with spirit.' Her version of interiority is self-absorption, repudiation of the world outside the self, and not an uncovering of what lies hidden beneath the surface. Her self-contemplation remains at the level of appearance. Surrounded by exemplars of surface, described in Rossetti's paint which, pushing hard up to the picture plane, flattens surface, she is contained, poised, but the circuit of her contemplation never goes within.

Jerome McGann notes the oddity of the mirror set behind the edge of Lilith's hair. Although it 'functions ... as a window ... its allusion to that typical piece of pictorial symbology is negative and ironic, for it does not face (spatially) outward and (temporally) forward, but inward and backward.'[71] This mirror is in fact referential. The only point of depth within the painting, it looks back into the history of Pre-Raphaelitism, already distant by the 1860s, and cites the large and ornate mirror behind the couple in William Holman Hunt's *The Awakening Conscience* (1853–54, Tate, London). Hunt's painting, though made as the disintegration of the Brotherhood was underway, stands as a centerpiece of its invocation of spiritual and moral values as a means to understand modernity, and as its corrective, and of the accompanying conviction that these values can be expressed and transmitted through the visual protocols of painting. Famously, *The Awakening Conscience* places within a determinedly modern setting a multitude of precisely researched details, all of which carry a symbolic addition to the painted narrative.[72] In this web of references and meanings, the mirror plays a central role: 'nature, seen through the French windows, is presented as a mirror image; it represents the woman's lost innocence, from which she has divorced herself by her present way of life,' in the words of one commentary.[73]

In *Lady Lilith*, Rossetti quotes this moralizing, spiritualizing mirror of Hunt's, placing his own version in the same segment of the composition, but now allowing it to carry a different charge.[74] If this nature is 'lost innocence,'

or something like it, then it is an innocence that is now unwanted and unsought, its place taken by the exfoliation of pigment which describes the roses, commencing with the bloom that touches the glass of the mirror and ending with the flowers filling the picture plane against (rather than 'behind') Lilith's head. Like her flowing hair and wristband, these flowers are metaphors for pigment itself, brushed onto the canvas with a movement of the hand which matches Lilith's sweeping motion through her heavy, highly realized hair. But this adjustment in the economy of the painting has a further aspect. Instead of a direct reference from the objects of the physical, material world to the meaning which they signify, Rossetti's circuit, departing from the painted and now alien world of nature seen in the anti-naturalistic reflection of the mirror, doubles back on itself to reaffirm its own inwardness. There is no meaning to the image of nature in the mirror. It is, as McGann notes, a negation, a refusal of any path out of the picture and into the space which Hunt's earlier picture so forthrightly occupies.

Lilith, described as 'subtly of herself contemplative' in Rossetti's matching poem, 'Beauty's Body,' 'draws men to watch the bright net she can weave, / Till heart and body and life are in its hold.'[75] Trapping the spectator (note that 'watch') within the self-contemplating circuit of the painting, *Lady Lilith* suggests a further version of the veiling medium of 'St Agnes of Intercession.' We can read the second, but invisible, surface of the (hand)mirror Lilith plies as evidence of this. What she sees within it is only an endless replay of her own self, and that image, denied us by the angle of her hand, is an image of the blockage of the power of the visual to register reality. Self-referring, it signifies only itself, its own character as medium, as superficial physical substance, rather than the capacity to know and communicate the realities and truths of the world outside its own constitution. In this way, the painting is an image of the shutting down of the visual sense in 'St Agnes of Intercession,' it is a renunciation of the ability of the visual to see beyond itself—'before the mirror she cares not to look, and *could not*,' says Swinburne (my emphasis)—and the focus on the visual on its own constitution in Aestheticism of Rossetti's type is no more than the acknowledgement that there is now nowhere else to look.

But this also is not the final word. For it may also be that Rossetti's inability or unwillingness to finish 'St Agnes of Intercession' in 1850 and his completion of the story as a sceptical enquiry into the visual 20 years later has to do not only with visual incapacity, but also with the evident visual richness and ambition of works like these. The story questions the ability of the visual to act as the conduit through which a spiritualized understanding and critique of modernity might be made and made comprehensible. *Lady Lilith* or works like it, such as *The Beloved* (1865–66, Tate, London), *The Blue Bower* (1865, Barber Institute of Fine Arts, University of Birmingham) or *Monna Vanna* (1866, retouched 1873, Tate, London), if they reinforce that position,

also operate in other ways. Each of these paintings asserts a capacity in the visual, material quality of paint and in the metaphors of paint and medium which it sets going across the surface of its canvas for pleasure and for the evocation of those things that belong to the surface rather than to depth, to somatic and sensual experience rather than to intellectual penetration into meaning or significance.

This is clearly the way in which these images were understood and consumed by Rossetti's circle and by the patrons who first bought them. Arthur Hughes thought that the first owner of *Bocca Baciata*, George Price Boyce, 'will kiss the dear thing's lips away.'[76] Discussing this response, Barbara Bryant quotes Swinburne's opinion that the painting was 'more stunning than can be decently expressed.'[77] Rossetti himself was plain that *Monna Vanna* 'represents ... the Venetian ideal of female beauty.'[78] A physical sensuousness is central to the impact and reception of these paintings. What is claimed here is that paint can be a sensual experience in its own right and that such an experience is somehow appropriate as a way of engaging with the world; in other words, that the very veiling of meaning which 'St Agnes of Intercession' is so concerned to explore as a characteristic of the visual is the source of its strength. The parodic surface of the story, with its ironic acknowledgement of Poe and the fictional playfulness of *Tristram Shandy*, is perhaps a device to force prose to stay equally shallow rather than allowing it to become profound. The lack of penetration into significance which painting enacts in its surfaces, its devotion to appearance and to a literal superficiality of experience as its greatest gift and achievement, is precisely what allows the visual to mean in a truthful way. There is, in other words, a certain category of experience, of truth, or of the world, which painting's confinement at the surface, at the sensuous limit of superficiality, allows it to access and communicate like no other medium. Indeed, that ability is so developed, so integrated into the nature of the medium itself, that it actually *is* that truth and that experience. The surfaces of *The Blue Bower* or *The Beloved* enact the swarming, febrile, and sensuous character of somatic experience, provoke it, are it. The medium here is what it purports to represent, there is no distinction. Painting is what it investigates, makes plain, and opens into understanding for its spectator.

This is a type of answer to the problem posed at the moment of Pre-Raphaelitism in 1848–50. Identity of self, world, and representation guarantees the ability of the work to deal adequately and justly with reality. If that adequacy cannot be explained through the mechanism of 'Hand and Soul,' as the Pre-Raphaelites first proposed, then the darker possibilities of blindness, delusion, and the deflection of reality in representation rehearsed in 'St Agnes of Intercession' come into play. Rossetti returned to complete the story on the basis of the experiments in painting he had begun in the 1850s with *Bocca Baciata*. The paintings of the 1860s and 1870s which followed both evoke negative aesthetics of the real and assert the identity of representation

and reality in the boldest way he can imagine. In doing so, he provided a vision of painting as, finally and paradoxically, *'material* enough' to be 'a soul of the age.'

Notes

1. *The Critic*, 9, February 15, 1850, 94–5.

2. After the first two numbers the title was changed to *Art and Poetry: Being Thoughts Towards Nature Conducted Principally by Artists.*

3. *The Critic*, 9, June 1, 1850, 278.

4. *The Guardian*, August 28, 1850, 623.

5. The core PRB group involved in *The Germ* comprised Dante Gabriel and William Michael Rossetti, William Holman Hunt, John Everett Millais, F.G. Stephens, Thomas Woolner, and James Collinson. For an important account, see the introduction William Michael Rossetti wrote to the facsimile reprint of *The Germ*, London: Elliot Stock, 1901. For general accounts see Tim Barringer, *The Pre-Raphaelites: Reading the Image*, London, Weidenfeld and Nicolson, 1998; *The Pre-Raphaelites*, exh. cat., ed. Leslie Parris, London: The Tate Gallery in association with Allen Lane and Penguin, 1984; Elizabeth Prettejohn, *The Art of the Pre-Raphaelites*, London: Tate Publishing and Princeton, NJ: Princeton University Press, 2000.

6. William Michael Rossetti, 'Introduction,' in *The Germ*, p. 6. See also, 'there was a league of unquiet and ambitious young spirits, bent upon making a fresh start of their own, and a clean sweep of some effete respectabilities' (p. 8).

7. According to Peter Bürger, such an attempt is characteristic of avant-garde practice, and arguably in this quite specific sense the PRB marked the arrival of an artistic avant-garde in English culture. Avant-garde groups, according to Bürger, aim to overcome the relegation of art to the margins in bourgeois societies, as an irrelevance or a mere pastime when art is 'unassociated with the life praxis of men;' see Peter Bürger, *Theory of the Avant-Garde*, trans. Michael Shaw, Manchester: Manchester University Press and Minneapolis: University of Minnesota Press, 1984, p. 49.

8. Thomas Carlyle, *Past and Present*, 1843, rpt, London: Dent and New York: Dutton, 1960, pp. 6, 7. Emphasis in the original.

9. Carlyle, *Past and Present*, p. 8; John Ruskin, *Academy Notes, 1859*, in *The Works of John Ruskin*, eds E.T. Cook and A. Wedderburn, 39 vols, London, George Allen and Sons and New York: Longmans, Green & Co., 1903–12, vol. 24, p. 244.

10. Carlyle, *Past and Present*, p. 121.

11. Jerome McGann, *Dante Gabriel Rossetti and the Game that Must be Lost*, New Haven and London: Yale University Press, 2000, p. 36, p. 7.

12. John Ruskin, *The Art Criticism of John Ruskin*, ed. Robert L. Herbert, 1964, rpt, Gloucester, Massachusetts, Peter Smith, 1969, p. 395, as cited in McGann, *Dante Gabriel Rossetti*, p. 77.

13. F.G. Stephens, *Dante Gabriel Rossetti*, London: Seeley & Co. and New York: Macmillan & Co., 1894, p. 10.

14. F.G. Stephens [John Seward, pseud.], 'The purpose and tendency of Early Italian art,' William Michael Rossetti (ed.), *The Germ*, 2, February 1850, p. 58.

15. *Ibid.*, p. 59, p. 60. The intellectual relationship between Stephens and Rossetti was a close one at this and later periods.

16. *Ibid.*, p. 64.

17. Dante Gabriel Rossetti, 'St Agnes of Intercession,' in *The Works of Dante Gabriel Rossetti*, ed. William Michael Rossetti, London: Ellis, 1911, p. 558.

18. The most significant of whom is John Ruskin. Writing in support of the PRB in 1851, Ruskin picked up Stephens's linkage of modernity and call for 'closer communion with nature' ('The purpose and tendency of Early Italian art,' p. 58): 'The Pre-Raphaelites … intend to return

to early days in this one point only—that, as far as in them lies, they will draw either what they see, or what they suppose might have been the actual facts of the scene they desire to represent, irrespective of any conventional rules of picture-making' (Letter to *The Times*, May 13, 1851, in *The Works of John Ruskin*, vol. 12, pp. 321–2).

19. See Virginia Surtees, *The Paintings and Drawings of Dante Gabriel Rossetti (1828–1882): A Catalogue Raisonné*, 2 vols, Oxford: Clarendon Press, 1971, cat. 31. The painting of the reclining woman in the background was added much later according to William Holman Hunt, *Pre-Raphaelitism and the Pre-Raphaelite Brotherhood*, 2 vols, London and New York: Macmillan & Co., 1905, vol. 1, p. 76.

20. For Rossetti's reluctance, see Stephens, *Dante Gabriel Rossetti*, p. 11 and Hunt, *Pre-Raphaelitism and the Pre-Raphaelite Brotherhood*, vol. 1, p. 114.

21. Alastair Grieve, *The Art of Dante Gabriel Rossetti: The Pre-Raphaelite Period 1848–50*, Hingham, Norfolk, UK: Real World Publications, 1973, p. 2. Grieve sees connections to the drawings Rossetti produced in this period, in which, in a similar way, he 'seems to have questioned the basic purpose of composition and space in pictures,' p. 4. According to Grieve, Rossetti's graphic technique was as radical as his oil painting. In this case this is achieved partly by translation across media so that 'the pen strokes resemble the engraving style of contemporary illustrators like John Leech,' p. 3.

22. William Bell Scott, *Autobiographical Notes of the Life of William Bell Scott*, ed. W. Minto, 2 vols, London: Osgood, McIlvaine & Co. and New York: Harper, 1892, vol. 1, p. 250.

23. Prettejohn, *The Art of the Pre-Raphaelites*, p. 140.

24. *Ibid.*, p. 145.

25. See William Michael Rossetti, 'Introduction,' *The Germ*, p. 8.

26. As reported by J. Comyns Carr, *Some Eminent Victorians: Personal Recollections in the World of Art and Letters*, London: Duckworth & Co., 1908, p. 66.

27. Michael Baxandall, *Patterns of Intention*, New Haven and London: Yale University Press, 1985, pp. 8–10.

28. I cite these sonnets from Jerome McGann's website, *The Complete Writings and Pictures of Dante Gabriel Rossetti: A Hypermedia Research Archive*, entry on *The Girlhood of Mary Virgin* at http://www.rossettiarchive.org/docs/9-1848.s40.raw.html.

29. Rossetti seems to have accorded the visual priority in his own ambition during this period and earlier. This is widely noticed in the biographical and early critical literature; for instance, Marillier reports 'a statement of his brother that he could not remember any date at which it was not an understood thing in the family that Gabriel was to be a painter;' H.C. Marillier, *Dante Gabriel Rossetti: An Illustrated Memorial of His Life and Art*, London: George Bell and Sons, 1899, p. 6.

30. See William Michael Rossetti's comment in *The P.R.B. Journal: William Michael Rossetti's Diary of the Pre-Raphaelite Brotherhood, 1849–1853*, ed. W.E. Fredeman, Oxford: Clarendon Press, 1975, p. 33.

31. See Jan B. Gordon, 'The imaginary portrait: fin de siècle icon,' *University of Windsor Review*, 5, Fall 1969, 81–104; D.M.R. Bentley, 'Rossetti's "Hand and Soul",' *English Studies in Canada*, 3, Winter 1977, 445–57; John Pfordresher, 'Dante Gabriel Rossetti's "Hand and Soul": sources and significance,' *Studies in Short Fiction*, 19, 1982, 103–32; Richard Giles, 'The House of Life: a Pre-Raphaelite philosophy?,' *The Pre-Raphaelite Review*, 2 (2), May 1982, 101–8; McGann, *Dante Gabriel Rossetti*, pp. 88–93.

32. Dante Gabriel Rossetti, 'Hand and Soul,' in William Michael Rossetti (ed.), *The Germ*, 1, January 1850, 23.

33. *Ibid.*, p. 26.

34. *Ibid.*, p. 28.

35. *Ibid.*, p. 29.

36. *Ibid.*, p. 30.

37. *Ibid.*, p. 31.

38. See William Michael Rossetti, *P.R.B. Journal*, p. 64, where in his entry for March 21, 1850, Rossetti records that 'Gabriel [finished his design] of Chiaro's painting [later destroyed]. He is now

engaged, as regards writing, on a tale entitled "An Autopsychology" [the first title], originally suggested to himself by an image he introduced into "Bride-chamber Talk",' that is, the poem eventually known as 'The Bride's Prelude,' begun in 1848–50 and left incomplete after later revisions. Even at the very end of the periodical's life, when the PRB were tentatively costing a possible fifth number, it was the chance of printing 'St Agnes of Intercession' which proved attractive. See William Michael Rossetti, *P.R.B. Journal*, p. 229.

39. The 'dual' work which partners this story is therefore proposed as the drawing 'How They Met Themselves' (1851/1860, Fitzwilliam Museum, Cambridge), see Surtees, cat. 118, for Rossetti's references to the 'bogie drawing.'

40. See William Michael Rossetti's account in his notes to *The Works of Dante Gabriel Rossetti*, p. 680.

41. *Ibid.*

42. I am relying here on the analysis put forward by Jerome McGann in the pages devoted to this story in the website, *The Complete Writings and Pictures of Dante Gabriel Rossetti*; see http://www. rossettiarchive.org/docs/9p-1850.s121.raw.html. On Poe, see Alastair Grieve, 'Rossetti's illustrations for Poe,' *Apollo*, 97, 1973, 142–5.

43. 'St Agnes of Intercession,' in *The Works of Dante Gabriel Rossetti*, p. 566. Evidence of Rossetti's interest in this subject can be gleaned from a contemporary poem, 'Sudden Light,' the first two stanzas of which begin 'I have been here before' and 'You have been mine before;' *The Works of Dante Gabriel Rossetti*, p. 200. See also Jan Marsh, *Dante Gabriel Rossetti: Painter and Poet*, London: Weidenfeld and Nicolson 1999, p. 48 for Rossetti's contemporary identification with Dante.

44. Like the enthusiasm for Poe, the gothic reflects a staple of Rossetti's reading as a youth and young man; see Marsh, *Dante Gabriel Rossetti*, p. 22, p. 29.

45. 'St Agnes of Intercession,' in *The Works of Dante Gabriel Rossetti*, p. 557.

46. Unlike his narrator, Rossetti did not submit *The Girlhood of Mary Virgin* to the test of the RA, but showed at the Free Exhibition held at Hyde Park Corner. In the story, the RA represents an ambition unfulfilled, although one of which Rossetti is sceptical.

47. 'St Agnes of Intercession,' in *The Works of Dante Gabriel Rossetti*, p. 557.

48. *Ibid.*, p. 558.

49. *Ibid.*, p. 561.

50. *Ibid.*, p. 558.

51. *Ibid.*

52. *Ibid.*, p. 560.

53. *Ibid.*, p. 561.

54. *Ibid.*, p. 570.

55. *Ibid.*, p. 557. It seems likely that these reminiscences at the end of the story were added as part of the work Rossetti did on the original draft of 1850 when he returned to it around 1870. Both the quotations at the start of the story appear in the 1850 draft manuscript now at Duke University (see the electronic version in the *The Complete Writings and Pictures of Dante Gabriel Rossetti* at http://www.rossettiarchive.org/docs/nb0004.duke.rad.html). The draft breaks off about midway through the narrative, at the point where the narrator reads the critic's poem in the gallery.

56. *Ibid.*, p. 566.

57. *Ibid.*

58. *Ibid.*, p. 567.

59. *Ibid.*

60. Compare the account, quoted above, which Rossetti's narrator gives of the moment of despair in 'Hand and Soul:' 'Am I not as a cloth drawn before the light, that the looker may not be blinded; but which sheweth thereby the grain of its own coarseness; so that the light seems defiled, and men say, 'We will not walk by it.'

61. F.G. Stephens, *Dante Gabriel Rossetti*, p. 54.

62. *The Age of Rossetti, Burne-Jones and Watts: Symbolism in Britain 1860–1910*, exh. cat., eds Andrew Wilton and Robert Upstone, London: The Tate Gallery Publishing and Paris and New York: Flammarion, 1997, p. 96.

63. Elizabeth Prettejohn, *Rossetti and His Circle*, London: Tate Gallery and New York: Stewart, Tabori & Chang, 1997, p. 30.

64. See Virginia M. Allen, '"One strangling golden hair": Dante Gabriel Rossetti's *Lady Lilith*,' *The Art Bulletin*, 66, June 1984, 285–94.

65. On these paintings as 'Venetian,' see Alastair Grieve, 'Rossetti and the scandal of art for art's sake in the early 1860s,' in Elizabeth Prettejohn (ed.), *After the Pre-Raphaelites: Art and Aestheticism in Victorian England*, Manchester: Manchester University Press and New Brunswick, NJ: Rutgers University Press, 1999, pp. 24–6.

66. Marillier, *Dante Gabriel Rossetti*, p. 133.

67. Stephens, *Dante Gabriel Rossetti*, p. 68.

68. *Ibid.*, p. 69.

69. Cited in Prettejohn, *Rossetti and His Circle*, p. 30.

70. William M. Rossetti and A.C. Swinburne, *Notes on the Royal Academy Exhibition*, London: J.C. Hotten, 1868, facsimile reprint, New York: AMS Press, 1976, p. 46.

71. See the website *The Complete Writings and Pictures of Dante Gabriel Rossetti*, entry for *Lady Lilith* at http://www.rossettiarchive.org/docs/s205.rap.html.

72. Ruskin 'Letter to *The Times*, May 25, 1854,' in *The Works of John Ruskin*, vol. 12, p. 334.

73. *The Pre-Raphaelites*, exh. cat., ed. Leslie Parris, p. 121.

74. It has been suggested that John William Waterhouse's 1894 painting, *The Lady of Shalott* (Leeds City Art Gallery) is also indebted to *The Awakening Conscience* in its use of the compositional device of a mirror behind the action and reflecting a segment of nature not otherwise visible in the design. See Gail-Nina Anderson and Joanne Wright, *Heaven on Earth: The Religion of Beauty in Late Victorian Art*, exh. cat., London: The Djanogly Art Gallery, University of Nottingham Arts Centre in association with Lund Humphries, 1994, p. 125. This use of a mirror within the composition occurs elsewhere in Waterhouse, and Anderson and Wright suggest a connection to Hunt's *The Lady of Shalott* (c. 1886–1905, Wadsworth Atheneum, Hartford, Connecticut) and its companion illustration for the Moxon Tennyson. See *Heaven on Earth*, p. 120. Another interesting point of comparison is Waterhouse's painting *Destiny* (1900, Towneley Hall Art Gallery and Museums, Burnley, England).

75. Dante Gabriel Rossetti, 'Beauty's Body,' in *The Age of Rossetti, Burne-Jones and Watts*, exh. cat., eds Wilton and Upstone, p. 102.

76. Cited in John Nicoll, *Dante Gabriel Rossetti*, London: Studio Vista, 1975, p. 125.

77. *The Age of Rossetti, Burne-Jones and Watts*, exh. cat., eds Wilton and Upstone, p. 97.

78. Cited in *The Pre-Raphaelites*, exh. cat., ed. Leslie Parris, p. 215.

Reconstructing Pre-Raphaelitism: the evolution of William Michael Rossetti's critical position

Julie L'Enfant

Among the original Pre-Raphaelite Brotherhood (PRB) was the serious and practical William Michael Rossetti. Today he is known mainly as the diarist of the Brotherhood and the editor of its magazine, *The Germ*; he is also recognized as a literary critic and the tireless promoter of the reputations of his distinguished siblings, Dante Gabriel and Christina. Some 67 volumes bear his name as author or editor. In his own day, however, he was well known as an art critic. In 1867 he published *Fine Art, Chiefly Contemporary*, a selective collection of his reviews, but much of his art criticism, which appeared regularly in English and American periodicals until 1878, has never been republished. These writings on art show a broad, eclectic taste and an evolving point of view that not only produces a new perspective on Rossetti's development as a critic but also sheds light on his role in defining Pre-Raphaelitism.[1]

William Michael Rossetti had aspirations as a poet; yet as the PRB came into being in 1848 he was already a clerk in the Excise Office (later called the Inland Revenue), where he would serve for almost 50 years. He became the secretary of the PRB and kept its journal, which was not a personal record, like his later diaries, but a chronicle of day-to-day events that has been an invaluable resource to scholars on how the young men thought and worked.[2] William Michael Rossetti also became editor of the PRB magazine, *The Germ*. The magazine had been his brother Dante Gabriel's idea, but as usual when Dante Gabriel made plans, William Michael took care of the practical details.[3] When PRB members failed to produce promised work, William Michael Rossetti would include his own productions, or those of Dante Gabriel and Christina. William Michael wrote the sonnet that appears on the cover of each of the four issues of *The Germ*. Crabbed in style, it has been the object of some derision through the years; nevertheless it does, with careful reading, yield some idea of the PRB's goals.[4] As Rossetti explained in his preface to a 1901 reprint of *The Germ*:

What I meant is this: A writer ought to think out his subject honestly and personally, not imitatively, and ought to express it with directness and precision; if he does this, we should respect his performance as truthful, even though it may not be important. This indicated, for writers, much the same principle which the P.R.B. professed for painters,—individual genuineness in the thought, reproductive genuineness in the presentment.[5]

The Germ also gave William Michael Rossetti his first opportunity to write criticism: for each issue he supplied a poetry review. The first is of Arthur Hugh Clough's *Bothie of Toper-na-fuosich*, which establishes a basic critical stance for the rest.[6] Rossetti commends the poem, which concerns the romantic adventures of some Oxford undergraduates, for appropriateness of style to subject, the old idea of decorum. He also insists, with the authority that would mark all his writing, on certain standards of style, criticizing Clough's poem for metrical irregularities and commenting closely on its language.[7] Yet Rossetti was never overbearing as a critic, declaring in that same review that 'the inventor is more than the commentator, and the book more than the notes.' A later review of Robert Browning's 'Christmas Eve and Easter Day' does not presume to criticize the extravagances of the master's style, seen as true to his complexities of thought.[8]

William Michael Rossetti's literary reviews in *The Germ* led to an opportunity to write art reviews for *The Critic*, a weekly periodical of modest circulation. Although the offer did not include payment, Rossetti gladly accepted, as he recounted in his 1906 memoir, *Some Reminiscences*: he wanted a forum in which to champion the Pre-Raphaelite brothers 'at a time when every man's hand was against them, and the abuse of their performances had reached a singular excess of virulence.'[9] Yet his ideal, even then (at least in hindsight) was an unbiased opinion:

For a little tartness of tone to artists or writers in the opposite camp, or (what is still more difficult to avoid) for a little smoothing down of edges when friends had to be dealt with, I ought perhaps to apologize, and so I do; but I can honestly assert that, beyond this narrow margin, I never paltered with my personal perception (which may have been accurate or inaccurate) of the strict truth.[10]

In fact, art reviewing in mid-nineteenth-century London was not distinguished by its objectivity. More than 300 periodicals—quarterlies, monthlies, weeklies, and daily newspapers—carried reviews of the many exhibitions in the London season at the Royal Academy, the British Institution, the National Institution, the Society of British Artists, the Royal Water Colour Society, and assorted galleries. Artists enjoyed a close relationship with the viewing public; indeed, it was generally presumed that the purpose of art was to communicate ideas and feelings to that public.[11] Yet this audience was by and large unschooled; thus, on a practical level, reviewers (usually writing anonymously and not uncommonly with 'tartness of tone') told viewers what to look for at the major

exhibitions, where walls were crowded with hundreds of similar-looking canvases. Reviewers typically selected 20 or 30 works to comment on, focusing their remarks on the subject matter but also dispensing a certain amount of useful jargon about composition, design, 'expression,' and 'coloring.'[12] Many reviewers were penny-a-liners with no particular knowledge of art, but others with the knowledge to employ considered principles could justly be called 'critics.' John Ruskin is generally recognized as the leading voice among them and indeed is given credit for establishing the intellectual respectability of art criticism in England.[13] Although English art critics did not form distinct schools in the way of their French counterparts, a strong partisan spirit operated in Victorian art criticism, with conservative critics, at the *Art Journal* and *Athenaeum*, for example, doing battle for the Royal Academy, and liberal critics such as Ruskin championing the cause of rebellious elements such as the Pre-Raphaelite Brotherhood.[14]

Rossetti's early reviews in *The Critic* share the confidence of the PRB in their power to reject the outworn academic rules of art and embody, through the study of nature, serious ideas lacking in the British school. In June 1850, an anonymous reviewer in the *Athenaeum* had pilloried the 'pre-Raffaelites' as a puerile and uncouth version of the Nazarenes, earlier German painters also sometimes known as 'Pre-Raffaelites.'[15] In notices on Dante Gabriel Rossetti's *Ecce Ancilla Domini* (1850, Tate, London) and Millais's *Christ in the House of His Parents* (1849–50, Tate, London) William Michael Rossetti refuted the notion that the PRB merely copied the archaizing German artists by arguing that their ultimate source was nature.[16] But Rossetti was not uncritical of his brothers: after having denied at some length the charge of 'incorrect perspective' in Millais's *Christ in the House of His Parents*, he admitted that there was a certain ugliness in the figures. The salvation of that work, in his view, was its treatment of the subject, which he found 'throughout human: the types humanly possible and probable; never mere symbol.' Moreover, he saw in the whole 'poetry, not of the judgment, but of the mind and the hand'—a distinction that defies logical analysis but serves to establish, even at this early stage, his requirement of something more than the factualism often seen as the heart of the Pre-Raphaelite approach. William Holman Hunt's *A Converted British Family Sheltering a Christian Missionary from the Persecution of the Druids* (1849–50, Ashmolean Museum, Oxford), discussed in the same 1850 review, possessed that factual quality, being 'in every respect conscientiously conceived and executed.' Yet Rossetti noted 'a certain crudity of colouring' and, while applauding its disregard of all merely conventional rules, regretted the over-insistence of its composition. 'Composition founded on beauty when not incompatible with likelihood, is a true principle, not lightly to be departed from,' he wrote.[17]

Clearly William Michael Rossetti was not averse to pictorial devices producing aesthetic pleasure. In early reviews, he often spoke of these matters in terms of 'poetry,' drawing on the critical vocabulary he had employed

earlier in literary criticism for *The Germ*, where he looked for serious subjects from the poet's soul and what he called 'truth in style.'[18] He found the work of Mark Anthony, for instance, to be 'instinct with poetry' and possessed of 'poetic perceptions most forceful in their appeal.'[19] The idea that style must be appropriate to the artist's subject allowed Rossetti to respond favorably to many academicians such as David Cox, whose works bear little resemblance to early Pre-Raphaelite productions. Nevertheless, he scorned work he considered 'slosh.' With regard to the *Disarming of Cupid* (1850, The Royal Collection) by William Edward Frost, he asked, 'For how many years more are these smooth lifeless unlifelike faces to simper, these limbs to pose and curl, these arms to remain waving?'[20]

William Michael Rossetti soon moved on to a more prominent periodical, *The Spectator*, where he wrote art reviews from 1850 until 1858. In 'Pre-Raphaelitism,' an 1851 article for *The Spectator*, Rossetti explicated the new school for the first time.[21] He stresses the Ruskinian idea that the Pre-Raphaelite brothers try to see nature through their own eyes, disregarding conventional academic rules (but not the 'positive rules established by nature') and confining themselves to 'actual or presumable fact.' Yet Rossetti takes care to distinguish his position from Ruskin's, explicitly questioning the oft-quoted dictum that young artists 'should go to Nature in all singleness of heart, and walk with her laboriously and trustingly ... rejecting nothing, selecting nothing, and scorning nothing; believing all things to be right and good, and rejoicing always in the truth.'[22] He also once again discounts the idea that the Pre-Raphaelites imitate early Italian art, attributing any kinship with these masters not to similarities in style but rather to affinities in aim ('truth'), process ('exactitude of study from nature'), and outlook ('earnestness and thoroughness'). F.G. Stephens, another Pre-Raphaelite who turned critic early on, was not so defensive about influences on the group. In a series of articles in *The Crayon*, Stephens treats Giotto and the early Renaissance masters as the 'first Pre-Raphaelites,' then discusses the modern Brotherhood in terms of two major resolves that mirror Ruskin's program: to study nature, not artistic conventions, and to give each picture a motive (that is, have it convey a lesson or record a noble act).[23] Whereas Rossetti certainly respected moral seriousness, as in Hunt's *The Awakening Conscience* (1853–54, Tate, London), he hardly ever elaborated on the moral message a work might contain. The difference in the outlooks of the two critics can be seen in their reactions to Millais's *Autumn Leaves* (1855–56, Manchester City Art Galleries): Stephens, almost alone among contemporary critics, found a serious idea there (the 'four fate-like children' burning leaves as 'the dark night cometh'); Rossetti, on the other hand, focused on the picture's intense emotion and color, which he compared to the Venetians.[24]

William Michael Rossetti always had the highest regard for Millais's pictorial powers. Indeed, he believed that Millais effected a turning point

in the fortunes of the PRB with such pictures as *A Huguenot* (1851–52, The Makins Collection) and *The Order of Release* (1852–53, Tate, London).[25] By 1855, according to Rossetti, the Pre-Raphaelites had actually improved the British school. It still had too many run-of-the-mill sentimental narratives and stock landscapes, he told the readers of *The Crayon*, but the quality of subjects and executive skill had been raised. 'Let there be no mistake about what Pre-Raphaelitism means,' he wrote, explaining that it has nothing to do with the technique or subject matter of artists before Raphael but rather with 'a resolute adherence to truth of feeling and truth of fact, and a resolute disregard of all mere grace or all mere dexterity.' At its lowest it is 'reverent faith in Nature' (whether mere copyism or something more poetic), while at its highest it is a deep sincerity that invents a new idea.[26]

Meanwhile, Rossetti's outlook had been broadening. He was writing for other journals as well as *The Spectator* on the growing number of exhibitions in London; he also went abroad, both as a tourist and as a working journalist.[27] Of particular importance to his development was the 1855 Universal Exposition in Paris. Rossetti was confronted there by a panoply of national schools, but the French dominated the exhibition, and he found himself admiring such 'dandyish' artists as Jean-Louis Hamon. Despite his unflagging admiration for Pre-Raphaelite pictures, Rossetti was constrained to admit that the French had superior 'style,' by which he meant not an artist's individual manner but 'that workmanlike or artist-like competence, sureness, and savoir faire' displayed by the French. Such skill moved Rossetti to question the very purpose of art:

Acknowledging in its fullest sense the axiom that the greatest artist is
he who embodies the greatest ideas, we have still to ask, What are those
ideas to be? We would answer—Ideas of form, colour, and expression. The
man who has observed most in visible nature, who has the most deeply
and nobly felt what he has observed, and renders that with the most
exquisite and absolute intensity, he is the greatest man in high art.[28]

'Realism' was the common thread in all the schools at the exposition, with the Pre-Raphaelites the best among them, Rossetti concluded.[29] But it was necessary to position the PRB against their putative counterparts in France, the Realists. Rossetti thought little of Gustave Courbet as either an artist or theorist on the grounds that Courbet denied imagination its proper role in art.[30] His emphasis on tangible facts particularly rankled Rossetti, as subsequent essays in the *Edinburgh Weekly Review* make clear. The Pre-Raphaelites, he declared, understood 'facts' to encompass intangible subjects drawn from history or literature: realism for the PRB referred to the manner of execution.[31] As Rossetti explained it, the artist must have 'sincerity of conception' and make his representation of imagined subjects 'look *like* a fact.' (In other words, we might say, whereas Courbet refused to paint angels because he could not see them, the Pre-Raphaelites created believable angels by painting each

other.)[32] Rossetti also believed that the Pre-Raphaelites' devotion to beauty distinguished them from Courbet and his followers. If the PRB were, as was sometimes charged, cold to conventional notions of beauty, such a fault could be attributed to the 'enthusiastic and uncurbed perception of the student of nature, that there is beauty in *everything*; and in part from the laborious effort to realize to the full, which will sometimes defeat itself.' When beauty is part of the subject, Rossetti observed, 'it is as much in the logic of Pre-Raffaelitism to strive after beauty as after truth.'[33]

In the 1860s Rossetti confronted his growing sense of the importance of aesthetic qualities in a series of Royal Academy reviews for *Fraser's Magazine*. These important essays, which were signed, frame the issue in terms of the relative importance of subject and style, concluding that whereas style ('mere execution') is inferior to the intellectual component of art, it is nevertheless more notable. Excellence of execution did not necessarily mean 'high finish' to Rossetti, who had grown exasperated with the legion of Pre-Raphaelite followers whose primary goal he took to be minute detail. He praised the new broad manner of Millais, by that time a successful academician, in such works as *The Eve of St Agnes* (1863, private collection). 'A smear of the brush of Veronese, or even of Reynolds, has higher technical merit than a portrait by Denner,' Rossetti wrote, going so far as to assert, although with some reluctance, that the Royal Academy should choose a 'good picture of a cat' over a 'bad picture of Christ.'[34]

With this critical stance—far removed from the moralism of Ruskin— William Michael Rossetti appraised the works of such artists as Edward Burne-Jones, Albert Moore, James McNeill Whistler, and Frederic Leighton. In 1863 W.M. Rossetti said presciently that Leighton practiced 'the art of luxurious exquisiteness; beauty, for beauty's sake; colour, light, form, choice details, for their own sake, or for beauty's,' thus giving early expression to the idea of 'art for art's sake,' although it is important to note that he found Leighton wanting in psychological and factual accuracy.[35] Rossetti used various catchphrases for works with appropriate style such as 'success,' 'true pictorial conception,' and 'living spirit.' Often he spoke of a work that 'met its own standard.' 'Mr. Whistler, in *The Last of Old Westminster*, does more, with a rapid style which might be censured as loose and sketchy but for its perfect understanding and keeping according to its own standard, than minor men could do with tenfold effort and persistency,' he wrote in 1863.[36] Rossetti places these *Fraser's Magazine* on 'style, subject matter, and successes in art' at the forefront of *Fine Art, Chiefly Contemporary* (1867), suggesting a development in his thought by the 1860s from a critical program of realism tempered with certain stylistic requirements to a progressive aestheticism.[37] That William Michael Rossetti testified on behalf of Whistler in his suit against Ruskin in 1878 could also be taken to signal his conversion from 'truth to nature' to a thoroughly modern formalism.[38]

This aesthetic slant in William Michael Rossetti's art criticism in the 1870s would appear to make him the ideal apologist for the second phase of Pre-Raphaelitism, characterized by a poetic medievalism and led by his now reclusive brother, Dante Gabriel. Like Ruskin, William Michael Rossetti held that revivalist styles should express a living spirit of the past, not merely imitate its outward forms.[39] He found more of that spirit in Pre-Raphaelite medievalism than in the neoclassicism of artists such as Leighton and Moore. In 1864 he praised Burne-Jones's watercolor *The Merciful Knight* (1863–64, Birmingham Museum and Art Gallery) as the work of a 'new genius,' the 'greatest colourist who now exhibits in our water-colour school, and the only inventor in the right artistic sense of the word.'[40] Yet the work of Burne-Jones was problematic for Rossetti, for reasons explained in 'Pre-Raphaelitism: its starting point and sequel' (1876). Here he looks at two aesthetes associated with the new poetic phase of the movement, Burne-Jones and Whistler. He sees Burne-Jones as a 'living recast' of medieval Italian painting who, nevertheless, went so far in the direction of 'style' that he was at times morbid and artificial. Whistler was 'fathered upon Pre-Raphaelitism' in the sense that his work depended on 'truth and delicacy of impression, apart from conventional standards of inspiration or execution,' but he, too, overemphasized style. Rossetti concludes by affirming his belief in the original Pre-Raphaelite aims—serious ideas and 'entire adherence to visible fact'—and calling for new painters to arise and fulfil them.[41]

Rossetti's final post as an art reviewer was at the *Academy*, a prestigious journal founded by Charles D. Appleton. Writing of the opening exhibition of the Grosvenor Gallery in 1877, Rossetti paid tribute to the genius of Burne-Jones but also discussed the gloomy aura of his work in terms of *Weltschmerz*, observing that such art for art's sake ultimately turns inward upon itself.[42] Of the Grosvenor in 1878, Rossetti wrote: 'The most serious deficiency is in historical painting: we have and we enjoy here the ideal; but not to any reasonable degree the historical, with its deep interest in strong and significant facts.'[43] Yet ideas alone—as from the first—failed to satisfy him. Rossetti was disappointed on this occasion by Alphonse Legros, one of the realists he most admired. Legros's *Le Repas des Pauvres* (1877, Tate, London) had seriousness, actuality, and freedom from mere tricks; 'we can hardly say, however, that it makes a picture.'[44] Millais, on the other hand, could always be relied on for pictorial grace, but he often disappointed Rossetti by his lack of serious thought.

William Michael Rossetti's mature critical position can be characterized as 'aesthetic realism,' an approach requiring the kind of critical balancing natural to his dialectical turn of mind.[45] But the Grosvenor naturally appealed to his aesthetic side, especially noticeable in relation to his colleague F.G. Stephens, for many years the critic at the *Athenaeum*. In 1878, for instance, Rossetti

singled out a newcomer, Cecil Lawson, for special praise. Lawson's *In the Valley: a Pastoral* was, he wrote, graceful, harmonious, and poetic; his works on view showed 'his possession of the three precious qualities—strength, sweetness, and sentiment.'[46] Stephens, on the other hand, admired the power and originality of Lawson's work, but, saying no more about their particular qualities, used them as his point of departure to lament the tendency of landscape painters in recent years to paint only 'air' and 'light' to the neglect of foreground objects and other aspects of the truth. Stephens sounded the original Pre-Raphaelite watchwords of 'truth' and nature' far more regularly than did William Michael Rossetti.[47]

Rossetti's method in the *Academy*, as throughout his career, was thorough— Royal Academy notices usually ran in five separate articles that totaled, on average, some 25 columns of small and densely packed print—and, while observations on individual works could be lively and even amusing, the articles as a whole might well be regarded as prolix and lacking in style. In about 1875 Rossetti's reviews in the *Academy* began to refer to space limitations. Whether Appleton demanded it, or Rossetti simply grew tired of the grind of frequent reviewing, his reviews became somewhat shorter. Even so, they were not as succinct as F.G. Stephens's reviews in the *Athenaeum* or as polished as Sidney Colvin's graceful essays in the *Fortnightly Review*. But Rossetti's undogmatic position and catholic tastes required the methodical examination of numerous works, and the resulting reviews have an impressive weight and substance. Taken together, they provide wide-ranging, reliable information on exhibitions as well as even-handed evaluations of a wide array of artists. In 1878, however, Appleton unceremoniously replaced Rossetti with a younger writer, J. Comyns Carr.

Meanwhile, William Michael Rossetti had also been engaged in assorted literary labors, most notably editions of Swinburne, Whitman, and Shelley. When he was unable to secure another post as an art reviewer, Rossetti accepted an offer to write literary reviews for the *Athenaeum*, which he did during the 1880s and 1890s.[48] He had remained close to his family, living in the same house as Christina and their mother, occasionally boarding with Dante Gabriel at Cheyne Walk. In 1874 he married Lucy Brown, daughter of Ford Madox Brown. Their new household (from which his mother and sister eventually moved) grew rapidly, with five children born to William Michael and Lucy between 1875 and 1881; William Michael Rossetti also continued to provide the chronically indebted Dante Gabriel with financial and emotional support. After Dante Gabriel's death in 1882, William Michael set about to preserve and promote his reputation as artist and poet. He edited several volumes of Dante Gabriel's poetry, each with a short memoir. He also planned an edition of selected letters with a memoir by Theodore Watts (later Watts-Dunton), whom he believed could be more frank about Dante Gabriel's gifts than could a brother.[49] Yet Watts was dilatory, and eventually Rossetti himself

wrote the memoir that constitutes the first volume of the *Family-Letters of Dante Gabriel Rossetti* (1895).[50]

Rossetti wrote the memoir in his usual sombre, deliberate style. It is a closely knit narrative, with none of the amateurish ramblings of John Guille Millais's *Life and Letters of Sir John Everett Millais* (1899). We recognize a Pre-Raphaelite dedication to the truth. Rossetti hints at his brother's shortcomings as a husband (here is not the sunny image-making of Georgiana Burne-Jones in her memorials to her husband). He deals so fully with Dante Gabriel's addiction to chloral and the related mental aberrations that some contemporaries charged him with sensationalism and exploitation.[51] On the other hand, as he asserted in his preface, he told only what he chose to tell. He omitted Dante Gabriel's illicit liaisons, especially those with the married Jane Morris and the less than respectable Fanny Cornforth.[52] Nor did he reveal Dante Gabriel's chronic borrowing and indebtedness. Yet he was frank, within his boundaries of discretion. His method is factual (never, for instance, does he reconstruct conversations and scenes, as does Georgiana Burne-Jones). Scandalous events such as the death of Elizabeth Siddall and the subsequent exhumation of Dante Gabriel's poems from her grave are recounted in a documentary style reminiscent of William Michael Rossetti's early poem 'Mrs. Holmes Grey.'

Rossetti became Christina's literary executor as well upon her death in 1894. His major effort on her behalf was *The Poetical Works of Christina Georgina Rossetti* (1904), accompanied by a substantial memoir, undertaken with some reluctance since he did not share her religious faith. Again he wrote with a Pre-Raphaelite devotion to the truth, discussing such previously private matters in Christina's 'hushed life-drama' as her broken engagement to James Collinson in the days of the PRB and a later courtship, carried out largely in poems, with a beloved whom Rossetti revealed to be Charles Cayley.[53]

Rossetti's preface to the *Poetical Works* also addresses the issue of whether he should include material the poet herself had not published. One of Rossetti's earlier editions of Christina's work, *New Poems* (1896), had been criticized on the grounds that he 'raked together all that [he] could find.' He denied that charge, yet did not pretend to deny his belief that everything from the hand of an important writer is worth preserving.[54] Rossetti was, in fact, in possession of an overwhelming mass of family letters and papers, having become, with Christina's death, the last surviving member of the immediate family, apart from his children.[55] Setting about to organize and make proper use of these archives, Rossetti conceived a plan to publish a selection of these copious materials in five volumes. Three appeared in his lifetime, but no publisher was interested in the fourth and fifth.[56] Rossetti's labors were met with some scorn in his own day: one anonymous reviewer in 1898 referred to him as 'that giant of mediocrity, grinding his family annals to dust in the dark.'[57] Rossetti was sadly aware of this, but persevered in his mission to preserve his family heritage.[58]

William Michael Rossetti also continued to function as spokesman (and sometimes apologist) for the Pre-Raphaelites. With William Holman Hunt and F.G. Stephens, he became one of the grand old men of the Pre-Raphaelite movement. His viewpoint on their youthful revolution can be found in several essays. In 1881 the *Magazine of Art* invited him to supply an account that would correct the many errors in print. As always, he wrote modestly about the movement, formulating their aims in terms of their likes ('the serious earnest simplicity of the earlier Italian art') and dislikes (the affectation and 'meagre generalising' of the art of the day), and admitting an element of 'juvenility' to the proceedings.[59] Perhaps his most systematic statement of the movement's aims, often quoted today, appeared in his memoir of Dante Gabriel in *Family-Letters* (1895):

1, To have genuine ideas to express; 2, to study Nature attentively, so as to know how to express them; 3, to sympathize with what is direct and serious and heartfelt in previous art, to the exclusion of what is conventional and self-parading and learned by rote; and 4, most indispensable of all, to produce thoroughly good pictures and statues.[60]

Rossetti would also acknowledge more clearly in this 1895 statement that meticulous detail had been seen as desirable in the early days, at least in artistic training.[61]

Rossetti wrote with more detachment in his preface to the 1901 reprint of *The Germ*. He recalls the Pre-Raphaelites as 'striplings' with 'the temper of rebels' who were trying to invent art for themselves with no master except their own powers of mind and hand. It really amounted, he says, to each artist developing his own individuality by 'disregarding school rules' and going straight to nature. This account includes a more positive view of the British School, with the admission that the Pre-Raphaelites in their revolutionary ardor had 'contemned some things and some practitioners of art not at all contemptible.'[62]

William Michael Rossetti's 1906 autobiography, *Some Reminiscences*, fits the movement into the context of his long career as a civil servant and man of letters, and reminds us how brief—just a little over two years—the original association was. He was inclined to refer to Pre-Raphaelitism in quotation marks in these volumes and hardly bothered to restate its original aims, referring incidentally to 'minute and solicitous study of nature' or 'their two leading principles—the need for serious inventive thought in works of art, and for close and detailed study of nature in their carrying out.' The group's cohesion came not from clear precepts, in Rossetti's view, but rather 'the link of comradeship,' shown in these volumes to include many ancillary figures.[63] Rossetti gives William Holman Hunt credit for originating the movement and asserts that he was the most admired within the group; on the other hand, he gives his brother, Dante Gabriel, credit for 'giving shape and tone to the

P.R.B.,' maintaining that he was 'generally recognized as holding the primacy in an intellectual, though not in the pictorial and practical, relation.'[64] Such assignments of credit were by this time hotly contested, particularly in the wake of Hunt's two-volume memoir, *Pre-Raphaelitism and the Pre-Raphaelite Brotherhood* (1905), which some felt magnified his own role. F.G. Stephens had taken particular offense at Hunt's account; in fact, as *Some Reminiscences* points out, a number of 'keen antipathies' had sundered the members of the movement in the preceding 50 years. William Michael Rossetti was of a pacific nature, however, and remained on good terms with all.[65]

Indeed, William Michael Rossetti was never doctrinaire about Pre-Raphaelitism. His repeated statements of the movement's ideals include serious ideas and close study of nature—Hunt's approach—but, in the end, are more about perception than theory. Despite his disclaimers, his view owed a good deal to Ruskin, particularly the older critic's idea of the 'innocent eye.' We can see this clearly in brief notes by Rossetti on his critical position, not published in his lifetime, beginning 'The moment I see a picture.'[66] The notes demonstrate that he had no ideological preconceptions about what art should do, rather that he registered his impression of a work, then tried to formulate an unbiased opinion.[67] They also confirm what is evident from an examination of Rossetti's reviews: harmony of color was the technical element that concerned him most, along with related matters of tone and paint handling. He seldom analyzed drawing or composition, preferring to leave such technical matters to professional artists. A work of art had to produce pleasure to gain Rossetti's favor, not teach a lesson or impress with skill. In this stance he was allied with Walter Pater, whose 1873 preface to *The Renaissance* had declared that 'in æsthetic criticism the first step towards seeing one's object as it really is, is to know one's own impression as it really is, to discriminate it, to realise it distinctly.'[68] On the other hand, the student of Rossetti's criticism will not be surprised to find this remark in the notes: 'I have not included in my "points" such immensely important quantities as Invention, Intellect, Beauty nor even Expression. Critics of the present day seem to be comparatively indifferent to such qualities: to me they seem the highest of all …'

Rossetti concluded with these words:

Upshot—Form a sincere opinion whether you like a picture or statue, & on what grounds you like or dislike it, & express such opinion in total disregard of the question whether other people share it or the contrary. Also—Don't take up with any prevalent fad, but let your own substantial opinion be your own criticism, at one time as at another: I might add—Be prepared to admit the merit of any & every sort of painting, provided only it is a good thing from its own point of view.

In the same way, true Pre-Raphaelites, according to William Michael Rossetti, had as their mission to see the subject for themselves and embody it in appropriate form. This view of Pre-Raphaelite aims was shaped by his own

nature—serious, thorough, and high-minded, yet with an eye for beauty and grace.

As diarist and art critic, William Michael Rossetti chronicled the Pre-Raphaelite movement and its impact on Victorian art, and over the years he would recount its history with great care for fact. The same sincere thoroughness informed his work as poet, literary critic, editor, and biographer. Throughout his long and varied career, Rossetti maintained the dedication to truth and friendship that characterized the original PRB. As a result, his prolific writings provide one of the best sources on Pre-Raphaelite theory and practice.

Notes

1. This chapter derives from my PhD thesis at the University of Minnesota, 'Truth in art: William Michael Rossetti and nineteenth-century realist criticism' (1996), published in slightly different form as *William Rossetti's Art Criticism: The Search for Truth in Victorian Art*, Lanham, MD and Oxford: University Press of America, 1999. My study of Rossetti is greatly indebted to Roger W. Peattie, whose 'William Michael Rossetti as critic and editor, together with a consideration of his life and character,' unpublished PhD thesis, University College, University of London, 1966, provided the first survey of Rossetti's critical writings. Also invaluable were Peattie, 'William Michael Rossetti's art notices in the periodicals, 1850–1878: an annotated checklist,' *Victorian Periodicals Newsletter*, 8, June 1975, 75–92; and 'W.M. Rossetti's contributions to the *Edinburgh Weekly Review*,' *Victorian Periodicals Review*, 19 (3), Fall 1986, 108–10.

2. The journal presents a somber view of the PRB, and, in any case, it is fragmentary (having been partially destroyed by Dante Gabriel Rossetti). Nevertheless, it remains a valuable source. See William Michael Rossetti, *The P.R.B. Journal: William Michael Rossetti's Diary of the Pre-Raphaelite Brotherhood, 1849–1853*, ed. William E. Fredeman, Oxford: Clarendon Press, 1975, pp. xvii–xxvii.

3. Sharon W. Propas has given a full account of William Michael Rossetti's administration of *The Germ*, which involved all the practical concerns of editing, publication, and publicity. 'William Michael Rossetti and the *Germ*,' *Journal of Pre-Raphaelite Studies*, 6 (2), May 1986, 29–36.

4. The sonnet begins with the lines 'When whoso merely hath a little thought/Will plainly think the thought which is in him—/Not imaging another's bright or dim' and offers the artist this advice: 'Ask: "Is this truth?"' Rossetti's 1901 explanation refers to William Bell Scott's remark that it would take 'a Browning Society's united intellects' to decipher the sonnet. See William Bell Scott, *Autobiographical Notes of the Life of William Bell Scott*, ed. W. Minto, London: Osgood, McIlvaine & Co. and New York: Harper & Brothers, 1892, vol. 1, pp. 324–5.

5. William Michael Rossetti, 'Preface,' in William Michael Rossetti (ed.), *The Germ*, 1850, rpt, London: Elliot Stock, 1901, p. 16.

6. *Ibid.*, pp. 34–46.

7. *Ibid.*, p. 35. Rossetti had developed his skills in the explication of poetry in PRB sessions under the tutelage of Coventry Patmore. William Michael Rossetti, *P.R.B. Journal*, November 2 and 7, 1849, pp. 22–3.

8. *The Germ*, pp. 187–92.

9. William Michael Rossetti, *Some Reminiscences of William Michael Rossetti*, 2 vols, London: Brown, Langham & Co. and New York: Charles Scribner's Sons, 1906, rpt, New York: AMS Press, 1970, p. 93.

10. *Ibid.*, pp. 94–5.

11. See A. Paul Oppé, 'Art,' in G.M. Young (ed.), *Early Victorian England 1830–1865*, 2 vols, London: Oxford University Press, 1934, vol. 2, pp. 101–76; and Paula Gillett, *Worlds of Art: Painters in Victorian Society*, New Brunswick, NJ and London: Rutgers University Press, 1990, especially chapter 7, 'Art publics in Late-Victorian England,' pp. 192–214.

12. Helene Roberts provides an overview of reviewers in 'Art reviewing in the early nineteenth-century periodicals,' *Victorian Periodicals Newsletter*, 6 (19), 1973, 9–20. According to Roberts, the vocabulary of their reviews derived from Roger de Piles's 'Balance of Painters,' which appeared in the *Artist's Repository*, an early art periodical in England (pp. 12–13).

13. See, for example, John Charles Olmsted, *Victorian Painting: Essays and Reviews, vol. 3, 1861–1880*, New York: Garland Publishing, 1985, p. xvii. Ruskin both enthralled and enraged the Victorians, and it seems to have been customary to put Ruskin in one category and all other critics in another. Rossetti himself did this in an 1867 review of Francis Palgrave's *Essays on Art*. See William Michael Rossetti, '*Essays on Art*, by Francis Turner Palgrave,' *Fine Arts Quarterly Review*, n.s. 1, October 1866, 302–11. Reprinted in William Michael Rossetti, *Fine Art, Chiefly Contemporary*, London: Macmillan & Co., 1867, rpt, New York: AMS Press, 1970, pp. 324–34.

14. On French critics of the mid-nineteenth century, see Joseph C. Sloane's *French Painting Between the Past and the Present: Artists, Critics, and Traditions from 1848 to 1870*, Princeton: Princeton University Press, 1951. For the partisan spirit in English criticism, see George P. Landow, '"There began to be a great talking about the fine arts",' in Josef L. Altholz (ed.), *The Mind and Art of Victorian England*, Minneapolis: University of Minnesota Press, 1976, pp. 124–45.

15. 'Royal Academy,' *Athenaeum*, June 1, 1850, 590–91; quoted in Olmsted, *Victorian Painting*, p. 101.

16. Sometimes these disavowals seem disingenuous, as when William Michael Rossetti asserts that *Ecce Ancilla Domini* is clearly based on a study of nature but has a 'material embodiment' from Italian devotional paintings, which offer the best expression of religious sentiment. See William Michael Rossetti, 'The National Institution,' *The Critic*, July 1, 1850, 334–5. Malcolm Warner has argued persuasively that Pre-Raphaelites did see, and use, certain Italian 'primitives' in 'The Pre-Raphaelites and the National Gallery,' in Malcolm Warner, Susan P. Casteras et al., *The Pre-Raphaelites in Context*, San Marino, CA: Henry E. Huntington Library and Art Gallery, 1992, pp. 1–11. For William Michael Rossetti's review of Millais's *Christ in the House of His Parents* (exhibited without title as No. 518), see 'The Royal Academy Exhibition,' *The Critic*, July 15, 1850, 359–60.

17. W.M. Rossetti, 'The Royal Academy Exhibition,' *The Critic*, July 15, 1850, 360. Rossetti would also find fault with Ford Madox Brown on the score of pictorial grace. See 'Mr Madox Brown's exhibition, and its place in our school of painting,' *Fraser's Magazine*, 71, May 1865, 598–607.

18. Dante Gabriel Rossetti had a hand in some of these early reviews. His contributions, identified and reprinted by William Michael in a collection of his brother's works, stress this quality of 'poetry' and no doubt helped shape William Michael's ideas. See *The Works of Dante Gabriel Rossetti*, William Michael Rossetti, ed., rev. edn, London: Ellis, 1911, pp. 570–86 and n. 680–81.

19. William Michael Rossetti, 'Exhibition of the Society of British Artists,' *The Critic*, April 15, 1850, 199.

20. William Michael Rossetti, 'The Royal Academy Exhibition,' *The Critic*, June 1, 1850, 286.

21. William Michael Rossettti, 'Pre-Raphaelitism,' *The Spectator*, 24 October 4, 1851, 955–7.

22. John Ruskin, *Modern Painters I*, in *The Works of John Ruskin*, eds E.T. Cook and A. Wedderburn, 39 vols, London: George Allen and Sons and New York: Longmans, Green & Co, 1903–12, vol. 3, p. 624.

23. F.G. Stephens's series of articles called 'The two Pre-Raphaelitisms' appeared in *The Crayon*, 3, August 1856, 225–8, October 1856, 289–92, and November 1856, 321–4, and concluded December 1856, 353–6. This periodical, one of the first significant art publications in the United States, was edited by W.J. Stillman, a follower of Dante Gabriel Rossetti. See Anthony Burton, 'Nineteenth-century periodicals,' in Trevor Fawcett and Clive Phillpot (eds), *The Art Press: Two Centuries of Art Magazines*, London: Art Book Company, 1976, p. 8.

24. F.G. Stephens, 'The two Pre-Raphaelitisms; third article,' *The Crayon*, 3, November 1856, 324, and William Michael Rossetti, 'R.A. Exhibition—second visit,' *The Spectator*, May 24, 1856, 570.

25. William Michael Rossetti, 'Art news from England,' *The Crayon*, 1, May 23, 1855, 328; 'The Pre-Raphaelite Brotherhood,' *Magazine of Art*, 4, 1881, 436.

26. William Michael Rossetti, 'Art news from London—No. 1,' *The Crayon*, 1, April 25, 1855, 263.

27. Other journals in which William Michael Rossetti's reviews appear include *Weldon's Register*, the *London Review* and the *Chronicle*. On occasion he published reviews in prestigious art journals such

as the *Fine Arts Quarterly Review* or *Portfolio*, but most of his reviews after leaving *The Spectator* appeared in more general periodicals such as *Fraser's Magazine*.

28. William Michael Rossetti, 'Fine arts section of the Paris exhibition,' *The Spectator*, September 22, 1855, 983.

29. William Michael Rossetti, 'Fine arts section of the Paris exhibition—No. IV,' *The Spectator*, October 20, 1855, 1098.

30. William Michael Rossetti, 'Fine arts section of the Paris exhibition—No. III,' *The Spectator*, October 13, 1855, 1063. Significantly, William Michael Rossetti, a committed political liberal, took no notice of Courbet's radical politics.

31. William Michael Rossetti, 'The abstract and naturalism in art,' *Edinburgh Weekly Review*, February 28, 1857, 3–6; 'The externals of sacred art,' *Edinburgh Weekly Review*, March 28, 1857, 67–9.

32. Dante Gabriel Rossetti used William Michael as one of his models for the angel Gabriel in his *Ecce Ancilla Domini*. William Michael Rossetti, *P.R.B. Journal*, April 7, 1850, p. 69.

33. William Michael Rossetti, 'Pre-Raffaelitism,' *Edinburgh Weekly Review*, March 7, 1857, 23.

34. William Michael Rossetti, 'The Royal Academy Exhibition,' *Fraser's Magazine*, 71, June 1865, 740.

35. William Michael Rossetti, 'The Royal Academy Exhibition,' *Fraser's Magazine*, 67, June 1863, 790.

36. *Ibid.*, p. 793.

37. William Michael Rossetti, *Fine Art, Chiefly Contemporary*, pp. 1–39. On the development of aestheticism in nineteenth-century British art, see Elizabeth Prettejohn (ed.), *After the Pre-Raphaelites: Art and Aestheticism in Victorian England*, Manchester: Manchester University Press and New Brunswick, NJ: Rutgers University Press, 1999, especially Alistair Grieve, '[Dante Gabriel] Rossetti and the scandal of art for art's sake in the early 1860s,' pp. 17–35.

38. William Michael Rossetti was actually ambivalent about testifying against Ruskin. See diary entries published by Roger W. Peattie in 'Whistler and W.M. Rossetti: "Always on the easiest & pleasantest terms",' *Journal of Pre-Raphaelite Studies*, n.s. 4, Fall 1995, 87–90. See also L'Enfant, *William Rossetti's Art Criticism*, pp. 312–14.

39. John Ruskin, 'The Nature of Gothic,' in *Stones of Venice*, in *The Works of John Ruskin*, vol. 10, pp. 180–269.

40. William Michael Rossetti, 'Art-Exhibitions in London,' *Fine Arts Quarterly Review*, 3, October 1864, 36–7.

41. William Michael Rossetti, 'Preraphaelitism: its starting point and sequel,' *Art Monthly Review*, 1, August 31, 1876, 102–5. Rossetti's criticism calls to mind Ruskin's analysis of 'Naturalism' in 'The Nature of Gothic,' where artists are divided into 'men of facts,' 'men of design,' and 'men of both,' the first two categories liable to go to extremes of morbidity. See John Ruskin, 'The Nature of Gothic,' in *The Works of John Ruskin*, vol. 10, pp. 219–20.

42. William Michael Rossetti, 'The Grosvenor Gallery,' *Academy*, 11, May 5, 1877, 396.

43. William Michael Rossetti, 'The Grosvenor Gallery (first notice),' *Academy*, 13, May 18, 1878, 446.

44. *Ibid.*, p. 447.

45. William Michael Rossetti's 'aesthetic realism' resembles ideas of Johann Wolfgang von Goethe, whose work he knew and admired. See Goethe's 1798 essay 'On Realism in Art' in *Essays on Art and Literature*, ed. John Gearey and trans. Ellen von Nardroff and Ernest H. von Nardroff, Princeton: Princeton University Press, 1994, pp. 74–8.

46. William Michael Rossetti, 'Grosvenor Gallery (second notice),' *Academy*, 13, June 1, 1878, 494.

47. Elsewhere in the same review Stephens remarked: 'There are only two generally safe masters in Art, the one absolute, the other partial—masters for the real and the ideal; these are Nature and the Antique.' F.G. Stephens, 'The Grosvenor Gallery,' *Athenaeum*, May 15, 1878, 642.

48. Roger W. Peattie, 'Introduction,' *Selected Letters of William Michael Rossetti*, University Park and London: Pennsylvania University Press, 1990, pp. xviii–xxiii.

49. William Michael Rossetti, 'Preface,' in *The Collected Works of Dante Gabriel Rossetti*, ed. William Michael Rossetti, London: Ellis and Elvey, 1888, p. xxxv.

50. William Michael Rossetti (ed.), *Dante Gabriel Rossetti: His Family-Letters with a Memoir by William Michael Rossetti*, 2 vols, London: Ellis and Elvey and Boston: Roberts Brothers, 1895, vol. 1, p. xii.

51. Helen Rossetti Angeli, *Dante Gabriel Rossetti, His Friends and Enemies*, London: Hamish Hamilton, 1949, pp. 18–19.

52. His silence regarding Jane Morris is not surprising: she was still alive (d. 1916), as was William Morris (d. 1896). Fanny Cornforth, who served as Dante Gabriel's housekeeper in his last years, was also still living. For a recent account of these liaisons, see Fiona MacCarthy, *William Morris: A Life for Our Time*, New York: Knopf, 1995, especially pp. 219–27 and pp. 258–9.

53. William Michael Rossetti, 'Preface,' in *Poetical Works of Christina Georgina Rossetti*, ed. William Michael Rossetti, London: Macmillan & Co., 1906, pp. li–liv. See also Jan Marsh, *Christina Rossetti: A Writer's Life*, New York: Viking, 1995, especially pp. 89–123 and pp. 287–93.

54. William Michael Rossetti, 'Preface,' in *The Poetical Works of Christina Georgina Rossetti*, p. vii.

55. The eldest Rossetti sibling, an Anglican nun, had died in 1876; their mother, Frances Rossetti, died in 1886. Lucy Brown Rossetti died in 1894, eight months before Christina.

56. William Michael Rossetti published *Ruskin, Rossetti, Preraphaelitism: Papers: 1854–63*, London: George Allen, 1899; *Praeraphaelite Diaries and Letters: Papers 1854 to 1862*, London: Hurst and Blackett, 1900; and *Rossetti Papers, 1862 to 1870: A Compilation*, London: Sands & Co., 1903. Portions of the remainder have been published in William Michael Rossetti, *The Diary of W.M. Rossetti 1870–1873*, ed. Odette Bornand, Oxford: Clarendon Press, 1977, and William E. Fredeman, 'A shadow of Dante: Rossetti in the final years (extracts from W.M. Rossetti's unpublished diaries, 1876–1882),' *Victorian Poetry*, 20 (3–4), Autumn–Winter 1982, 217–45.

57. The remark occurred in a review, perhaps by Edmund Gosse, of Mackenzie Bell's *Christina Rossetti in Literature*. See Peattie, 'Introduction,' in *Selected Letters of William Michael Rossetti*, p. xxi.

58. *Ibid.*, p. 613.

59. William Michael Rossetti, 'The Pre-Raphaelite Brotherhood,' *Magazine of Art*, 4, 1881, 435.

60. William Michael Rossetti (ed.), *Dante Gabriel Rossetti: His Family-Letters*, vol. 1, p. 135.

61. *Ibid.*, pp. 129–30. Rossetti did not relent on the question of Ruskin's influence, however, but continued to maintain that Ruskin had exerted little or no influence on the group's original ideas. See, for example, William Michael Rossetti's 1901 introduction to the reprint of *The Germ*, p. 7.

62. William Michael Rossetti, 'Introduction,' in *The Germ*, p. 7.

63. William Michael Rossetti, *Some Reminiscences*, p. 160 and p. 71.

64. *Ibid.*, p. 68.

65. Both William Michael Rossetti and F.G. Stephens were disturbed by William Holman Hunt's autobiography, *Pre-Raphaelitism and the Pre-Raphaelite Brotherhood*, which appeared in 1905. The impassioned outbursts of F.G. Stephens, who was greatly offended by Hunt's unflattering comments about his conduct and abilities, are found in the Angeli-Dennis Papers, Special Collections, University of British Columbia Library, Box 14, Folder 10, particularly a series of ten letters between December 18, 1905 and February 22, 1907. Rossetti's more pacific replies are in the Stephens papers, Bodleian Library, Ms. Don. e. 76. See William Michael Rossetti, 'Reminiscences of Holman Hunt,' *Contemporary Review*, 98, October 1910, 385–95, which is typical of William Michael Rossetti's generous appraisals of colleagues.

66. The author wishes to thank Professor Roger W. Peattie for a photocopy of this undated manuscript, which is found among the Angeli-Dennis Papers, University of British Columbia Library. 'The moment I see a picture' was written no earlier than 1874 in view of its familiar reference toward the end to 'the latest experiment in Impressionism,' although it bears some resemblance to Rossetti's sketch of the judgmental process of the 'true critic' in his *Fraser's Magazine* review of July 1864.

67. See his statement in *Some Reminiscences*: 'I have occasionally been asked what was the principle upon which I proceeded in framing my criticisms. I am not clear that there was any principle extending much beyond what I have just stated—the endeavour to form and to express an unbiased opinion' (p. 95).

68. Harold Bloom connects Pater with John Ruskin in this emphasis on perception, although his 'art-for-art's sake' aesthetic was a rejection of Ruskin's 'overtly moral humanism.' See Bloom's introduction to *Selected Writings of Walter Pater*, ed. Harold Bloom, New York: Columbia University

Press, 1974, pp. vii–xxxi. Although perhaps occasioned by Pater's writings, Rossetti's two-page critical credo does not put forward ideas substantially different from his earlier theory and practice; and it contains nothing suggesting the cultivation of aesthetic experience akin to Pater's influential desire to burn with the 'hard, gem-like flame.' See Walter Pater, *The Renaissance: Studies in Art and Poetry*, London: Macmillan & Co., 1873, rpt, New York: Random House Modern Library, 1961, especially preface, pp. xxv–xxvii, and conclusion, p. 197.

The quest for Christ: William Holman Hunt and the writing of artistic motivation

Michaela Giebelhausen

The spring of 1860 was an important turning point in William Holman Hunt's career. At last, his work commanded high prices and column inches. At 33, he had arrived. The years of hard labor and lonely travels in the Middle East seemed to have paid off. Hunt had received the unprecedented sum of £5500 for *The Finding of the Saviour in the Temple* (1854–60, Birmingham Museum and Art Gallery). The picture was the talk of the town. People thronged to see it, and the critics were full of praise for this ambitious new departure in scriptural painting.

For the artist this moment of success provoked some personal reflections. In the week following the private view Hunt mused on posterity and the fragility of the historical record, writing to his friend, the artist and writer, Edward Lear:

Yesterday I turned out an old desk with old papers of my youth up to the time I went abroad—as I read the draughts of old letters and was thus reminded of the awful difficulties I had to get bread to put into my mouth—and of the not smaller difficulty I had in striving to conquer the defects of the insufficient education of my boyhood for the new position I had to fit myself for. I was overcome with a feeling of intense pity for the poor wretch of ten years ago. I have now destroyed them all so that no biographer might get hold of them in future years …[1]

Hunt's sudden encounter with a past self, 'the poor wretch of ten years ago,' elicited pity and triggered acts of erasure. His pre-emptive strike was directed at the imaginary figure of the biographer intent on reconstructing the artist's life from personal papers. Such thoughts may well have been prompted by the collaboration with F.G. Stephens on a pamphlet written to accompany the exhibition of *The Finding of the Saviour in the Temple*.[2]

This pamphlet—grandly titled *William Holman Hunt and His Works: A Memoir of the Artist's Life, with Descriptions of His Pictures*—offered a short

biography of the artist, an overview of his *oeuvre* to date and a detailed exegesis of *The Finding of the Saviour in the Temple*, together with an account of the trials and tribulations of painting in the Middle East. It rehearsed the main motives of Hunt's autobiography, *Pre-Raphaelitism and the Pre-Raphaelite Brotherhood* (1905): the struggle to become an artist and overcome parental prejudice, the Pre-Raphaelite 'fight for art' which Hunt first elaborated in his essays for the *Contemporary Review* in 1886–87, and the drama of producing work while abroad. These themes combined to present Hunt as the determined Pre-Raphaelite protagonist; his work as poetic, thoughtful, manly, and Protestant; and the Brotherhood as a decisive influence on the course of contemporary English art: a national and international success story.

Writing a life: the romance of toil

By 1905 when Hunt finally published his monumental two-volume autobiography, he was the only painter member of the original Brotherhood still alive. This was his opportunity to 'right' the history of Pre-Raphaelitism: determined, complete, and seemingly conclusive. The monumentality of Hunt's endeavor registered with his readers. The literary critic and travel writer Maurice Hewlett, who had given Hunt advice during the preparation of the volumes, remarked: 'It is a monument, clearly, of life and aims and achievements which must outline your pictures because such words are immortal, and no pigments can be.'[3] For an artist who was obsessed with the longevity of his art, the autobiography indeed became a means of ensuring that his work survived in a print medium other than engraving.

This carefully constructed legacy has attracted wide scholarly attention. In an insightful essay, Laura Marcus has questioned the widespread uncritical use of Pre-Raphaelite biographical and autobiographical writings as historical evidence.[4] Marcus has demanded that they be read as literary texts and has exposed their modes of construction and conformity to literary genres. For some time now, literary scholars have studied the forms of autobiography. Linda Peterson has argued that the autobiographer never simply offers up 'the raw facts of his experience' but 'constructs a life from the models of prior autobiographical texts.'[5] The tensions between the conventions of genre and a life's raw data are evident in the striking discrepancies between Hunt's copious private and public writings: a clear indication of their 'constructedness,' which has not escaped art historians.[6]

In her study of artists' life writings, Julie F. Codell has identified two popular blueprints for the Victorian artist as autobiographer: Benvenuto Cellini's swaggering and swashbuckling life, begun in 1588, and Benjamin Robert Haydon's belligerent and beleaguered account of the misunderstood

romantic genius.[7] These modes stand in stark contrast to better-known Victorian forms of life writing such as the autobiographical tales of introspection, doubt, and spiritual awakening that poured forth from the pens of, for example, Thomas Carlyle, John Henry Newman, or John Ruskin.[8]

Codell has elsewhere argued that Hunt's autobiography should be read in the context of an increasingly professionalized art world and has drawn attention to the fact that 'His artistic role, not his personal life, constituted "Hunt".'[9] In fact, Hunt rejected the introspective modes of Victorian autobiography and focused on the construction of his professional persona as imperial art worker. This stance is borne out even in the autobiography's form, which emulated the pattern and prose of Benvenuto Cellini's memoirs. Three characteristics, in particular, inspired Hunt's mode of self-fashioning: the primacy of the voice as narrative device which lends immediacy to the account, the figure of the artist/soldier who is a man of art and action, and the picaresque structure which revolves around adventure and the making of art.[10]

However, the picaresque mode of Cellini's *Life*, lively and engaging as it was, was unable to capture the seriousness of Hunt's self-portrayal. In my view, the autobiography's richly textured tapestry of memories privileged two themes: 'the century's painter of the Christ' and the 'true Pre-Raphaelite.'[11] Hunt actively endorsed these two sobriquets which were regularly bestowed on the artist during his lifetime. His textual self-fashioning needs to be re-thought in the light of these; they were instrumental in shaping the image of 'Hunt,' the artist.

Hunt staged the formation of his artistic identity as a 'drama of self-identification'—to borrow from Hayden White's discussion of romance—that was driven by work on, and discussion of his various representations of, Jesus Christ.[12] I propose to read Hunt's professional self-fashioning as a covert and reluctant romance that is interwoven with character traits drawn from Samuel Smiles's popular Victorian gospel of self-help. The romantic emplotment was already evident in the 1860 pamphlet, the first public formulation of Hunt's life and work. But it was most clearly articulated in the essays Hunt wrote for the *Contemporary Review* (1886–87), which focused on the Brotherhood's 'fight for art' and the adventurous tale of painting *The Scapegoat* (1854–55, Lady Lever Art Gallery, Port Sunlight, Merseyside).[13]

In the autobiography, the romance structure is still present, but disavowed— at least in any facile form—as the opening paragraph makes clear. Hunt here describes the common fallacies governing the notion of artistic production:

> Art is generally regarded as a light and irresponsible pursuit, entailing for
> its misuse no penalty to the artist or to the nation of which he is a citizen. It
> is further assumed that a being endowed with original taste may, after some
> perfunctory essays, be happily inspired, and that he will then, with a few
> days of wrapt energy, be able to convert his thoughts into a masterpiece.[14]

The artist illustrates his point with reference to a popular and possibly imaginary novel that he claims to have read in his youth. With unmistakeable irony he presents the central character, a 'young *hero of romance*, in easy circumstances ... born with fine tastes and talents.' According to Hunt, the young man idles away his time on a range of ridiculous pursuits until suddenly one day inspiration strikes: he 'shut himself up in a weird chamber, and on the white walls he elaborated a composition representing the "Judgement of the Dead by the Living".'[15] Hunt instantly exposed the fictitious nature of this account of artistic production and starkly reminds his reader: 'Pictures are not produced thus. Long years are needed to train the eye and hand before a man can represent on a flat surface any forms of creation under the simplest conditions.'[16] This sober interjection shatters the story's underlying romantic premise and also questions more generally the validity of the romantic mode in the retelling of artists' lives. Hunt denigrated inspired artistic production as a fiction and suggested that his own account, laid out at length in the ensuing thousand or so pages, was based entirely on remembered facts and unrelenting labor.

For his descriptions of the processes of artistic production, Hunt drew on the rhetoric of Samuel Smiles's *Self-Help* (1859), which extolled the application of manly character traits such as courage, perseverance, energy, and industry—all deployed in the grand pursuit of forming national identity. In the chapter on 'Workers in Art,' Smiles promoted 'painstaking labour' as the root of artistic success and claimed that lasting fame was only 'purchased by study, trials, and difficulties.'[17] As George P. Landow has argued, Hunt conceptualized 'the artist's task as a moral and religious experience' in which the pursuit of painting was 'a bizarre combination of heroic battle, scientific expedition, and penance.'[18] Hunt endorsed 'incessant labour' as the basis for his own approach to work, which was indeed painfully slow and marred by self-doubt and setbacks.

Hunt's deliberate rejection of romance as a narrative mode through which to write the movement's history and his own artistic motivation foregrounded — in the words of Marcia Pointon—'the effect of veracity ... dependent on the myths of production that were intrinsic to the paintings from their very inception.'[19] The autobiography conceptualizes the making of Hunt the artist as a sequence of trials and tribulations to be endured and overcome; these always center on the challenge of painting Christ.

Framing *The Light of the World*

Of Hunt's images of Christ, *The Light of the World* (1851–53, Keble College, Oxford) (Figure 5.1) was the first to be publicly shown and remains the best known. Now in Keble College chapel, it is installed in its very own side chapel

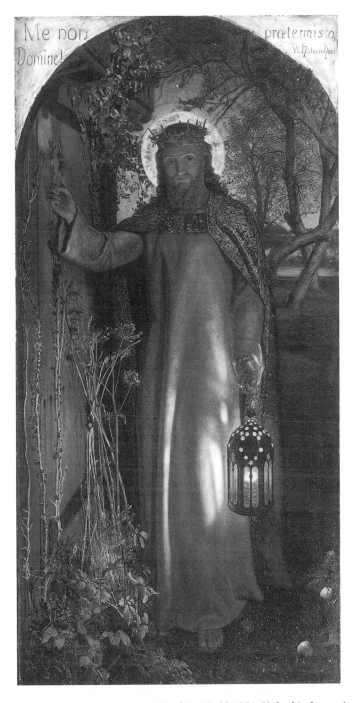

5.1 William Holman Hunt, *The Light of the World*, 1851–53, by kind permission of the Warden and Fellows of Keble College, Oxford

away from the exuberance of William Butterfield's high Victorian interior. Here, a sign in capital letters commands: 'press the red button to illuminate the painting.' As the spotlight flares up for all of two minutes, a picture of detailed realism and complex symbolism is revealed. It demands contemplation and close scrutiny. Despite the adverse viewing conditions—sequestered behind an altar table and sporadically lit—the message of the painting seems clear. We encounter Jesus roaming the earth at night. He has stopped and knocked at the door of the human soul, overgrown with weeds and the hinges rusty, and is patiently waiting to be admitted.

When the painting made its first public appearance at the Royal Academy exhibition in 1854 the process of interpretation immediately began. John Ruskin was the first to offer a compelling and detailed reading.[20] Modern scholars have picked over shards, read between the lines, and looked behind frames. In doing so we have discovered that the artist experienced a profound spiritual awakening in about 1851 and have traced its echoes in works such as *The Light of the World* and its material counterpart, *The Awakening Conscience* (1853–54, Tate, London). In Judith Bronkhurst's catalogue raisonné of Hunt's *oeuvre*, *The Light of the World* is illustrated without its frame, showing the inscription on the spandrels of the canvas as an integral part of the work: 'Me non praetermisso, Domine!' (Don't pass me by, Lord!).[21] The artist's *cri du coeur* was not intended for public view; yet its mere existence always carried with it the possibility of discovery. Part of a game of interpretative hide and seek, this statement was whispered rather than staunchly proclaimed, but it was uttered nevertheless.

The work's deeply personal meaning was avowed privately several times and to different correspondents, most explicitly in a letter Hunt wrote to his friend, the painter and poet, William Bell Scott on August 19, 1883.

... I painted the picture with what I thought, unworthy though I was, to be divine command, and not simply as a good subject. When I found it I was reading the Bible, critically determined if I could to find out its flaws for myself, or its inspiration ... I came upon the text, "Behold ... " ... the figure of Christ standing at the door haunted me, gradually coming in more clearly defined meaning, with logical enrichments, waiting in the night—every night—near the dawn, with a light sheltered from chance of extinction, in a lantern necessarily therefore, with a crown on His head bearing that also of thorns; with body robed like a priest, not of Christian time only, and in a world with signs of neglect and blindness. You will say it was an emotional conversion ... [22]

Some 30 years earlier, while still at work on the painting in August 1853, Hunt had made a similarly private if more obscure statement to Thomas Combe, his patron and friend, and the picture's intended owner:

It is difficult for me to explain how very unsatisfactory it is after having sat before a work for a long period of a short life time, and after having laboured in this while to make it a mirror to reflect the better part of one's mental and

spiritual self, and with such care that no gross feature shall be remain [*sic*] printed upon its surface, that it is at last approached only with fear lest one's hot breath should taint it ... it is more difficult than I can tell to reconcile oneself to parting with such a friend to another, who will only esteem it as a clever trick, instead of a work with as much meaning as one's lower nature is capable of setting down: and yet this is the usual fate of artists after finishing a picture. The work is bought by a dealer, or purchaser, who has no manner[23]

Tantalizingly, here the fragment ends. It bears witness to a strong personal investment and a saddened awareness that this passes unrecognized by the world at large: the dealer, the purchaser, the audience. To them the work is 'a clever trick,' a reference to the astounding wizardry of Pre-Raphaelite technique, perhaps. These statements—addressed to friends in private or hidden from view—reveal the motivation behind *The Light of the World* as an intensely private matter of faith finally found.

Rarely is art historical research into an artist's motivation any more straightforward than this. But when we turn to Hunt's autobiography to double check the facts, a routine gesture of meticulous scholarship, we draw a blank. Here we find no mention of the artist's 'emotional conversion.' *The Light of the World* is presented as just an interesting subject, whereas in the letter to Scott it clearly signifies much more for the artist. In chapter eleven Hunt recounts the events of summer and autumn 1851, spent for the most part in the country with John Everett Millais and Charles Collins who were working on their pictures for next year's Royal Academy exhibition. The rural retreat provided ample opportunity to discuss matters of art, and conversations repeatedly dwelt on the question of what made a good subject for a painting. This was a concern the Pre-Raphaelites shared with most Victorian artists who placed high importance on innovative and engaging subject matter.

One such discussion was triggered by Millais's interest in Hunt's sketch, which can be identified as the sheet showing the worked-up drawing of *The Light of the World*, as well as two versions of a lightly pencilled couple, now in the Ashmolean Museum.[24] Whilst appreciative of the scriptural subject, Millais was more interested in the historical genre scene of two star-crossed lovers, which Hunt had drawn to suggest that his friend should inject some narrative tension into a nondescript love scene he had been pondering. His suggestion, Hunt implied, was to contribute to the final formulation of the immensely popular *A Huguenot* (1851–52, The Makins Collection). In this context, Hunt chose to discuss *The Light of the World* as simply a good subject rather than to share the profound religious experience which had prompted it.

The fact that the discussion of the painting remained focused on subject matter alone may seem surprising, especially given that Hunt's letter to Scott had been in the public domain since the posthumous publication of Scott's *Autobiographical Notes* in 1892. There can be no doubt that Hunt knew of his friend's reminiscences as he quoted from them in his own memoirs.[25] Whilst

Hunt was keenly aware of the ways in which the Pre-Raphaelites were being written and offered his version of the story—the definitive version—he chose to ignore the fact that his 'emotional conversion' had already been made public. The stray letter published in Scott's reminiscences, a token of Hunt's experience of conversion, offers a stolen glimpse similar to that which restorers and photographers have caught when peeping behind the frame of *The Light of the World*. It is a statement of belief, hidden from view but waiting to be discovered. In keeping with Hunt's chosen form of self-narration, which marked him as an artist and contrasted sharply with the conventions of the conversion narrative, the picture's deep personal meaning remained unavowed. *The Light of the World* was introduced as a suitable subject on a par with star-crossed lovers and other historical and literary themes, the staple of Pre-Raphaelite preoccupations. In Hunt's autobiography the drama of conversion and spiritual awakening was acted out in more complex ways.

'Such words are immortal:' pronouncing the quest

Maurice Hewlett, one of the autobiography's first readers, singled out in 1905 the scene of Carlyle's visit to the artist's studio for particular praise: 'What a picture … you give of Carlyle—haranguing you before the Light of the World!'[26]

In this passage, the autobiography's central set piece, the parameters of how to become 'the century's painter of the Christ' were defined. Hunt framed the problem of representing Jesus Christ as the dramatic encounter between the young artist and the wise old man who pronounces the difficult quest, the quintessential trope of romance. In the notorious full-page diatribe, Carlyle rejected *The Light of the World* as an inadequate and inaccurate representation of Christ. The Carlyle of Hunt's account sorely regretted that 'a veritable contemporary representation of Jesus Christ' did not exist, whose metonymic quality would make it possible to conjure up the lost past.[27] He longed for a 'faithful' image of the 'Son of Man' which would show 'what manner of man he was, what His height, what His build, and what the features of His sorrow-marked face were, and what His dress.'[28] After dismissing the efforts of the entire history of art, Carlyle sketched his own image of Christ which in some ways prefigures and recalls Hunt's *The Shadow of Death* (1870–73, Manchester City Art Galleries):

I see the Man toiling along in the hot sun … going long stages, tired, hungry often and footsore … His rough and patched clothes bedraggled and covered with dust, imparting blessings to others which no human power, be it king's or emperor's or priest's, was strong enough to give to Him … I see Him dispirited, dejected, and at times broken down in hope … I see Him unflinching in faith and spirit … This was a man worth seeing the likeness of, if such could be found.[29]

In Hunt's definitive account of his self-fashioning as a Pre-Raphaelite artist, it was Carlyle's passionate plea for a historical representation of Christ that identified the nature of the quest. It emphatically redirected the artist's preoccupation with material representation, away from allegory towards a more historical approach. The artist used the figure of Carlyle to sketch his first impression of a historical Jesus. His search for artistic identity became part of a broader discourse at the heart of nineteenth-century Protestantism. Hunt not only shared liberal Protestantism's view 'that much of the teaching of Christ's life is lost by history being overlaid with sacerdotal gloss,' but also engaged in a form of séance similar to Carlyle's conjuring up of the departed spirits as he aimed 'to make the [biblical] story live as history.'[30] Hunt's project was driven by a desire for both historical fact and meaningful fiction, narrative modes that the historicization of Jesus had enabled. These new forms of narration were most controversially played out in the arena of biography and encapsulated in that emphatically modern idea: the 'life of Jesus.' Among the most important and influential of these reinterpretations were David Friedrich Strauss's *Das Leben Jesu* (1835), translated into English in 1846, and Ernest Renan's *Vie de Jésus* (1863), almost immediately available in English.[31]

While Jesus became the hero of biographical romance, Hunt deliberately refuted that role for the artist. He insisted that artistic 'excellence … can be won only by incessant labour,' and went on to equate it with 'a passion which ever leaves him [the artist] unhappy when not wrestling with some besetting sin discovered in his own practice.'[32] Labor alone offered the antidote to a sinful practice that constantly needed purging of its own inadequacy. The often-quoted encounter with Carlyle summed up the trajectory of Hunt's career: the near impossible task of painting an image of Christ which was factual, historical, and imaginative—in a word, believable.

It is the benefit of hindsight which structured the moment and bestowed satisfying vindication and perhaps even a touch of irony. By the time Hunt recounted Carlyle's damning assessment of *The Light of the World*, the painting itself was beyond reproach: a Protestant icon, it had risen above criticism. In 1905, more so than today perhaps, no reader could have been unaware of the picture's phenomenal success, manifest in the huge numbers of prints sold and the large third version's recent intercontinental exhibition tour.[33]

In contrast to the page-long remembered dialogues on art in which Hunt habitually allowed himself the final word, Carlyle's rant elicited no audible response. The artist's one attempt at an explanation was immediately brushed aside by the increasingly agitated sage.[34] It was not in the telling that Hunt wished to make his claim for 'the century's painter of the Christ' but in the showing, which underlies the autobiography's entire narrative logic. Deeds, and paintings, speak louder than words. In place of a spirited defence of the picture's merits, we encounter an abandoned attempt at explanation. The

wildly gesticulating Mrs Carlyle shushed the artist. His words were muffled; they remained half-spoken, unuttered even. The artist is left owing his readers a full explanation.

Telling failures

A life remembered has the advantage of lucidity which a life merely lived mostly lacks. In the studio Hunt was silenced. The encounter of the sage and the young artist, which occurs one third into the monumental text, served as the narrative hinge. Carlyle's ambiguous plea for a 'veritable contemporary representation' of Christ is echoed in Hunt's desire to make 'the [biblical] story live as history.'[35]

Carlyle pronounced *The Light of the World* a failure and the history of art littered with failed representations of Christ. Hunt's artistic project was at once ennobling and impossible. But the drama and despair of the moment were mellowed by hindsight. A life's ambition so cruelly curbed by Hunt's Carlyle has of course been vindicated by the life since lived, written, and remembered. The autobiography's set piece invites a reading backward and forward across the text and time.

In an earlier chapter Hunt recorded a conversation with Millais on the difficulty of painting the risen Christ, which occurred over *Christ and the Two Marys* (1847–48, 1897, Art Gallery of South Australia, Adelaide).[36] Millais had advised his friend to look for inspiration at some old masters in the British Museum print room; a suggestion Hunt rejected. For him the language of the old masters was dead. He sought a new pictorial language in which to portray Christ with urgency and immediacy. In *Christ and the Two Marys*, the artist endeavored to convey the astonishment and awe of encountering the risen Christ. The two Marys on their way to the sepulcher are seen from the back and represent every man and woman of faith. The picture is Hunt's first attempt to make Christ relevant for a contemporary audience. It also tallied with his demand for art generally: 'What I sought was the power of undying appeal to the hearts of living men.'[37]

The picture had a protracted period of gestation. After Hunt experienced difficulties with the new Pre-Raphaelite technique of the 'wet white' ground as well as the unusual subject matter, he abandoned the painting in 1847, finally to complete it only in the 1890s.[38] The canvas remained in the artist's studio, half-finished and turned to the wall. He did not exhibit it during his lifetime. In the autobiography the work was made to embody the difficulties of the true Pre-Raphaelite and painter of the Christ, setting up the possibilities for a later triumph. The lengthy discussion of Hunt's first attempt at representing Christ served several functions. It specified the difficulties inherent in the artist's quest for a contemporary representation of Christ and gave him ownership

of the new technique that would become essential in early Pre-Raphaelite art. Furthermore, it clarified his relationship with Millais and marked out the workmanlike Hunt, rather than the celebrated prodigy, as the innovative artist, the true Pre-Raphaelite in the making.[39]

These claims surfaced in an extended conversation with Millais that the artist purported to remember almost verbatim half a century later. The testimony of recorded dialogue—severely criticized by William Michael Rossetti and perceptively analyzed by Laura Marcus—was instrumental in securing for Hunt the authoritative voice which presented him as eye witness and protagonist of the Pre-Raphaelite movement.[40] As the last surviving painter of the original Brotherhood, he could literally 'speak' of those bygone days with a directness not available to historians and biographers who had to rely on mediated sources. The privileged position of the first-person narrator who is both youthful protagonist and wise old man provided Hunt with several modes of narration. Some of the autobiography's crucial moments are contained in dialogue form which favors showing over telling. This narrative strategy suggests action and is not usually associated with a genre of writing prone to introspection and confession. The claims Hunt made in remembered dialogues are lively and persuasive. But for all their immediacy, the use of dialogue, a stylistic trope mostly associated with fiction, raises questions about accuracy, memory, and poetic license in the retelling of one's life.

In his endeavor to create a modern religious painting Hunt conceptualized failure as a necessary and moral part of the quest. Even his Carlyle thought so. In the autobiography, the little-known, frankly awkward *Christ and the Two Marys* figures as a sign of future trials and tribulations. As such it was important in the teleological narrative of Hunt's career, offering a constant reminder of the naked fear of failure. At the other extreme of his career, Hunt incorporated his fifth and final image of Christ, *The Triumph of the Innocents* (1876–78, The Walker Art Gallery, Liverpool), into the narrative of labor. The original full-scale version was begun in Jerusalem on unsuitable canvas in 1876 and as a result beset with technical problems which preoccupied the artist for years. His detailed account of the difficulties and how he finally overcame them served to reiterate the autobiography's opening assertion— least the reader had forgotten—that the artist's life is no romance:

I was seriously shattered in health for a time by my long struggle
with evil fate. I have told this melancholy story in detail, as it is a
useful contrast to the general idea that the profession of art is ever
followed under happy circumstances and in light mood.[41]

The toil was commensurate with the praise the work received. In a lecture delivered at Oxford and subsequently published in *The Art of England*, Ruskin hailed *The Triumph of the Innocents* as the artist's finest work yet, uttering an ominous proviso: 'if health is granted to him for its completion, it will, both

in reality and in esteem, be the greatest religious painting of our time.'[42] The message was clear: the practice of art should come with a health warning. It demanded total dedication and investment of all one's resources—mental, physical, and financial. Being an artist is a risky business.

Hunt's tales of danger and hard work culminated in his Middle Eastern exploits where he himself was literally 'toiling along in the hot sun,' as Carlyle had envisaged Jesus. Even before his departure to the Middle East, friends repeatedly pointed out the risks to his life and work. Fellow artist and friend, Augustus Egg reminded Hunt that he was now poised for a stellar career at home; 'after a continuously bitter struggle' it seemed foolish to embark on such a hazardous venture.[43] Hunt recalled that others 'pressed me to remember the fate of Wilkie [who had died on his return journey from the Middle East in 1841], and hesitate before taking a course which would probably end, if not in leaving my bones in the desert, at least in implanting in my blood Syrian fever, that would leave me a miserable invalid for the rest of my days.'[44] Never slow to spot a good story, Hunt singled out the episode of painting *The Scapegoat* for one of his articles published in the *Contemporary Review* in 1886–87. Hunt's several sojourns in the Middle East furnished the narrative of artistic labor with real and imagined dangers: thieving brigands, bed bugs, stomach aches, and leaking roofs; disobedient servants and unreliable models; high winds blowing dust onto the wet canvas; scorching sunlight that burnt his models' skin to the wrong shades of red and brown; materials delayed and marred on their treacherous journey East. Such were the adverse conditions to be overcome in the quest for Christ.

Haunted encounters

By the time Hunt's autobiography was published, *The Light of the World* had become a popular Protestant icon. It was his only seminal religious work to be permanently installed in ecclesiastical settings: one version is housed in Keble College chapel, another in St Paul's Cathedral. Its religious motivation had thus been vindicated, even if Hunt's public pronouncements took a very different form.

As we have seen, Hunt attempted to place the painting in the autobiography's dominant narrative of toil. The figure of the artist as worker—thinker and poet, diligent and thoughtful—was a keynote of textual portrayals of Hunt, from the pamphlet written to accompany the exhibition of *The Finding of the Saviour in the Temple* in 1860 onwards.[45]

However, *The Light of the World* sits somewhat uneasily in this tale of toil. In the pages of the autobiography discussions of the painting remained focused on subject matter and execution. The narrative privileged an artist who actively searched for an original subject and overcame immense difficulties

in finally realizing his idea. These trials seem faintly ridiculous and pale in comparison with later Eastern adventures and adversities. And yet they have remained memorable. Who does not recall Hunt's midnight painting sessions in late November? To keep the cold at bay the artist had his feet in a sack of straw while valiantly wrestling with the brass lamp which was either billowing smoke or red hot and close to meltdown.[46] There is also the astounding length he went to in securing the right accessories for his Christ, which range from the expensive brass lamp—commissioned to his own design—to finally requisitioning his mother's heavy linen tablecloth as just the right material for the robe.[47] Featuring prominently in both popular accounts and scholarly interpretations, such details provide some of the most enduring Pre-Raphaelite anecdotage in the history of a movement rich in constantly retold anecdotes.[48]

Hunt's elaborate descriptions of his work on *The Light of the World* also served another, more important purpose. They charted the difficulties in translating his personal experience of the divine into a detailed, material representation destined to function in the Victorian art world. The picture's insistence on the 'real' was not merely a result of the diligent application of the Pre-Raphaelite style; it was also an essential prerequisite for giving a visual form to the artist's transcendental experience. Whilst Hunt elaborated his struggle with the picture's material aspects and moonlit setting in such memorable detail, he was surprisingly reticent about the figure of Christ itself.

For a description of the central figure we need to look once more at Hunt's letter to Scott, in which he wrote: 'the figure of Christ standing at the door haunted me, gradually coming in more clearly defined meaning, with logical enrichments, waiting in the night—every night—near the dawn.' Note that there is no indication of toil here. The artist is haunted and meaning is gradually revealed to him in ever-increasing detail. The figure appears as in the painting: 'with a light sheltered from chance of extinction, in a lantern necessarily therefore, with a crown on His head bearing that also of thorns; with body robed like a priest.'[49] The artist concluded, 'You will say it was an emotional conversion.' In fact, it reads like the description of an apparition.

In this regard, it resonates with an episode recounted in the autobiography. As we have seen, Hunt's chatty and episodic chapter eleven dealt mostly with the sojourn in Ewell. It freely mixed discussions of art and the *The Light of the World* and youthful banter with seemingly unrelated scenes of supernatural sightings, real and imagined. One late night Hunt walked to Kingston station to meet Charles Collins, who was frightened of the dark and ghosts, and escort him to Worcester Park Farm where the painter's friends were lodging. Along the way Hunt discovered a hut whose door was 'overgrown with tendrils of ivy, its step choked with weeds' and therefore perfect for his picture. As he 'dwelt upon the desolation of the scene, and pictured in mind the darkness of that inner chamber, barred up by man and nature

alike,' the artist affords us a brief glimpse of himself in the role of Christ. Lantern in hand, he stood in front of the door to gather empirical evidence of how to render the details of his night scene. The true Pre-Raphaelite was once again on a mission to fulfill the Ruskinian doctrine of truth to nature. Thus preoccupied with his planned picture, his thoughts departed from the empirical and turned to an incident that had happened several years earlier: the sighting of a ghost. The circumstances were similar. Hunt was walking back from the station at night, accompanied by the stationmaster and the light of his shaking lantern, when suddenly he noticed 'some white creature.' Here is Hunt's description of the encounter:

> Yet I kept my eyes riveted on the approaching being. When we had come nearer I interrupted our idle chat, saying, 'But it is steadily coming towards us.' ... The mysterious midnight roamer proved to be no brute, but had the semblance of a stately, tall man wrapped in white drapery round the head and down to the feet. Stopping within a few paces from us, he seemed to look through me with his solemn gaze. Would he speak? I wondered. Was his ghost clothing merely vapour? I peered at it; it seemed too solid for this, and yet not solid enough for earthly garb.[50]

The apparition disappeared as quietly as it had come. The tension of the moment was deflected as the narrative switched back to the episode which framed the recollection of the supernatural encounter. Hunt finally caught up with a petrified Collins who had mistaken him, lantern in hand, for a ghost.

There is an implicit conflation here between Hunt himself on the walk to Kingston, the apparition in his recollection—a 'stately, tall man ... in white drapery' with 'solemn gaze'—and the phantasmagoric Christ of *The Light of the World*. When examining the account of the 'unexplained experience' alongside that of the genesis of the picture given in the letter to Scott, similar descriptive patterns emerge which suggest a reading of the 'ghost story' as a coded and displaced account of Hunt's conversion experience. His description of painting by 'divine command' lacked all the customary references to labor-intensive toil characteristic of Pre-Raphaelite work. The subject was simply 'found;' perusing the Bible, Hunt 'came upon the text.' The figure of Christ at the door 'haunted' him and 'gradually [came] in more clearly defined meaning, with logical enrichments.' In short, it appeared just as the 'white creature' had done.

A similarly disquieting and anecdotal incident occurs later in the autobiography when Hunt revisited the house in Cheyne Walk where he had painted *The Light of the World*. It proved difficult to gain access to the house, which in his evocative description seemed almost haunted, 'only echoes spoke of deserted chambers and untrodden stairs.'[51] Hunt had to knock several times before (in a phrase redolent of the gothic novel) 'the bolts were gratingly withdrawn ... and the caretaker, tall and upright, stood in the void with a lantern in his left hand.' The artist's knocks are answered by the caretaker who

inadvertently appears in a pose that brings to mind the Christ of *The Light of the World*. This perhaps was where Christ had been 'found' by Hunt, prior to being committed to canvas. As the small party explored the house, the caretaker 'finally stood lantern in hand, in innocent ignorance of its fitness, in the very place where my model had stood to receive the conflicting lights that expressed the meaning of my picture.' The story of production is inverted here. The finished Christ is seen and recalled before the work from the model is mentioned.

Unlike Hunt's descriptions of working from the model for *The Shadow of Death*, the artist tells us next to nothing about the model for *The Light of the World*. He only gives details of the accessories and describes the difficulties of conceiving the head of Christ. Several people, male and female, modeled for Christ's features and complexion.[52] Yet Christ's body remains shrouded in mystery and his mother's tablecloth. The ghostly apparition, of course, did not fit Hunt's version of the Pre-Raphaelite project, which depended on exacting labor rather than divine inspiration. It was repressed and returned in somewhat unlikely guises. The autobiographical account is peppered with apparitions and mistaken identities, re-enactments and inversions that recall the pose of Christ. These anecdotes inflect the customary tales of artistic toil. Jeremy Maas has convincingly suggested that one Henry Clark was the main model for Christ. Arthur H. Clark has described how his grandfather posed in the back garden of the family home in Homerton, 'month after month, generally at night, while Hunt painted *The Light of the World*.'[53] The artist's reluctance to impart these mundane mechanics of painting make the Christ of *The Light of the World* a truly divine apparition which comes into view effortlessly, as described in his letter to Scott.

The theme of spiritual awakening which the image represents is repeatedly invoked in the autobiography. But conversion here tends to take place in the sphere of art: it is a conversion to the 'true,' to the Pre-Raphaelite cause. In chapter eleven, which provided the context for the genesis of *The Light of the World*, Hunt also commented on changes in the manner of Ford Madox Brown's work. He claimed that Brown had purged his practice of the influence of his Belgian teacher Baron Wappers by gradually adopting elements of the Pre-Raphaelite technique. To Hunt, Brown's stylistic development seemed 'to prove the stages of his conversion.'[54] As Hunt continued working on *The Light of the World* he reported further conversions to the cause. For example, when the artist John Phillip confronted Pre-Raphaelite work at Millais's studio, he recanted his artistic principles and subsequently produced work that bore witness 'of his complete conversion to all that he understood to be Pre-Raphaelitism.'[55] Even if Hunt's personal conversion remained unavowed in the autobiography, the conversion to Pre-Raphaelite principles formed a recurring theme. This rewriting of the personal as public shunned the customary tales of introspection and doubt, and allowed *The Light of the World* to function as art and as popular icon.

'Saying is nothing, doing is all'

As Hunt's tale drew to a close and approached the here and now of writing, the young artist had become the wise old man. Consequently, the narrative voice switched from the youthful exuberance of showing to the *ex cathedra* of telling. This transition occurs in the final three chapters, collectively entitled 'Retrospect.' The first of these is headed by a quotation from Ernest Renan which could well serve as the motto of Hunt's autobiographical account: 'In morals, as in art, saying is nothing, doing is all.'[56] If morals and art share the deed as their domain, then the stance of the silent artist, which Hunt so memorably invoked in the encounter with Carlyle, is a moral one. 'Retrospect' presents a meditation on the functions of art, the achievements of the Pre-Raphaelite project—in its configurations as brotherhood and ism—and an assessment of Hunt's own work, which is worth quoting at length:

> Life, as the years advance, becomes a more sacred trust, and it is of vital
> importance to decide that one's course is not undertaken without just
> consideration. I am persuaded that my decision to realize my purpose of painting
> in the East, at whatever cost it might be, was no rash one. It was certain that the
> time had come when others in the world of thought besides myself were moved
> by the new spirit, which could not allow the highest of all interests to remain
> as an uninvestigated revelation. From the beginning of my attempt till this time
> many thinkers of various schools have devoted themselves to elucidate anew the
> history treated in the gospels, and the desire for further light cannot be quenched.
> The conviction I started with, that much of the teaching of Christ's life is lost
> by history being overlaid with sacerdotal gloss, is widely shared by others. The
> subjects I have treated have been few for the extent of time I have expended
> upon the pictures; but I console myself with the reflection that my object gave
> some degree of magnitude to the attempt, and that thus the lack of quantity may
> in the end not be taken altogether as a mark of incapacity or indolence. I have
> established my claim as a pioneer for English art in study of historic truth ... [57]

The reflective old man claimed his Eastern exploits as the defining moments of his career, thus reaffirming the romantic emplotment inherent in the preceding narrative.

His conviction that the life of Christ needed to be retrieved as history and freed from centuries of clerical encrustations of course echoes Carlyle's desire for a 'veritable contemporary representation' of Christ, depicting 'the man how he really lived.' Hunt, now the wise old man, confidently proclaims his role as explorer and pioneer in the search for historic truth. That search was at its most acute when dealing with the life of Jesus, which was being rediscovered and interpreted, written and rewritten as myth and romance by authors such as Strauss and Renan. Hunt actively engaged in contemporary debates about Jesus, and his images are informed by that extensive literature. The claim to pictorial truth which he shared with his Pre-Raphaelite brothers

was focused on the figure of Christ. As the century's painter of the Christ, he became the true Pre-Raphaelite.

The pose of the taciturn and consequently moral artist, who eschewed the luxury of prolix arguments in the comfort of his studio in favor of action in the field, served to bring out the contrast between the doers and the talkers of the original Brotherhood. Hunt distinguished between the practitioners, Millais and himself, and 'the majority of the seven [who] only talked' and whose 'neglect of daily experiment in work should be followed by absence of interest in new questions of practice.'[58] His contention was that the talkers, in particular F.G. Stephens and William Michael Rossetti, had exaggerated the part that Dante Gabriel Rossetti had played during the formative years. 'In writing the History of Pre-Raphaelitism'—with a capital H—he felt obliged to 'correct erroneous conclusions from any source.'[59] Consequently, he set out to dispel the widely held view that Rossetti had been the originator of the movement. In the guise of the historian, Hunt tracked the construction of Rossetti's role across a range of texts. After examining the evidence, he staged his counterclaim with meticulous attention to detail. He also drew on private source materials such as diaries and letters which helped to reconstruct the course of events. Hunt thus aimed to demonstrate that his was indeed *the* History of the movement while at the same time condemning rival accounts as 'romantic fable' or 'altogether a romance.'[60]

Hunt's artistic project—to make biblical narrative come alive as history—was matched by the textual strategies of the autobiography that were predicated on the first person narrator's multiple roles. At once protagonist and key witness, insightful commentator and meticulous historian, Hunt ensured that his account of the movement was lively and credible. The overt rejection of romance as a narrative paradigm was crucial in presenting autobiography as truthful history. It enabled the representation of artistic struggle as true and meaningful labor and also allowed the dismissal of counterclaims as mere romance and fable. Although the autobiography's dominant theme—the quest for Christ—was in fact encoded as romance, the romantic emplotment was tempered to suggest a teleological drive for a life dominated by trials and tribulations. In the autobiography, the original 'fight for art' had become an unspoken quest for Christ that structured the retelling of the artist's career as a crusade whose missionary zeal was fulfilled in the dissemination of prints and the intercontinental tour of *The Light of the World* which, as Hunt assured us, was undertaken 'in true imperial spirit.'[61] In similar imperial language Stephens extolled the virtue of engravings:

Indeed, a national service is rendered by the publication of really noble transcripts from noble pictures like these. Where the pictures cannot go, the engravings penetrate. Their appeal is infinitely extended, the artist's fame is justified and heightened, and all the good which such thoughtful

and purposeful art can effect—and certainly this is incalculable upon
the minds and actions of men—is multiplied a thousand-fold.[62]

Hunt is the artist as missionary whose own conversion inspired those taking
place in front of his works: conversions to art and to Christ.

Hunt's textual self-representation corroborates Howard Helsinger's
assertion that Victorian autobiography was a 'literary mode' conceived 'not
as intimate speech but public discourse,' written not for oneself or for one's
contemporaries, 'but for posterity.'[63] That Hunt had one eye firmly on posterity
was evident in the admission that he manipulated the extant record of his life
and erased 'the poor wretch of ten years ago' given in the letter to Edward
Lear quoted at the beginning of this chapter.

With the autobiography he finally exerted total control over his image
and aimed to secure the immortality that only words could bestow. Here he
presented the pursuit of painting not so much as the intimate speech act it
often was, but as public discourse. Consequently, his engagement with Christ
was conceived as both professional challenge and public service. The artist
attempted to create an image of Christ that was free from traditional pictorial
conventions and capable of addressing a mid-Victorian audience with a
strong degree of emotive immediacy. His desire to reconcile intricate pictorial
symbolism with a realist form of representation led him to experiment with
meticulously researched oriental settings to capture a sense of the historical
Jesus. This conception fit the Ruskinian test of 'truth to nature' which the Pre-
Raphaelites had adopted and also fulfilled a wider cultural need to reconfigure
the image of Christ in an age increasingly plagued by doubt. The quest for
Christ thus obtained the status of public discourse. Hunt presented himself as
the thoughtful art worker, a professional driven by Carlyle's gospel of labor
which equated work with worship. Hunt's form of worship encompassed art
and Christ in equal measure. The story of Hunt's life is that of the artist: the
artist as thinker and poet, explorer and missionary. Its narrative form echoes
that most traditional and exuberant of artist's lives, Cellini's. While its penchant
for the picaresque served Hunt well when recounting his extensive travels in
the Middle East, he was keen to imbue the story of his professional life with
a strong sense of mission. Consequently, he emphasized unrelenting labor
and presented his life as a quest for a 'veritable contemporary representation'
of Christ, which his Carlyle had so fervently craved. Hunt's autobiography
presented a professional agenda which tied together the claims of the true
Pre-Raphaelite and of the leading religious painter of his generation.

Notes

1. Letter from Hunt to Edward Lear, April 24 [1860] (John Rylands Library, Manchester, Ms Eng. 1214/40).

2. [F.G. Stephens], *William Holman Hunt and His Works: A Memoir of the Artist's Life, with Descriptions of His Pictures*, London: James Nisbet & Co., 1860.

3. Letter from Maurice Hewlett to Hunt, December 13, 1905 (Getty Research Institute, Los Angeles, Hunt Family Papers 860667-11).

4. Laura Marcus, 'Brothers in their anecdotage: Holman Hunt's *Pre-Raphaelitism and the Pre-Raphaelite Brotherhood*,' in Marcia Pointon (ed.), *Pre-Raphaelites Re-Viewed*, Manchester and New York: Manchester University Press, 1989, pp. 11–21.

5. Linda H. Peterson, *Victorian Autobiography: The Tradition of Self-Interpretation*, New Haven and London: Yale University Press, 1986, pp. 57–8.

6. Amongst the first scholars to focus on these discrepancies were Judith Bronkhurst, '"An interesting series of adventures to look back upon": William Holman Hunt's visit to the Dead Sea in November 1854,' in Leslie Parris (ed.), *Pre-Raphaelite Papers*, London: The Tate Gallery, 1984, pp. 111–25; Marcia Pointon, 'The artist as ethnographer: Holman Hunt and the Holy Land,' in Pointon (ed.), *Pre-Raphaelites Re-Viewed*, pp. 22–44.

7. Julie F. Codell, *The Victorian Artist: Artist' Lifewritings in Britain, ca. 1870–1910*, Cambridge and New York: Cambridge University Press, 2003, pp. 121–6.

8. Thomas Carlyle, *Sartor Resartus*, London: Sanders and Otley, 1838; John Henry Newman, *Apologia pro Vita Sua*, London: Longman, Green, Longman, Roberts, and Green, 1864; John Ruskin, *Praeterita*, Orpington, Kent: George Allen, 1885–89.

9. Julie F. Codell, 'The artist colonized: Holman Hunt's "bio-history", masculinity, nationalism and the English school,' in Ellen Harding (ed.), *Reframing the Pre-Raphaelites: Historical and Theoretical Essays*, Aldershot, England: Scolar Press and Brookfield, VT: Ashgate, 1996, pp. 211–29; p. 214.

10. Marcus, 'Brothers in their anecdotage,' pp. 18–19.

11. Mrs Meynell remarked that 'Mr. Hunt was Pre-Raphaelitism, and what he was he has remained,' Frederic Farrar and Mrs Meynell, *William Holman Hunt: His Life and Work*, London: Art Journal Office, 1893, p. 1. The moniker 'the Painter of the Christ' first appeared in Wyke Bayliss, *Five Great Painters of the Victorian Era: Leighton, Millais, Burne-Jones, Watts, Holman Hunt*, London: Sampson Low, Marston & Co., 1902, p. v. For more recent usage of the term 'the true Pre-Raphaelite,' see Anne Clark Amor, *William Holman Hunt: The True Pre-Raphaelite*, London: Constable, 1989.

12. Hayden White, *Metahistory: The Historical Imagination in Nineteenth-Century Europe*, Baltimore and London: The Johns Hopkins University Press, 1974, pp. 8–9.

13. William Holman Hunt, 'The Pre-Raphaelite Brotherhood: a fight for art,' *Contemporary Review*, 49, 1886, 471–88; Part II, 737–50; Part III, 820–33; also 'Painting "The Scapegoat",' *Contemporary Review*, 1887, 21–38 and 206–20.

14. William Holman Hunt, *Pre-Raphaelitism and the Pre-Raphaelite Brotherhood*, 2 vols, London and New York: Macmillan & Co., 1905, vol. 1, p. vii.

15. *Ibid.*, vol. 1, pp. vii–viii [my emphasis].

16. *Ibid.*, vol. 1, p. viii.

17. Samuel Smiles, *Self-Help: With Illustrations of Character and Conduct*, London: John Murray, 1859, p. 154 and p. 157.

18. George P. Landow, 'William Holman Hunt's "The Shadow of Death",' *Bulletin of the John Rylands Library*, 55 (1972), 197–239; 205.

19. Pointon, 'The artist as ethnographer,' p. 34.

20. John Ruskin, 'Letter to *The Times*,' May 5, 1854, in *The Works of John Ruskin*, eds E.T. Cook and A. Wedderburn, 39 vols, London: George Allen and Sons and New York: Longmans, Green & Co., 1903–12, vol. 12, p. 328.

21. Judith Bronkhurst, *William Holman Hunt: A Catalogue Raisonné*, 2 vols, New Haven, CT and London: Yale University Press, 2006, vol. 1, p. 151.

22. William Bell Scott, *Autobiographical Notes of the Life of William Bell Scott … and Notices of His Artistic and Poetic Circle of Friends, 1830 to 1882*, ed. W. Minto, 2 vols, London: Osgood, McIlvaine & Co. and New York: Harper, 1892, vol. 1, pp. 312–13.

23. Letter from Hunt to Thomas Combe, August 22, 1853 (John Rylands Library, Manchester, Ms Eng. 1213/2).

24. Hunt, *Pre-Raphaelitism and the Pre-Raphaelite Brotherhood*, vol. 1, pp. 289–93. The sheet of sketches for *The Light of the World* (1851, Ashmolean Museum, Oxford) is illustrated *ibid.*, vol. 1, p. 291.

25. Hunt, *Pre-Raphaelitism and the Pre-Raphaelite Brotherhood*, vol. 2, pp. 425–6.

26. Letter from Maurice Hewlett to Hunt, December 13, 1905 (Getty Research Institute, Los Angeles, Hunt Family Papers 860667-11).

27. Hunt, *Pre-Raphaelitism and the Pre-Raphaelite Brotherhood*, vol. 1, p. 356.

28. *Ibid.*, vol. 1, p. 357.

29. *Ibid.*, vol. 1, p. 358.

30. *Ibid.*, vol. 2, pp. 409–10.

31. David Friedrich Strauss, *The Life of Jesus, Critically Examined* [1835], ed. Peter C. Hodgson, London: SCM Press Ltd, 1973; Ernest Renan, *The Life of Jesus*, London: Trübner & Co. and Paris: M. Lévy Frères, 1864.

32. Hunt, *Pre-Raphaelitism and the Pre-Raphaelite Brotherhood*, vol. 1, p. viii.

33. For a detailed account of the picture's 'afterlife,' see Jeremy Maas, *Holman Hunt and* The Light of the World, 2nd edn, Aldershot: Wildwood House, 1987; for the extended tours, see chapters six to eight, pp. 122–90.

34. Hunt, *Pre-Raphaelitism and the Pre-Raphaelite Brotherhood*, vol. 1, p. 356.

35. *Ibid.*, vol. 2, p. 410.

36. *Ibid.*, vol. 1, pp. 81–91.

37. *Ibid.*, vol. 1, p. 48.

38. See Bronkhurst, *William Holman Hunt*, vol. 1, pp. 123–5.

39. Hunt, *Pre-Raphaelitism and the Pre-Raphaelite Brotherhood*, vol. 1, pp. 78–9.

40. William Michael Rossetti, *Some Reminiscences of William Michael Rossetti*, 2 vols, London: Brown, Langham and Co. and New York: Charles Scribner's Sons, 1906, vol. 1, p. xi; Marcus, 'Brothers in their anecdotage,' p. 16.

41. Hunt, *Pre-Raphaelitism and the Pre-Raphaelite Brotherhood*, vol. 2, p. 342.

42. Quoted from *ibid.*, vol. 2, p. 341.

43. *Ibid.*, vol. 1, p. 348.

44. *Ibid.*, vol. 1, pp. 349–50.

45. [Stephens], *William Holman Hunt and His Works*, p. 13.

46. Hunt, *Pre-Raphaelitism and the Pre-Raphaelite Brotherhood*, vol. 1, p. 299.

47. *Ibid.*, vol. 1, pp. 308–9.

48. Hunt's letter to Thomas Combe, which recounts the struggle to acquire and use the accessories of Christ in hilarious detail, has featured in most modern accounts of the picture's genesis; see, for example, the following catalogue entries: *William Holman Hunt*, exh. cat., Liverpool: Walker Art Gallery, 1969, p. 32; *The Pre-Raphaelites*, exh. cat., ed. Leslie Parris, London: Tate Gallery, 1984, p. 119; also Maas, *Holman Hunt and* The Light of the World, p. 37.

49. Scott, *Autobiographical Notes*, vol. 1, pp. 312–13.

50. Hunt, *Pre-Raphaelitism and the Pre-Raphaelites Brotherhood*, vol. 1, p. 296.

51. *Ibid.*, vol. 2, pp. 337–8, for the whole episode and my two subsequent quotations.

52. *Ibid.*, vol. 1, p. 347.

53. Maas, *Holman Hunt and* The Light of the World, p. 40.

54. Hunt, *Pre-Raphaelitism and the Pre-Raphaelite Brotherhood*, vol. 1, p. 277.

55. *Ibid.*, vol. 1, p. 339.

56. *Ibid.*, vol. 2, p. 404.

57. *Ibid.*, vol. 2, pp. 408–9.

58. *Ibid.*, vol. 2, p. 437.

59. *Ibid.*, vol. 2, pp. 418–19.

60. *Ibid.*, vol. 2, p. 421 and p. 370.

61. *Ibid.*, vol. 2, p. 417.

62. [Stephens], *William Holman Hunt and His Works*, pp. 79–80.

63. Howard Helsinger, 'Credence and credibility: the concern for honesty in Victorian autobiography,' in George P. Landow (ed.), *Approaches to Victorian Autobiography*, Athens, Ohio: Ohio University Press, 1979, pp. 39–63; p. 40.

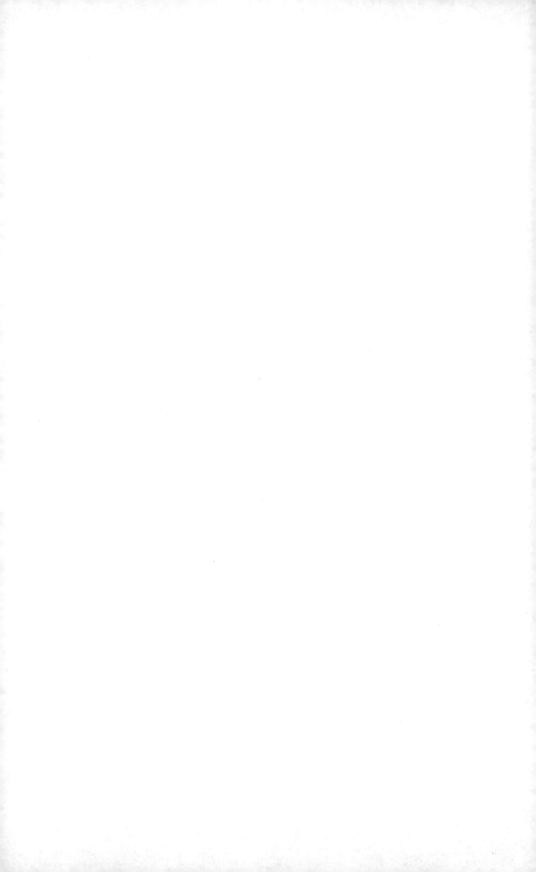

6

Written out? The case of Ford Madox Brown

William Vaughan

In a cartoon by Max Beerbohm (Figure 6.1), William Holman Hunt towers, with his fierce red beard, over a squat and scowling Ford Madox Brown. They are standing before an unidentified painting by the latter. Hunt is either giving Brown mild praise or instructing him on what to do. Brown does not look happy as he receives the domineering Hunt's oration. Quite possibly such a scene never took place. But it is the kind of scene that could be imagined in 1922 by Beerbohm because it fitted in with the prevailing narratives on Pre-Raphaelitism. Equally significantly, this picture is the only image focusing on Brown to be found in this book of satires by Beerbohm on the Pre-Raphaelite circle. Clearly, by this time Brown was seen as a marginal figure in the movement. That he was seen as such was largely due to the impact of the book written by the presiding figure in this cartoon, namely Hunt's *Pre-Raphaelitism and the Pre-Raphaelite Brotherhood.*[1] Published in the last years of the artist's life, this work more than any other remained the key narrative on the Pre-Raphaelites and their world until the 1960s, when the group began to undergo a major scholarly re-assessment.

The 1960s also saw the first major Brown retrospective, that mounted by Mary Bennett in Liverpool.[2] Yet though this important achievement aroused interest, it did not immediately stimulate a substantial re-evaluation. Subsequently, Brown has found more strident apologists, who have felt that the artist has had a hard time of it. As Newman and Watkinson put it in their study of 1991, 'We believe the time is ripe for a new assessment of this great original, the most underrated figure in British art of the nineteenth century.'[3] Certainly there seems to be something curious about the situation. A major artist, of undoubted originality and profundity, the creator of a number of key pictures in the mid-Victorian period—notably *Work* (1852–65, Manchester City Art Galleries), *The Last of England* (1852–55, Birmingham Museum and Art Gallery) and *An English Autumn Afternoon* (1852–54, Birmingham

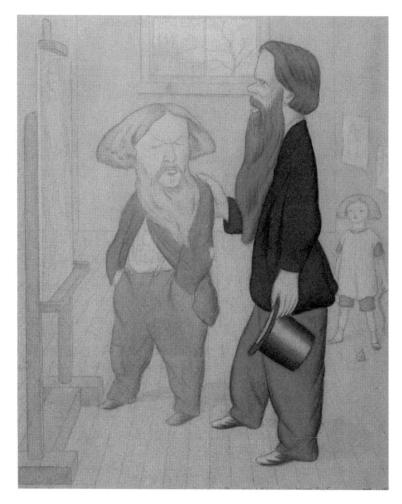

6.1 Max Beerbohm, 'Holman Hunt Patronizing Madox Brown,' from *Rossetti and his Circle*, London: W. Heinemann, 1922, plate 10

Museum and Art Gallery)—he never seems to have quite found his place in assessments of the age. Since Newman and Watkinson's book—mindful also perhaps that the 'time was ripe'—there have been a number of studies which have sought to re-interpret and re-cast the artist. Notable amongst these have been the two essays by Colin Trodd and Paul Barlow in *Reframing the Pre-Raphaelities* of 1996[4] and the full-length study of Brown's artistic persona by Kenneth Bendiner which appeared in 1998.[5]

For most commentators, the enduring problem in providing an assessment of Brown's position has remained his relationship with Pre-Raphaelitism. Older than the founding members of the Pre-Raphaelite Brotherhood

(PRB), and never officially part of the group, he has nevertheless been read persistently in terms of it. Defenders have tended on the whole to see him as having been in effect 'written out' of the narratives of the movement, or else to have been ascribed roles that do not really relate to his contribution. This was the view taken, for example, by Lucy Rabin in her dissertation 'Ford Madox Brown and the Pre-Raphaelite History-Picture' of 1973.[6] Rabin reads Brown as being the archetypal Pre-Raphaelite, who provided the ingredients out of which Hunt, Millais, and Rossetti forged their movement. Something similar, indeed, is argued by Newman and Watkinson in their study.

On the other hand there have been those who see Pre-Raphaelitism as something of a red herring in relation to Brown, a diversion that draws attention away from his true aims and achievements. This is in effect the position adopted by Bendiner. Discussing Brown's relationship to Pre-Raphaelitism, he writes the following:

Many features of Brown's art reflect Pre-Raphaelitism. He was a key figure in this art movement from its inception in 1848 through its later stages. Yet Brown's art diverges from and plays against the ideals of Pre-Raphaelitism at several points in his career. His works are distinctive, even eccentric; while other major Pre-Raphaelites eventually achieved critical acclaim, Brown never quite did so. Perhaps in consequence, his art as a whole has not been seriously studied to any large extent.[7]

Bendiner's claim poses problems. His assertion that Brown has not been studied to any serious extent is surely an overstatement of the situation; particularly in consideration of the contributions made by the scholars mentioned above and others such as Deborah Cherry.[8] There have been many complex and illuminating engagements with the difficulties of this challenging artist. Leaving this point on one side, however, we can surely agree that the relationship with Pre-Raphaelitism is clearly an issue that needs to be explored further before we can get closer to understanding Brown's position. Bendiner's way of talking about this relationship itself bears witness to the ambiguities. For in the brief paragraph quoted above he sketches out in three consecutive sentences three different ways of seeing it. In the first he describes Brown's art as 'reflecting' pre-Raphaelitism. In the next sentence, this image of passive receptiveness is replaced by one of active opposition—for we are told that Brown's art 'plays against the ideals of Pre-Raphaelitism.' Finally we are given the image of total identity, when Brown is simply described as a 'major Pre-Raphaelite,' albeit one that did not receive the same measure of critical acclaim as the others.

Bendiner's study is a serious and illuminating work, and I do not cite this contradictory passage in order to attempt to undermine it. What I wish to draw attention to, rather, is the way that it highlights the very problem that this whole book is addressing. For Bendiner, like Newman and Watkinson, Rabin, and so many others before, is writing about Pre-Raphaelitism as

though it is some monumental given, a movement with a discrete set of ideals and a clearly defined practice. Yet as this book makes clear, Pre-Raphaelitism was being constantly defined and redefined throughout its long history—the practice lasted, we should remember, in one form or another for over 50 years.

Hunt's book certainly played a major part in the 'writing out' of Brown's role in the formation of the Pre-Raphaelite Brotherhood. Yet Hunt's position had been determined to a considerable degree by the previous 'writing-in' that had occurred, largely at the hands of Rossetti and his circle. The tensions in the relations between Brown, Hunt, and Rossetti reached back, in fact, to before the founding of the Pre-Raphaelite Brotherhood, when Rossetti had been Brown's pupil. Although this relationship did not last long, Brown became a close personal and family friend. Undoubtedly Brown's wide cultural interests, his fluency in several languages, and his continental upbringing did much to endear him to the intellectual family of Italian political refugees—a pattern that was to be repeated later in his life with other *émigré* groups. In 1874 relations were to become even closer with the Rossettis when Dante Gabriel's brother William Michael married Brown's daughter Lucy. Increasingly in later life, Brown formed part of what Hunt referred to as the 'Brown–Rossetti centre.'[9] It was this center, Hunt became convinced, that was trying to undermine the true nature of Pre-Raphaelitism, confounding it with an unsound and dishonest form of continental revivalism.

It is perhaps a further sign of Brown's continental connections that two years earlier, in 1872, his second daughter, Catherine, married the German Schopenhauerian and music scholar Franz Hueffer. It was the offspring of this marriage, Ford Madox Hueffer (later the modernist novelist Ford Madox Ford) who was to write the definitive biography of Brown in 1896.[10] Such contacts reinforced Brown's own continental background. They were to become doubly important as Pre-Raphaelitism began to attract international interest in the 1870s. Interest focused predominately around the work of Rossetti, yet Brown was one of those who became caught up in the wake of his former pupil's rising stardom abroad.

Prior to this period Brown's success had been limited. While Hunt, Millais, and Rossetti had all established distinct—and increasingly different—audiences for their work, Brown had managed to attract no more than a small band of devotees. He had, it is true, established some critical success with his exhibition of 1865, when Palgrave, for one, assigned him 'one of the leading places among our very small but honoured company of genuine historical painters.'[11]

Palgrave's term is significant, for it is really as a history painter rather than as a 'Pre-Raphaelite' that Brown made his most original contribution. This is a point that has been stressed by Bendiner. But perhaps what needs to be emphasized further—particularly in light of the subsequent reputation

of his representations of contemporary life—is that his major achievement was his alignment of history painting with the practices of realist art, in particular the recording of directly experienced events. As Newman and Watkinson have observed, Brown's major contemporary subject paintings are autobiographical.[12] This does not mean that they are about self-representation in the same way as Courbet's contemporaneous *The Artist's Studio* (1855, Musée d'Orsay, Paris).[13] Although Brown is physically present in some paintings (he is the husband in *The Last of England*, and had originally included himself in the foreground of *Work*),[14] they are not narratives about his life, but topics derived from direct experiences. He is the witness in such works, not the self-describer. Furthermore, he is using his experience to make a broader commentary on society. Brown's paintings are, as he himself said of *The Last of England*, 'in the strictest sense historical.'[15]

The particular nature of Brown's form of contemporary history painting is sometimes buried beneath debates about who in the Pre-Raphaelite circle first attempted subjects of modern life. This is indeed how Hunt himself saw the matter. In his assault on Brown in *Pre-Raphaelitism and the Pre-Raphaelite Brotherhood* he goes out of his way to make the somewhat dubious claim that Brown followed himself and even Rossetti in this matter. Yet what he overlooks is the fact that Brown's attitude to modern subject matter was fundamentally different from his. Inspired by contemporary theological practice, Hunt did not so much observe the contemporary world as inscribe it with a religious purpose. Brown, by contrast, observes events within their social context. While both painted with a meticulous sense of the specific, they were looking at and for different things. Essentially—as the Surrealists were later to recognize—Hunt's realism is hallucinatory. The object is not painted for its own sake but is a sign for something else, usually, as has been suggested, a religious allegory.[16] The sheep on the headland are strayed souls; the goat in the desert is Christ. Even the most challenging of his representations of contemporary life, *The Awakening Conscience* (1853–54, Tate, London) is not an exercise in objective observation. The subject is serious enough, but it is treated in terms of melodrama, drawing on myths about prostitutes and fallen women which Hunt himself must have known to be only partially relatable to experience. Indeed, one might accuse him of a degree of hypocrisy in the matter, since the model for the woman starting up in horror in realization of the error of her ways was in fact his mistress, Annie Miller.[17] The treatment of the subject in this picture is a world apart from that in Brown's *Work* where an actual event witnessed by the artist (the laying of sewers in a Hampstead road, part of the process of urban improvement in the period) forms the kernel of the theme, and all the characters included represent not some allegory, but themselves. The workers are workers, the tramps are tramps, the aristocrats are aristocrats. None of them are 'symbols,' though taken together they can provide a synecdoche for society and the place of labor within it. *The Last of*

England—a more emotive subject—emerged from Brown's experience of his friend Woolner's emigration. *An English Autumn Afternoon*—one of the most poignantly convincing images of suburban landscape ever painted—was a scene that Brown said he painted because it 'lay outside a back window'—a sentiment that caused much annoyance to Ruskin.[18] By focusing on the everyday, rather than nature as a miraculous witness of the Divine, Brown was aligning himself with the 'low' form of realism that Ruskin detested and that he associated with degenerate French art. In fact Brown's attitude to the recording of experience is closer to that of his French Realist contemporaries than to any of his fellow Britons. He does connect with the practice in his native country, however, in his incorporation of observed events within elaborate forms of narration—ones that, by his own avocation, can be related to the progresses of Hogarth.

Brown's attempts to establish a leading position with his particular form of historical narrative failed, as did his efforts to reform the organization of art practice in this country. His attempts to found an independent exhibiting society—in which artists would actually take control of the marketing of their own work (the Hogarth Club)—foundered and from that time on he was, like other contemporaries, at the mercy of the dealers.[19] His art could not be as conveniently commodified as the art of the Pre-Raphaelites. He did not have a 'line' in the way that Rossetti and Burne-Jones did. His painting was too infrequent and too various, too difficult and 'quirky' in its challenge.

In one sense, however, Brown did provide leadership. This was in his voluminous textual account of his work. The 1865 exhibition catalogue presents his own work in his own terms. Not since William Blake's critical catalogue to his own one-man show in 1809 (which may have formed a direct model)[20] had such a sententious catalogue been made, and for much the same purpose. Undoubtedly this verbose document played a large part in drawing critical attention to his work and gaining it respect, even if this did little to improve his fortunes in other ways. Undoubtedly, too, Brown's own prolixity was a spur to Hunt to use such means to mount his own apologia when he himself had his one-man show at the Fine Arts Society in 1886.

It is one of the ironies of this situation that it was Brown's closest associate in the Pre-Raphaelite group, Rossetti, who successfully managed to redefine Pre-Raphaelitism in a manner that accorded with the mounting aestheticizing tendencies of the age. While Brown had been a leader in the 1850s, and made a bid to bring the Pre-Raphaelites within the sphere of the modern Hogarthian historical practice he developed at that time, he became in the 1860s a follower—and a badly treated one at that—of the new aestheticism and Morris's related decorative revival. Eventually it was as a tributary to that story that Brown became 'written into' Pre-Raphaelitism by William Michael Rossetti and subsequently by Ford; largely as a kind of conduit that allowed the idealism of German revivalism to flow through into Pre-Raphaelitism

stimulating the neo-medieval idealism of Rossetti and Burne-Jones. Such commentators certainly saw themselves as vindicating Brown and saving him from the neglect that had been meted out to him as a history painter. But they were in effect making him a tributary to the brand-name Pre-Raphaelitism that was then enjoying an international renown, especially after the successes of Burne-Jones at successive Paris World fairs in 1878 and 1889.

This growing 'continental' interpretation of Pre-Raphaelitism sent Hunt increasingly on the defensive. Recalling this moment in *Pre-Raphaelitism and the Pre-Raphaelite Brotherhood*, he wrote:

The party of medievalists had increased and was now daily gaining a wider world of admirers. It traced itself to the original example of Overbeck and through Madox Brown to Rossetti, through the channel of whose labours the love of nature could more or less be found mingled with it, but its true recommendation was its antiquarianism … [21]

Hunt remained keen to stress that this antiquarianism was never part of the Pre-Raphaelites' original agenda: 'German antiquarianism, which was Brown's last form of allegiance to Continental dogma, was one of the principle enemies which we originally committed ourselves to destroy.'[22] Hunt in fact linked his attack on Brown's 'continental dogma' to a more general account of the detrimental effects of continental training on British artists. In this context, he noted that Leighton considered his tutelage 'under a German painter … had been a serious misfortune to him, which he had made a great effort to counteract in his subsequent practice.'[23] Hunt then went on to imply that Leighton had relied too much on French academic-classical models, which rendered his work perfect but superficial. He was 'an elegant yacht of dainty and finished capacity for pleasure service, without pretensions to serve as a transport carrying men bent on tragic purpose.'[24]

In Hunt's own first account of Pre-Raphaelitism—written at the time of his show at the Fine Art Society—'Pre-Raphaelitism: a fight for art' in the *Contemporary Review*,[25] Brown had hardly been mentioned at all. He had simply made an appearance as Rossetti's teacher. This exclusion may have been deliberate, an attempt to play down the role that had already been ascribed to Brown in a number of publications, notably William Sharp's life of Rossetti of 1882.[26]

It was the signs of such claims spreading to the continent, however, that spurred Hunt to stronger action. Hunt appears to have become aware of this first when Robert de la Sizeranne sent him the proofs of his article 'La Peinture Anglaise contemporaine: ses origines pre-raphaelites' for the *Revue des deux mondes* for comment. While approving La Sizeranne's high valuation of the Pre-Raphaelites, Hunt was dismayed to see Brown given a key place in this narrative. He wrote back to the French critic protesting that he was 'quite misinformed' in his supposition that Brown had been a leading influence in the founding of the Pre-Raphaelite Brotherhood. La Sizeranne replied with a

detailed letter in which he cited several sources—including Scott, Stephens, Knight, and Quilter—as the basis for his assumption. La Sizeranne even went so far as to quote from Hunt's own *Contemporary Review* article, in which he had spoken of the 'genius' evident in Brown's Westminster Hall Cartoon of *Harold*.

La Sizeranne's refusal to concede to Hunt's objection caused the English artist to return to the attack when he came to publish his own account of the Pre-Raphaelite movement in *Pre-Raphaelitism and the Pre-Raphaelite Brotherhood*. After quoting Robert de la Sizeranne's letter in full (something that La Sizeranne himself had already done in his own book on British art),[27] Hunt went on to comment that: 'Unfortunately these various contributors to history are not independent witnesses, as they at first appear to be, but are dependent for their information on the "Brown–Rossetti" centre.'[28]

In his account Hunt focused, as has already been seen, on the 'antiquarianism' of Brown as a reason for removing him from a central position in the development of Pre-Raphaelitism. There was another Germanic trait, however, from which he was equally keen to distance himself. This is what he termed Brown's 'grim grotesqueness of invention.'[29] This attack on 'grim grotesqueness' was an attempt to find flaw in the realist side of Brown's art, a side that presented a greater challenge to Hunt's position than did the medievalism. For Hunt's own extreme form of realism could easily be seen as being as individualistic and grotesque as anything that Brown had essayed. Hunt was particularly keen to isolate and dismiss as a personal quirk that bleaker view of nature that could be argued to be Brown's most profound artistic achievement. While the attack on antiquarianism could be seen as a salvo directed at the 'Brown–Rossetti centre,' and in particular the writings of William Michael Rossetti and William Sharp, the assault on the grotesque seems to have had more the work of Brown's biographer, Ford Madox Ford, in its sights.

Ford was, in many ways, a more formidable figure to challenge. His biography of his grandfather was, despite the family connection, a meticulous and carefully balanced piece of research. Ford, moreover, tended to support much of what Hunt said, particularly about the origins of the Pre-Raphaelite Brotherhood. It is typical of Ford's approach that he should explore this carefully and in full. Thus, he cites Brown's own account, given to Ford on his deathbed.

As to the name Pre-Raphaelite, when they began talking about the early Italian masters, I naturally told them of the German P.R.'s, and either it pleased them or not, I don't know, but they took it. I don't know, for one thing, whether they ever asked me to become a P.R.B.; I suppose they did; but I never would have to do with societies—they're bound to end in cliquishness; besides, I was a good deal older than they were. Of course it was Rossetti who kept things going by his talking, or it wouldn't have lasted as long as it did, and really he talked them into founding it.[30]

Ford set down these words when Brown was on his deathbed, transcribing what he could of the artist's attempt to leave behind a record of his life. Indeed Ford said they were 'the last comprehensible words that the present writer heard Madox Brown utter.'[31] Reversing the normal response to deathbed utterances, he used this as an argument not to accept their 'absolute reliability' and added to them a statement by Hunt to the effect that Brown never had been invited to join the Pre-Raphaelite Brotherhood. Ford said he was 'inclined to agree with Mr. Hunt that Madox Brown was never asked to become a P.R.B.,' adding: 'I do not think that it was until quite lately that Madox Brown was regarded by members of the brotherhood other than the Rossettis as being intimately connected with the movement.'[32]

While siding with Hunt on the issue of whether Brown was or was not asked to be a member of the Pre-Raphaelite Brotherhood, Ford shifts the debate into a completely different direction, that of Brown's realism, locating its origins in the work of Holbein. In this case the evidence quoted is of a picture now tantalizingly lost. This is the portrait of Mr Bamford, which Ford mentions as having been painted in 1846. 'The *Portrait* is of interest historically, as being one of the works by which Madox Brown's claim to be considered the Father of Pre-Raphaelitism must stand or fall.'[33] It cannot have endeared Ford to Hunt that the former confessed some personal national pride in Brown's supposed allegiance to Holbein: 'As a Teuton, I like to think—and I feel certain—that whatever of Madox Brown's art was most individual was inspired by those Basle Holbeins in the year 1845.'[34] Ford also quotes Brown as saying of his 1846 *Portrait of Mr. Bamford*: 'Wishing to substitute simple imitation for *scenic* effectiveness, and purity of natural colour for scholastic depth of tone, I found no better way of doing so than to paint what I called a *Holbein of the nineteenth century*.'[35]

Ford admits Brown's manner was not particularly close to that of Holbein. Nevertheless, he sees the Swiss artist as providing a salutary stimulus towards realistic observation so different from the romantic revivalism, which he regards as a more Pre-Raphaelite trait. Ford must presumably have been aware as well of the central place given to Holbein in the development of German realism, particularly in the case of Wilhelm Leibl in Munich.[36] Ford finds this essential realism most evident in *The Last of England*, which achieves through its remorseless observation of the truly tragic: 'It pays its tribute to the stern force of irresistible, slow-brooding Destiny quite as unmistakeably as any of the great tragedies have done. It is as remorseless in its own way as either *Lear* or the *Bacchae* of Euripides.'[37]

Ford's assessment was echoed by many writers around 1900, who saw Brown as having provided a more serious contribution to the realist movement of the nineteenth century than the Pre-Raphaelites, who were largely to be valued for their romantic and symbolist tendencies. Hunt clearly wished to counter such a view. Given that fact, it is surprising that his attack on Brown was not more thorough. It would seem that the reason for that was that he himself needed

Brown as an acolyte, in order to demonstrate how central Pre-Raphaelitism had been in the realist movement. Mindful of the critical status Brown's work had achieved, Hunt was careful not to undermine this but sought instead to show how dependent Brown was, at his best, on what he had initiated. What he needed to do was to claim Brown's realist masterpieces for Pre-Raphaelitism by proving that they had only been painted after Brown had abandoned his original 'Germanic' manner and adopted the practice of the Pre-Raphaelites — thereby proving to be one of the very few British artists trained abroad who managed to overcome this disadvantage and develop a true, manly, British style. As a sign of Brown's own recognition of this situation, he quoted a letter Brown had written in 1850 when Hunt was exhibiting his *Valentine Rescuing Sylvia from Proteus* (1851, Birmingham Museum and Art Gallery):

I wish I had seen you to-night, for I am full of your picture and should like to shake you by the hand. I have had serious thoughts of joining [sic] P.R.B. on my pictures this year, but in the first place I am rather old to play the fool, or at least what would be thought to be doing so; in the next place I do not feel confident enough about how the picture will look, and unless very much liked I would not do it; but the best reason against it is that we may be of more service to each other as we are than openly bound together.[38]

Hunt also took pains to stress that he felt no personal animus against Brown, implying that they had always been the best of friends, whereas in fact they appear to have seen very little of each other after the late 1860s. His main presentation of Brown is as a tragic figure, embittered by experience, who suffered from extreme paranoia.[39]

There is a moving anecdote that Hunt tells about Brown in the latter part of his book that stresses this tragic view of him. In 1890 a banquet was given at the Mansion House by the Lord Mayor of London in honor of art and literature. Millais was seated next to the host, Frederic Leighton — the then President of the Royal Academy — surrounded by academicians. Brown had also been invited and had been given a place immediately opposite them. Hunt, seated lower down the table, observed that:

There were many vacant places between him and me, and I asked him to come and take the chair next to me, explaining that he would meet friends whose conversation would interest him. 'Thank you' he said, 'I would rather sit here.' I left him alone, severely frowning at his diplomaed brothers of the brush, where he remained, all the evening, silent. A mutual friend told me that Brown had said he wished particularly to draw the attention of the academicians to the fact, that although he was not a member of the Academy, he had been conspicuously honoured by the civic authorities with a central place at the high story.[40]

Brown could never free himself, Hunt implies, from the need to seek official recognition, lacking once again the 'independent spirit' that Hunt alone had managed to preserve.

It is easy enough to show how strong the bias of Hunt's book was against Brown, and how he used a literal meaning of the word Pre-Raphaelite Brotherhood to rewrite the part Brown played in it. In his defense, it must be said that he was encountering an alternative narrative that was even more loaded. But in doing so he may well have done the movement he espoused a great disservice. For whereas the view of La Sizeranne and Richard Muther — following that promoted by the 'Brown–Rossetti centre'—presented Pre-Raphaelitism as making an important contribution to an international modern movement, Hunt's view returned it to the quirky, insular, and anecdotal. As Julie Codell has stressed, Hunt's interpretation of Pre-Raphaelitism aligns it with the increasingly defensive Imperialism that predominated in the late Victorian and Edwardian eras.[41] It is not hard to see why there was so little space for Brown in such a narrative.

Notes

1. William Holman Hunt, *Pre-Raphaelitism and the Pre-Raphaelite Brotherhood*, 2 vols, London and New York: Macmillan & Co., 1905; 2nd edn, 2 vols, London: Chapman and Hall, 1913. Quotations in this article are from the reprint of the first edition, New York: AMS Press, 1967.

2. *Ford Madox Brown 1821–1893*, exh. cat., Liverpool: Walker Art Gallery, 1964.

3. Teresa Newman and Ray Watkinson, *Ford Madox Brown and the Pre-Raphaelite Circle*, London: Chatto and Windus, 1991, p. 1.

4. Colin Trodd, 'The laboured vision and the realm of value: articulation of identity in Ford Madox Brown's *Work*,' and Paul Barlow, 'Local disturbances: Ford Madox Brown and the problem of the Manchester murals,' in Ellen Harding (ed.), *Reframing the Pre-Raphaelites*, Aldershot: Scolar Press and Brookfield, VT: Ashgate, 1996, pp. 61–98.

5. Kenneth Bendiner, *The Art of Ford Madox Brown*, University Park, PA: Pennsylvania State University Press, 1998.

6. Lucy Rabin, *Ford Madox Brown and the Pre-Raphaelite History Picture*, New York: Garland Publishing, 1978; originally presented as the author's doctoral thesis, Bryn Mawr College, 1973.

7. Bendiner, *The Art of Ford Madox Brown*, p. 1.

8. Deborah Cherry, 'The Hogarth Club: 1858–1861,' *Burlington Magazine*, 122, 1980, 237–44.

9. Hunt, *Pre-Raphaelitism and the Pre-Raphaelite Brotherhood*, vol. 2, p. 424.

10. Ford Madox Ford [Ford M. Hueffer], *Ford Madox Brown: A Record of his Life and Work*, London and New York: Longmans Green and Co., 1896.

11. Quoted in Newman and Watkinson, *Ford Madox Brown and the Pre-Raphaelite Circle*, p. 1.

12. Newman and Watkinson, *Ford Madox Brown and the Pre-Raphaelite Circle*, p. 119.

13. The French title of this painting is *L'atelier du peintre*.

14. Newman and Watkinson, *Ford Madox Brown and the Pre-Raphaelite Circle*, p. 122.

15. The catalogue of Brown's 1865 exhibition; cited in Ford [Hueffer], *Ford Madox Brown*, p. 100.

16. For a discussion of Hunt's use of religious symbolism, see in particular George P. Landow, *William Holman Hunt and Typological Symbolism*, New Haven: Published for the Paul Mellon Centre for Studies in British Art by Yale University Press, 1979.

17. *The Pre-Raphaelites*, exh. cat., ed. Leslie Parris, London: The Tate Gallery in association with Allen Lane and Penguin, 1984, p. 121. Catalogue entry by Judith Bronkhurst.

18. Ford Madox Brown, *The Diary of Ford Madox Brown*, ed. Virginia Surtees, New Haven and London: Published for the Paul Mellon Centre for Studies in British Art by Yale University Press, 1981; see the entry for July 13, 1855.

19. Cherry, 'The Hogarth Club 1858–61.'

20. Newman and Watkinson claim that Blake's example was a direct inspiration to Brown. This seems highly possible, given the great interest in Blake in the Rossetti circle at the time and the involvement of Dante Gabriel and William Michael in the publication of Alexander Gilchrist, *Life of William Blake, 'pictor ignotus': with Selections from his Poems and Other Writings*, London: Macmillan & Co., 1863. See Newman and Watkinson, *Ford Madox Brown and the Pre-Raphaelite Circle*, p. 100, p. 206.

21. Hunt, *Pre-Raphaelitism and the Pre-Raphaelite Brotherhood*, vol. 2, p. 362.

22. *Ibid.*, vol. 2, p. 227.

23. *Ibid.*, vol. 2, p. 144.

24. *Ibid.*, vol. 2, pp. 144–5.

25. William Holman Hunt, 'The Pre-Raphaelite Brotherhood: a fight for art,' *Contemporary Review*, 49, 1886, 471–88, Part II, 737–50, Part III, 820–33.

26. William Sharp, *Dante Gabriel Rossetti; a Record and a Study*, London: Macmillan & Co., 1882.

27. Robert de la Sizeranne, *English Contemporary Art*, trans. H.M. Poynter, Westminster: A Constable, 1898.

28. Hunt, *Pre-Raphaelitism and the Pre-Raphaelite Brotherhood*, vol. 2, p. 424.

29. *Ibid.*, vol. 2, p. 227.

30. Ford [Hueffer], *Ford Madox Brown*, p. 63.

31. *Ibid.*, p. 64.

32. *Ibid.*, p. 65.

33. *Ibid.*, p. 49; apparently this was in the manner of Holbein and is now lost. (It was recorded as lost by Mary Bennett in *Ford Madox Brown, 1821–1893*, exh. cat., p. 4.)

34. Ford [Hueffer], *Ford Madox Brown*, p. 412.

35. *Ibid.*, p. 410.

36. *Wilhelm Leibl zum 150. Geburtstag*, exh. cat., eds Götz Czymmek and Christian Lenz, Munich: Neue Pinakothek, 1994, p. 65.

37. Ford [Hueffer], *Ford Madox Brown*, p. 414.

38. Hunt, *Pre-Raphaelitism and the Pre-Raphaelite Brotherhood*, vol. 1, pp. 246–7.

39. *Ibid.*, vol. 1, p. 156.

40. *Ibid.*, vol. 2, pp. 382–4.

41. Julie F. Codell, 'The artist colonized: Holman Hunt's "bio-history", masculinity, nationalism and the English school,' in Harding (ed.), *Reframing the Pre-Raphaelites*, pp. 211–30.

Absent of reference: new languages of nature in the critical responses to Pre-Raphaelite landscapes

Jason Rosenfeld

The year 1852 marked the emergence of a new type of criticism in British art circles, particularly with respect to landscape painting. It evolved over the course of the year in reviews of the British Institution and Society of British Artists, and culminated in notices of the Royal Academy exhibition in May. Much of the discussion revolved around Pre-Raphaelitism, the most contentious art movement of the day. Yet by 1852, the fourth year of its existence, Pre-Raphaelitism had partly overcome the generally hostile criticism of the previous two years, and writers were beginning to view its methods as acceptable, if still often misguided, approaches to picture-making. Additionally, as the acknowledged talent of the group, John Everett Millais, turned towards less controversial subject matter, critics found it easier to show their appreciation of his efforts and, in turn, the group as a whole.

The particularity of the language of art criticism was crucial to decoding and establishing the newness of Pre-Raphaelite works. Writers developed a radical approach in this period, one marked by an absence of reference to earlier artists and styles. Even in specialist journals with formed traditions of art critique, there was a tendency to explore the works on their own terms. A concurrent issue was the concept of a national school of art rising within the moribund Royal Academy (RA) and the consequent question: did the lack of a reference to artistic tradition in the reception of these works imply an untethering of the Pre-Raphaelite Brotherhood (PRB) from connection to a school—are they or are they not part of a British tradition? Additionally important in the defining of Pre-Raphaelitism are strategies of endorsement through reference to contemporary artists, as opposed to old masters, found in the early writings of two Pre-Raphaelite brothers, William Michael Rossetti and F.G. Stephens.

Reaction to Pre-Raphaelite pictures was, in general, more positive than not in 1849, witheringly negative in 1850, and mostly poor in 1851, especially in the mainstream press. Yet in the breakthrough year of 1852, critics for the first time responded appreciatively and enthusiastically to Pre-Raphaelitism, particularly the brand found in Millais's pictures. For example, in *Punch* Tom Taylor found in the 22-year-old's Royal Academy exhibits 'more loving observation of Nature, more mastery in the reproduction of her forms and colours, more insight into the sentiment of our greatest poet [Shakespeare], a deeper feeling of human emotion, a happier choice of a point of interest, and a more truthful rendering of its appropriate expression,' than the critic had seen in anything else on view.[1] Millais's two submissions, *Ophelia* (1851–52, Tate, London) and *A Huguenot* (1851–52, The Makins Collection), attempted to appeal directly to audiences through their straightforward compositions, clear literary and historical references, and emphasis on human figures, faces, and emotions.[2] And it is precisely their clear and accessible emotional interface that set them apart from earlier, more convoluted, Pre-Raphaelite works. As a result, the artist's previously derided finely honed style and his extravagantly precise approach to nature could be overlooked as other, perhaps more traditional, aspects of his paintings came to be recognized, especially in the depiction of Hamlet's doomed lover. Taylor wrote:

The woven flowers have escaped from her relaxing fingers, and are borne idly with the long mosses of the stream, past the lush July vegetation of the river bank. The red-breast pipes on the willow spray, the wild roses give their sweetness to the summer air, the long purples peer from the crowding leaves, the forget-me-nots lift their blue eyes from the margin as she floats by … Talk as you like … about the needless elaboration of those water-mosses, and the over making-out of the rose-leaves, and the abominable finish of those river-side weeds matted with gossamer, which the field botanist may identify leaf by leaf. I tell you, I am aware of none of these. I see only that face of poor drowning Ophelia. My eye goes to that, and rests on that, and sees nothing else, till—buffoon as I am, mocker, joker, scurril-knave, street-jester, by trade and nature—the tears blind me, and I am fain to turn from the face of the mad girl to the natural loveliness that makes her dying beautiful.[3]

At last, Taylor found himself able to accept the glaring and hyper-real Pre-Raphaelite vision of nature due to the truth of the figure and the allure of a well-known subject. The *Punch* critic most appreciated Ophelia's enigmatic expression, as this allowed for empathy with the character's emotional state and presumably made the picture more interesting and accessible to a wider variety of viewers. Taylor, who was particularly qualified to discuss this picture as he was a playwright, was at pains to point out that the details no longer distracted him from his awareness of the whole or, rather, they did not inhibit what he conceived of as the appropriate response to the picture, as opposed to their effect on critics in previously exhibited

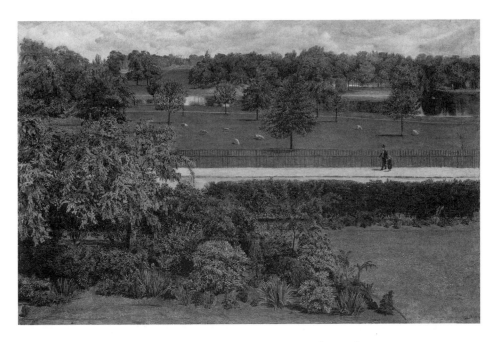

7.1 Charles Allston Collins, *May, in the Regent's Park*, 1851, oil on mahogany, Tate, London

works such as *Ferdinand Lured by Ariel* (1849–50, The Makins Collection) or *The Woodman's Daughter* (1850–51, Guildhall Art Gallery, London).[4]

While Taylor reacted to *A Huguenot* in the same way that he considered *Ophelia*, he did not consider either painting to be a landscape in the traditional sense, for though natural accessories were prominent, the emphasis on figures troubled his sense of aesthetic hierarchies. But there is a connectedness between the Pre-Raphaelite approach to nature and the landscape painting tradition that must be acknowledged in this period — even if in the RA of 1852 only the PRB associate Charles Allston Collins's *May, in the Regent's Park* (1851, Tate, London) (Figure 7.1) conformed to strictures of the pure landscape genre. For Taylor, it was Millais's appeal in his pictures to the 'thought and brains' which prevails, since the painter 'may paint as elaborate river banks, as true brick wall, as brilliant plush, and as real a silk dress, but the heads are not stereotype, and once conceived and painted, are conceived and painted for ever.'[5] Millais's achievement was one of permanence — distinctly atemporal, and singularly successful.

This was a common critical reaction to the Pre-Raphaelite imaging of nature in 1852. Many commentators found the broader range of Royal Academy productions in a rut, increasingly similar year after year, their overall tone repetitive.[6] As *Fraser's Magazine* wrote, on every wall:

... the viewer finds the same identical sheep, and cows glassed in the same water, or browsing under the same patriarchal trees—the green lanes, with every turn of which he is intimate, are reproduced without the slightest variation, with the same old trunk cut down on the foreground that has lain there as long as he can remember—the same evening shadows fall on the same upland, with a cottage on the left and a clump of autumnal foliage on the right ... and by the time he has finished his tour of inspection, he has arrived at a tolerably clear conclusion that, whatever may be said on behalf of the merits of the exhibition, the less that is said of its originality the better.[7]

In this atmosphere the Pre-Raphaelites seemed no longer stealthy and unwelcome rebels—a perception critics promoted in 1850 when the meaning of the secret initials 'PRB' became public and the religious intent of their pictures was questioned. Instead they represented a breath of new life within a stale convening. The Pre-Raphaelites were applauded for bringing something novel to the tired RA crowd and for enlivening the productions of other artists. *Fraser's Magazine* praised *Ophelia* and *A Huguenot*, finding pathos in Ophelia's face in a picture where the 'poetical reality' of the natural surroundings was combined with the artist's 'willfulness of taking Nature as she is, instead of *composing* her into a picture.'[8] The idea of taking nature as it is instead of artificially composing, in a picturesque sense perhaps, gives a clue as to why critics had such problems with Collins's landscape, as will be seen. Even though *Ophelia* ran the risk of competing with each viewer's preconceived ideal of the Shakespearean heroine and her story, the painting boldly argued for an original and compelling conception of the character's deadly and undeserved plight through its touching treatment of her face and the truthfulness—as opposed to the ideality—of her surroundings. While *Ophelia* contains references beyond the narrative description in Millais's chosen scene from *Hamlet* (easily justified as her death was rarely staged), *A Huguenot*, with its concentration of meaning into a single moment, was conversely seen as benefiting from its lack of excessive natural detail. By 1852, Pre-Raphaelitism could operate successfully in the public's eye on either level.

Nevertheless, in acknowledging the PRB's innovations, some writers cautioned that such formal qualities were not always cumulatively effective. The critic of the conservative, urban middle class *Athenaeum* took a related position to that of *Punch* and *Fraser's Magazine* while more fully praising the faithful representations of nature in the pictures.[9] Millais, routinely if falsely presented as the leader of the PRB, was seen as having finally burst 'to some extent ... his self-imposed bonds.' *Ophelia*, with its 'marvellous' finish and 'moss and flowers and vegetable details ... mirrored as in a glass,'[10] found favor on technical terms, but the painter's depiction of the heroine with gaping mouth and simple expression was seen as shallow and unenlightening. It left a dull impression and communicated no sense of the character's past or her present pathos. For this critic, *A Huguenot* was the artist's most successful

7.2 William Mulready, *Blackheath Park*, oil on panel, 1832–52, Victoria and Albert Museum, London

work to date, a distinction the picture retained over time. In his obituary of Millais, the Pre-Raphaelite F.G. Stephens referred to the picture as 'the unsurpassable masterpiece of his youth.'[11] Its realism and emotional tone interacted perfectly in the eyes of contemporaries. As Millais's first popular success, *A Huguenot* led to a number of financially lucrative images of couples in similarly dire predicaments and expanded the painter's growing reputation while also turning the tide of opinion in the *Athenaeum,* which had maintained unmitigated hostility towards the Brotherhood since 1850.[12]

In 1852, the Pre-Raphaelite painting that came closest to a pure landscape was Charles Allston Collins's *May, in the Regent's Park,* a picture in which the possibility of a dichotomy between extreme naturalism and intense emotionality was necessarily elided. The developing language of nature in paint and print is most evident in critical responses to this work and to a similar landscape of a London park exhibited in the Royal Academy of 1852. This was William Mulready's *Blackheath Park* (Victoria and Albert Museum, London) (Figure 7.2), a picture begun in 1832. The populist *Art Journal* was rather tempered in its praise of Mulready's picture:

A pre-Raffaellesque eccentricity we scarcely expected to see exhibited under this name. It is a small picture—a very minute transcript from a locality of no pictorial quality, the work being simply valuable for its intensity of execution ... The water is a failure ... in the whole there is an attractive softness and sweetness of execution, which we presume is proposed as a lesson to those youths who 'babble of green fields.'[13]

It is clear that the critic's judgment of quality in the image refers to the brown cast of the vegetation and the indeterminate specifics of a site that was not typically a place of artistic dalliance, as well as the purportedly undistinguished composition. The *Athenaeum* more positively referred to *Blackheath Park* as 'a refreshing little *green* bit of nature,'[14] although the picture shares little of the green coloration of Collins's work or even William Holman Hunt's *Hireling Shepherd* (1851–52, Manchester City Art Gallery), also exhibited at the RA in 1852, and was by an artist not part of the PRB circle. The *Art Journal* instead privileges Mulready's naïve, simplistic view, which is marked by its straightforwardness, in contrast to pictures by those who seek the elevated and ideal and nostalgic vision of a verdant Britain, as illuminated at the end of the quote with the citation of Falstaff's passing in Shakespeare's *Henry V* and his deathbed remembrances of the 'green fields' of his youth.[15]

At 13.5 by 24 inches, *Blackheath Park* is only slightly smaller than *May, in the Regent's Park*, but it is much broader in conception and design. The picture is equally divided between ground and sky and has a conventional color scheme while retaining the brightness associated with Mulready since the 1830s, along with a fine elaboration and finish.[16] The *Art Journal*'s description of it as 'a pre-Raffaellesque eccentricity' significantly intersects with these new critical languages of nature. The same writer described Collins's work as 'among the most eccentric of the curiosities of landscape painting,' the term or catchphrase 'eccentric' being reserved exclusively in this context as a distinction for images of nature that smacked of Pre-Raphaelitism and not for any other landscapes.[17] This is not to imply that Mulready had been influenced by the Pre-Raphaelites in his decision to return to landscape painting in the early 1850s, but rather that critics enlisted certain particular modes of description to divide pictures and establish styles. This is evident in a *Times* editorial of May 7, 1851, a scorching critique of the Pre-Raphaelites, presumably by the paper's art critic, Samuel Phillips:

> To become great in art, it has been said that a painter must become as a little child, though not childish; but the authors of these offensive and absurd productions have contrived to combine the puerility or infancy of their art with the uppishness and self-sufficiency of a different period of life. That morbid infatuation which sacrifices truth, beauty, and genuine feeling to mere eccentricity, deserves no quarter at the hands of the public ... [18]

John Ruskin responded to this with a letter that defended the artists, writing in a well-known passage on Collins's *Convent Thoughts* (1850–51, Ashmolean Museum, Oxford) that:

> ... I happen to have a special acquaintance with the water plant, *Alisma Plantago* ... and, as I never saw it so thoroughly or so well drawn, I must take leave to remonstrate with you, when you say sweepingly, that these men "sacrifice truth, as well as feeling to eccentricity". For as a mere botanical study of the water

lily and *Alisma*, as well as of the common lily and several other garden flowers, this picture would be invaluable to me, and I heartily wish it were mine.[19]

For Ruskin, 'eccentric' was inappropriate. It was Phillips who was unable to recognize the literal truth of Collins's representation.[20]

Critics of *May, in the Regent's Park* took issue with its format and approach to nature. They either were not willing to consider it as connected to traditional topographic landscapes, found the link too obvious to mention, or simply belittled the image. One implication was that since Collins was perceived as a Millais disciple, he was damned from the start, reflecting hostility to the PRB in conservative periodicals. For instance, the *Illustrated London News* noted that 'the absurdity of the production is the more obvious from its being so misplaced—a tea-tray, not a picture frame, was its appropriate vehicle,'[21] connecting Collins's practice to contemporary concepts of mass production and the iconography of consumer goods. It was a picture, the review continued, that was worthy of the pantry. The *Art Journal* offered a fairly lengthy description, considering the customary brevity of their reviews:

Certainly among the most eccentric of the curiosities of landscape painting: a view across the enclosure in the park from one of the dining-room windows, at least one of the gardens facing the park. The principal of the composition is a large bush of pink 'May', with parterre shrubs and flowers; then we have the line of park palings; then the park and trees; but we must say that all this is exquisitely painted, the May and foreground material are marvellously described, and all kinds of inexorable straight lines are boldly and importunately brought forward, despite the useless and absurd rules of composition, and the elaborate 'finish', which is not redolent of nature.[22]

This publication's contention that Collins employed 'useless and absurd rules of composition' is worth considering, as it signals an aspect of the picture that must have seemed particularly perplexing to viewers accustomed to certain forms of landscape. This aspect constitutes one of the picture's advanced elements. A parallel recessional layout was nothing new, relating to a tradition in European landscape stretching back to the seventeenth-century paintings of Nicolas Poussin and Claude Lorrain. What is new in Collins's conception is the emphasis solely on parallel structure, without the use of any typical landscape compositional tricks to draw the viewer's eye into the picture. There are no serpentine forms that wind into depth, nor any straightforward shrinking of objects to provide an easy transition back into space, nor diagonal lines—orthogonals—that reach into depth.[23] In Collins's picture, the trees on the lawn of the park stand out as frieze-like and solitary, arrayed across the expanse like the sheep that graze in and around them. Their rigid dark trunks are compositionally echoed by the thicker posts of the railing before them. Despite the presence of the hawthorn on the left edge of the painting, this traditional coulisse, or framing motif, fails to function as such due to the plethora of foliage around it. Instead we are presented with an embankment

of multi-colored greenery stretching from the herbaceous plants in the left foreground up to the undifferentiated branches in the background. And for all the variety of botanical interest in the picture, there is a curiously static quality to it as a whole. The foreground plantings of individually separated shrubs and borders are arranged before us for maximum recognition and visibility. The bodies of the two strolling figures do not overlap—they are perfectly framed in a section of the fence. Each sheep and each tree occupies its own space, and the swan floats in the background in an expanse of dark reflection, highlighting its luminosity. This sense of calm and permanence is reflected in the brushwork of the artist, in his painstaking, labored style and in his multiple glazes. And this, combined with the composite horizontal order of the scene, preserves in paint a proprietary order inherent in the view, a hierarchical framing of the particularities of a look, of a carefully manicured and manipulated and privileged vista, of a social construct despite, or perhaps as a result of, the 'useless and absurd' compositional deviations.[24]

Collins's picture is unique among early works of the Pre-Raphaelite circle in that it is a pure and finished landscape meant for exhibition. The landscape focus in most early Pre-Raphaelite works was in the form of nature depicted in figural subjects, and it was in the treatment of figures that the movement established its initial influence, before other artists took up pure landscapes later in the decade. A resolute mark of the increasing acceptance of the Pre-Raphaelite style was evident in the indirect flattery afforded by other artists who assumed aspects of Pre-Raphaelite practice regarding nature, many of whom were older than the members of the Brotherhood.

A prime example is Daniel Maclise, whose seven-foot wide *Alfred the Saxon King (Disguised as a Minstrel) in the Tent of Guthrum the Dane* (1852, Laing Art Gallery, Newcastle upon Tyne) (Figure 7.3) was the 46-year-old Royal Academician's major contribution to the summer exhibition of 1852. *The Examiner* described the painting as 'occupying deservedly the first place in the chief room,'[25] and it was a reprise of the subject of Maclise's now lost cartoon submission for the Westminster Palace frescoes competition of 1846. While *The Times* found it highly accomplished, Tom Taylor in *Punch* was not so amenable. After musing about consigning the work to the cellar, Taylor took Maclise to task for his unenviable display of body parts and discordant coloration, the latter a frequent complaint about this particular academician's work. On the profusion of closely observed vegetation he wrote:

Look at those branches loaded with hawthorn bloom—every petal made
out, every leaflet drawn with pains, but the whole cut in tin; not a flicker of
living light—not a pin's point of true imitation about a thing which, unless
truly imitated, is nothing. Observe that mass of fern in the right corner.
Compare its leaden ponds with the dewy dankness of Mr. Anthony's fern
brake, in that round picture on your left. There is the true living reality; here
is the metallic counterfeit. The critic in the Times wrote of this picture, 'Mr.

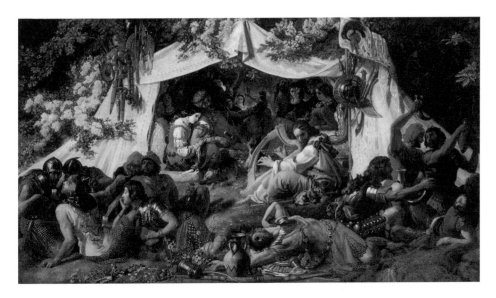

7.3 Daniel Maclise, *Alfred the Saxon King (Disguised as a Minstrel) in the Tent of Guthrum the Dane*, 1852, oil on canvas, Laing Art Gallery, Newcastle upon Tyne

Maclise has here done all that the Pre-Raffaelites have attempted'. There must have been a slip in the types. No doubt what the eminent critic wrote was 'Mr. Maclise has here attempted all that the Pre-Raffaelites have done'.[26]

Taylor found no promise in Maclise's adoption of Pre-Raphaelite manners, a style which as the text reveals he instinctively preferred, and disparaged this picture as 'an example of the tawdriest style of third-rate theatrical grouping.'[27] For Taylor it was both a matter of personal taste and that Maclise's naturalistic detail and artificial expressions could not compete with the emotion and pathos of Millais's contributions. While the ferns that Mark Anthony (1817–86) painted in his *Beech Trees and Ferns* were praised here and in *Fraser's Magazine*[28] for their immediacy and actuality, Maclise's details were castigated as tin or metallic, non-natural, a reference to the harshness of their coloration, depiction, and finish, and also to contemporary architectural debates over the evils of new industrial materials, here set against older variants of architectural sculptural forms such as carved wood and stone.[29] Anthony's small-scale pleinairism was far more suited to an adoption of Pre-Raphaelite techniques than Maclise's grand pictures, in which the discordant detail, handled well or not, conspired with other factors to sink them in the eyes of critics, much as it had works by Hunt, Millais, and Collins in earlier years.[30]

Writers also held that unlike Ophelia in Millais's picture, whose expression seemed completely suited to the moment depicted, Maclise's figure of Alfred wore an inappropriate look of intensity, as a calm countenance would have

been sufficient both in character and for the circumstances. This alleged fault was compounded by others in the picture, including what the *Athenaeum* cannily termed the 'fricasee [sic] of limbs.'[31] But certain characteristics were increasingly coming to be recognized as Pre-Raphaelite, owing largely to Ruskin's writings. As the *Fraser's Magazine* critic pointed out, the 'little scraps of pre-Raphaelitism scattered over works entirely different in spirit and character' served only to draw attention from the object of other artists' pictures. Consequently, he described Maclise's *King Alfred* in this way: 'Surely never did pre-Raphaelitism luxuriate in greater precision, or excessive minuteness of finish, than in the may and chestnut-blossoms' in this work.[32] Yet this was not enough to make a convincing picture.[33]

William Michael Rossetti's reflections on Maclise's picture are somewhat at variance with those previously mentioned and provide a basis for evaluating the early stage of his long career as a critic.[34] Writing for the liberal-leaning intellectual readership of *The Spectator*, where he had worked since November 1850, Rossetti proclaimed *King Alfred* the best historical picture of the year, except for the submissions of the Pre-Raphaelites, and approved of its subject and character.[35] His position differed from Taylor's assessment in *Punch*, finding the protagonist's expression well-suited to the scene, pointing out 'the eagerness with which Alfred, his brow knit as one who abstracts his thoughts, strains to catch the heedless talk of the right hand drinkers in their cups, while the nervous tension of his hand shows that his harping is not suspended.'[36] Rossetti reads Alfred as reflective of the specifics of the incident. He is in the enemy camp. He is an interloper. He is in disguise. He is trying to find out information about the Danes' plans. For Rossetti, Maclise effectively conveyed the pose, attitude, and awareness of such a furtive character, whereas other critics' expectations of a more generalized heroic figure went unsatisfied. This is not only typical of Rossetti's criticism—a search for realism and authenticity, that is to say, truth, in contemporary art—but is paralleled in Pre-Raphaelite art, where the specific is paramount. As for Maclise's employment of nature in the scene, Rossetti remarked:

[The picture's] working shows more even than his wonted excessive precision and surface-finish; the may and chestnut-blossoms, for instance, being surprisingly exact. All is extraordinary as a specimen of skill, and we feel the ease and mastery of the painter across the great apparent labour: yet is it not finish in the true sense of the word. Mr. Maclise's object-painting is like the copy of a wonderful imitation, or like a reflection in a steel mirror. He gives us the form and the colour, but neither the thing, nor the look of the thing,—as may be felt on viewing the fern in the right foreground.[37]

The idea of the painter's manner being likened to a reflection in a steel mirror again summons the specter of modern materials in these pictures, as a way of negating the facility of the artist, accentuating the lack of invention in the

forms, and questioning the merits of technology. It also calls to mind the idea of hardness of execution, the 'earnest effort to paint nature as in a looking-glass,' as Ruskin characterized a common misconception of early Pre-Raphaelitism in his Edinburgh lectures of 1853.[38] This metaphor is how Rossetti describes the success of Pre-Raphaelite imaging of nature against Maclise's failure. Significantly, he does not connect Maclise literally with Pre-Raphaelitism, instead concurring with Taylor in *Punch* in finding the artist's natural details too mechanical. Exactitude does not translate into the kind of truth that Hunt and Millais achieved in their pictures. Yet Rossetti was willing to praise the painter's obvious effort and invention, and so placed Maclise above the crowd. By 1852, in the eyes of some critics, Pre-Raphaelitism's adherence to naturalistic detail was welcome, but only if used in such a way that, when melded with a subject, it proved neither a distraction nor mere accessory, and few were the writers who missed its significance.

The *Art Journal* brought up a similar point in its uncharacteristically lengthy piece on Maclise's picture. This magazine was the voice of the conservative establishment and boasted a readership of over 25,000. Its chief critic was Ralph N. Wornum, who in 1848 edited the Royal Academy lectures of Barry, Opie, and Fuseli, and in 1853 would become keeper and secretary of the National Gallery. He took umbrage with Maclise's inaccurate use of armor, a betrayal of a more and more demanded principle of historical painting and, in practice, a tenet of Pre-Raphaelite accuracy in depiction. He was, however, greatly taken by the representations of nature:

> The redundant resource and illimitable invention shown in this picture are
> truly marvellous ... We have seen much of late in the way of microscopic
> painting, but everything that has appeared is utterly extinguished by
> this picture. Those are severely modelled in paint—this is essentially
> nature ... We cannot wish the sweetly-scented May were not there; but
> we do wish that the dicing party did not come so hard against it.[39]

The elevated subject justifies the means for Wornum; he was able to overlook the temporal inaccuracies in costume and accouterments in order to delight in the white May bush, the horse chestnuts, and other flora, the aspects that were, as he put it, 'essentially nature.' Even the difficulty that Maclise encountered in melding vegetative background and bodies was but a minor problem, a fragmentary quality in the picture also noted in the *Illustrated London News*.[40] Wornum voiced a similar response to Millais's *A Huguenot*, a picture he also admired. The bias toward history painting remained strong in conservative circles, and ambitious pictures such as *King Alfred* by established academicians were welcome despite their evident, if literally unnoted, Pre-Raphaelite sympathies. Yet, as one writer wrote more openly in *The Examiner*, clearly voicing the opinion of more than a few publications, 'contact with Pre-Raphaelitism is really dangerous.'[41]

Maclise's adoption of a Pre-Raphaelite style in his imaging of natural forms was also reflective of peer pressure and commercial imperatives. The dealer C.M. Wass wrote to John Linnell at that time that 'in these days of Pre-Raphaelism [sic] in a picture the subject of which is the figures, it is quite necessary to make the work satisfactory, that they should have as much form and finish as the landscape.'[42] The result of this entreaty was that in the period of initial Pre-Raphaelite influence on other artists, Linnell completely ignored Wass's advice and actually broadened his style, moving towards generalizing treatment rather than specificity.[43] He refused to succumb to these particular edicts of the marketplace, making idyllic, anti-naturalistic pictures in Redhill, Surrey which garnered their own set of supporters.

An older and more established artist who adopted Pre-Raphaelite detail in his RA submissions was Richard Redgrave, who had been elected a full academician in 1851. His *The Woodland Mirror* was exhibited in 1852 (Roy Miles Fine Paintings) and it continued trends in his own work of the 1840s—closer handling, brighter color, smaller-scale—causing the *Punch* critic to cite it along with Anthony's *Beech Trees and Ferns* and Hunt's *Hireling Shepherd* as the only three worthy works of landscape in the exhibition.[44] The *Art Journal* praised *The Woodland Mirror* as 'apparently wrought out with much assiduity from the spot itself, or detailed drawings … strikingly imitative of nature … the most truthful of these close scenes that has yet been exhibited by its author.'[45] This dearth of innovative landscapes was becoming a rallying cry for many critics. Tom Taylor wrote:

Landscape painters at least should be true, and unconventional: and yet, it is strange to see how almost every man of them will insist on putting nature into his livery. Infinite as her aspects are, from the pearly cool of early morning, through all the gradations of hot noon, and limpid eventide, to the solemn twilight, when the gaunt trees stand up blackly against the clear horizon—wide as the range would seem to be, from the spring childhood of the year to its winter old age—vast as the accessible world has grown in these days of railways and steam-boats—how we see each single artist contenting himself with his own little batch of effects, applied year after year in his own little corner of the world.[46]

The language here refers to the persistence of the picturesque, wherein nature is codified into a mannered depiction and a range of signature effects adopted by each artist, irrespective of the particularities of a scene. Variety, both in terms of geographical locales now accessible through new modes of transport, and the innate changeability of weather and light, were in general avoided by landscape practitioners. The new artist, he writes, should be both unconventional—not swayed by tradition—and true. He should depend on the clarity of his own vision.

Taylor complained of Linnell's repetitiveness and Thomas Creswick's unvarying color and tone, despite the latter's multiple locations and subjects.[47]

The monotony of most Royal Academy landscapes, he complained, stood in contrast to the reality of nature, whose aspects are so varied and weather so inherently changeable, and whose mood can be conveyed in so many different forms. This critique of conformity and conservatism forms the basis of later constructions of this period as representing the end of the English landscape tradition, its point of exhaustion: the high mode of landscape devolved into tricks and rote forms. Taylor in *Punch*, while plainly stating the problem, had little to offer by way of solution. His citation of the works of Redgrave, Anthony, and Hunt—pictures barely related in terms of imagery or scale or subject—is ultimately and frustratingly incoherent. He considered Hunt's *The Hireling Shepherd* a landscape and not Millais's *Ophelia*, yet he failed to explain the distinction.[48] He was not working with a coherent definition of landscape.

Other writers were attempting to formulate a more cogent conception of modern landscape painting in the period. William Michael Rossetti's early criticisms of his fellow Pre-Raphaelites are his first and, as such, they tend to be heavily descriptive rather than analytical, formally oriented, while remaining cognizant of the particular emotional expectations of the audience and its delight in stories and pathos.[49] Significantly, in writings beginning with *The Critic* and *The Spectator* in 1850, Rossetti developed a comparative mode that tended to set works against those of contemporary artists rather than, as was conventional, past practitioners.[50] This was part of a strategy to install a member or members of the PRB within the critical establishment in order to develop a new mode of discussion and influence public opinion. As Rossetti wrote in the PRB journal on February 2, 1850, regarding the offer of an unpaid post at *The Critic*: 'This proposal is not, I think, disadvantageous for the P.R.B., as it would enable us to review the exhibitions in our own feeling, and might besides lead to some other literary employment.'[51]

Rossetti's first notice of the annual British Institution show at its premises at 52 Pall Mall, a show 'supreme in rampant mediocrity'[52] as he described it, is remarkable for not making a single art historical reference. This is atypical of most criticism of this period. A glance at any contemporary review would find comparisons of modern artists with the pantheon of Rubens or Potter, Raphael or Murillo, Rembrandt or Titian. Rossetti's approach in his early work was novel if, admittedly, not particularly enticing. He emphasized interconnections among living artists, had a firm eye for detail and composition, and seemed aware of contemporary taste. In fact, his writing at this stage is somewhat populist: the reader needed little background in connoisseurship or art history to comprehend his reviews or references. Though it may indicate merely that he was not working for scholarly journals and that he was a novice writer, Rossetti's approach is precisely the one that writers on the Pre-Raphaelites subsequently adopted from 1850 to 1853. When critics turned their gaze to pictures by the leading lights of the Brotherhood, they felt less secure in

evoking the types of artistic examples from the past that were customary in criticism and that would have given their arguments weight and verity. It is as if they were unsure how to approach pictures by Millais, Hunt, or Collins. The Pre-Raphaelite style presented them with an insoluble hermeneutic and rhetorical challenge. There was no set artistic precedent to accommodate them.

In the *Athenaeum* review of the British Institution of 1852, the paper's critic provided a typical and traditional approach to landscape:

> Mr. Linnell exhibits here one of those sylvan scenes to which he imparts a
> national air without losing any of the poetry belonging to the incident chosen
> for embodiment. A *Boar Hunt in England – Olden Time (No. 45)* gives striking
> evidence of the science to which this distinguished artist has subjugated
> the materials of his palette. Mr. Linnell has had large and general truths in
> view, to which he has subordinated the details in which an ordinary artist
> would have sought refuge ... For gorgeousness of arrangement and vigour
> of hand this picture might be likened to the productions of Rubens.[53]

The review associates Linnell's choice of familiar English landscapes with nationalism. The critic's use of the word science refers to the painter's craft and not an investigatory technique of comprehensive understanding in the modern sense, while his invocation of the idea of general truths relates to Sir Joshua Reynolds's *Discourses on Art*. The critic gives the work the ultimate endorsement in invoking Peter-Paul Rubens, whose landscapes were familiar to visitors to the National Gallery and who formed a comparison to previous artistic achievement that was a common trope in the period.[54] For Rossetti, while this was not Linnell's finest effort, it was 'a work of manifest power: the mid-background, and massive windy heath-covered mound, especially impressive.'[55] He avoided discussing the generalized foreground flora.

Even the more conservative critics were prepared to condone the use of specific natural forms in paintings: the *Athenaeum*, for example, commented on 'that variety of botanical and geological detail which gives such help to the picturesque.'[56] Detail is a necessary accessory, a useful adjunct to the time-honored aesthetic virtues of the picturesque, but an excess of detail could become a distraction. It is not strong enough to carry a picture, especially one marred by false sentiment or expression, at which point the detail becomes overpowering. George Cole's (1810–83) *Landscape with Cattle*, for example, received high marks and comparisons to both Paulus Potter and the contemporary Brussels-based painter and printmaker Eugène Verboeckhoven (1798–1881). Seventeenth-century Dutch art remained the standard that contemporary landscapes must strive to reach, while figure groups must be judged against the Spanish realism of Diego Velázquez and Bartolomé Esteban Murillo.[57] In April, the magazine's review of the exhibition of the Society of British Artists noted that Henry John Boddington (1811–65) 'for the fiftieth

time signed his pleasing and truthful river landscapes, with the large leaves of the water-coltsfoot and the rosy spikes of the *Epilobium* in the foreground.'[58] These are pictures produced in a depressingly machine-like manner, without variety or originality.[59] Rossetti appeared to concur with the *Athenaeum*: '[Boddington] has so intimate a knowledge of a variety of natural aspects, and such eminent skill of hand, he is so well up in his art, and his manner is so agreeable, that we regret he will not take the one step further which would free him from a certain *cliqueishness* [sic], and make him altogether one of the select few.'[60] For Rossetti, Boddington was ultimately too derivative and lacked the courage to put his innate understanding of nature to work in a novel manner.

In Rossetti's review, he did allow himself a simple reference to a past artist in a note on Richard Elmore's *Buckland Village* and its Turneresque 'faithfulness of character.'[61] Turner, dead less than four months, was technically an artist from the past, but hardly an old master. In bemoaning the absence of quality in the lesser London exhibits in such reviews and refraining from employing the same language as his fellow critics, Rossetti decontextualizes these artists in the way that other critics would the Pre-Raphaelites. Well aware of the manner of contemporary criticism, he appears to have been attempting to redirect critical approaches in order to recast the work of his fellow brothers. He was not at a loss for comparative discourse but, rather, tried to bend his writing to concentrate on the present and to illuminate the aspects of contemporary practice that he felt should now determine quality. This, however, was strictly a project of early Pre-Raphaelitism. For by 1856, when Millais's style had evolved in works such as *Autumn Leaves* (1855–56, Manchester City Art Galleries), Rossetti could quite confidently use Venetian art, and in particular Giorgione, in his assessment of the meaning of Millais's poetic and narrativeless picture, in order to elevate it above the mean.[62]

But in the early 1850s, acutely and intimately aware of the brazenness of the Pre-Raphaelite project, he developed a strand of criticism that approached new art on its own terms, instead of through the tried and true referential methods of his predecessors. In this way, Pre-Raphaelitism would stand a chance of making an impact, whereas otherwise it could not fail to drown due to innate biases and cultural dispositions against manipulated innovation. Hunt mentioned later in his life that his aim in painting *The Hireling Shepherd* was to present 'not dresden china bergers, but a real Shepherd, and a real Shepherdess, and a landscape in full sunlight, with all the color of luscious summer without the faintest fear of the precedents of any landscape painters who has rendered Nature before.'[63] This idea of a kind of painting lacking precedents is equivalent to William Michael Rossetti's reference-free criticism. The publishing critics within the Pre-Raphaelite Brotherhood form a younger generation of writers on art in England in the early 1850s. Without intending to construct a category of 'Pre-Raphaelite criticism,' it is true that Rossetti, and

later F.G. Stephens, pursued a form of critical discourse which is as advanced in approach as that of their fellow brothers who painted. The achievements of the literary arm of the PRB, in this respect, proved quite influential.[64]

Notes

1. '"Our Critic" among the pictures,' *Punch*, 22, May 22, 1852, 216. Taylor's critique followed the events of the previous year when, in May of 1851, John Ruskin's two letters defending the movement were published in *The Times*, and later that summer Ruskin published a more substantial pamphlet titled *Pre-Raphaelitism*. While the Pre-Raphaelites were avid readers of the humor magazine, *Punch* had slaughtered Millais's 'blasphemous' *Christ in the House of His Parents* (Tate, London) in 1850. See 'Pathological exhibition at the Royal Academy. (Noticed by our surgical advisor.)' *Punch*, 18, May 18, 1850, 198. And in 1851 the magazine had been good-naturedly scornful of *Mariana* (1850–51, Tate, London). See 'Punch among the Painters,' *Punch*, 20, May 17, 1851, 219. For art criticism in the first decade of *Punch*, see Richard D. Altick, *Punch: The Lively Youth of a British Institution, 1841–1851*, Columbus: Ohio State University Press, 1997, pp. 668–89.

2. For *Ophelia*, see Malcolm Warner in *The Pre-Raphaelites*, exh. cat., ed. Leslie Parris, London: The Tate Gallery in association with Allen Lane and Penguin, 1984, pp. 96–8, and Kimberley Rhodes, 'Degenerate detail: John Everett Millais and Ophelia's "muddy death",' in Debra N. Mancoff (ed.), *John Everett Millais: Beyond the Pre-Raphaelite Brotherhood*, New Haven and London: Yale University Press, 2001, pp. 43–68. For *A Huguenot*, see Malcolm Warner's entries on the picture in *Great British Paintings from American Collections*, exh. cat., eds Malcolm Warner and Robyn Asleson, New Haven: Yale Center for British Art, 2001, pp. 193–5, no. 58, and in *The Pre-Raphaelites*, exh. cat., ed. Parris, pp. 98–9, no. 41. *Millais*, exh. cat., eds Jason Rosenfeld and Alison Smith, London: Tate Publishing, 2007, pp. 68 and 94.

3. '"Our Critic" among the pictures,' 216. The criticism is phrased in an imagined and satirical conversation with a traditionalist painter, 'M. Glip,' and a conservative critic, 'Mr. Squench.'

4. Taylor attended Cambridge on a Trinity Fellowship, started at *Punch* in 1844, was called to the Bar in 1846, taking chambers in Crown Offices Row, spent two years as Professor of English Language and Literature at London University, was editor of *Punch* from 1874 to 1880, and served as art critic of *The Times* from 1857 to his death in 1880. His plays include *Our American Cousin* (1858), *The Ticket-of-Leave Man* (1863), and *The Fool's Revenge* (1869). Millais first met him after this review was published and in 1864 painted his son, John Wycliffe (private collection). See *Millais: Portraits*, exh. cat., ed. Malcolm Warner and Peter Funnell, Princeton: Princeton University Press and London: National Portrait Gallery Pub., 1999, pp. 129–30.

5. '"Our Critic" among the pictures,' 217. Ruskin similarly recognized the difficulty of characterizing these artists within the tradition of landscape painting, lecturing in Edinburgh in 1853 that 'as landscape painters, their principles must, in great part, confine them to mere foreground work.' John Ruskin, *Lectures on Architecture and Painting, Delivered at Edinburgh, in November, 1853*, 'in *The Works of John Ruskin*, eds E.T. Cook and Alexander Wedderburn, 39 vols, London: George Allen and Sons and New York: Longmans, Green & Co., 1903–12, vol. 12, p. 158.

6. This is in distinction to the reaction to the previous year's exhibition which drew generally more favorable responses. See, for example, Wilkie Collins, 'The Exhibition of the Royal Academy,' *Bentley's Miscellany*, 29, June 1851, 617–27.

7. 'Art and the Royal Academy,' *Fraser's Magazine*, 46, August 1852, 230.

8. 'Art and the Royal Academy,' 234. Compare this to the more tempered assessments in the conservative *Art Journal* and *Athenaeum*, whose critics found no sympathy with the heroine. See [Ralph N. Wornum], 'The Exhibition of the Royal Academy, 1852. the eighty-fourth,' *Art Journal*, o.s. 14, n.s. 4, June 1, 1852, 174; 'Royal Academy,' *Athenaeum*, May 22, 1852, 581; and Rhodes, 'Degenerate detail,' pp. 52–3, which avoids more sympathetic criticism of the picture.

9. The art critic of the *Athenaeum* in the 1850s (by 1854 at least) was George Walter Thornbury who 'had little use for the Gothic revival and the idealization of the Middle Ages' and was moderate at best towards John Ruskin's writings on such matters. He was more appreciative of Ruskin's art criticism. Thornbury purportedly wrote his *Life of J.M.W. Turner* under the observation of Ruskin, a particularly unnerving experience, as Ruskin could be overbearing in this capacity. See Leslie A. Marchand, *The Athenaeum: A Mirror of Victorian Culture*, Chapel Hill: University

of North Carolina Press, 1941, pp. 354–7. Thornbury had been preceded by Frank Stone, who wrote a number of particularly inimical reviews of Pre-Raphaelite works in 1850. F.G. Stephens wrote unsigned weekly articles for *The Athenaeum* from February 1860 to January 1901. William Michael Rossetti wrote that '*The Athenaeum* was not decidedly an adherent of the Pre-Raphaelite School of Art; but certainly for many years, Stephens' criticisms favoured the artists of that school.' Cited in Marchand, *The Athenaeum*, 91, from H. Allingham and E. Baumer Williams (eds), *Letters to William Allingham*, London and New York: Longman, Green & Co., 1911. Editors' marked copies are in the Library of the City University, London. See Dianne Sachko Macleod, 'F.G. Stephens, Pre-Raphaelite critic and art historian,' *Burlington Magazine*, 128, June 1986, 398–406.

10. 'Royal Academy,' *Athenaeum*, May 22, 1852, 581.

11. F.G. Stephens, 'Obituary of John Everett Millais,' *Athenaeum*, August 15, 1896, 233.

12. Marchand, *The Athenaeum*, 91. Many in the extended Pre-Raphaelite circle wrote for the *Athenaeum* after the 1850s, including Dante Gabriel, William Michael, and Christina Rossetti, William Allingham, James Hannay, and Theodore Watts-Dunton.

13. [Wornum], 'The Exhibition of the Royal Academy, 1852,' p. 167. See also Allen Staley, *The Pre-Raphaelite Landscape*, Oxford: Clarendon Press, 1973, 2nd edn London and New Haven: Published for the Paul Mellon Centre for Studies in British Art by Yale University Press, 2001.

14. 'Royal Academy,' *Athenaeum*, May 8, 1852, 519.

15. *Henry V*, 2.3.16–17, adapted from Psalm 23:2. William Shakespeare, *Henry V*, ed. E.F.C. Ludowyck, Cambridge: Cambridge University Press, 1966, p. 63, and *King Henry V*, ed. T.W. Craik, London and New York: Routledge, 1995, pp. 182–3.

16. The latter was noted by critics then and now. See *Mulready*, exh. cat., ed. Marcia Pointon, London: Victoria and Albert Museum, 1986, pp. 50–52, 60.

17. One journal remarked that this year saw the group managing 'to dismiss some of the wilder points of eccentricity which laid them open to ridicule on former occasions. As it is, they have certainly much to get rid of, and much naturalness to embody with their painstaking art.' 'Exhibition of the Royal Academy,' *Illustrated London News*, 20, May 8, 1852, 368. For Julie L'Enfant, the term 'eccentricity' connotes the critics' cautioning the public against the attempt 'to purify art by putting sentiment and expression above technical matters,' an aim commensurate with that of the Nazarenes and other artists seen as 'primitive.' But it is clear that for writers like Ruskin, the term 'technical' could mean many things and the notation 'eccentric' is more nuanced in meaning. See Julie L'Enfant, *William Rossetti's Art Criticism: The Search for Truth in Victorian Art*, Lanham, MD and Oxford: University Press of America, 1999, p. 35.

18. [Samuel Phillips], 'Exhibition of the Royal Academy. Second notice,' *The Times*, 20, May 7, 1851, 8. See [G.E. Buckle, Stanley Morison, Iverach McDonald et al.], *The History of The Times, Volume 2: The Tradition Established 1841–1884*, London: The Times, 1939, pp. 438–9.

19. 'To the Editor of the "Times",' May 13, 1851, in *The Works of John Ruskin*, vol. 12, p. 321.

20. In 1853, Ruskin took issue with critics' use of the term 'puerility,' writing that he found it strange that 'the rendering of the most noble expressions of human feeling in Hunt's Isabella [*Claudio and Isabella*, 1850, Tate, London], or of the loveliest English landscape in Millais's Ophelia, should be declared 'puerile.' Ruskin, *Lectures on Architecture and Painting*, in *The Works of John Ruskin*, vol. 12, p. 161.

21. 'The Royal Academy. (Second Notice.),' *Illustrated London News*, 20, May 22, 1852, 407.

22. [Wornum], 'The Exhibition of the Royal Academy, 1852,' p. 166.

23. Compare Collins's picture to John Constable's twin prospects of his father's gardens painted in 1815, similar both in the bird's eye view taken from an upper floor window and in the somewhat casual nature of the layout and subject: *Golding Constable's Flower Garden* and *Golding Constable's Kitchen Garden*, (both 1815, Ipswich Museums and Galleries, Ipswich Borough Council). See Michael Rosenthal, *Constable: The Painter and his Landscape*, New Haven and London: Yale University Press, 1983, pp. 93–101. There are similarities in terms of muted atmospheric perspective, and specific geographic elements displayed across the surface in a form of mapping a complete terrain. See Stephen Daniels, 'Re-visioning Britain: Mapping and landscape painting, 1750–1820,' in *Glorious Nature: British Landscape Painting 1750–1850*, exh. cat., catalogue by Katherine Baetjer and essays by Michael Rosenthal, Kathleen Nicholson, Richard Quaintance, Stephen Daniels and Timothy J. Standring, London: Zwemmer and New York: Hudson Hills Press in association with the Denver Art Museum, 1993, pp. 61–72.

24. The view was from 17 Hanover Terrace, where Collins lived with his mother and brother, the novelist Wilkie Collins. Collins, it turns out, also manipulated the view. He seems to have combined the perspective from the first floor drawing room with that of his painting room on the second floor. This telescoping of foreground and distance also contributes to the formal modernity of the picture.

25. *The Examiner*, May 1, 1852, 277.

26. '"Our Critic" among the pictures. A cruise about the line,' *Punch*, 22, May 29, 1852, 232–3.

27. *Ibid.*, 233.

28. *Fraser's Magazine*, 46, August 1852, 235. Exhibited as number 107 at the RA of 1852, John Miller sold Anthony's picture on May 21, 1858 at Christie's (165) to the dealer Ernest Gambart for £315. It is unlocated.

29. The critic's equating of Maclise's ferns with tin and 'metallic counterfeit' is remarkable for reflecting a debate on material authenticity that was concurrently active in architectural circles and that would be a great bone of contention between John Ruskin and Benjamin Woodward in the building of the Oxford University Museum.

30. As for Anthony, William Michael Rossetti later wrote of him that 'he became anxious to graft something of Præraphaelitism upon the style which came naturally to him and in which he excelled. This did not really improve his work … ' *Some Reminiscences of William Michael Rossetti*, 2 vols, London: Brown, Langham & Co. and New York: Charles Scribner's Sons, 1906, vol. 1, p. 141.

31. 'Royal Academy,' *Athenaeum*, May 22, 1852, 582.

32. *Fraser's Magazine*, 46, August 1852, 233.

33. See also 'Royal Academy,' *Athenaeum*, May 22, 1852, 582–3 for a scathing review. The picture has been more praised in modern times, was part of the *Vikings and Gods in European Art* exhibition at the York City Art Gallery in the summer of 1997, and is now appreciated for its high color, draughtsmanship, and subtle Christian allusions. See *Daniel Maclise 1806–1870*, exh. cat., eds Richard Ormond and John Turpin, London: Arts Council of Great Britain in association with the National Portrait Gallery, 1972, pp. 97–8; John Turpin, 'Daniel Maclise and his place in Victorian art,' *Anglo-Irish Studies*, 1, 1975, 51–69; and Nancy Weston, *Daniel Maclise: Irish Artist in Victorian London*, Dublin: Four Courts Press, 2001, pp. 204–9. See also Peter Murray, *Daniel Maclise (1800–1870) Romancing the Past*, Dublin: Gandon Editions, 2008.

34. See L'Enfant, *William Rossetti's Art Criticism*, p. 52.

35. The PRB were unfamiliar with *The Spectator* before Rossetti began to work there, but the group was under the favorable impression that 'its tactics are somewhat hostile to the Academy, in so far at least as the aim of keeping it up to public responsibility may be so construed.' Nonetheless, Rossetti found the editor 'not of very P.R.B. tendencies, and no great admirer of Anthony, my review of whom at Suffolk Street, I had brought with me, fancying it would be appropriate.' *The P.R.B. Journal: William Michael Rossetti's Diary of the Pre-Raphaelite Brotherhood, 1849–1853*, ed. William E. Fredeman, Oxford: The Clarendon Press, 1975, p. 79, entry of November 5, 1850. The review referred to is [William Michael Rossetti], 'Exhibition of the Society of British Artists,' *The Critic*, 9, April 15, 1850, 199–200.

36. [William Michael Rossetti], 'The Royal Academy Exhibition,' *The Spectator*, 25, May 8, 1852, 446.

37. *Ibid.*, 446–7.

38. Ruskin, *Lectures on Architecture and Painting* in *The Works of John Ruskin*, vol. 12, p. 156. The discourse on mechanical reproduction also alludes to photography, the connection to which Ruskin similarly dispensed with in saying that if critics compared Pre-Raphaelite pictures to copies of photographs, then it exploded their own argument, for they would be admitting that PRB works were then true to nature. Ruskin, *Lectures on Architecture and Painting* in *The Works of John Ruskin*, vol. 12, p. 157.

39. [Wornum], 'The Exhibition of the Royal Academy, 1852,' p. 167.

40. 'Exhibition of the Royal Academy,' *Illustrated London News*, 20, 369. The reviewer described how 'the botanical minutiae of the May and honeysuckle clustering around the tent, and of the daisies and dandelions in front, show how genius misdirected may devote itself unduly to trifles in the midst of scenes of momentous interest.'

41. Quoted from 'The Royal Academy Exhibition,' *The Examiner*, May 22, 1852, 326.

42. C.M. Wass letter to Linnell, December 17, 1853, cited in *John Linnell: A Centennial Exhibition*, exh. cat., ed. Kathleen Crouan, Cambridge: Cambridge University Press in association with the Fitzwilliam Museum, 1982, p. xvii.

43. *Ibid.*

44. The *Art Journal* was not so positive, writing of Anthony's work (No. 107): 'A large circular picture, representing strictly the material proposed in the title. The ground is entirely over-grown with fern, and strewn with dead leaves, and lies immediately under the spreading boughs of the lofty beeches. In lightness, colour, and form, the ferns are most perfectly imitated; indeed, the picture seems to be a most diligent study from nature, in which nothing has been omitted. The subject, however, was scarcely worth painting, and the picture is, consequently, of little value.' [Wornum], 'The Exhibition of the Royal Academy, 1852,' p. 167.

45. [Wornum], 'The Exhibition of the Royal Academy, 1852,' p. 166. Similarly, Redgrave's *The Lost Path*, painted in 1852 and exhibited in the Royal Academy in 1853 (340), was his first of a series concerned with children lost in the woods, a popular theme in art of this period. It was also his first comprehensive effort in a Pre-Raphaelite landscape style, with large figures, a heightened color key and extraordinary attention to detail in the foreground. Contemporary critics noticed this connection. The painting is illustrated in *The Royal Academy (1837–1901) Revisited: Victorian Paintings from the Forbes Magazine Collection*, exh. cat., text by Christopher Forbes, introduced and edited byAllen Staley, New York: Forbes, 1975, p. 124. It was offered at Christie's, November 25, 2003.

46. '"Our Critic" among the pictures. Something about some portraits and landscapes,' *Punch*, 23, June 26, 1852, 7.

47. Creswick's *The Sunset Hour* was engraved in the *Illustrated London News*, 20, May 22, 1852, 408.

48. See Kay Dian Kriz, 'An English arcadia revisited and reassessed: Holman Hunt's *The Hireling Shepherd* and the rural tradition,' *Art History*, 10 (4), December 1987, 476–8, for critical reactions to the picture. Hunt's picture has more depth and recession, but is equally dominated by figures and bears a profundity of foreground detail.

49. Much of his early criticism from *The Spectator* is collected in William Michael Rossetti, *Fine Art, Chiefly Contemporary*, London: Macmillan, 1867, rpt., New York: AMS Press, 1970.

50. And Rossetti quickly tempered his innate skepticism of contemporary artists in responding to Ford Madox Brown's advice 'against being too downright and sarcastic in the Art notices I write for the *Critic*;' William Michael Rossetti, *P.R.B. Journal*, entry of February 22, 1850, p. 57.

51. William Michael Rossetti, *P.R.B. Journal*, p. 51. See also entry of May 6, 1851 wherein Rossetti discusses how he was going about promulgating a Pre-Raphaelite primacy in his Academy reviews in *The Spectator*. William Michael Rossetti, *P.R.B. Journal*, pp. 91–2. Hunt praised Rossetti for this in the second edition of his *Pre-Raphaelitism and the Pre-Raphaelite Brotherhood*, 2 vols, 2nd edn, London: Chapman and Hall, 1913, vol. 2, p. 340, which greatly salutes Rossetti's role, in comparison to the more qualified assessment in the first edition of his memoirs: William Holman Hunt, *Pre-Raphaelitism and the Pre-Raphaelite Brotherhood*, 2 vols, London and New York: Macmillan & Co., 1905, vol. 2, pp. 420–21.

52. [William Michael Rossetti], 'The British Institution,' *The Spectator*, 25, February 28, 1852, 206.

53. 'The British Institution,' *Athenaeum*, February 14, 1852, 201. An engraving of the 6 x 10-foot picture was published in the *Illustrated London News*, 20, March 20, 1852, 240.

54. Rubens's *An Autumn Landscape with a View of Het Steen in the Early Morning* (probably 1636, NG66) was part of the Sir George Beaumont Gift of 1823–28, and his *Sunset Landscape with a Shepherd and his Flock* (c. 1638, NG157) was bequeathed by Lord Farnborough in 1838.

55. [William Michael Rossetti], 'The British Institution,' 207. Rossetti avoided discussing the foreground, which would not have measured up to the detailed Pre-Raphaelite stylistic approach of this period.

56. 'The British Institution,' *Athenaeum*, February 14, 1852, 202.

57. It is interesting to note that George Vicat Cole (1833–93), son of George Cole, was exhibiting in London for the first time this year. He would go on to become, in 1880, the first landscapist admitted to the Royal Academy since Thomas Creswick had that honor in 1851.

58. 'Society of British Artists,' *Athenaeum*, April 3, 1852, 384. The identification of flora species was part of the critical language of this period and particularly suited to describing Pre-Raphaelite

landscape paintings. See Ruskin's discussion of *Alisma Plantago* in Collins's *Convent Thoughts* discussed above.

59. Other Society regulars like Alfred Joseph Woolmer (1805–92), known as 'the English Diaz' (Narcisse Diaz de la Peña, 1807/8–76), garnered the same notices.

60. [William Michael Rossetti], 'Exhibition of the Society of British Artists,' *Spectator*, 25, April 3, 1852, 327.

61. *Ibid.*, 328.

62. [William Michael Rossetti], 'R.A. Exhibition—second visit,' *The Spectator*, 29, May 24, 1856, 570.

63. Letter of January 21, 1897 from Hunt to J.E. Phythian, Manchester City Art Gallery, quoted in John Duncan Macmillan, 'Holman Hunt's *Hireling Shepherd*: Some reflections on a Victorian pastoral,' *Art Bulletin*, 54, March 1972, 188.

64. A discussion of the conservative political positions of many art periodicals of the time is found in George P. Landow, '"There began to be a great talking about the fine arts",' in Josef L. Altholz (ed.), *The Mind and Art of Victorian England*, Minneapolis: University of Minnesota Press, 1976, pp. 124–45. See also William E. Fredeman, 'Pictures at an exhibition: late-Victorian and modern perspectives on Pre-Raphaelitism,' in Jerome J. McGann (ed.), *Victorian Connections*, Charlottesville: University of Virginia Press, 1989, pp. 179–99.

Poetic, eccentric, Pre-Raphaelite: the critical reception of Simeon Solomon's work at the Dudley Gallery

Colin Cruise

Solomon is a genius of eccentricity, he can do nothing like
other people ...

<div align="right">

Art Journal, 1865, 45

</div>

Any merit [his paintings] may have is obscured by their sickly prurience.
They correspond in painting to some of the most objectionable
performances of Mr Swinburne in poetry ... Mr Solomon is an example
of a clever artist misled or marred by offensive mannerism.

<div align="right">

The Times, February 14, 1870, 4

</div>

'In the world of art,' claimed Max Nordau in 1893, 'the religious enthusiasm of degenerate and hysterical Englishmen sought its expression in Pre-Raphaelitism.'[1] This chapter explores textual responses to Pre-Raphaelitism's continual challenge and disruption of academic painting, suggesting a particular role for periodical art reviewing and other journalism in the critical reception of works by members of the 'second generation' of Pre-Raphaelites. These reviews were particularly important, I claim, in developing a negative terminology to describe the 'new painting' of the 1860s. Their language, derived at times from medical discourse, implied sexual, mental, and moral disorder and identified the 'new painting' as threatening, even degenerate, some 30 years before such ideas were to preoccupy theoreticians of culture like Max Nordau. I examine this language in relation to Simeon Solomon, whose paintings *Poetry* (1864, Grosvenor Museum, Chester City Council) (Figure 8.1) and *In the Summer Twilight* (1869, Seymour Stein) (Figure 8.2) provide my key examples.

8.1 Simeon Solomon, *Poetry*, 1864, watercolor on paper, Grosvenor Museum, Chester City Council

The poetic context

The period between 1865 and 1885 saw a redefinition of the terms used to write or speak about the subject in painting. The rise of newspaper and periodical art journalism and the importance given to art, exhibitions, and critical writing were significant contributions to the debate around the visual arts at this time.[2] In these reviews we can observe an extension of 'Pre-Raphaelitism' as a critical

8.2 Simeon Solomon, *In the Summer Twilight*, 1869, watercolor on paper,
Seymour Stein

term, an accretion of qualities to it and a strong critical reaction against it. The
period also marks the formation of an Aesthetic painting and the opening
of several significant exhibiting venues for young artists, notably the Dudley
and Grosvenor Galleries. In related fields, it also saw the first publication of
Swinburne's *Poems and Ballads* (1866) and of Rossetti's collected poems (1870).
Rossetti's death on April 9, 1882 and the commemorative exhibition at the
Royal Academy in the winter of 1882–83 were also important in establishing a
history of Pre-Raphaelitism and a particular role for Rossetti in the formation
of the 'new' painting of the 1860s.

Pre-Raphaelite artists had continued to invite, encourage, and, indeed,
take for granted a deep interdependence between painting and poetry. Pre-
Raphaelite practices challenged the expectations of the viewer in relation
to poetry and its consolations, finding pictorial means by which to unsettle
the traditional relations between the 'sisters' who made up the 'sister arts'
relationship. The idea that the 'poetic' might be a concept linked to a certain
kind of painting and its relationship to a certain kind of poetry was an integral
part of early Pre-Raphaelite practice—the single element, it might be fair to
say, which links that group with the younger artists who formed around

Dante Gabriel Rossetti in the late 1850s and 1860s. There are obvious links between early Pre-Raphaelite practice and English Romantic poets—Shelley and Keats immediately suggest themselves—and to Tennyson, as a kind of late Romantic poet. These affiliations and homages, however, were relatively soon abandoned by younger painters in favor of rediscovered poets like Villon, Dante, and Blake or the contemporary poet, Algernon Charles Swinburne, who was enjoying notoriety in the 1860s and who became a vital part of the Rossetti circle.[3]

Isobel Armstrong observes that the Pre-Raphaelites had lived during the revival of interest in poetry around which there was a 'strenuous and self-conscious exercise in criticism.' She notes, too, the consequential rise in periodicals dealing with poetry and literature.[4] Something of the same growth is apparent in the criticism of the visual arts after the 1860s, notably in the space given over to art criticism in newspapers and periodicals where critical language is developed out of a variety of observations: technical, historical/comparative, and narrative or literary assumptions about the illustrative function of the pictorial. But 'poetic' had abandoned any consolatory connotations it might have had for the pictorial when poetry had become more contentious as a form. Although Tennyson was a popular choice for artists seeking a poetic source for a picture, and although the Pre-Raphaelites worked on the Moxon edition of his works of 1857, other poets who invited pictorialization—like Browning and Swinburne—were more awkward or more challenging in their own right. Poetry of unregulated passion and desire, such as Swinburne's, presented different pictorial problems from that of nature poetry or dramatic histories. The 'consolations of poetry' might be said to have been abandoned on the publication of Swinburne's *Poems and Ballads*, which appeared to extend some of the stylistic features of Pre-Raphaelite painting into newly problematized areas. Thus, the medievalism of the Pre-Raphaelites, considered an affectation by critics, became extended or distorted by a poetry of desire, lust and death, of 'effeminacy' and 'degeneracy.' The Border ballads, an inspirational source for both Rossetti and Swinburne, with their obtrusive repetitions, jarring rhythms, and violent imagery, challenged artists to picture violence and lust in novel ways which avoided the well-worn modes of history painting and the paraphernalia of the life room and studio. 'New' painting had become allied to the 'new' poetry in themes hitherto avoided, if not tacitly forbidden, in English art. The clerical or ecclesiological medievalism of the 1840s gave way to a 'medieval' sensuality which contravened contemporary sexual mores. Hence, in some of the reviews quoted in this chapter, we can clearly see the continued scathing use of 'medievalism' as an insult. Now, in the 1860s, however, it was associated with other departures from modern, reasonable, mediated, and middle-class expectations—away from sanity and healthfulness and towards decadence, mysticism, and sexual passion. This medievalism of the painting of the 1860s is not that of Pugin's architectural

theories advanced in the 1840s. It has two alternative sources and meanings: first, in the formative early medievalism at the death of the classical world or second, in the later medieval world which gives way to the Humanism of the Renaissance when Catholicism became newly engaged with classical learning. These are models of a transitional medievalism rather than a settled model adopted as a civic ideal in the town halls of industrial northern England or as the motif of historical fresco cycles. In both painting and poetry it is a model for synthesis and innovation rather than for revival or renovation.

Some of these new artistic practices were viewed in explicitly gendered terms. For Alfred Austin, later Poet Laureate, the two great poets of the day, Tennyson and Browning, could be summed up by the terms 'feminine' and 'studious.' Tennyson's muse is 'essentially—we must not say the muse of a woman, for we should be rendering ourselves liable to misconception, but— a feminine muse.'[5] Swinburne has taken 'one step farther' than Tennyson towards the expression of the feminine in poetry—a mere imitator of the classical mode when he attempts classical subjects, his métier is the 'sexual region,' the erotic impulse, a characteristic of the 'unmitigatedly mischievous' feminine influence in all of the contemporary arts. But, observes Austin, this further unites the poet with the tendency of modern novelists:

What is the love of which many of our men-novelists—men, at least, as far as nominal sex is concerned, though certainly not men as authors or in any literary sense—and nearly all our women-novelists, so freely discourse? It is the love—had we not better call it the lust?—which begins with seduction and ends in desertion, or whose agreeable variations are bigamy, adultery, and, in fact, illicit passion of every conceivable sort under every conceivable set of circumstances.[6]

While this list of transgressions is domestic in bias, it must be obvious from the few examples Austin quotes from Swinburne's poems such as 'Dolores' that Swinburne's muse has pushed him not only one step further than Tennyson and contemporary novelists, but many steps further. Perhaps, in some sense, Swinburne is pushed many steps backwards, too, for while in some ways his sexual aesthetic is deeply personal, even idiosyncratic, in others it is dependent upon the decadent 'transitional medievalism' that provides him with images and metaphors to enable him to express a poetic version of his desire.

Austin's survey of Swinburne's work is based on concepts of the 'proper' and 'improper:'

Our 'proper' feminine novelists; and the, on the whole, 'proper' feminine muse of Mr. Tennyson was only the precursor of the 'improper' feminine muse of Mr. Swinburne. There is nothing masculine about the one any more than about the other; or what advantage there is on either side in that particular lies, as we have said, with the muse of the former. Both, however, are substantially feminine muses; only one is the feminine muse of the Hearth, whilst the other is the feminine muse of the Hetairae.[7]

Swinburne's sado-masochistic desires, giving way to extreme physical descriptions of biting and bruising, for instance, are influential because they bring to English poetry a new set of motifs which do not depend upon images of the natural or the domestic to describe them but which are focused upon the body, sometimes even upon fetishized fragments of it—the hair, the throat, the eyelid. Yet Swinburne's appeal to a language of a classical decadence in which to frame these bodily fragments is ambiguous. The classical world is in flames and, as it dissolves, certainties and order dissolve, too; the world is made chaotic again just at the point where order and faith, promised by the revival of medievalism a generation before, had seemed possible.

Visual poetics

The term 'poetical' is encountered in the third volume of *Modern Painters* where Ruskin posits it as being a property of visual, as well as literary, art:

Poetical feeling, that is to say, mere noble emotion, is not poetry. It
is happily inherent in all human nature deserving the name, and is
found often to be the purest in the least sophisticated. But the power
of assembling, by *the help of the imagination*, such images as will excite
these feelings, is the power of the poet, or literally of the 'Maker.'[8]

In reviewing Millais's *Autumn Leaves* (1855–56, Manchester City Art Galleries) (Figure 8.3), shown at the Royal Academy in 1856, in his *Academy Notes* for that year, Ruskin used 'poetic' to describe both the conception and execution of the work:

By much the most poetical work the painter has yet conceived; and also,
as far as I know the first instance existing of a perfectly painted twilight,
but to give the glow within the darkness is another matter; and though
Giorgione might have come near the glow, he never gave the valley mist.
Note also the subtle difference between the purple of the long nearer
range of hills, and the blue of the distant peak emerging beyond.[9]

The *Art Journal* critic, on the other hand, reviewing the same work at the same exhibition, took its several compositional elements as some kind of affront to common-sense as well as to the prevailing standards of beauty and good taste. The identification of a 'mystic poetry' in the work was certainly not to its credit:

This composition will, perhaps, be interpreted by the admirers of "pre-Raffaelite"
Art as an essential sign of the divine afflatus. It contains three figures [sic],—girls
with a heap of leaves before them, to which they have just set fire, as indicated
by the ascending smoke. Is it that here the painting will be as nothing—that these
withered leaves shall be read as a natural consummation, a type of death—that

8.3 John Everett Millais, *Autumn Leaves*, 1855–56, oil on canvas,
Manchester City Art Galleries

the human forms in their youth shall signify life, or will it be discovered that
the twilight of the day shall describe the twilight of the year? The three figures
represent, perhaps, priestesses of the seasons offering up on the great altar of the
earth a burnt sacrifice in propitiation of winter. In what vein of mystic poetry will
the picture be read? The artist awaits the assignment of the usual lofty attributes.
The work is got up for the new transcendentalism, its essences are intensity and
simplicity, and those who yield not to the penetration are insensible to fine Art.
Simply, there is a small society of young ladies busied in gathering and burning
withered leaves, a heap of which is piled up before them. There is no colour in
the picture, it is painted entirely for sentiment. Two of the figures are dressed
precisely alike, and all in a taste remarkably plain. The hair of each hangs most
unbecomingly about their ears and faces, and their features are devoid of all beauty,
and coloured into very bad complexion. Such is the picture as we see it. The leaves
are very minutely drawn. We had almost forgotten a significant vulgarism; it is,
that the principal figure looks out of the picture at the spectator. The look of the
lady in "Peace" [i.e. *Peace Concluded*] is also fixed on the spectator. We are curious
to learn the mystic interpretation that will be put upon this composition.[10]

For all the talk of vulgarisms, it is evident from this criticism that its author
has grasped Millais's intentions, however obscure and unfamiliar, and that

the ways of communicating his ideas through details and composition are challenging. But, for this critic, the conventions of academic art are contravened by Millais's painting and his stylistic innovations are mere obfuscations. Nevertheless, it is clear that *Autumn Leaves* was a pivotal work in advancing a new kind of relationship with poetry and, arguably, is Millais's supreme achievement in that manner. It is not a painting *about* poetry but it is productive of a kind of poetry or, perhaps more accurately, of some kind of poetic feeling in the way that Ruskin suggested. Millais is 'maker,' the artist who has assembled a painting akin to poetry which will, in Ruskin's words, 'excite these [poetic] feelings.' The notion of language and motif implied in the work are such that a critical response in the viewer is that of 'reading poetry' with all the implications such a concept has within a predominantly literary culture. While Rossetti is now recognized as the chief instigator of the new poetic painting in the 1860s and 1870s, Millais's experiment with arranging the landscape and figure motifs into a poetical composition are arguably more radical and, at the same time, more traditional than Rossetti's. Millais's attention to incidental detail and his intense observation of natural effects are held to be at odds stylistically with the absence of expression, the awkward grouping of the figures, and the lack of perspectival recession, all of which the *Art Journal* critic noted, if disapprovingly.

Autumn Leaves was suggestive for several works by Simeon Solomon and Burne-Jones a decade later. Paintings such as Burne-Jones's *Le Chant d'Amour* (1865, Museum of Fine Arts, Boston) or Solomon's *In the Summer Twilight* (Figure 8.2), which I discuss further below, make use of Millais's twilit background, his staring female figures, and his otherworldly or mystical atmosphere—of his 'poetic' effect, in other words. Indeed, they so extend Millais's pictorial vocabulary that it barely has the same function; they strove to render the 'strange' yet stranger.

Solomon is a particularly interesting figure to consider in the contexts of 'poetic' painting and its critical reception. Steeped in the conventions and characteristics of both Pre-Raphaelite and Aesthetic painting, his works often raised important questions as to the purpose—and therefore the 'meaning'—of the 'new' painting. He made a genuine and concentrated effort to move away from the formative realist-symbolism of the first phase of Pre-Raphaelitism to a more complete symbolic painting. When he is engaged in the former, as in *Poetry* (Figure 8.1), we see a strong relationship not only with Rossetti's female subject paintings of the late 1850s and 1860s but, significantly, with Millais's experimental works of the 1850s. Solomon's painting strongly locates ideas of beauty upon the face and upper body of a woman; the face, indeed, might 'stand in for' the other absent and unseen parts of the woman's body. His depiction of beauty is idiosyncratic, a quality in part due to the handling of paint, his emphasis being on the shadows cast by the features rather than their regularity or otherwise. Though a little clumsy, this effect heightens the sensitivity of the expression and distances the work from the conventional

beauties of Baxter prints or *Keepsake* illustration. The features are a little too large for the small face; the eyes are large and long, their size accentuating privacy and internality. The painter announces his seriousness both by the medium—the experimental type of watercolor practiced by Solomon, Rossetti, and Burne-Jones, and by the self-consciously primitive handling. These elements find their resting place in this pale, unusual beauty who sits in front of us but is unaware of her surroundings.

The confrontational regard of the woman is mitigated by the absence of expression. Pictorially the painting presents us with the disruption of the material and the immaterial—the everyday concreteness of the setting with the middle-class, even aspirational, objects and dress—and the origin of the sitter's abstraction—the open book. The motif is, to an extent, derived from Millais—the female subject, the dishevelled hair, the vacant expression, can all be found in *Autumn Leaves*. Their use here anticipates several works by Rossetti, such as the portrait of Jane Morris, *The Blue Silk Dress* (1866–68, Kelmscott Manor, Oxfordshire). There are shared compositional and thematic links, too, with Rossetti's later, more ambitious, subject works, *La Pia de' Tolomei* (1868–80, Spencer Museum of Art, University of Kansas) and *The Day Dream* (1880, Victoria and Albert Museum, London). Solomon's *Poetry* is something of an allegory—not a personification of the Muse of poetry but an embodiment of the internal reception of poetry, of the effects of the poetic. In this he differs from Rossetti, for *The Blue Silk Dress* seems more a homage to the sitter, Jane Morris, herself. Thus, while the painting is not a portrait, neither is it a heroic abstraction. It is, instead, an awkward, if intense, combination of two traditional modes. The intimacy of the portrayal emphasizes the privacy of the act of reading and its effects: dreaminess, almost complete self-abandonment. The rationality often ascribed to the iconography of reading is here supplanted by irrationality, an abandonment to fantasy or the imaginary. The materiality of the surroundings—flowers, pictures, Chinese ceramics—speak of the culture of the young woman, even as she is transcended into the immaterial realm of the imagination. Perhaps all of these attributes have helped in the passage to this realm, but it is poetry which finally delivers the female reader there. The sitter is not absorbed in reading—this is no homily upon female literacy—but absorbed by the fantasies produced by reading. The book is always unread by the viewer and can only be conjectured or imagined. The painting is, therefore, doubly about the imagination and the unseen. Further, the sitter's desires are forever withdrawn from us into blankness. Given Solomon's closeness to Swinburne at this date, we might conjecture that the text is related to Swinburne's poetic works. The model is depicted with her hair down, suggesting a similarity to Solomon's portrayal of Juliette, the Marquis de Sade's heroine, shown at the Royal Academy in 1863. Thus, the fantasies engaged in might be sexual in nature, the sitter's calm abstraction providing a disguise for a deep and moving sexual desire.[11]

Eccentricity and madness at the Dudley Gallery

As Rossetti's paintings were known only to a small circle in the 1860s and 1870s, the period in focus in this chapter, it was the artists he influenced, like Burne-Jones, Solomon, and Walter Crane, who attracted the greatest amount of invective in the contemporary press. It was not the Royal Academy which was to provide the focus for the widest discussion of 'poetic' painting, but rather the new alternative exhibiting venues. Solomon, for example, began his exhibiting career early—in 1858, aged 18, in a gallery in Pall Mall run by Ernest Gambart, the Belgian picture dealer. He showed two drawings there.[12] In the following year he made his debut at the Royal Academy with *Isaac Offered* (1858, current location unknown) but, although these ventures augured well for his future, there is no doubt that his career expanded with his connection with the Dudley Gallery. Other galleries which afforded alternative exhibiting space included the Berners Street Gallery and even the ostensibly traditional Old Watercolour Society where, in 1864, Edward Burne-Jones made his debut with *The Merciful Knight* (1863–64, Birmingham Museum and Art Gallery). Walter Crane remembered seeing it there:

We had a glimpse into a magic world of romance and pictured poetry, peopled with ghosts of 'ladies dead and lovely knights', a twilight world of dark mysterious woodlands, haunted streams, meads of deep green starred with burning flowers, veiled in a dim and mystic light, and stained with low-toned crimson and gold.[13]

It is significant that Crane's terminology draws upon the same set of references as the most adverse critics of the Pre-Raphaelites—medievalism and mysticism—and that the twilight effect, arguably Millais's most significant gift to the subsequent 'new painting' and his most poetic device, should be the binding agent of the diverse compositional and thematic elements Crane found in Burne-Jones. This repertoire of subjects, allusions, and effects shared by the new generation of Pre-Raphaelites became the focus of adverse criticism as the 1860s progressed.

The Dudley Winter Exhibition of watercolors first opened in 1864, but in 1867 added an annual exhibition of oil paintings to its schedule, inevitably placing itself in competition with the Royal Academy. The gallery was a hired suite of rooms at the Egyptian Hall in Piccadilly. It grew out of the shows held by Gambart, who rented rooms first in Pall Mall and then at the Egyptian Hall in the late 1850s for relatively small commercial exhibitions selling contemporary art. This impetus was taken up by a committee of artists and critics—W.S. Coleman, Henry Moore, Edward Poynter, Arthur and Walter Severn, and Tom Taylor—and their committee was augmented by the artists of the St John's Wood School. Several sets or cliques, therefore, were constituents of the Dudley, including that faction which Crane was to describe as the 'Poetry—without—Grammar' group.[14] The Dudley was unique in allowing

young, sometimes untrained, amateur artists to show their works alongside those of established artists. Many artists who later achieved some eminence either began or significantly extended their professional exhibiting careers there: Walter Crane, Luke Fildes, Edward Poynter, Robert Bateman, Marie Spartali, and Simeon Solomon among them. The gallery was particularly important in offering women artists the opportunity to exhibit their works, and the exhibitions helped augment those held by the Society of Female Painters; Rebecca Solomon and Florence Claxton, among others, showed there.

The *Art Journal* critic remarked that:

On entering the Dudley Gallery, the general impression is that the exhibition has achieved a decided success. The walls are hung with works which pleasantly meet the eye; an unusual variety of style, and even of subject, give to the room a lively and attractive aspect, while here and there a salient drawing, probably by some artist as yet unknown to fame, seems to tell of a new star above the horizon.

Despite some doubts about the exhibition's overall quality, the reviewer expressed some hope for future Dudley exhibitions by invoking the idea of poetic painting and, by implication, of a higher level of achievement: 'Still, if we mistake not, more than one poet found an advent in the opening of this wisely tolerant exhibition.'[15]

Walter Crane remembered this time as somewhat momentous: 'the opening of this Dudley Gallery General Exhibition was quite an epoch, and it was the means of bringing many new artists to the front and to recognition.'[16] Crane links this epoch to a new period in London's artistic life marked by the activities of bohemian art students and their masters and the liveliness of the studios of Bloomsbury, like those of Hamo Thornycroft or Simeon Solomon. Reviewing the Dudley Watercolour Exhibition in 1869, *The Times* noted many similar elements: the association of 'new painting' with design and particularly with the nascent Arts and Crafts Movement and the new theories of Aestheticism, as well as with the older Pre-Raphaelite Brotherhood. This critic saw that the poetic and prosaic, the ugly and the beautiful, were problematic categories for these young artists:

In the Dudley Gallery we look out for and find unhackneyed talents and unfamiliar styles. In the Dudley Gallery, as in other watercolour exhibitions, landscape has the predominance. Such figure drawings as there are belong most of them to the school which, for want of a better term, is often called 'Preraphaelite'; a more descriptive title would be 'Archaic', or 'Mediaeval' ... It is the outcome in painting of the influences which breed ritualism in worship, what has been called Mort d'Arthurism in poetry, and the worship of Gothic run mad in architecture. It is dear to the taste which installs itself wherever it can in mediaevally devised houses, fitted up with mediaeval chairs and tables, presses and cupboards, wall-papers, and window hangings, all 'brand new and intensely old'; which feeds its fancy on old pictures and old poetry, its faith on old legend and ceremonial, and would fain, if it dared, dress itself in the garb of the 15th century ... It numbers

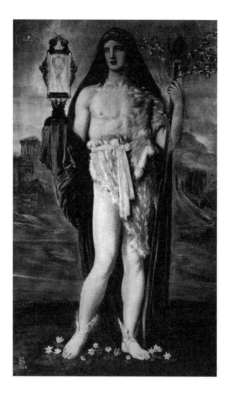

8.4 Frederick Hollyer, after Simeon Solomon, *Sacramentum Amoris*, photographic print, Victoria and Albert Museum, London

a few leaders of rare gifts and real imagination, but most of these only pass through the school. The minds which continue in it are of the weaklier and more effeminate order. Of the robust imagination which detects and developes [sic] latent beauty under the most unfavourable outward conditions of actual life this school shows no trace. It is helpless if denied its antique masquerading properties.[17]

The critic took issue not only with the general tendency of Dudley watercolor exhibitions towards medievalism, but also with Solomon's work, singling out:

'A Priest of the Eastern Church', a nude figure, in a fawnskin, bearing a transparent chalice enclosing a Cupid, called 'Sacramentum Amoris' [1868, current location unknown] [Figure 8.4], and a bevy of young men and maidens in the Watteauish costumes, in which Cosway and Battoni used to dress their sitters, grouped round a lady at the piano, with the title, 'A Song' ['A Prelude by Bach'].[18]

The language of criticism here blended aesthetic commentary with moralized disapproval:

All these drawings show the painter's strength and weakness—a rare sentiment of colour, determined affectation and mannerism, with a sickliness in the flesh tones, which is peculiarly unpleasant. The first is the tiniest. The harmony of the vestments of wrought gold brocade, the censer, and the black and gold background, with the deep-toned, but bloodless, face and black hair, is rich and satisfying. The drawing of the Bacchus, if Bacchus it be, who bears the chalice, is feeble, and the colour thin and poor. In the group round the singer, of which the colour is refined, but the arrangement affected, and *tableau vivant* like, all the heads are taken from one model—the same one who always serves Mr. Solomon, and has sat to him since we can remember.[19]

While the 1860s and early 1870s were important in establishing a growth market in contemporary art in England, it was a difficult time for English Pre-Raphaelitism, as several of my quotations have shown. Although we might have expected that the early vilification and derision of the group following its formation in 1848 had been abandoned, the emphasis in periodical criticism of the 1860s had moved away from the original members of the Brotherhood and onto more abstract and shifting categories of 'the Pre-Raphaelite' and 'Pre-Raphaelitism.' In a significant re-appraisal of Pre-Raphaelitism, the *Illustrated London News* claimed that in 1870:

the number of works (especially among figure-subjects) which, even to the most catholic taste, will appear eccentric or peculiar, is perhaps greater even than usual … The principal cause or source of these peculiarities appears to be a certain revived dilettanti spirit of mediaevalism, or revival of other later bygone sentiments, characteristics and styles. Many of the peculiarities are offshoots from almost forgotten pre-Raphaelitism; but instead of uniting (which was the professed object of that schism) primitive simplicity of feeling to modern scientific truth, the former is often regarded as all in all, or one particular quality of art is exalted at the expense of all others.[20]

The fear that the Dudley was harbouring a *new*—and more tendentious—school of Pre-Raphaelitism can be inferred from reading periodical criticism from around 1868 onwards. It is a fear compounded by the relative popularity of the new style not offset by the presence of elders and worthies—as it would have been at the Royal Academy—but undiluted. It is sufficient to quote briefly from two reviews from different periodicals to show that critics were united in their disapproval of Solomon, who was once regarded as a prodigy but who is now 'a genius of eccentricity.' These quotations both refer to the Dudley exhibition of 1868.

This style of art has its passionate admirers, and it is only because in most hands it degenerates into an unwholesome and mischievous eccentricity, which some enthusiasts have chosen to dignify as the mark of genius, that we thus point attention to it. It trusts to imitation of the weakness of immature art instead of impregnation with its spirit, and we fear that it is leading away many young artists who, better directed, might do good work.[21]

Eccentricity has always distinguished the Dudley Gallery. And what can be
more singular and abnormal than the productions—clever withal—of Simeon
Solomon [and] Spencer Stanhope … Solomon is a genius of eccentricity, he
can do nothing like other people, and in being exclusively like himself, he
becomes unlike to nature. As for choice of subject, most religions of the world
have struck by turns the painter's fantastic and splendour-loving fancy.[22]

We should note that the 'unlike to nature' might encode two different implied
failings in Solomon—that he does not measure up to the technical minuteness
of close observation of some of the leading Pre-Raphaelite painters, and that
somehow he, his art, and/or his demeanor do not conform to the acceptable
norms of contemporary society. Crucial here is the identification of a decadent
eccentricity, unmanly or effeminate in nature. The reviewer seeks to use
Solomon himself, rather than his work alone, as exemplary of the corruption
of a modern school of art. Notable in these reviews is a general tendency
to see certain choices of subject or color, or handling of paint, as uniting
unmanliness and eccentricity, suggesting a web of connections between a
kind of painting, a kind of personal sexuality, and even a kind of madness.
Solomon showed his watercolor *In the Summer Twilight* (Figure 8.2), a kind of
homoerotic and Sapphic restatement of Millais's *Autumn Leaves* (Figure 8.3),
at the same exhibition. Critics were clearly vexed by the poetic subject matter
and couched their criticisms in terms of personal abuse. The critic of the
Graphic found Solomon to be 'less outrageous in his notions, but still afflicted
with a mannerism which people of sense must wonder at:'

Here is evidently a fine mind full of fine power, and yet ludicrously
warped by pre-conceived whims and fancies … *In the Summer
Twilight*, is in a higher strain, and reaches even to beauty; but oh!
the excessive mannerism of it, and the morbidness of style.[23]

The advice meted out to the artist by the *Illustrated London News* is undisguised
abuse: '[Solomon has to] eschew the mawkish sentimentality so essentially
distinct from genuine poetic feeling and effeminate insanity which repel
healthy tastes from such drawings—realistic only in the matter of knee-
breeches.'[24] This critic strives to separate the 'genuine poetic feeling' from
Solomon's 'mawkish sentimentality,' while a term like 'effeminate insanity'
used as art criticism mimics that of a different discourse, a medical one, of the
study of mental disorder.

Henry Maudsley, the pioneer in the modern care of mental illness in
Britain, began to publish his first papers in the 1860s, which culminated in his
formative books of the early 1870s. In *Responsibility in Mental Disease* (1874)
Maudsley set out a diagrammatic concept of centric and eccentric spaces in
society in relation to mental health. His words here, too, relate the phenomenon
of 'eccentricity' to intellectual or artistic activities, to the origination 'of some
new thought or new thing in the world:'

There are antagonistic forces at work in the determination of the orbit of human thought as there are in the determination of the orbit of the planets—a centrifugal or revolutionary force working in the restraining influence of habit; the resultant of their opposing actions being the determination of the path of the evolution of mind. Add to the eccentric impulse the ardent enthusiasm and passionate energy with which a belief is maintained and propagated, the self-suffering faith which overcomes incredulity, gradually gaining disciples, and we have an explanation of the resemblance which has been noticed between the prophetic inspiration of genius and the mania of insanity. For the insane temperament may, according to the direction of its development, conduct its possessor to madness, or make him the originator of some new thought or new thing in the world; the faith and labour with which he labours in the achievement of his aim actually saving him from the madness which he might otherwise have suffered.[25]

Maudsley, however, is anxious not to confuse such eccentricity with a full-blown insanity, although he suggests a close, even developmental, relationship between the two states.

Those who devote themselves specially to the study or treatment of insanity are sometimes charged, not always unjustly, with the disposition to confound eccentricity with insanity, and to detect disease where persons not so biased fail to perceive anything abnormal. Eccentricity is certainly not always insanity, but there can be no question that it is often the outcome of insane temperament, and may approach very near to or actually pass into insanity.[26]

While eccentricity can be closely linked to madness—even found in family members where insanity is suffered by one member—its behavioural manifestation in, for example, religious enthusiasm, 'poetical delirium' or 'the eager advocacy of extreme social or political theories,' however 'sad, foolish or dangerous,' might act as a kind of safety valve: 'but for them, the result might unhappily be actual insanity. They are a vicarious relief, a sort of masked madness.'[27]

The various reviewers of the Dudley exhibitions, therefore, appear to reflect Maudsley's specific medical discourse, seeing the act of painting in relation to concepts of suspect genius and eccentricity. Particular configurations are seen as representing abnormal mental states. A specific medical meaning would appear to be implied in the constant reiteration of the term 'eccentric,' and the critic, in invoking it, can congratulate himself in his watchfulness on behalf of public morals and pictorial health. *The Times* was particularly alert in relation to the Dudley Winter exhibition of 1870:

While in no way disposed to deny due meed of merit, however shown, we believe it to be our duty, in the interest of good art no less than in that of healthy and manly sentiment, to protest against the principles and practices of this school, and to caution the Committee of the Dudley Gallery against what we cannot but call the visible tendency to give too many and too good places to its productions. It is of ill omen for the Exhibition that we come away

from it with almost a livelier impression of the deformities and caricatures of this kind upon its walls than of good, honest, healthy drawings.[28]

The critic suggested that a newly constituted selection committee should, in the future, 'take precaution against the predominance of any one school; and the aspect of this year's exhibition strongly suggests the conclusion that some precaution against the predominance of one school is necessary.' Solomon emerges as the paradigmatic figure upon whom the most vitriolic response is focused. In his work the critic discerned that 'a fine, if fantastic, sense of beauty, an almost passionate feeling of colour, and a powerful though usually morbid, imagination, are traceable through all that provokes protest and sins against propriety.' Finally, Solomon, like Swinburne in Alfred Austin's account, effectively stands accused of following an 'improper muse:'

The protest is uppermost before such drawings as, 'In the Summer Twilight' and, the 'Autumn' and 'Winter'. Any merit they may have is obscured by their sickly prurience. They correspond in painting to some of the most objectionable performances of Mr Swinburne in poetry ... Mr Solomon is an example of a clever artist misled or marred by offensive mannerism.[29]

The critical language is morally loaded, 'eccentricity' being only one of the charges. Other terms like 'affectation,' for example, are contrasted with 'manliness,' which is linked to a concept of healthiness and workmanship in the observation which followed, where Solomon is compared unfavorably with Poynter, one of his closest friends:

E.J. Poynter, A.R.A., may be claimed as a leader by the school of which Mr Solomon is the typical representative. But the claim is barred by the facts. A certain leaning to archaism and some proclivities to the eccentricity of that school may be traced in Mr Poynter's work, but these are quite overcome by his thoroughness of workmanship, care and power of drawing manliness of sentiment, and a healthy feeling for beauty, without sickliness, which give a value to his work in the eyes of all qualified to form a sound judgement.[30]

The gendered connotations of madness identified by Elaine Showalter in *The Female Malady* (1987) are given a different emphasis when this medicalized language (as noted in Maudsley's work) is used against a male artist, as it is in this *Times* criticism. In this context 'effeminacy' (as the product of 'eccentricity,' perhaps) might be evidence of a greater madness than female hysteria, connoting a voluntary abandonment of male rationality, control, professional standards, and access to success.[31] We can conjecture, however, that another factor in Solomon's work is being hinted at but is too difficult to confront openly, its advocacy of same-sex desire. The language for identification of such desire was yet to be formulated and, in these criticisms, in its place is a vocabulary of abuse. Swinburne's rejection of his former friend following the trial for indecency in 1873 points to the way in which such language could

be casually adopted. 'It is hideous to lose a friend by madness of any kind, let alone this.'[32] Even here, in a private exchange from one intimate friend to another, the 'let alone this' covers the actual fact of Solomon's sexual nature and replaces it with 'madness,' a word placed like a stone on the grave of the artist's career.

Towards the 'Fleshly School' controversy

The scholarly literature on Pre-Raphaelitism has tended to ignore anonymous periodical and other art journalism in favor of that by famous writers whose opinions have been anthologized, such as Robert Buchanan's 'The fleshly school of Poetry', first published anonymously in the *Contemporary Review* in 1871, and Swinburne's review of Solomon's *A Vision of Love Revealed in Sleep*, originally published in the Oxford University student periodical, the *Dark Blue*, in 1871. Yet periodical criticism is interesting for the very reason that the views were expressed to a wide audience composed of the general public and artists, both professional and amateur. It is illuminating to revisit, if briefly, both Buchanan and Swinburne in the context of the periodical criticism I have surveyed.

Buchanan, himself a poet, published his review under the pseudonym 'Thomas Maitland.' His essay is ostensibly about Rossetti's poetry and refers to the 'eccentricities of the Pre-Raphaelites.'[33] It makes clear connections between the 'new' poetry and painting, and between stylistic and thematic peculiarities and moral failings—indeed, one of the predominant images is of moral disease or, rather, of a kind of poetic disease that has had dire moral effects. Comparing Solomon and Rossetti, Buchanan finds them to be distinctive colorists but accuses Rossetti of an insanity similar to that found by periodical reviewers in Solomon and his Dudley Gallery works.[34] He observes of Rossetti that the qualities:

which impress the casual spectator of the photographs from his pictures, are to be found abundantly among his verses. There is the same thinness and transparence of design, the same combination of the simple and the grotesque, the same morbid deviation from healthy forms of life, the same sense of weary, wasting, yet exquisite sensuality; nothing virile, nothing tender, nothing completely sane; a superfluity of extreme sensibility, of delight in beautiful forms, hues, and tints, and a deep-seated indifference to all agitating forces and agencies, all tumultuous griefs and sorrows, all thunderous stress of life, and all straining storm of speculation.[35]

Solomon reappeared later in Buchanan's essay on Rossetti's poetry, but again only to reaffirm the unnaturalness, monstrosity, and nastiness of this outgrowth of Pre-Raphaelitism and to unite its pictorial and poetic branches:

... it is neither poetic, nor manly, nor even human, to obtrude such things as the themes of whole poems. It is simply nasty. Nasty as it is, we are very mistaken if many readers do not think it nice. English society of one kind purchases the *Day's Doings*. English society of another kind goes into ecstasy over Mr Solomon's pictures—pretty pictures of morality, such as 'Love dying by the breath of Lust'. There is not much to choose between the two objects of admiration, except that painters like Mr Solomon lend actual genius to worthless subjects, and thereby produce veritable monsters ...[36]

Perhaps the subsequent notoriety of this criticism derives from its length rather than its content (Buchanan's text was 16 pages long) since 'The fleshly school' simply extends and elaborates the language of the adverse Dudley Gallery reviews of the 1860s. Swinburne's 'Notes on *A Vision of Love* and other studies' reads either as a kind of parody of Buchanan's objections or as a deliberate intensification of the periodical reviews in their hostility to Solomon's 'eccentric' tendencies. Although he alluded to the artist's current reputation and reception from 'unskilled and untrained judgements,' it was a feint protest, its perceptions lost in a welter of alliteration and hyperbole:

All great and exquisite colourists have a mystery of their own, the conscience of a power known to themselves only as the heart knows its own bitterness, and not more communicable or explicable. In this case the pictorial power is so mixed with personal quality, so informed and suffused with a subtle energy of sentiment, that a student from without may perhaps be able to note, not quite inaccurately or unprofitably, the main spiritual elements of the painter's work. In the work of some artists the sentiment is either a blank or a mist; and none but technical criticism of such work can be other than incompetent and injurious. The art of Mr. Solomon is of a kind which has inevitable attraction for artists of another sort, and is all the more liable to suffer from the verdicts of unskilled and untrained judgements. But an artist of his rank and quality has no need to cry out against the rash intrusion of critical stragglers from the demesne of any other art. He can afford the risk of such sympathies, for his own is rich in the qualities of those others also, in musical and poetic excellence not less positive than the pictorial; and as artist he stands high enough to be above all chance of the imputation cast on some that they seek comfort in the ignorant admiration and reciprocal sympathy of men who cultivate some alien line of art, for conscious incompetence and failure in their own; fain to find shelter for bad painting under the plea of poetic feeling, or excuse for bad verse under the plea of good thought or sentiment. By right of his innate energies and actual performances, he claims kinship and alliance with the foremost in all fields of art, while holding in his own a special and memorable place.[37]

Swinburne's review constantly sees the art of Solomon in relation to poetry, recognizing, indeed, almost no distinction between the two forms and implying a new dependency between them. He notes that his own poem 'Erotion' was written in response to Solomon's picture of that name. Yet his review never refers to Pre-Raphaelitism as a movement or as the name of a style or ideology, and in this it contrasts with Buchanan and the anonymous newspaper and periodical reviewers who preceded him. Perhaps because

Swinburne was a part of the circle of artists so frequently vilified by the press, he himself could not use the term abusively (or even, perhaps, in praise).

Both Buchanan's and Swinburne's critiques are, to an extent, valedictory: they mark the beginning of the end of Solomon's public career. Swinburne notes, almost prophetically, that:

Withdrawn from the roll of artists, his name would leave a void impossible to fill up by any worthiest or ablest substitute; by any name of master in the past or disciple in the present or future. The one high test requisite for all genuine and durable honour is beyond all question his; he is himself alone, and one whose place no man can take.[38]

Conclusion

Periodical criticism of the 1860s had developed a language with which the 'new' painting could be vilified. It did so by identifying a gallery, the Dudley, and an individual painter, Simeon Solomon and his paintings. More generally, it characterized Pre-Raphaelitism as a suspect force in English painting. Twenty years later, in the 1880s, the term 'poetic' had clearly become part of an amateur's Aesthetic vocabulary. In 1881 the *Magazine of Art* satirized the latest 'art talk' in London's most fashionable gallery. 'At the Grosvenor they hear four phrases, which are used indiscriminately for all the pictures—poetic, imaginative, creative, and decorative.'[39] Of these 'four phrases,' poetic is the most culturally over-laden. The term—like other favored current critical terms such as 'intense' and 'mysterious'—may have consolidated its popularity following the success of Pater's *Studies in the History of the Renaissance*, which was published in a single volume in 1873 but had its origins in his earliest periodical essays of the 1860s. Pater observed that Botticelli was 'before all things a poetical painter, blending the charm of story and sentiment, the medium of the art of poetry, with the charm of line and colour, the medium of abstract painting. So he becomes the illustrator of Dante.'[40] Pater is both subtle and reductive here; he implies, nevertheless, that poetic painting is temperamental before it is illustrative in impulse. Pater's practice as an art critic, rather than as a historian of art, derived from his interest in poetics; the 'introduction' to the *Renaissance* grew from his periodical review of William Morris's poems. His consideration of poetry ranges from French twelfth-century romances to Michelangelo's sonnets, and is further extended to Winckelmann and, by implication, to Pater's own poetic encapsulation of Winckelmann's ideas. As Horace's *Ars Poetica* is not solely about poetry but also about the arts generally, so Pater's *Renaissance* is not solely about the visual arts but also about poetry as a central feature of artistic practice.

Paterian, poetical Aesthetic criticism offered a vocabulary for the discussion and assessment of art in the closing decades of the nineteenth century. It

was challenged in theories of decadence and degeneration suspicious of the Aesthetic, such as Nordau's critique with which this chapter opened. Oscar Wilde and others took up Pater's apologia for the poetic centrality of the visual arts, but it was powerless in the face of a popular, highly transmitted critical language which encoded the suspicions of a class and its preoccupation with normalcy and orthodoxy. Ultimately, it fell victim to the same forces that ended Solomon's career and which made him, a generation later, a touchstone for a more clearly stated 'gay sensibility' in English culture.

Notes

1. Max Nordau, *Degeneration*, London: William Heinemann and New York: D. Appleton, 1895, translated from the second edition of the German work, Book 2, p. 94. For a discussion of the effects of categorization of the feeble mind in England, see Mark Jackson, *The Borderland of Imbecility: Medicine, Society and the Fabrication of the Feeble Mind in Late Victorian and Edwardian England*, Manchester: Manchester University Press, 2000.

2. For a discussion of the role of periodicals and criticism, see Laurel Brake, *Subjugated Knowledges*, Basingstoke and London: Macmillan & Co., 1994. For discussions of some of the wider debates around the newly recognized importance of the visual arts, see George P. Landow, '"There began to be a great talking about the fine arts",' in Josef L. Altholz (ed.), *The Mind and Art of Victorian England*, Minneapolis: University of Minnesota Press, 1976, pp. 124–45.

3. For a discussion of the Rossetti–Swinburne friendship, see, for example, Elizabeth Prettejohn, *Rossetti and His Circle*, London: Tate Gallery Publishing and New York: Stewart, Tabori & Chang, 1997.

4. Isobel Armstrong, *Victorian Scrutinies*, London: Athlone Press, 1972, p. 2.

5. [Alfred Austin], 'The poetry of the period: Mr Swinburne,' *Temple Bar*, 26, July 1869, 457.

6. *Ibid.*, 467–8.

7. *Ibid.*, 469.

8. John Ruskin, *Modern Painters III*, in *The Works of John Ruskin*, eds E.T. Cook and A. Wedderburn, 39 vols, London: George Allen and Sons and New York: Longmans, Green & Co., 1903–12, vol. 5, p. 29 (Ruskin's emphasis). Ruskin here appears to be playing with the obsolete word, from Middle English, 'maker' meaning poet, but the etymological root he hints at might be the Greek verb *poieo*, to make, with its variable meanings of creating poetry.

9. John Ruskin, *Academy Notes*, 1856, in *The Works of John Ruskin*, vol. 14, pp. 66–7.

10. 'The Royal Academy. Exhibition The Eighty-Eighth: 1856,' *Art Journal*, June 1, 1856, 171.

11. Several reviewers mistook Solomon's Juliette for Shakespeare's heroine Juliet when the painting was first exhibited at the Royal Academy. For example, 'Mr Solomon's "Juliette", 508, is designedly as far from Shakespeare's ideal as is the Juliet of Mr Frith' according to the *Guardian*, June 24, 1863, 582.

12. Jeremy Maas, *Gambart: Prince of the Victorian Art World*, London: Barrie and Jenkins, 1975, pp. 127–8.

13. Walter Crane, *An Artist's Reminiscences*, London: Methuen, 1907, p. 84. Crane's first exhibited work at the Dudley was a painting called *Twilight* (exh. 1866, current location unknown).

14. *Ibid.*, p. 84.

15. 'General Exhibition of Water-Colour Drawings,' *Art Journal*, April 1, 1865, 110.

16. Crane, *An Artist's Reminiscences*, p. 85.

17. *The Times*, February 15, 1869, 4.

18. *Ibid*. The possibility that *Sacramentum Amoris* disappeared as early as 1869 is discussed by Roberto Ferrari in his essay, 'Pre-Raphaelite patronage: Simeon Solomon's letter to James Leathart and Frederick Leyland,' in *Love Revealed: Simeon Solomon and the Pre-Raphaelites*, exh. cat., ed. Colin Cruise, London and New York: Merrell in association with Birmingham Museums and Art Gallery, 2005, pp. 47–55.

19. *The Times*, February 15, 1869, 4.

20. 'Fine Arts General Water-colour Exhibition,' 56, *Illustrated London News*, February 12, 1870, 181.

21. *The Times*, February 4, 1868, 4.

22. 'The Fourth General Exhibition of Water-Colour Drawings. Dudley Gallery,' *Art Journal*, 1865, 45.

23. *Graphic*, February 12, 1870, 247.

24. *Illustrated London News*, February 12, 1870, 182. The critic is here referring to *In the Summer Twilight*.

25. Henry Maudsley, *Responsibility in Mental Disease*, London: Henry S. King and New York: D. Appleton & Co., 1874, pp. 54–6.

26. *Ibid*., pp. 55–6.

27. *Ibid*., p. 270.

28. 'Dudley Gallery Water-Colour Exhibition,' *The Times*, February 14, 1870, 4.

29. *Ibid*.

30. *Ibid*.

31. See Elaine Showalter, *The Female Malady: Women, Madness and English Culture 1830–1980*, London: Virago, 1987, especially chapter 4, which deals with the impact of Maudsley's work and ideas. Jenny Bourne Taylor notes the use of eccentricity to connote mental instability in her critical edition of Wilkie Collins's sensation novel, first published in 1875, *The Law and the Lady*, Oxford: Oxford University Press, 1992.

32. Swinburne to George Powell, June 6, 1873, in *The Swinburne Letters*, ed., C.Y. Lang, 6 vols, New Haven: Yale University Press and London: Oxford University Press, 1959–62, vol. 2, p. 253.

33. Thomas Maitland [Robert Buchanan], 'The fleshly school of poetry: Mr D.G. Rossetti,' *The Contemporary Review*, 18, October 1871, 342.

34. In this respect, however, Buchanan anticipates Pater's suggestion, aired in his essay on Rossetti, about poetry as a *mania*: 'one of Plato's two higher forms of "divine" mania has, in all its species, a mere insanity incidental to it, the "defect of its quality", into which it may lapse in its moments of weakness; and the insanity which follows a vivid poetic anthropomorphism like that of Rossetti may be noted here and there in his work, in a forced and almost grotesque materialising of abstractions, as Dante also became at times a mere subject of the scholastic realism of the Middle Age.' Walter Pater, 'Dante Gabriel Rossetti,' in *Appreciations: With an Essay on Style*, 1889, library ed., London: Macmillan & Co., 1915, p. 209. The essay was written in 1883. Both may have had in mind and may have been playing variations upon Aristotle's observation in the *Poetics* that 'poetry is the work of a genius rather than of a madman; for the genius is by nature adaptable, while the madman is degenerate.' See D.A. Russell and M. Winterbottom (eds), *Classical Literary Criticism*, rev. ed., Oxford: Oxford University Press, 1989, p. 72.

35. Thomas Maitland, 'The fleshly school of poetry,' 338.

36. *Ibid*.

37. A.C. Swinburne, 'Simeon Solomon: notes on his "Vision of Love" and other studies,' *The Dark Blue*, 1 (5), July 1871, 576–7.

38. *Ibid*., 577.

39. Reprinted from *The Magazine of Art*, 1881, in Bernard Denvir, *The Late Victorians: Art, Design and Society 1852–1910*, London: Longmans, 1986, p. 227.

40. I quote from the fourth edition as reproduced in Walter Pater, *The Renaissance: Studies in Art and Poetry*, reprint of the 1893 text, edited with textual and explanatory notes by Donald L. Hill, Berkeley: University of California Press, 1980, p. 40.

Exhibiting the avant-garde: the development of the Pre-Raphaelite 'brand'

Matthew Plampin

This chapter will explore the choices made by Pre-Raphaelite painters regarding the exhibition of their work, from Dante Gabriel Rossetti's submission of *The Girlhood of Mary Virgin* (1848–49, Tate, London) to the Free Exhibition in 1849, to Ford Madox Brown's one-man show of 1865. It will discuss the assumptions and agendas which lay behind the decisions that were made; the mesh of paradigms which governed how these artists saw themselves and their productions and wished their peers, critics, and public to see them; and the unique status held by practitioners of Pre-Raphaelitism in a rapidly evolving art world. The group emerged as the status of paintings as luxury commodities in a developed capitalist marketplace was becoming firmly established, and both demand and the prices involved were rising exponentially. Study of the Pre-Raphaelites' adaptation to this changing situation will form the core of this piece. Their challenge to the art establishment will be interpreted as a calculated rebellion that was as concerned with commercial interests as aesthetic and moral principles. The rush of publicity which surrounded the initial 'Pre-Raphaelite controversy' was built upon in distinct ways by the different painters of the movement, but each displayed an awareness of the need for self-promotion which ensured their enduring prominence in an increasingly competitive market.

The 'strategic use of scandal'

Pre-Raphaelitism is often understood as an avant-garde movement;[1] recent critical definitions of the avant-garde which stress its 'civil disobedience in the face of an assumed consensus of values' seem to support this identification.[2] For the Pre-Raphaelites, this 'consensus' found embodiment

UNIVERSITY OF WINCHESTER
LIBRARY

in the Royal Academy of Arts (RA); the movement had been formulated in conscious opposition to the practices and principles of that institution and its membership. They noted almost with satisfaction the vitriol with which their paintings were received by certain academicians,[3] and they saw the virtues of their style as being thrown into sharp relief through contrast with the more conventional pictures of the annual summer exhibition.[4] Essential to this stance was continual reference to their 'special' or 'superior' position in society. This concept, classical in origin, had been revived and adapted first in the Renaissance and then again in the Romantic era; it identified the artist as a profoundly important figure, who had an almost mystical access to intense feelings.[5] Accordingly, during the 1850s, the Pre-Raphaelites tended to view themselves as misunderstood geniuses, bold, honest innovators whose deeply prescient work was neglected and abused by a jealous, moribund establishment—a self-image which received frequent articulation.[6] The RA, as the prime manifestation of this loathed establishment, even became the site for displays of very 'artistic' anger. Both John Everett Millais and Ford Madox Brown were alleged to have thrown tantrums in the summer exhibition over their treatment by the hangers. The former, according to Dante Gabriel Rossetti, 'yelled for several hours' in 1855,[7] whereas the latter, in 1852, was said to have turned away from the display 'in speechless indignation and walked out of the building.'[8] The reason for these protests was the same—the poor positions they believed had been given to their pictures on the Royal Academy walls—but the ultimate results, as will be discussed later in the chapter, were somewhat different.

In his analysis of the Baudelarian flâneur, Walter Benjamin assigns an economic motivation to the mid-nineteenth-century avant-garde. He writes that 'in the flâneur, the intelligentsia sets foot in the marketplace—ostensibly to look around, but in truth to find a buyer.'[9] Recent historians have developed this notion, arguing that the figure of the avant-garde artist appeared in Europe just as the production of art 'was beginning to be regarded as just one of a number of kinds of commodity production;' it was a 'reaction' to the artist's changing economic position in industrial society, intended to attract the attention of clients.[10] The Pre-Raphaelite rebellion can thus be seen to have had a pronounced economic aspect, of which the artists themselves were fully aware. In 1851, for example, Millais wrote to Mrs Thomas Combe of a potential patron:

Putting aside the good work of purchasing from those who require encouragement, such patrons will be respected afterwards as wise and useful men amongst knavish fools who should be destroyed in their revolting attempts to crush us—attempts so obviously malicious as to prove our rapid ascendancy. It is no credit to a man to purchase from those who are opulent and acknowledged by the world, so your friend has an opportunity for becoming one of the first-named wise patrons who shall, if we live, be extolled as having assisted in our (I hope) final success.[11]

Millais here carefully presents Pre-Raphaelitism as a worthy battle against forces of malevolent, ignorant complacency, which an open-minded patron should find both ideologically and commercially appealing. His words propose another concept found in modern definitions of the avant-garde, that of the artist's perception of an audience divided into 'empathetic' and 'alien' factions; the first counteracts the effect of the second, and encourages the artist to persist on his or her path of non-conformity.[12] This idea, as I will argue later in the chapter, was an influential factor in the Pre-Raphaelites' decisions regarding exhibition.

After the revelation of meaning of the mysterious initials 'PRB' and the Royal Academy exhibition of 1850, which included Millais's notorious *Christ in the House of His Parents* (1849–50, Tate, London),[13] the Pre-Raphaelite Brotherhood (PRB) attained, in the words of William Bell Scott, 'immediate notoriety.'[14] The young painters, suddenly famous, began to attract curious patrons from all over the country and beyond.[15] William Holman Hunt would later present as risible the idea that 'our object was to attract great attention to ourselves by our extravagant work,'[16] but the publicity value of the Pre-Raphaelite controversy for those involved was both undeniable and enormous. The idea of the 'Brotherhood' provided a focus for public attention, with people either being appalled or attracted by its suggestion of concerted insurrection. Brown's refusal to join up and 'play the fool,'[17] as he put it, indicates that for some the PRB had taken on the aspect of a blatant publicity stunt, with membership involving being held up for public amusement and ridicule.

Modern marketing theorists such as Jonathon Schroeder have looked to nineteenth-century avant-garde exhibition practices for precedents of a tactic encountered all too often in twenty-first-century advertising, which he terms the 'strategic use of scandal.' Orientating his discussion around Edouard Manet's exhibition of the heavily censured *Olympia* at the Paris Salon in 1863, Schroeder argues for the utility of controversial publicity surrounding images in 'building brand recognition.'[18] This certainly proved to be the case for the Pre-Raphaelite Brotherhood and Pre-Raphaelitism in general; it became one of the most recognizable 'brands' in mid-Victorian art, loaded with preconceptions and associations, which were instantly accessible to anyone with even a passing interest in painting. In 1850, the fascination with the Brotherhood was intense—William Michael Rossetti noted that it was 'one of the topics of the season'[19]—but there were longer term ramifications also. An issue had been created that would effectively divide the British art world for years. At the end of the 1850s, according to Elizabeth Prettejohn, 'the most reliable way to establish a distinctive critical voice' was still 'to adopt an aggressive stance for or against Pre-Raphaelitism;'[20] and even decades later, the 'brand' was seen to encompass paintings which were far removed from the movement's original tenets.

In search of empathy: the Academy and beyond

A vital event for the Pre-Raphaelite 'brand' in the years immediately following the initial 'scandal' that surrounded its creation was its annual confrontation with the RA at the summer exhibition. Hunt and Millais exhibited all of their major work there and took pride in its inflammatory character; in late 1854, for example, Hunt remarked to Thomas Seddon of his recently completed *The Scapegoat* (1854–55, Lady Lever Art Gallery, Port Sunlight, Merseyside) that it 'has that aspect which cannot fail to attract attention in an Exhibition.'[21] The establishment had ways of combating this avant-garde invasion. There was outright rejection, of course, but to the first generation of Pre-Raphaelite painters a more vexatious problem was that of hanging. As mentioned above, Brown was a particular victim of the practice of 'skying' pictures on the walls at Trafalgar Square. In 1851, he wrote to Lowes Dickinson that his *Seeds and Fruits of English Poetry* (1845–51, Ashmolean Museum, Oxford) had been 'placed too high, and shone all over, which hurt it,'[22] and his storming out of the building the following year, after turning his back on prominent academician and future president Francis Grant, was provoked by the similar treatment of *Jesus Washing Peter's Feet* (1852–56, Tate, London). Having refused to become a part of the 'Brotherhood,' his profile was markedly lower than that of Hunt or Millais, but these artists also found cause to complain about what Hunt would later call 'the determined bitterness of the Academy.'[23] He told Seddon that he expected *The Scapegoat* to be mistreated: 'The hangers are glad to find any excuse for putting it in a bad light, and then such a work finds double enemies. Surely you have had many examples of this before your eyes for the last few years and the consequences are not enviable in any.'[24]

Poor placing at the Royal Academy exhibition was thus regarded as something that could actually have a deleterious effect on an artist's career. For a Pre-Raphaelite there was an additional dimension: this situation amounted to a humiliating public disciplining of the 'disobedient' avant-garde artist, an effective quelling of the rebellion and subordination of its participants to the value judgements of the establishment. Millais, who can perhaps be said to have had a somewhat different long-term agenda to his fellow Pre-Raphaelites, confronted the Academy over this issue; his case will be studied in more detail later. The others, however, preferred to seek exhibition elsewhere.

The first Pre-Raphaelite painting to be shown in public, Rossetti's *The Girlhood of Mary Virgin*, was not shown at the RA at all; it was placed instead at the Free Exhibition of 1849, held that year at St George's Place, near Regent Street. Rossetti's decision to submit there was taken without consulting his 'brethren,' and has been portrayed by them as an impulsive and even cowardly choice,[25] as rather than being judged by a committee on the basis of merit, such as at the RA, painters approaching 'The Free' could simply buy themselves sufficient wall space, and then arrange their works as they

pleased.[26] From a promotional point of view, however, it can be seen as a well-considered, if opportunistic move. 'The Free' was a second-tier venue; most of those who contributed had little chance of attaining any success, as the *Art Journal* put it, 'through the ordinary channels of exhibition.'[27] Rossetti's picture, although modest in size, thus attained an immediate prominence and a positive reception.[28] This helped to lay the foundation for the Rossetti 'myth' developed over the years that followed, as the artist himself became increasingly reclusive; there was a widespread (and very Romantic) belief that the movement was directed from the shadows by a presiding genius, whose own work, seen by only a select few, was the very pinnacle of the movement. In part, this 'myth' enabled Rossetti to survive in the following decades without the regular public exhibition which was vital to other artists; it also meant that he was regularly attacked (and therefore publicized) in the press during the period of the 'scandal,' despite the fact, observed acerbically by Brown, that 'he had done *nothing* to merit it.'[29]

The Free Exhibition, which was renamed the National Institution in 1850,[30] was favored by several less prominent Pre-Raphaelite painters as well. James Collinson and Walter Deverell both showed paintings there,[31] as did Brown, who also, in 1848, almost became involved in its administration.[32] His pictures, by his account at least, were well received, perhaps, like Rossetti, due to a qualitative gulf between them and much of the rest of the display; certainly the price he set for the *Wycliffe* (1847–48, repainted 1859–61, Bradford Art Galleries and Museums) in 1848 was far beyond that of anything else present.[33] Unlike Rossetti, however, Brown did not succeed in selling any pictures at 'the Free,' and soon abandoned sending paintings there.[34] Brown's diaries from the 1850s record a grinding and very un-Romantic poverty, and his exhibition strategy, if it can be so described, was simply a desperate search for a venue that would accept his work, display it satisfactorily, and thus give it some chance of selling. Fruitless submissions were made to other metropolitan galleries, including the Winter Exhibition at the British Institution (BI) on Pall Mall. It was, like the Free Exhibition, inferior to the Royal Academy rather than a true alternative to it, a place for 'second division' artists to eke out their livings,[35] and where more famous painters might send low-quality works in the hope of a quick sale on the basis of their names. Millais used the BI in 1847, at the very outset of his career, but his rapid ascent to fame and fortune made any return unnecessary.[36] Brown had made similar early applications there,[37] but lacking the renown that their publicized transgression had brought the Pre-Raphaelite Brotherhood and having renounced the Academy after its 'skying' of *Jesus Washing Peter's Feet*, financial desperation forced him back in the mid-1850s. He submitted *An English Autumn Afternoon* (1852–54, Birmingham Museum and Art Gallery) in 1854, which turned out to be a doubly unfortunate move, as not only did it fail to sell, it also sparked off the mutual and enduring animosity between Brown and John Ruskin.[38]

This enmity cost Brown both publicity and private customers. Ruskin's high-profile support had become a crucial (if problematic) part of the Pre-Raphaelite 'brand.' During the early 1850s, a time when their opponents were attempting to dismiss Pre-Raphaelite paintings as grotesque, evanescent absurdities, Ruskin repeatedly stressed their serious intellectual aspect. He located their creators prominently in his progressive interpretations of art history, citing them, for example, as modern practitioners of a 'stern' and 'daring' naturalism equivalent to that which had effectively begun the Renaissance in thirteenth-century Italy. Their rebellion, Ruskin asserted, was one of 'truth against tradition;'[39] like his great idol, Turner, they had 'defied all false teaching,' and thus elicited the dismayed 'shrieking' of the art establishment.[40]

Ruskin's involvement with Pre-Raphaelitism has been understood, by both his contemporaries and in more recent writing, as the effective legitimization of a rogue movement, which made it acceptable both commercially and critically.[41] Ruskin himself was far from a mainstream figure, however; although he appealed to a mass readership, his critical approach, as George Landow has argued, was predominantly polemical.[42] Like the Pre-Raphaelites, he viewed his work as a challenge to stale, meaningless aesthetic traditions. He deliberately courted controversy, acquiring a reputation that sold books and won him both admirers and enemies. By May 1851, when Ruskin wrote to *The Times* to defend the Pre-Raphaelite pictures in that year's RA exhibition, he was a potent avant-garde 'brand' in his own right. The Pre-Raphaelites appreciated the promotional value of his involvement, Rossetti noting in 1853 that 'anything he says in favour of one's work is of course sure to prove invaluable in a professional way,'[43] but 'the great Ruskin' was not content simply to admire the artists he had adopted.

Central to the Ruskin 'brand' was his absolute belief in his own critical authority. He attempted to 'improve' Pre-Raphaelitism, to make it strive for conformity with his own particular vision of artistic perfection. Part of his 1851 defense of the movement was that it was 'incomplete,'[44] the clear implication being that his supervision was needed to bring it to true greatness. The close mentoring Ruskin favored, however, proved incompatible with the defiant self-image of the avant-garde artist, which he had himself admired. The eventual results could be described as the product of a 'brand' conflict, as Ruskin's own teaching was effectively rejected as 'false.' His attempted guidance of Millais famously ended in a dramatic personal rupture, and a shift in stylistic direction for the painter. Rossetti, who was next in line, endured Ruskin for longer as he was a good source of private patrons, but he found the critic's attentions vexatious nonetheless.[45] By the end of the 1850s, Hunt and Millais were entirely independent of Ruskin, even hostile towards him, with the latter especially keen to stress the distance between their aesthetic philosophies.[46] This hostility, shared by Brown, can be seen as

a manifestation of what Donald Kuspit has described as the 'anti-criticism' stance of avant-garde artists; secretly desiring legitimacy, they harden themselves towards the critic who mixes praise, or 'empathy,' with fault-finding (as Ruskin certainly did), thus continually making the artists aware of their own uncertainty.[47] They preferred to seek the more unqualified approval that could be attained in the saleroom.

The Pre-Raphaelites' quest for sales led them to seek exhibition beyond the metropolis. Brown, in particular, pursued from 1850 what Ford Madox Ford termed 'a policy of decentralisation,' sending his works to as many provincial galleries as practically possible.[48] Most notable among these for Brown, and indeed Pre-Raphaelitism as a whole, was the annual exhibition of the Liverpool Academy. It was here that the movement can be said to have found its first 'empathetic' audience. In 1851, Hunt's *Valentine Rescuing Sylvia from Proteus* (1851, Birmingham Museum and Art Gallery), which had been returned unsold from the RA, became the first Pre-Raphaelite painting to be shown in Liverpool, and it won the £50 prize awarded by the Academy council; he stated in his autobiography that this 'was greatly encouraging not to me alone but to the whole of our circle.'[49] Between 1851 and 1858, the prize was given twice each to Hunt, Millais, and Brown, and honorable mentions were given to Pre-Raphaelite sympathizers such as Mark Anthony and William Dyce.[50] Kuspit writes that the avant-garde artist needs the 'empathetic' audience to 'bespeak his or her own sense of potential.' He argues that this audience provides a sense of 'legitimacy' that might be 'secretly desired' by the artist.[51] There can be little doubt that the Pre-Raphaelites desired the 'legitimacy' represented by the Liverpool prize; Brown extensively re-worked the 1856 prize winner, *Jesus Washing Peter's Feet*, even clothing the upper part of Jesus' torso in order to ensure that the picture stood the best possible chance of securing the award.[52]

The 'alien' audience was not entirely absent in Liverpool. Hunt later recalled that after his submission of *Valentine Rescuing Sylvia from Proteus*, 'I almost daily received anonymous letters and newspapers from the Mersey city with every variety of abuse of my picture, both in prose and doggerel.'[53] In 1857, the award of the prize to Millais's *The Blind Girl* (1854–56, Birmingham Museum and Art Gallery) caused a sensation similar to the original Pre-Raphaelite 'scandal' in 1850. The Academy was so deeply divided on this issue that a proportion of its members left in order to establish the Society of Arts, a separate, anti-Pre-Raphaelite organization.[54] This only strengthened the resolve of the 'empathetic' faction, who proceeded to give the following year's prize to Brown's *Chaucer at the Court of Edward III* (1856–68, Tate, London), but this was the last time a Pre-Raphaelite would win. Nonetheless, several important northern contacts were fostered through the Liverpool Academy, most notably the Scottish tobacco merchant John Miller. Miller had lent *The Blind Girl*, having bought it at the Royal Academy in 1856, and

he continued to purchase works by Millais and Hunt;[55] he was also centrally involved in the next form of Pre-Raphaelite exhibition to be discussed here.

Private clubs and public exhibitions

As early as 1851, certain Pre-Raphaelites were considering an institutional as well as an artistic challenge to the authority of the RA, by the establishment of their own exhibition venue.[56] Hunt became one of the most enthusiastic advocates of this cause in the first half of the decade, writing to Seddon of his desire to become an 'active rebel,'[57] and telling Brown (who he viewed as his natural ally in this matter) of his notion that:

> ... long before you, Gabriel or I are elected associates of the highly
> honoured and esteemed Royal Academy, it will be necessary for us to
> consider whether we prefer having our pictures hung out of sight in that
> institution, or taking measures for their better exhibition elsewhere.[58]

Nothing happened, however, until 1857, when a particularly bad year at the RA prompted the staging of an exhibition at Russell Place in London. The painters were supported in this venture by the various allies they had made in the north of England and particularly by Miller, who secured loans from others, provided items from his own collection, and gave copious advice. He instructed Brown, who was one of the principal organizers, only to hang 'first rate' art, restricting the number of works included and thus making the exhibition 'the reverse of the Royal Academy both in quality and quantity.'[59] 'Our little exhibition,'[60] as Dante Gabriel Rossetti described it, led to the foundation of the Hogarth Club the following year, which was dedicated to the display of recent works by its artist members, thus creating an independent Pre-Raphaelite exhibiting institution.

These venues provided a forum for debate within the Pre-Raphaelite circle. Deborah Cherry has argued that the exhibitions in the Hogarth were partly designed to emphasize the changes that had occurred in the movement; the second exhibition in the summer of 1859, for example, juxtaposed Hunt's *Valentine Rescuing Sylvia from Proteus*, which demonstrated the tight handling of the early PRB style, with Henry Wallis's recent and far more loosely painted *The Stonebreaker* (1857–58, Walker Art Gallery, Liverpool).[61] Rossetti also contributed to both the Russell Place and the Hogarth Club exhibitions, rare appearances that actually managed to enhance his 'myth' rather than diminish it; the appearance of *Bocca Baciata* (1859, Museum of Fine Arts, Boston) at the third Hogarth exhibition in the spring of 1860 clearly showed the distance that now lay between him and his one-time 'brethren.'[62] A possible reason for the otherwise recalcitrant Rossetti's willingness to display his work in these exhibitions is that, despite their initial intention to rival and surpass the RA,

neither was open to the public. They were in fact decidedly exclusive, entrance being permitted by invitation only at Russell Place and by member's ticket at the Hogarth Club. These members were divided into three subscription classes, 'resident artistic,' 'non-resident artistic,' and 'non-artistic,' categories which clearly indicate the connections the club was trying to strengthen between London and the provinces, and between artists and their patrons.[63] The main purpose of these events was to introduce new clients to painters in a controlled environment based on the exclusion of any wider, and therefore possibly 'alien,' audience. Their openly commercial character sees the Pre-Raphaelites, like Benjamin's flâneur, making the search for a buyer their primary concern.

The most significant result of these exhibitions was the exposure of deep divisions in the movement itself. A clash of agendas weakened the Hogarth from the outset and caused it to dissolve after only two years. The perception of it as anti-Academy prevented several painters from applying for membership, including Millais and Augustus Egg, and Leighton's sudden resignation in 1860 was said to have been at the suggestion that his membership was a protest against the RA.[64] Yet, as mentioned above, the Hogarth was run more like a private gentleman's club than an exhibiting gallery, with membership candidates admitted by election after proposal and seconding by existing members, and an emphasis placed on the social aspect of the proceedings.[65] Ruskin, dismayed by the club's lack of intellectualism, resigned after it was proposed that a billiards table be installed. Despite his enthusiasm for such an institution in the early 1850s, Hunt's commitment to the Hogarth was weak, partly due to his desire to set himself apart from the developments in Pre-Raphaelitism (and Rossetti in particular) which it showcased,[66] but also because his own commercial strategy had evolved beyond the traditional artist–patron interaction which the club aimed to encourage. Evidence that it actually succeeded in doing this to any significant degree is scant,[67] and certainly Brown, optimistic at first, came to see both the Russell Place exhibition and the Hogarth Club as having been a waste of time.[68] They therefore failed both to bring about a marked improvement in the Pre-Raphaelites' commercial fortunes and, due to their exclusive, small-scale character, to mount an effective institutional challenge to the authority of the RA.

Public display of large numbers of Pre-Raphaelite paintings did occur, however, at the vast temporary exhibitions staged in England and France in the wake of the Great Exhibition of 1851. The Pre-Raphaelites' evident willingness to put themselves forward for inclusion in such events indicates the same paradoxical avant-garde desire for 'legitimacy' which motivated their competition for the Liverpool Academy prize. The Great Exhibition had contained no paintings; hence the French riposte, the Exposition Universelle of 1855, featured a purpose-built hall devoted to the fine arts, which included

a vast collection of works by their foremost painters and sizeable contributions from a series of guest nations, including Germany, Belgium, and Britain. It was, as Patricia Mainardi has argued, an event with political aims, intended to assert France as the world's foremost artistic power.[69] The wish of the Pre-Raphaelites to be included can be interpreted as similarly political; Millais asked the Combes to provide their examples of his and Hunt's work for the Exposition 'for the sake of showing the Frenchmen that we have a school of painters in this country (which they doubt).'[70] The Exposition was an opportunity for the representation of British art in an international forum, and the Pre-Raphaelites wanted to ensure that their movement was a significant presence. In this they were successful; paintings such as Millais's *The Order of Release* (1852–53, Tate, London) and Hunt's *Strayed Sheep (Our English Coasts)* (1852, Tate, London) were well received, with their creators even winning medals.[71]

The Manchester Art Treasures Exhibition (ATE) of 1857 presented a similar opportunity. A national rather than an international exhibition, composed of loans from private collectors and held in a purpose-built structure on the edge of the city, the aim of its executive committee in the three modern saloons was to create 'a chronological history of British painting.'[72] The Pre-Raphaelites were in a potentially good position. One of Hunt's major patrons, the local industrialist Thomas Fairbairn,[73] was the chairman of the exhibition, and Augustus Egg, whom Hunt later described as 'my true defender,'[74] was in charge of both loan applications and hanging in the modern saloons. Pre-Raphaelite paintings were thus largely well treated and were highly praised; Wallis's *The Death of Chatterton* (1856, Tate, London), hung 'on the line' in the center of the middle saloon, was often referred to as one of the most popular paintings in the entire exhibition.[75] Hunt was the best represented of them all, showing several major canvases, two of which had been supplied by the chairman and were thus given pride of place;[76] Brown, however, was horrified to find that in an echo of his experience in the RA in 1854, his *Jesus Washing Peter's Feet* was, in the words of Manchester artist Frederick Shields, 'almost out of sight in the roof space.'[77]

It could be argued that the Pre-Raphaelite presence at these events demonstrates not a 'secret' desire for legitimacy but an open one; that in allowing themselves to be slotted neatly into a 'consensus' view of the British school, they were effectively negating the challenge they had once made to the art establishment with a public display of 'obedience.' There can be no doubt that inclusion in such large-scale events, which incorporated a wide range of painting, lessened their impact, and even normalized them to an extent—the reverse of Brown's observation that Millais's pictures looked better when surrounded by the 'badness' of the RA exhibition.[78] They were praised at the Paris Exposition and the ATE, but in articles which also praised the establishment figures they had once pitted themselves against.[79]

The situation was the same in the fine art department at the London International Exhibition of 1862; Francis Palgrave, in his official *Handbook* to the exhibition, not only admires Hunt, Millais, Brett, and Hughes, but also lavishes encomiums upon Eastlake, Leslie, Etty, and others.[80] Even the *Art Journal*, one of Pre-Raphaelitism's most bitter and obdurate enemies during the 1850s, stated in 1862 that certain works by Hunt, Brett, and Millais 'need no ingenious theory or aggressive dogmatism for their defence; they will live wholly independent of the Pre-Raphaelite schism, and in the end have a part in the universal fellowship of the good and the true, which survives mere sectarian disputations.'[81] Their more offensive, anti-establishment elements were thus stripped from them by their effective assimilation into a state-sponsored canon.

The artist as advertiser and advertisement

The behavior of the French avant-garde towards the international exhibition, in one notable instance at least, was very different. Gustave Courbet went to some trouble to engineer a fierce dispute between himself and the administrators of the 1855 Exposition. He had submitted 14 works for display, but upon the rejection of three of them, including *The Artist's Studio* (1855, Musée d'Orsay, Paris) and *The Burial at Ornans* (1849, Musée d'Orsay, Paris), he decided to mount a one-man exhibition of his work almost directly outside the fine arts hall, stating that he was 'proclaiming liberty … saving the independence of art.'[82] It was, as Paul Greenhalgh has noted, an 'avant-garde precedent,'[83] and its primary value to Courbet, as with other avant-garde gestures studied in this essay, came in the form of publicity.

The precedent was followed in England in 1860, when the prominent art dealer Ernest Gambart mounted a special exhibition around Hunt's *The Finding of the Saviour in the Temple* (1854–60, Birmingham Museum and Art Gallery) at his German Gallery on New Bond Street. Gambart had prior experience with exhibiting Pre-Raphaelite paintings; in 1857, he had been involved in William Michael Rossetti's less than successful attempt to interest American patrons in English art by sending a travelling collection on a four-city tour. Works by Brown, Hunt, and Hughes were among those assembled, and it would not have escaped Gambart's notice that although outnumbered by more traditional works, and not any more fortunate in actually finding buyers, these paintings claimed the vast majority of both press and public attention.[84] Aware of the importance of drawing on public recognition of the Pre-Raphaelite 'brand,' in 1860 he actively promoted Hunt and his painting in defiance of the Royal Academy.[85] Huge figures were involved; over a thousand people a day were said to be going to the gallery, and Gambart famously paid Hunt £5500 for the picture itself. Under Gambart's guidance,

a Victorian promotional 'spectacle' had been created based, as Thomas Richards has put it, on 'a rhetorical mode of amplification and excess.'[86] Millais wrote to his wife that the exhibition was a 'tremendous success,' as it was both lucrative and popular, and that 'the RA are tremendously jealous.'[87] The story circulated that the RA president Charles Eastlake had begged Hunt to show at the Academy, but Hunt had turned him down: the final triumph of the 'active rebel.' At Gambart's suggestion, a promotional pamphlet was produced, written by F.G. Stephens under Hunt's supervision; its account of Hunt's career carefully combines avant-garde notions of rebellion against authority with more traditional, Romantic conceptions of artist biography, with the intention of broadening Hunt's appeal as much as possible whilst remaining sufficiently aligned with the Pre-Raphaelite 'brand.'[88] The artwork itself, subjected to the rigorous business logic of the dealer, was a commodity to be utilized for the maximum realization of profit, and even the artist himself became merely another marketing tool.

Brown's 1865 one-man show, based around his *Work* (1852–65, Manchester City Art Galleries), although doubtlessly inspired and encouraged by the success of *The Finding of the Saviour in the Temple*, differed from the earlier exhibition in several ways. Foremost amongst these was the lack of Gambart's participation; he was excluded due to a dispute between the dealer and the trustees of the Plint estate.[89] As a result, it was less of a 'spectacle' and did not include an enormous pay-off for Brown himself. Like Courbet in 1855, he financed and arranged the exhibition himself and had to be content with publicity as his sole reward.[90] But his was not a defiant gesture in the face of the establishment, designed to whip up a 'scandal;' Brown approached the exhibition in a rough imitation of Gambart's style, as if he were marketing a commodity. He erected placards bearing positive reviews in the exhibition rooms,[91] and he published a pamphlet that he had written himself. The tone of this pamphlet is one of considered populism. It contains anecdotes of the creation of *Work* and fictional extrapolations of various details in the painting which stress both its themes and its contemporaneity;[92] in this way, Brown appeals to the experience of a mass audience and attempts to relate the painting to their daily lives. He also placed adverts in the popular press and on hoardings in railway stations and other public places, attempting to emulate contemporary methods of product and entertainment promotion; indeed, his venue, the Burleigh Gallery at 191 Piccadilly, was known for popular exhibitions of a less than edifying kind.[93] Dante Gabriel Rossetti was amused by the incongruity of an artist adopting the most basic, sensational techniques of commerce, but his initial inclination to affectionate mockery soon gave way to admiration of the prominence this approach gained the venture. After seeing a hoarding advertising the exhibition near the Treasury, he wrote to Brown that 'I see a new career open to you on the strength of that great idea.'[94]

Brown's embracing of a commercial identity seemed justified by its results. Rossetti urged him to capitalize on the sudden boost to his reputation, a process which he conceived in largely social terms, telling Brown he should 'get about a little more than hitherto now, to keep up your start.'[95] As well as spreading word about 'Madox Brown's admirable exhibition' amongst his circle of rich acquaintances,[96] he repeatedly told the artist himself that by living in Finchley, and therefore outside the central London radius within which a potential patron could be convinced to make a casual studio visit, he was putting himself at 'a very simple but terribly real disadvantage.'[97] Perhaps most significantly, Rossetti proposed Brown for membership at the Garrick Club, the fiercely exclusive private members' club favored by artists, writers, and musicians,[98] to which he belonged. Millais, also a member, was secured as a 'seconder,' but before things could go any further 'a party question' was made of Brown's election, and it was abandoned to avoid the humiliation of a 'blackball.' Rossetti explained to Brown that 'there is a strong feeling against independent exhibitions;'[99] the Garrick, like all private clubs, was a haven of the establishment, and the one-man show, after Hunt and Gambart's adaptation of the Pre-Raphaelite 'brand' in 1860, was associated with defiance of the Royal Academy and therefore unacceptable. That it also shared features with less elevated forms of display and exchange was doubtlessly another reason for the club's animosity. Brown's exhibition may have heightened his fame, but it also sealed his exclusion from the higher realms of cultured society. Rossetti could only assure him that it was not personal, and that were Hunt to apply for membership, he, too, would be rejected.

Pamela Gerrish Nunn has written that being a Pre-Raphaelite was 'very much a question of connections,'[100] and this was certainly how Rossetti managed to survive and even flourish despite an almost complete absence from public exhibitions.[101] Along with his extensive list of contacts, he cultivated a 'bohemian' persona, appearing increasingly eccentric and remote, famous yet unseen. As with the avant-garde, modern critical definitions of bohemianism have stressed its role in industrial capitalist societies as a means of enhancing the artist's success in the marketplace. For example, Marilyn Brown concludes that the transgressions of the 'bohemian' character caused only superficial confusion amongst the normative order and left it 'ultimately intrigued;' there is little evidence, she argues, to suggest that bohemianism 'involved real or permanent social dissidence,' meaning that it was at its core 'an acceptable, sentimental bourgeois myth.'[102] Rossetti, himself no dissident, developed an individualized version of this 'myth' which made a virtue of his apparent distance from the commercial art world.

Rossetti often socialized with his regular clients and introduced them to other artists and acquaintances, in the hope that expansion of the social circle would produce more custom. This shift from public to private provided an effective means of filtering the 'empathetic' audience from the 'alien' and

preserving his sense of detachment from the mainstream. William Michael Rossetti described his brother's house at Cheyne Walk as a vibrant community filled with 'artists, writers and picture-buyers;' a place where art was not only produced, but also sold at the source. In an increasingly impersonal market, it offered an 'authentic' experience, which patrons could applaud themselves for having had. William Bell Scott gave a succinct summary of the Rossetti 'myth' when he wrote that although 'unknown to the public,' the artist had 'the respect of the intelligent.'[103] It was Hunt, however, who best appreciated the commercial value of Rossetti's approach, noting bitterly that by the late 1850s, 'retirement from the outward struggle was no longer a disadvantage, but a distinct gain to him,' as a widespread view held that he was the foremost Pre-Raphaelite, who had painted many astounding masterpieces, but 'his studio could only be visited by a favoured few.'[104] An illusion of discovery, of achieving admittance to a select, unconventional intellectual group, was essentially being developed and utilized by Rossetti as a marketing strategy.

Millais re-branded

Both Brown and Rossetti paid attention to each other's tactics. Brown, following Rossetti's advice, moved to 37 Fitzroy Square and acquired a 'circle' of his own, within which contacts were made, whilst Rossetti considered mounting a one-man exhibition.[105] It was necessary for artists seeking to develop beyond the associations of the Pre-Raphaelite 'brand' to be versatile in their combination or exchange of paradigms of artistic identity. Millais provides a salient example of this, and it is with a brief discussion of his career during the 1850s and early 1860s that this chapter will conclude. As mentioned above, at the time of the initial Pre-Raphaelite 'scandal,' he conceived of himself as an embattled genius, bravely confronting a corrupt system: an avant-garde stance percolated through Romanticism. His confrontation with the establishment, however, was ultimately geared towards gaining acceptance and official recognition. Whilst Brown, upon discovering his work had been 'skyed' at the RA, had walked out in disgust, Millais 'yelled' until the paintings were re-hung to his satisfaction, playing on the 'celebrity' (as Thomas Woolner put it) that his controversial early career had earned him.[106] He did not desire this acceptance for the movement as a whole. Whereas instances of a strong corporate mentality are common amongst other Pre-Raphaelites, Millais not only remained aloof from group ventures such as the Hogarth Club, but also displayed an increasingly competitive attitude towards his 'brethren,' particularly Hunt, whom he regarded as his main rival. In 1856 he wrote to his wife that the work 'poor old Hunt' had brought back from the East 'disappoints all,' noting with pleasure the contrast with his own position: 'the comparison which has so often been made between our relative merits ceases for ever

with this year.'[107] This competitiveness was not simply about perceptions of their relative abilities or financial positions; Millais wished to distance himself from the 'brand' which had won him early prominence in order to attain the particular professional status which could only be conferred by the RA.

Colin Trodd has emphasized the 'dichotomous nature' of the RA in the mid-nineteenth century, in that it was seen both as a professional body organized around 'the idea of the purity of culture,' and 'the central market for the exhibition of art in an increasingly diversified art world.'[108] Certainly Millais enjoyed great commercial success as a result of his exhibition at the RA, particularly after he was made an associate in 1853; his paintings always found buyers at Trafalgar Square. Hunt, after a failed 1856 attempt to become an associate, which he was keen to describe later as an 'experiment' rather than a cherished ambition that 'only made me more resolved patiently to go my own way,' wrote that 'the badge of the Academy' led directly to 'approval and patronage.'[109] Millais's desire was more for 'approval' than 'patronage' and not the 'secret' legitimacy pursued by the avant-garde; he sought open, formal acceptance by the establishment. Throughout the 1850s, he was careful to avoid adopting commercial strategies which might affect this campaign, refusing the advances of dealers such as Gambart,[110] aware that such activity might jeopardize his chances with the RA.

By the middle of the century, the practice of art was generally regarded as a profession; the 1861 census listed painters with the 'learned professions and engineers.' The RA, however, remained an 'elite,' as P.J. Cornfield has argued, 'consciously an exclusive society, declining to seek a universal membership.'[111] H. Byerley Thompson's *The Choice of a Profession* of 1857 divides the professions into two basic classes, the 'privileged' and the 'unprivileged.' The latter survived on ability and reputation alone, and had no choice but to operate in an open, competitive market. Thompson classified painting as an 'unprivileged' profession. In contrast, the former, which included the Church, the law and medicine, were closed to free competition, and required some public evidence of competence, in the form of an examination or formal appointment; 'privileged' professionals, he added, were 'generally drawn from a superior class.'[112] The RA, I would argue, represented an attempt to create a 'privileged' realm within an 'unprivileged' profession. Academicians' status granted them a security denied to other painters. In addition, election to even associate level meant social as well as professional elevation; after his 1853 associateship, Millais rapidly became socially distanced from the other Pre-Raphaelites. He referred to the self-made businessmen and industrialists upon whom the other 'brethren' were dependent for their livings with disdain, lamenting the lack of opportunity to sell his work 'to gentlemen.'[113] By the time he was made a full academician a decade later, he was mixing with the aristocracy[114] and being spoken of by Rossetti (in relation to Brown's nomination for the Garrick) as someone who was 'very influential.'[115] In the

RA exhibitions themselves, he was as concerned with the reactions of the academicians to his work as with the views of the press or the public, or the prices fetched.[116]

The most lucid demonstration of Millais's absorption into the 'consensus of values' represented by the RA was his repeated defense of its practices, in public and private, thus completely repudiating the avant-garde stance on which Pre-Raphaelitism had been based. Flushed with the triumph of *The Black Brunswicker* (1859–60, Lady Lever Art Gallery, Port Sunlight, Merseyside) in 1860, for example, he wrote that the RA was 'the only place for a man to find his real level.'[117] This painting had been bought by Gambart; once he felt his position in the Academy was safe, Millais eagerly entered the commercial art world he had avoided up to that point, and many of his pictures were sold through the dealer in later years, bringing massive profits to both men.[118] These paintings needed no spectacular promotion; they could easily be sold on reputation alone, as the productions of a major artist of the time, a genius of the Academy. Millais had been re-branded.

Arguing for the relevance of art history to marketing theory, Schroeder cites the art market as 'the exemplar of consumer culture;' he identifies art as representing 'the highest goals of humans,' but also—simultaneously—'the most crass commercialism and speculation.'[119] One of the aims of this chapter has been to demonstrate the prominence of this paradox in the development of the Pre-Raphaelites. Despite their absolute faith in their own artistic importance, the Pre-Raphaelites were also, from the beginning, active in the promotion and sale of what they produced. Such commercial awareness and involvement had become a vital professional attribute of the mid-nineteenth-century artist, and the Pre-Raphaelites, close to the vanguard of the European avant-garde, are characterized as a movement by their sophisticated engagement with their intended market.

Notes

1. For example, Diane Sachko Macleod, *Art and the Victorian Middle Class: Money and the Making of Cultural Identity*, Cambridge and New York: Cambridge University Press, 1996, p. 143. The Pre-Raphaelites are here described as 'avant-garde in their defiance of orthodoxy.'

2. Donald Kuspit, 'Avant-garde and audience,' in Sally Everett (ed.), *Art Theory and Criticism: An Anthology of Formalist, Avant-Garde, Contextualist and Post-Modernist Thought*, Jefferson and London: McFarland and Co., 1991, p. 171.

3. For example, William Michael Rossetti (ed.), 'The P.R.B. Journal 1849–53,' in *Præraphaelite Diaries and Letters: Papers 1854 to 1862*, London: Hurst and Blackett, 1900, p. 279. On Friday May 2, 1851, Rossetti, then art critic for *The Spectator*, was at the RA private view. Having observed the strength of the Pre-Raphaelite contribution that year, he records with amusement having heard 'someone—by his looks, an Academician—observe, in reference to Millais' pictures, that no sarcasm could be too fierce for such absurdities.'

4. For example, Ford Madox Brown, 'Diary for 1856,' in Ford Madox Ford [Ford M. Hueffer], *Ford Madox Brown: A Record of His Life and Work*, London and New York: Longmans, Green and Co.,

1896, p. 125. Brown noted that on the walls of the Academy 'Millais looks ten times better than in his room, owing to contrast with surrounding badness' (May 19).

5. See P.M. Pasinetti, *Life for Art's Sake—Studies in the Literary Myth of the Romantic Artist*, New York and London: Garland, 1985, p. 6; and Ernst Kris and Otto Kurz, *Legend, Myth and Magic in the Image of the Artist*, New Haven and London: Yale University Press, 1979, pp. 99–102.

6. John Everett Millais, for example, who was in the habit of defining and redefining his artistic position to his wife in the letters he sent her from London at the time of the summer exhibition, wrote to her of his deep scorn for 'received conventionalities' in painting, and the opprobrium this brought his pictures, even declaring melodramatically that 'only when I am dead will they know their worth' (John Everett Millais, letters to Euphemia Millais, May 8, 1857 and April 28, 1859 in John Guille Millais, *The Life and Letters of Sir John Everett Millais, President of the Royal Academy*, 2 vols, London: Methuen and Co., 1899, vol. 1, p. 303 and p. 345). Dante Gabriel Rossetti shared similar views, writing in a consolatory note to Ford Madox Brown, 'we are but too transcendent spirits, far, far in advance of the age' (Dante Gabriel Rossetti, letter to Ford Madox Brown, December 4, 1852, in *Letters of Dante Gabriel Rossetti*, eds Oswald Doughty and John R. Wahl, 4 vols (1965–67), Oxford: Clarendon Press, 1965, vol. 1, p. 117).

7. Dante Gabriel Rossetti, letter to William Allingham, May 11, 1855, in Dante Gabriel Rossetti, *Letters*, vol. 1, p. 251. See also John Guille Millais, *Life and Letters*, vol. 1, p. 254, and William Bell Scott, *Autobiographical Notes of the Life of William Bell Scott*, ed. William Minto, 2 vols, London: Osgood, McIlvaine & Co. and New York: Harper, 1892, vol. 2, p. 29, for other accounts of this incident.

8. Ford [Hueffer], *Ford Madox Brown*, p. 85.

9. Walter Benjamin, 'Paris, the capital of the nineteenth century,' in *Walter Benjamin: Selected Writings, Volume Three 1935–1938*, trans. Edmund Jephcott and eds Howard Eiland and M.W. Jennings, Cambridge, MA and London: Belknap Press of Harvard University Press, 2002, p. 40.

10. Marilyn Brown, *Gypsies and Other Bohemians: The Myth of the Artist in Nineteenth Century France*, Ann Arbor, MI: UMI Research Press, 1985, p. 9.

11. John Everett Millais, letter to Mrs T. Combe, May 10, 1851, in John Guille Millais, *Life and Letters*, vol. 1, p. 102.

12. Kuspit, 'Avant-garde and audience,' pp. 174–5.

13. For the contemporary reaction to this painting, see Michaela Giebelhausen, 'Academic orthodoxy versus Pre-Raphaelite heresy: debating religious painting at the Royal Academy,' in Rafael Cardoso Denis and Colin Trodd (eds), *Art and the Academy in the Nineteenth Century*, Manchester: Manchester University Press, 2000, pp. 164–79, and J.B. Bullen, *The Pre-Raphaelite Body: Fear and Desire in Painting, Poetry and Criticism*, Oxford: Clarendon Press, 1998, pp. 16–34.

14. Scott, *Autobiographical Notes*, vol. 1, p. 277.

15. Macleod, *Art and the Victorian Middle Class*, pp. 160–95. For example, Francis McCracken, both Hunt's and Rossetti's first client, was Irish.

16. William Holman Hunt, *Pre-Raphaelitism and the Pre-Raphaelite Brotherhood*, 2 vols, London and New York: Macmillan & Co., 1905, vol. 1, p. 146. This was reportedly suggested to Hunt in 1850 by an Academy student 'some years my senior;' 'I thereupon mischievously said that he had divined our purpose, and besought him to respect the secret, on which he led me to his contribution for the year, telling me that, through the course we had taken, his work, being of modest aspect—and it was this—was entirely overlooked.'

17. Ford Madox Brown, letter to William Holman Hunt, undated (possibly 1851), in *ibid.*, vol. 1, p. 175.

18. Jonathon E. Schroeder, 'Edouard Manet, Calvin Klein and the strategic use of scandal,' in Stephen Brown and Anthony Patterson (eds), *Imagining Marketing: Art, Aesthetics and the Avant-Garde*, London and New York: Routledge, 2000, p. 47.

19. William Michael Rossetti, 'The P.R.B. Journal 1849–53,' in his *Præraphaelite Diaries and Letters*, p. 274. This remark is included in the entry for July 1850.

20. Elizabeth Prettejohn, 'Aesthetic value and the professionalisation of Victorian art criticism 1837–1878,' *Journal of Victorian Culture*, 2 (1), Spring 1997, 75.

21. William Holman Hunt, letter to Thomas Seddon, October 1854, in *William Holman Hunt's Letters to Thomas Seddon*, ed. George P. Landow, Manchester: John Rylands Library of Manchester, 1983,

p. 161; reprinted from the *Bulletin of the John Rylands University Library of Manchester*, 66 (1), Autumn 1983.

22. Ford Madox Brown, letter to Lowes Dickinson, May 14, 1851, in Ford [Hueffer], *Ford Madox Brown*, p. 73.

23. Hunt, *Pre-Raphaelitism and the Pre-Raphaelite Brotherhood*, vol. 2, p. 90.

24. William Holman Hunt, letter to Thomas Seddon, October 1854, in Hunt, *Letters to Thomas Seddon*, p. 161. Hunt already had personal experience of 'skying;' on May 2, 1851, William Michael Rossetti wrote in *The P.R.B. Journal* that in the Academy exhibition of that year, Hunt's *Valentine Rescuing Sylvia from Proteus* had been 'abominably shirked off into much the same position as his *Rienzi* of 1849 occupied.' William Michael Rossetti, 'The P.R.B Journal 1849–53,' in his *Præraphaelite Diaries and Letters*, p. 297.

25. In July 1850 William Michael Rossetti wrote that Dante Gabriel had 'at the last moment' decided to send his picture to the Free Exhibition. William Michael Rossetti, 'The P.R.B Journal 1849–53,' in his *Præraphaelite Diaries and Letters*, p. 273. Hunt later added, 'William Rossetti has since told me that one of the reasons for his brother's action was that he could "buy" a space on the walls of this gallery, which he did, rather than risk rejection by the Academy.' Hunt, *Pre-Raphaelitism and the Pre-Raphaelite Brotherhood*, vol. 1, p. 118.

26. *Catalogue of the Institution for Promoting the Free Exhibition of Modern Art*, London: J. Bradley, 1849, p. 1. The address states that exhibiting artists are required to pay a sum per foot as rent, 'and upon such space he is *free* to arrange, as he pleases, all those works which have been admitted for exhibition.'

27. 'The Hyde Park Gallery,' *Art Journal*, 11, April 1, 1849, 147.

28. *Ibid. The Girlhood of Mary Virgin* was placed at the head of the *Art Journal* review of the exhibition, and received the longest notice of any painting present; it was declared 'most successful as a pure imitation of early Florentine art that we have seen in this country.'

29. Ford Madox Brown, letter to Lowes Dickinson, October 17, 1853, in Ford [Hueffer], *Ford Madox Brown*, p. 90.

30. Economic realities forced the organizers to renounce their original plan, which was for an entirely free exhibition. It was only free during the last two weeks of the season; 'The Free Exhibition' was thus judged to be 'a misnomer.' *Catalogue of the Exhibition of the National Institution of Fine Arts*, London: G. Dewing, 1850, p. 3.

31. For example, in 1851 Deverell showed *The Banishment of Hamlet* (*Catalogue of the National Institution*, 1851, p. 7), and in 1852 Collinson showed *The Wreath* and *The Emigration Scheme* (*Catalogue*, 1852, p. 14).

32. Ford Madox Brown, 'Diary 1844–56,' in William Michael Rossetti (ed.), *Præraphaelite Diaries and Letters*, p. 74. Brown attended a meeting on November 6, 1848, but, alarmed by the amateurish incompetence he witnessed, declined to be on the committee and thus participate in the elections to official posts, remarking 'what a set of muffs! What will be the upshot of it I don't know and don't care.'

33. *Catalogue of the Free Exhibition*, 1848, p. 12. In an exhibition where nearly all the pictures were priced at under £50, and most at around £20, Brown asked £210 for the *Wycliffe*.

34. Hunt, *Pre-Raphaelitism and the Pre-Raphaelite Brotherhood*, vol. 1, p. 120. Hunt records that *The Girlhood of Mary Virgin* was sold at the asking price of £80 to the Marchioness of Bath. Brown showed a *Portrait of Mons. Dan Casey* at the Free Exhibition in 1849, but it was not for sale (*Catalogue of the Free Exhibition*, 1849, p. 10). He did not exhibit there again.

35. See Nicholas Tromans, 'Museum or market? The British Institution,' in Colin Trodd and Paul Barlow (eds), *Governing Cultures: Art Institutions in Victorian London*, Aldershot, England and Burlington, VT: Ashgate, 2000, pp. 44–55.

36. *Catalogue of the Works of British Artists in the Gallery of the British Institution, Pall Mall, for Exhibition and Sale*, London: W. Nichol, 1847, p. 17. Millais exhibited a work listed simply as 'a study.' John Guille Millais also writes of an extremely early painting by Hunt prepared for the British Institution, but he does not name the subject. John Guille Millais, *Life and Letters*, vol. 1, p. 46.

37. *Ibid.*, 1845, p. 9. This year, for example, he exhibited *Parisinia*.

38. William Michael Rossetti (ed.), *Ruskin: Rossetti: Preraphaelitism: Papers 1854–63*, London: George Allen and New York: Dodd, Mead & Co., 1899, p. 38. Brown's account of their initial disagreement is given here.

39. John Ruskin, 'Giotto and His Works in Padua' (1854), in *The Works of John Ruskin*, eds E.T. Cook and A. Wedderburn, 39 vols, London: George Allen and Sons and New York: Longmans, Green & Co., 1903–12, vol. 24, p. 27; also, for example, *Modern Painters III* (1856), in *ibid.*, vol. 5, p. 109. Pre-Raphaelitism is here termed a 'stern naturalist' movement.

40. John Ruskin, 'Pre-Raphaelitism' (1851), in Inga Bryden (ed.), *The Pre-Raphaelites: Writings and Sources*, 4 vols, London: Routledge/Thoemmes Press, 1998, vol. 3, p. 51.

41. David Masson, 'Pre-Raphaelitism in art and literature,' in Bryden (ed.), *The Pre-Raphaelites*, vol. 3, p. 81. Masson, a journalist sympathetic to the PRB, wrote for the *British Quarterly Review*, commenting upon the 'complete change' in attitudes towards the Pre-Raphaelite works in the Royal Academy Exhibition in 1852, which he attributed 'in a considerable degree to the generous intervention ... made by Mr. Ruskin last year.' More recently, Jeremy Maas has argued that 'since the rebellious Pre-Raphaelites had been championed by Ruskin, their provocative pictures were at least "safe".' Jeremy Mass, *Gambart: Prince of the Victorian Art World*, London: Barrie and Jenkins, 1975, p. 59.

42. George P. Landow, *The Aesthetic and Critical Theories of John Ruskin*, Princeton: Princeton University Press, 1971, p. 14.

43. Quoted in Maas, *Gambart*, p. 59.

44. Ruskin, 'Pre-Raphaelitism,' p. 50.

45. William Michael Rossetti (ed.), *Ruskin: Rossetti: Preraphaelitism*, p. 45. For example, in his diary for September 15, 1855, Brown notes that Rossetti has complained that Ruskin is, reportedly in Rossetti's words, 'sticking pins into him.' An undated letter from 1856 demonstrates the pleasure Ruskin took in close personal control; after a disagreement over a watercolor of *Beatrice at a Marriage Feast*, he tells Rossetti, 'I never, so long as I live, will trust you to do anything again, out of my sight' (p. 116).

46. John Everett Millais, letter to Euphemia Millais, April 26, 1859, in John Guille Millais, *Life and Letters*, vol. 1, p. 342. After an attack on John Brett, who he understands to be Ruskin's latest pupil, Millais declares of Ruskin himself: 'He does not understand my work, which is now too broad for him to appreciate, and I think his eye is only fit to judge the parts of insects.'

47. Kuspit, 'Avant-garde and audience,' p. 175.

48. Ford [Hueffer], *Ford Madox Brown*, p. 68. This 'policy' yielded positive results: Ford records that in 1852 he sold a sketch of *The Infant's Repast* to 'an entire stranger, Mr Edward Stanley' for £5 after its exhibition in Bristol (p. 84).

49. Hunt, *Pre-Raphaelitism and the Pre-Raphaelite Brotherhood*, vol. 1, p. 204.

50. Mary Bennett, 'The Pre-Raphaelites and the Liverpool Prize,' *Apollo*, 77, December 1962, 748.

51. Kuspit, 'Avant-garde and audience,' p. 175.

52. Ford Madox Brown, diary entry for June 30, 1856, cited in Ford [Hueffer], *Ford Madox Brown*, p. 130.

53. Hunt, *Pre-Raphaelitism and the Pre-Raphaelite Brotherhood*, vol. 1, p. 200.

54. Bennett, 'The Pre-Raphaelites and the Liverpool Prize,' p. 749. See also Macleod, *Art and the Victorian Middle Class*, pp. 152–3.

55. *Ibid.*, p. 752. Miller later bought *Autumn Leaves* (1855–56, Manchester City Art Galleries) and a copy of Hunt's *Eve of St Agnes* (1848, Guildhall Art Gallery, London).

56. Ford Madox Brown, letter to Lowes Dickinson, May 14, 1851, in Ford [Hueffer], *Ford Madox Brown*, p. 73. Brown wrote that Pre-Raphaelite paintings were so different from the standard fare in the RA that 'we ought to exhibit them quite apart.'

57. William Holman Hunt, letter to Thomas Seddon, December 22, 1855, in Hunt, *Letters to Thomas Seddon*, p. 172.

58. William Holman Hunt, letter to Ford Madox Brown, undated (late 1852), in Ford [Hueffer], *Ford Madox Brown*, p. 87.

59. John Miller, letter to Ford Madox Brown, undated (1857), in *ibid.*, p. 144.

60. Dante Gabriel Rossetti, letter to William Morris, undated (1857), in Dante Gabriel Rossetti, *Letters*, vol. 1, p. 324.

61. Deborah Cherry, 'The Hogarth Club 1858–61,' *Burlington Magazine*, 122, April 1980, 243.

62. Teresa Newman and Ray Watkinson, *Ford Madox Brown and the Pre-Raphaelite Circle*, London: Chatto and Windus, 1991, pp. 104–7. Rossetti showed the watercolors *Dante Drawing an Angel* (1853, Ashmolean Museum, Oxford) and *The Blue Closet* (1856–57, Tate, London) at Russell Place. He sent four watercolors to the first Hogarth show in January 1859, including *Mary in the House of St John* (1858, Delaware Art Museum, Wilmington). The third show featured *Bocca Baciata* (1859, Museum of Fine Arts, Boston), *Lucrezia Borgia* (1860–61, reworked in 1868, Tate, London), and *The Salutation of Beatrice* (1859, National Gallery of Canada, Ottawa). See Cherry, 'The Hogarth Club,' p. 241.

63. *Hogarth Club Rules*, London: private publication, 1860, p. 3. The 'non-artistic' members included John Miller, Thomas Plint, and Thomas Fairbairn.

64. Cherry, 'The Hogarth Club,' pp. 242–3.

65. *Hogarth Club Rules*, pp. 6–7. Other private club procedures were applied at the Hogarth, such as the exclusion of unwelcome candidates by 'blackballing.'

66. He was famously disgusted by *Bocca Baciata*, remarking on its 'gross sensuality of a revolting kind,' and was appalled that people 'speak to me of it as the triumph of *our school*.' William Holman Hunt, letter to Thomas Combe, May 31, 1860; cited in Cherry, 'The Hogarth Club,' p. 241.

67. A rare example: Dante Gabriel Rossetti, letter to Ford Madox Brown, February 10, 1861, in Dante Gabriel Rossetti, *Letters*, vol. 2, p. 395. 'Rose has expressed a wish to have something by Davis. He was … much pleased with those at the Hogarth.'

68. Ford Madox Brown, 'Diary 1858,' in Ford [Hueffer], *Ford Madox Brown*, p. 152. Of the Russell Place exhibition, Brown remarks 'on this I must have wasted at least four weeks.' Of the Hogarth Club, Ford writes, 'the ultimate result of his experience with the club was a determination to have nothing to do with societies in future' (p. 162).

69. Patricia Mainardi, *Art and Politics of the Second Empire: The Universal Expositions of 1855 and 1867*, New Haven and London: Yale University Press, 1987, p. 38.

70. John Everett Millais, letter to Mrs T. Combe, January 30, 1855, in John Guille Millais, *Life and Letters*, vol. 1, p. 245.

71. Mainardi, *Art and Politics of the Second Empire*, pp. 110–12. Millais won a second-class medal, Hunt a third-class. Their work was admired by Delacroix, among others; he noted in his journal that on one of his many repeat visits to the Fine Arts hall, 'I stayed there until about noon, examining the pictures by the Englishmen, whom I admire very much; I am really astounded at the sheep by Hunt.' Eugene Delacroix, *The Journal of Eugene Delacroix*, trans. Walter Pach, London: Jonathan Cape, 1938, p. 476, entry for June 30, 1855.

72. *Exhibition of Art Treasures of the United Kingdom held at Manchester in 1857: Report of the Executive Committee*, Manchester: George Simms, 1859, p. 4.

73. See Caroline Arscott, 'Employer, husband, spectator: Thomas Fairbairn's commission of *The Awakening Conscience*,' in Janet Wolff and John Seed (eds), *The Culture of Capital: Art, Power and the Nineteenth Century Middle Class*, Manchester and New York: Manchester University Press, 1988, pp. 159–90.

74. Hunt, *Pre-Raphaelitism and the Pre-Raphaelite Brotherhood*, vol. 2, p. 124.

75. For example, *A Peep at the Pictures: or, a Catalogue of the Principal Objects of Attraction in the Manchester Art Treasures Exhibition*, exh. cat., Manchester: John Heywood, 1857, p. 16. One of the many 'operatives' guides' produced for the ATE, *A Peep* tells its readers: 'You will generally find a crowd around this wonderful picture, but you must not pass on without seeing it, nevertheless.'

76. *Catalogue of the Art Treasures of the United Kingdom Collected at Manchester in 1857*, exh. cat., eds George Scharf and Augustus Egg, London: Bradbury and Evans, 1857. Hunt's exhibits included *Claudio and Isabella* (1850–53, Tate, London), *Strayed Sheep* and *The Hireling Shepherd* (1851–52, Manchester City Art Galleries); Fairbairn lent *Valentine Rescuing Sylvia from Proteus* and *The Awakening Conscience* (1853–54, Tate, London). Hunt declared in his autobiography that Egg had hung 'all my pictures well.' Hunt, *Pre-Raphaelitism and the Pre-Raphaelite Brotherhood*, vol. 2, p. 124.

77. Cited in Newman and Watkinson, *Ford Madox Brown*, p. 110. Brown also had the questionable distinction of being the only artist to submit an unsold painting, *Jesus Washing Peter's Feet*, for exhibition at the ATE (*Catalogue of the Art Treasures*, p. 131).

78. See the quotation from Brown in note 4.

79. At the Paris Exposition, Landseer was honored most highly of all British painters, being awarded one of the twelve medals of honor. See Mainardi, *Art and Politics of the Second Empire*, p. 110. Delacroix's highest praise was for Leslie, to whom he said no French artist could compare. See Delacroix, *Journal*, p. 467. At Manchester, a review from the *Manchester Guardian* stated that Hunt's *Claudio and Isabella* was 'the most impressive work in the whole of this English gallery,' but went on to say that 'no painter has so large a space in our English gallery as Landseer, and none has such a right to it.' *A Handbook to the Art Treasures Exhibition — Being a Reprint of Critical Notices Originally Published in the Manchester Guardian*, 2 vols, London: Bradbury and Evans, 1857, pp. 96–117.

80. *Handbook to the Fine Art Collections in the International Exhibition of 1862*, ed. Francis Palgrave, London and Cambridge: Macmillan & Co., 1862, pp. 35–61. The Pre-Raphaelite works on display included Brown's *An English Autumn Afternoon* and *The Last of England* (1852–55, Birmingham Museum and Art Gallery); Brett's *Val d'Aosta* (1858, private collection); Hunt's *The Light of the World* (1851–53, Keble College, Oxford), and *Valentine Rescuing Sylvia from Proteus*; Millais's *Spring (Apple Blossoms)* (1856–59, Lady Lever Art Gallery, Port Sunlight, Merseyside), *Autumn Leaves*, and *The Vale of Rest* (1858, partially repainted 1862, Tate, London).

81. *Art Journal*, 24, July 1862, 151.

82. Cited in Mainardi, *Art and Politics of the Second Empire*, p. 65.

83. Paul Greenhalgh, *Ephemeral Vistas: The Expositions Universelles, Great Exhibitions and World's Fairs 1851–1939*, Manchester: Manchester University Press, 1988, p. 202. It would be imitated by Manet in 1867.

84. Susan P. Casteras, 'The 1857–58 exhibition of English art in America and critical responses to Pre-Raphaelitism,' in Linda S. Ferber and William H. Gerdts (eds), *The New Path: Ruskin and the American Pre-Raphaelites*, New York: The Brooklyn Museum, 1985, p. 119. Brown's *King Lear and Cordelia* (1848–49, Tate, London) is said to have been 'perhaps the single most frequently mentioned painting.' Hunt was offered £300 for his smaller version of *The Light of the World* (which he refused), but sales activity was generally low, due to a catastrophic crash on the American stock market shortly before the exhibition tour began.

85. Maas, *Gambart*, p. 90.

86. Thomas Richards, *The Commodity Culture of Victorian England: Advertising and Spectacle 1851–1914*, London and New York: Verso, 1990, p. 54.

87. John Everett Millais, letter to Euphemia Millais, May 4, 1860, in John Guille Millais, *Life and Letters*, vol. 1, p. 357.

88. F.G. Stephens, *William Holman Hunt and His Works: A Memoir of the Artist's Life, with Description of His Pictures*, London: James Nisbet & Co., 1860. The Pre-Raphaelites are said to have eschewed 'quiet success and ordinary dexterity of execution,' 'boldly' pursuing their own course, and bravely facing 'the public opprobrium certain to follow an unconventional attempt' (p. 10). This is blended with a very Romantic evocation of the young, impoverished artist, pursuing his unique vision whilst starving in a draughty garret (p. 15).

89. Mary Bennett, 'The price of *Work*: the background to its first exhibition,' in Leslie Parris (ed.), *Pre-Raphaelite Papers*, London: Tate Gallery, 1984, p. 144.

90. Ford Madox Brown, letter to George Rae, April 19, 1865, in Ford [Hueffer], *Ford Madox Brown*, p. 212. Two months into the three-month run, Brown wrote that 'in reputation it cannot but do me good. Indeed, I have felt it already.'

91. This echoes the reprinting of press reviews in the back of Stephens's *William Holman Hunt*.

92. Ford Madox Brown, *The Exhibition of Work, and Other Paintings, by Ford Madox Brown*, London: McCorquodale and Co., 1865, pp. 27–31. For example, he writes that the beer-man's black eye 'was got probably doing the police of his master's establishment, and an encounter with some huge ruffian whom he has conquered in fight, and hurled out through the swing doors of the palace of gin prone on to the pavement.'

93. Newman and Watkinson, *Ford Madox Brown*, p. 142. Previous exhibitions had included 'Julia Pastrana, the female hairy monster, embalmed' and 'The Talking Fish.'

94. Dante Gabriel Rossetti, letter to Ford Madox Brown, March 28, 1865, in Dante Gabriel Rossetti, *Letters*, vol. 2, p. 549. A more teasing letter had been written on February 6 (p. 542).

95. *Ibid.*

96. Dante Gabriel Rossetti, letter to John Skelton, March 13, 1865, in *ibid.*, p. 547.

97. Dante Gabriel Rossetti, letter to Ford Madox Brown, October 2, 1865, in *ibid.*, p. 574.

98. Anthony Lejeune, *The Gentlemen's Clubs of London*, London: Parkgate, 1984, p. 14. An anonymous Garrick member from the 1870s is quoted as having said, 'it would be better that ten unobjectionable men should be excluded than that one terrible bore should be admitted.'

99. Dante Gabriel Rossetti, letter to Ford Madox Brown, April 30, 1865, in Dante Gabriel Rossetti, *Letters*, vol. 2, p. 554.

100. Pamela Gerrish Nunn, 'A centre on the margins,' in Ellen Harding (ed.), *Reframing the Pre-Raphaelites: Historical and Theoretical Essays*, Aldershot: Scolar Press and Brookfield, VT: Ashgate, 1996, p. 43.

101. After the initial 'scandal' of 1850, Rossetti exhibited in public only twice. In 1852, Lewis Pocock allowed him to submit two drawings to the winter exhibition of the Old Water-Colour Society (see Macleod, *Art and the Victorian Middle Class*, p. 162, and Dante Gabriel Rossetti, *Letters*, vol. 1, p. 117); and in 1864, W. Blackmore lent *Helen of Troy* to the Liverpool Academy 'much against my will but at old Miller's special wish' (Dante Gabriel Rossetti, *Letters*, vol. 2, p. 521).

102. Brown, *Gypsies and Other Bohemians*, pp. 6–9.

103. Scott, *Autobiographical Notes*, vol. 1, p. 314.

104. Hunt, *Pre-Raphaelitism and the Pre-Raphaelite Brotherhood*, vol. 2, p. 105.

105. Dante Gabriel Rossetti, letter to C.L. Polidori, June 25, 1864, in Dante Gabriel Rossetti, *Letters*, vol. 2, p. 508. Here, for example, Rossetti writes in reference to the panels of the Llandaff altarpiece: 'some day I must get them lent me for exhibition in London, whenever I collect my works together for that purpose—as I mean to do at some date, I hope not very distant, but probably not for a year or two yet.'

106. Cited in Scott, *Autobiographical Notes*, vol. 1, p. 29.

107. Cited in Newman and Watkinson, *Ford Madox Brown*, p. 98. From a letter of April 6, 1856.

108. Colin Trodd, 'The authority of art: cultural criticism and the idea of the Royal Academy in mid-Victorian Britain,' *Art History*, 20 (1), March 1997, 6.

109. Hunt, *Pre-Raphaelitism and the Pre-Raphaelite Brotherhood*, vol. 2, pp. 109–10.

110. John Guille Millais, *Life and Letters*, vol. 1, p. 215.

111. P.J. Cornfield, *Power and the Professions in Britain 1700–1850*, London and New York: Routledge, 1990, p. 186.

112. H. Byerley Thompson, *The Choice of a Profession*, London: Chapman and Hall, 1857, p. 4.

113. John Everett Millais, letter to Euphemia Millais, May 13, 1859, in John Guille Millais, *Life and Letters*, vol. 1, p. 346. Earlier that year, Millais had attributed the slow sale of his work to it not being 'vulgar enough for the city merchants' (April 7, 1859, *ibid.*, p. 339).

114. John Everett Millais, letter to Euphemia Millais, May 28, 1861, in *ibid.*, p. 363. For example, Millais here records dining with Lord Lansdowne.

115. Dante Gabriel Rossetti, letter to Ford Madox Brown, March 28, 1865, in Dante Gabriel Rossetti, *Letters*, vol. 2, p. 549.

116. John Guille Millais, *Life and Letters*. In 1856, for example, he wrote to his wife that 'nothing could be better,' for not only was *Autumn Leaves* well placed, he had also been congratulated by Landseer and Grant (April 29, 1856, vol. 1, p. 296).

117. John Everett Millais, letter to Euphemia Millais, May 2, 1860, in *ibid.*, p. 356.

118. Maas, *Gambart*, p. 126. Gambart paid £1000 for *The Black Brunswicker*.

119. Schroeder, 'Edouard Manet,' p. 47.

Millais in reproduction

Malcolm Warner

Pre-Raphaelite art was born into an age of mass reproduction. The boom in illustrated newspapers, magazines, and books in mid-nineteenth-century Britain, along with developments in the technology of printmaking and printing, profoundly affected the reception and experience of art among its various publics. Reproduction has been integral to almost all writing about art since that time, supporting art criticism and in some ways playing an interpretative role of its own. The case of John Everett Millais, probably the most widely and variously reproduced of all the Pre-Raphaelite artists, reveals much about the power of reproduction, both in the way Pre-Raphaelitism has been disseminated and understood, and in the workings of the modern art world generally. It shows how reproduction, like criticism, can both foster and hinder the interpretation of works of art; how the particular works chosen for reproduction help shape our view of an artist; how the methods by which they are reproduced help shape our view of those works. On occasion, it shows the artist with an eye on reproduction while creating originals, bearing out Walter Benjamin's idea of 'the work of art designed for reproducibility.'[1]

The first of Millais's paintings to be reproduced seems to have been *Christ in the House of His Parents (Christ in the Carpenter's Shop)* (1849–50, Tate, London): a wood-engraving appeared in the *Illustrated London News* on May 11, 1850, in a review of that year's Royal Academy exhibition (Figure 10.1). This may well have been the first reproduction of any Pre-Raphaelite painting anywhere. The review pages of the *Illustrated London News* captured the spirit of curious juxtaposition and general rough-and-tumble of the Royal Academy exhibitions themselves, and the text around the images suggested the buzz of visitor and critical comment on the works on display. Perhaps not completely by accident, the Millais shared a page with a prime example of the brand of highly conventional British painting that the Pre-Raphaelites despised and were defining their own style against,

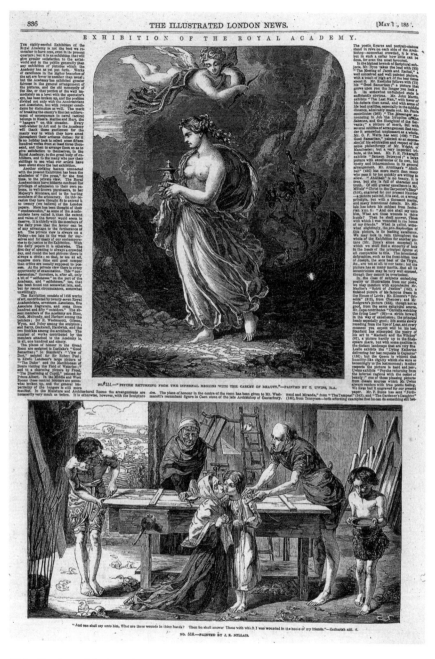

10.1 Review of the Royal Academy exhibition, *Illustrated London News*, May 11, 1850, 336, with wood-engraving after John Everett Millais, *Christ in the House of His Parents (Christ in the Carpenter's Shop)* (bottom)

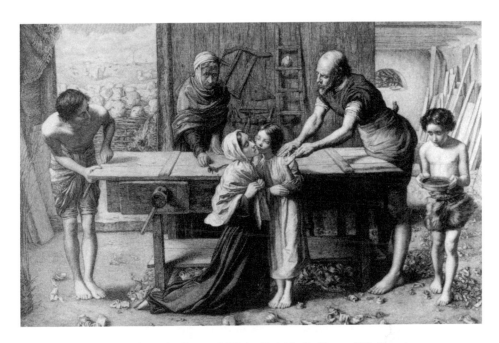

10.2 Ludwig Gruner, after John Everett Millais, *Christ in the House of His Parents*
(Christ in the Carpenter's Shop), steel-engraving, published by Moore, McQueen & Co.,
1868

Thomas Uwins's *Psyche Returning from the Infernal Regions with the Casket of
Beauty* (current location unknown).

The review was relatively favorable towards Millais, even praising him
for the 'sincerity of look' in the heads.[2] But the wood-engraving added a
crudeness of line to the image that emphasized what many perceived as a
wilful deformity in the original. *Punch* remarked that the figures in the painting
looked like 'mere portraits, taken from life at the Orthopaedic Institution,'
and Charles Dickens's attack on the representation of the Holy Family as ugly
and diseased is well known.[3] Whether conscious of such responses or not,
the anonymous wood-engraver of the *Illustrated London News* did to Millais's
painting what he or his fellow-engraver did not do to Uwins's, simplifying and
broadening almost to the point of caricature. Although the *Illustrated London
News* was sympathetic to Millais and his friends, it seems likely that by putting
reproductions such as this into wide circulation—many more people would
see the wood-engraving than the original painting—the newspaper helped
fuel the scandal surrounding the Pre-Raphaelites' first exhibited works. When
the same painting was reproduced again in 1868, in the more refined form of
a steel-engraving, it was under the artist's control, and he made sure that the
faces emerged as softer and more attractive (Figure 10.2).

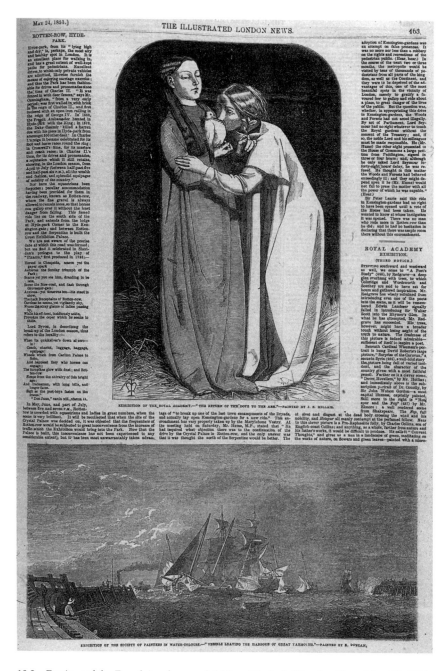

10.3 Review of the Royal Academy exhibition, *Illustrated London News*, May 24, 1851, 463, with wood-engraving after John Everett Millais, *The Return of the Dove to the Ark* (top)

The painting by Millais that the *Illustrated London News* chose to illustrate in its Royal Academy review of 1851 (Figure 10.3), the year after *Christ in the House of His Parents*, was *The Return of the Dove to the Ark* (1851, Ashmolean Museum, Oxford). To appreciate the extent of the discrimination and interpretation involved in such reproductions, one need only compare the harsh simplification of line and modeling in the Millais to the relatively subtle tones in the other reproduction on the same page, after a watercolor by Edward Duncan. Apparently the wood-engraver took the archaic qualities of the Millais as a cue to make something more like a fifteenth-century German woodcut than a modern reproduction. Again, the result can have done little to counter the popular idea that Pre-Raphaelitism was all about deliberately ugly faces. *Punch* published a parody of the *Illustrated London News*'s Royal Academy review in this year (Figure 10.4), and it featured another Millais in the show, *Mariana* (1850–51, Tate, London). The text offered mock praise to Millais for explaining the Tennyson poem from which the subject is taken: obviously the reason the longed-for gentleman 'cometh not' is that Mariana is so dreary-looking. Parodies like those in *Punch* are a special form of reproduction, but they are reproductions nonetheless. Often they were the only reproduction available for many years. Together with the *Illustrated London News* wood-engravings, they did much to spread the idea of the Pre-Raphaelites as provocative extremists.

Millais had his first major critical success with *A Huguenot* (1851–52, The Makins Collection), a scene from the St Bartholomew's Day Massacre, which was shown at the Royal Academy in 1852. As ever, for almost all the critics the focus of attention was the treatment of the faces. The *Illustrated London News*, which again featured a wood-engraving of the work, called the girl's expression 'a look of mild entreaty and earnest soul-wrapped affection' and 'a masterpiece of study and execution.'[4] Millais's great painting of *Ophelia* (1851–52, Tate, London) was in the same exhibition, but it was *A Huguenot*, with its touching story of star-crossed love and good-looking characters—good-looking even in the *Illustrated London News* wood-engraving—that stole the show and set Millais on his way to becoming the most popular living British artist.[5] One measure of the success of the work was that, as we shall see later in this chapter, it was to be published as a mezzotint engraving.

It was four years before another reproduction of a Millais appeared in the *Illustrated London News*, by which time Millais had become enough of a name to exercise some control over the process. For the full-page wood-engraving of *Autumn Leaves* (1855–56, Manchester City Art Galleries) that appeared in August 1856, he himself drew the heads of the girls on the woodblock, which was then cut by the highly skilled Henry Duff Linton.[6] The result is clearly superior to all previous efforts. *Autumn Leaves* was one of the pictures Millais showed at the Art Treasures exhibition in Manchester in 1857,

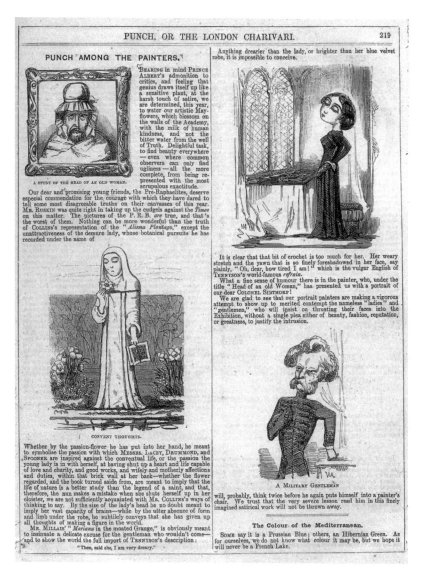

10.4 'Punch Among the Painters,' *Punch*, 20, 1851, 219, with parody of John Everett Millais, *Mariana* (top right)

and the illustration of it in the souvenir book of the show published by Cassell's was Linton's reduced copy of his own *Illustrated London News* wood-engraving of the year before—a reproduction of a reproduction.[7] The telltale similarities are details such as the treatment of the smoke on the left of the composition, which is just the kind of effect in a painting

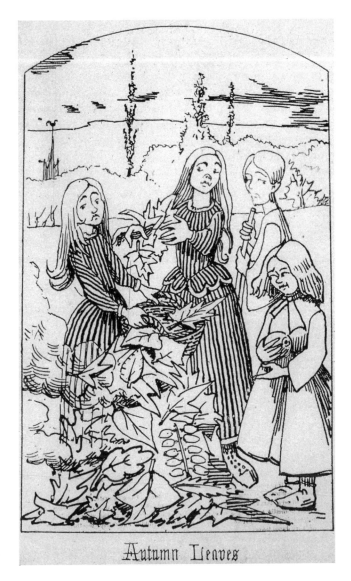

10.5 Parody of John Everett Millais, *Autumn Leaves*, from J.B. Waring, *Poems Inspired by Certain Pictures at the Art Treasures Exhibition, Manchester, by Tennyson Longfellow Smith ... etc.*, 1857

that presented problems of translation in the linear technique of wood-engraving.

One J.B. Waring published a book of comic poems on the Pre-Raphaelite pictures at the Manchester exhibition, each accompanied by a wood-engraved parody (Figure 10.5). The poem on the Tennysonian *Autumn*

Leaves was, appropriately enough, a spoof of Tennyson. Despite the artist's efforts, first to paint beautiful faces, then to make sure the beauty survived reproduction, the objects of the ridicule in both poem and print were the girls' faces. In contrast to the soft, rounded, 'Raphaelite' ideal that dominated early Victorian taste in feminine beauty, their features appeared hard and angular. It was not just their perceived plainness, but their plainness as set off by the lugubriousness of their expressions. The parodist turned the girls' noses up for plain and their mouths down for lugubrious, with the supposed origins of both—a morbidity bred of medievalism—hinted at in the Gothic lettering beneath.

The most elaborate parody of a Millais painting to be published was Frederick Sandys's well-known zincotype, *A Nightmare*, based on the artist's chief work at the Royal Academy exhibition of 1857, *A Dream of the Past: Sir Isumbras at the Ford* (1856–57, Lady Lever Art Gallery, Port Sunlight, Merseyside). It was issued during the exhibition as a single sheet rather than in a magazine or book. Here the butt of the satire was not Millais's painting *per se* but the Pre-Raphaelite group and its critical champion John Ruskin. The horse in the painting—whose size and prominence were much ridiculed in the press—became a braying ass branded 'J R OXON,' the knight became Millais, and the children with him became Dante Gabriel Rossetti and William Holman Hunt. Despite the broad humor of these transformations, Sandys rendered the dusky landscape background with subtlety and respect for the original. Mixing parody with appreciative reproduction in this way, his print implied a mixed response to Millais, one that had become commonplace in newspaper and magazine reviews: the Ruskinian pursuit of truth had led him into absurdities, but he was undoubtedly capable of great things.[8]

The early reproductions and parodies of Millais's paintings were ephemeral, but from 1856 his work began to appear in the more lasting and prestigious form of the mezzotint engraving. It is not surprising that his mezzotint debut was with what remained his most popular work, *A Huguenot*. Unlike the journalistic wood-engravings in the *Illustrated London News*, mezzotints were both reproductions and works of art in their own right. Although the engravers did not enjoy the status of the painters whose work they reproduced, they were certainly names, and people admired them as craftsmen, even as artists. The technique they used was known more strictly as 'mixed method:' the design was fairly fully laid down in etched line and stipple, then mezzotint used to provide the rich, velvety tones that so well represent painterly effects in the original. Mezzotints were fairly large—the *Huguenot* print is 25¼ inches tall—and intended for framing. By Millais's time their production, marketing, and distribution were a highly evolved and lucrative enterprise. Like most painters, Millais was keen to break into the mezzotint market. But financially he had to put *A Huguenot* down to experience. When he sold the original

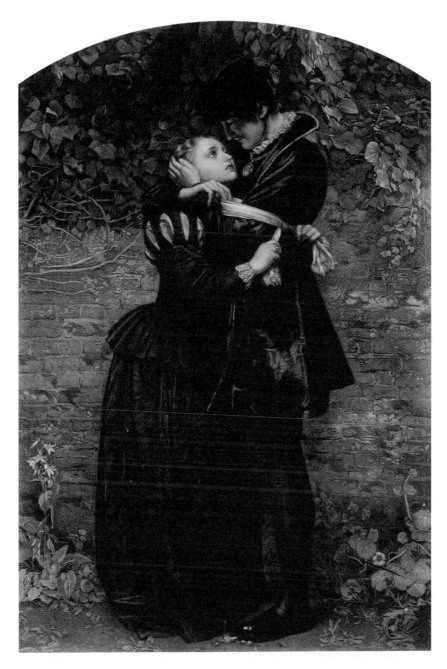

10.6 Thomas Oldham Barlow, after John Everett Millais, *The Huguenot*, mezzotint, published by D.T. White and Henry Graves, 1856

painting to the dealer David Thomas White, he did so for a good price, £250, but without reserving the copyright; this meant that the ownership of the copyright went, with the painting itself, to White. Recognizing the saleability of the painting as a print, White took it to the leading print publisher Henry Graves; they engaged the brilliant engraver, Thomas Oldham Barlow, changed the title from *A Huguenot* to *The Huguenot*, and co-published what turned out to be a highly successful print (Figure 10.6). White and Graves must have made £500 each from the venture. White gave Millais £50 for the sake of friendly relations, but it was a galling experience for the artist and he was much more careful about copyright from this point onward.[9]

On the same day as *The Huguenot*, Graves also published *The Order of Release* (Figure 10.7), after the painting Millais had shown at the Royal Academy in 1853 (1852–53, Tate, London). In this case Millais did reserve the copyright; he sold the painting to a collector for £400, then sold the copyright to Graves for 300 guineas (£315).[10] Though a one-time payment—Millais's income from prints always took the form of lump sums for copyrights, never royalties—this represented a solid increase in his return on the time and energy invested in the original. Looking at *The Order of Release*, one might wonder if Millais consciously designed a painting that would work well as a print. Certainly it had the main ingredients that pleased publishers, a touching storyline and an attractive female face, but there was a further aspect to its reproducibility. In the translation from a painting in colors to a smaller, monochromatic print, an image crowded with figures and objects (*Christ in the House of His Parents*, for instance) tended to lose its articulation and become mushy. Here the way the figures stood out boldly from an almost blank background made the image actually stronger as a print than as a painting—and there could hardly exist a more suitable vehicle for the mezzotint's velvety tones than the shiny coat of the dog at center stage. Flatteringly for Millais, Graves had *The Order of Release* engraved by the senior statesman of mezzotint engravers, Samuel Cousins. The *Illustrated London News* published the work as a wood-engraving too, but Graves made them wait until after the publication of his mezzotint. The wood-engraving was made from the mezzotint; it appeared with its own puff article rather than as an illustration to a review, and the text—which describes the woman's face as a 'triumph of tenderness'— was practically an advertisement for the mezzotint.[11] The enterprising Graves was to enjoy a virtual monopoly of prints after Millais throughout the 1850s and 1860s; he published 13 of them during that time, latterly at a rate of one a year.[12]

In a sense the mezzotints were limited editions, and in a sense they were not. There was an issue of what were called 'proofs;' these were impressions from fairly early in the print run rather than working proofs. *The Huguenot* and *The Order of Release* were issued in 950 proofs each, half signed by the artist and half unsigned. The signed proofs cost eight guineas (£8-8s); the

10.7 Samuel Cousins, after John Everett Millais, *The Order of Release*, mezzotint, published by Henry Graves, 1856

unsigned ones cost five guineas (£5-5s) with the title and so on printed underneath, and six guineas (£6-6s) without, since the absence of the 'letters' guaranteed an earlier impression. Then there was the actual edition 'as

published.' The size of this was not publicly declared like that of the issue of proofs and seems to have been limited only by the durability of the plate; in the cases of *The Huguenot* and *The Order of Release*, it was probably a further thousand or so impressions, and they were priced at two or three guineas (£2-2s or £3-3s) apiece.[13]

Like all publishers Graves sought to capitalize on successes and joined the dealers in encouraging Millais to follow *The Huguenot* with follow-up after follow-up. This was not just because the theme of love in adversity was such a good hook in itself, but also because people were more likely to buy a print if it made a good pair to one they already owned. One of the reasons why *The Black Brunswicker* (1859–60, Lady Lever Art Gallery, Port Sunlight, Merseyside) sold better as a mezzotint than *The Order of Release* may have been that it made a better pendant to *The Huguenot*.[14] Another variation on the same theme was *The Proscribed Royalist* (1852–53, Lloyd-Webber Collection), the mezzotint after which is probably the clearest example of how the faces of Millais's characters were subtly prettified in the mezzotints just as they were distorted in the early wood-engravings.[15] Through the mezzotint reproductions Millais was reaching a wide audience, but only with a certain, marketable kind of painting. Much of his more progressive, less immediately appealing early work—notably the series of subjectless mood-paintings beginning with *Autumn Leaves*—never appeared in mezzotint form.

Millais's art changed in many ways around 1870, and this was certainly the case with his face to the world in reproductions. The mezzotint after his painting *Yes or No?* (1871, Yale University Art Gallery, New Haven, CT) was a landmark print for him in that it was the first to be published by Thomas Agnew & Sons—in 1873. Agnew's was to be Millais's main publisher from that year until 1890, bringing out 25 prints after his paintings.[16] A scene of a young woman considering a proposal of marriage, *Yes or No?* was a highly engravable picture because it cried out for a sequel. Millais and Agnew's actually produced two: *No!* appeared in 1877, followed, in response to popular demand, by *Yes!* in 1878.[17] All three works in the series were engraved by Samuel Cousins. Figure 10.8 shows Cousins's mezzotint of *Yes or No?* as reproduced in the first Millais picture book, *The Millais Gallery*, published in Boston in 1878, in which the plates were all made from existing mezzotints by the photomechanical process of heliotype. This American publication also has the distinction of being the first to include close-up details of the artist's works.[18]

The Millais who comes through in Agnew's prints is, above all, the Millais of the fancy picture, the figure of a beautiful young woman or child (it is usually a single figure), involved in some activity or anecdote but with none of the serious historical drama of *The Huguenot* and its progeny. By this stage Millais was no longer a Pre-Raphaelite in the original sense of the term. He had become a painter of the Aesthetic movement, closer artistically to Whistler

10.8 Samuel Cousins, after John Everett Millais, *Yes or No?*, mezzotint, published by Thomas Agnew & Sons, 1873, as reproduced in heliotype in *The Millais Gallery*, Boston, 1878

than, say, to his old friend Holman Hunt. Millais's fancy pictures were a way of being Aesthetic and at the same time—*unlike* Whistler—insistently British. He paid open tribute to the Old Masters of the British School, Reynolds and Gainsborough, by making many of his fancy pictures eighteenth-century costume pieces—for instance *New-Laid Eggs* (1873, private collection) and *Stella* (1868, Manchester City Art Gallery), published as mezzotints by Agnew's

in 1875 and 1876 respectively. What more suitable modern paintings could there be for reproduction in mezzotint, which was how eighteenth-century portraits had themselves been reproduced? While publishing works in which Millais imitated Reynolds and Gainsborough, moreover, Agnew's was also publishing actual Reynoldses and Gainsboroughs. Their first venture in this line was Samuel Cousins's print after Reynolds's *The Strawberry Girl* (1773, the Wallace Collection, London), published in 1873—the very year they published their first Cousins after Millais, *Yes or No?*[19]

Millais signed no long-term or exclusive contracts with his publishers. In a typical year when he was mainly with Agnew's, they would publish one or two prints, and one would be published by another house, usually Thomas McLean's, Arthur Tooth's or the Fine Art Society. Because they dealt in his paintings as well as the prints after them, Agnew's would buy painting and copyright together. Typically a quarter to a third of the total amount would be for copyright. For the long-awaited *Yes!*, they paid Millais a total of £2,000 (more or less the top end of his scale), of which £1,400 was for the painting itself and £600 for the copyright.[20] Artists sold individual copyrights for greater sums than this, especially when publishers anticipated blockbuster prints with editions in the fives and tens of thousands, such as those after Frith's *The Railway Station* (published 1862) or Hunt's *The Finding of the Saviour in the Temple* (published 1867).[21] Many thousand of prints after Millais were made and sold *in toto* but in less enormous numbers per edition, normally one to two thousand including both proofs and the edition 'as published.' His strength commercially was not getting a fortune for any particular copyright, just selling more copyrights than most of his rivals. To put this in the perspective of his income as a whole, by the 1870s he was earning some £10,000 per annum, of which £1,000 came from the sale of copyrights.[22]

Alongside the fancy pictures, the mezzotint publishers also brought out a number of Millais's portraits of great and famous men of the age. In 1881 Agnew's published Thomas Oldham Barlow's mezzotint after his first portrait of Gladstone (1878–79, National Portrait Gallery).[23] Again the dark, amorphous background that Millais used in most of his works of this type was probably, to some degree, a device to make for a strong print. Occasionally a portrait would be published in the form of a free, spontaneous-looking etching or drypoint, rather than the usual intensively worked mezzotint. This kind of print was considered a more high-brow means of reproduction than mezzotint. It was associated with sophisticated, often foreign artists—such as James Tissot—and the kind of Millais that was treated in such a technique tended to be a self-portrait or portrait of a fellow artist such as James Clarke Hook.[24] When the bleak, moody landscapes of his later career were published, beginning with *Chill October* (1870, Lloyd-Webber Collection), they too tended to be etched (Figure 10.9).

10.9 Alfred Brunet-Debaines, after John Everett Millais, *Chill October*, etching, published by Thomas Agnew & Sons, 1883

Again, it is worth noting that much of the best of Millais's work was never reproduced at all, and that his reputation suffered as a result, both in his lifetime and after. One of the outstanding works in the Millais portraits exhibition at the National Portrait Gallery in 1999 was *Twins* (1875–76, private collection), a double portrait of Kate and Grace, the daughters of Thomas Rolls Hoare. The chief reason why this particular work was chosen for the cover of the exhibition catalogue was that it had never before been reproduced, in any form, either in the nineteenth or in the twentieth century. This private kind of portrait, shown at the Grosvenor Gallery then returned to the sitters' family and hardly seen in public again, dropped rapidly out of the artist's known *oeuvre* — an example of how the vagaries of reproduction can throw out of balance the form in which an artist's work comes down to posterity.

Millais died in 1896, and his son John Guille Millais's two-volume biography, *The Life and Letters of Sir John Everett Millais, President of the Royal Academy*, appeared in 1899. The illustrations remain the largest published collection of reproductions after Millais. As in the *Illustrated London News* reviews, they served to complement a text — except that now the text

represented the artist himself, through his letters and stories of his life, rather than the voice of critical comment. Many drawings were reproduced, to enhance the idea of a look behind the scenes. The by-now famous painting was presented not so much in relation to the work of other artists of the time, as in a public exhibition like the Royal Academy, but in relation to the artist himself, his private life, thoughts, and working processes. Some paintings appeared in reproduction for the first time. *A Dream of the Past: Sir Isumbras at the Ford*, for instance, had for over 40 years been available only in the Sandys parody.

The illustrations in *The Life and Letters* were photomechanical. They consisted of 300-or-so half-tones and eight plates made by the higher-grade process of photogravure. In some ways they were a footnote to the mezzotint phase of Millais's reproduction history. All were monochromatic, of course, and many were photographed from the mezzotints rather than from the original paintings. John Guille Millais also made use of Rupert Potter's photographs showing later works in various stages of completion in the artist's studio. This was interesting enough when he identified them as such, but in a good many cases he either failed to realize that the painting in question was unfinished or thought it not worth noting. Certainly it has not enhanced the reputation of Millais's later pictures. Even when the photographs were made from the finished originals, it must be said, the results were generally dismal. Probably there were technical and economic reasons why there were no color reproductions in *The Life and Letters*, or indeed any of the other books on the Pre-Raphaelites published around this time. But it seems that there was also a drag effect that made dingy monochrome acceptable for longer than it should have been. Thanks to the mezzotint, the monochromatic tradition of reproduction was long established: the mezzotint was a reproduction that was a work of art in itself; it conjured up the grace and refinement of eighteenth-century British culture; its lack of color seemed part of its dignity. Black and white photomechanical reproduction seemed to be continuing that tradition.

Methods of reproducing paintings in color certainly existed by the time of *The Life and Letters*, and a handful of Millais's paintings had been part of the world of color reproduction for 20 years. Between 1878 and 1887, five of his later child fancy pictures, including the emphatically Reynoldsian *Cherry Ripe* (1879, private collection) appeared in color in the Christmas supplements to the *Illustrated London News* and the *Graphic* magazine. The Christmas supplement reproductions were chromoxylographs, printed from a number of wood relief blocks; they occupied double-page spreads and so were about the same frameable size as the mezzotints. After they were published in the supplements, the copyrights of these works were, in a couple of cases, including *Cherry Ripe*, bought by Pears' Soap. Figure 10.10 shows not the chromoxylograph from the *Graphic* but the chromolithograph

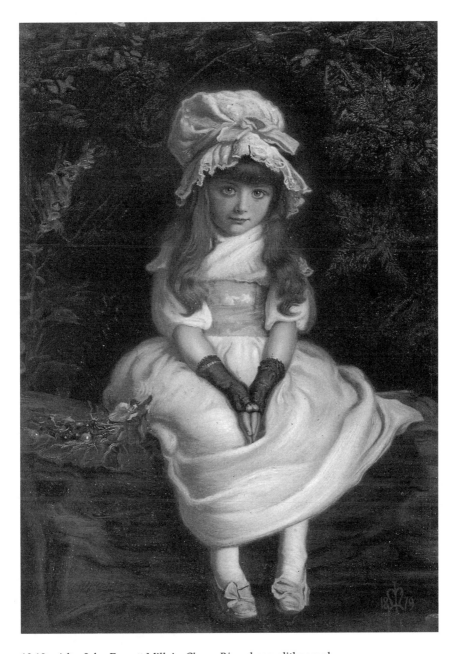

10.10 After John Everett Millais, *Cherry Ripe,* chromolithograph,
Pears Annual, 1897

published by Pears in their own *Pears Annual* in 1897. With these early color prints, as often with the mezzotints, deliberate changes were made in the translation from painting to reproduction: features were simplified and made more obvious, in both expression and prettiness, and there was often some trimming of supposedly superfluous background.

The early color prints after Millais, whether chromoxylographs or chromolithographs, were pitched at a different audience from that for the mezzotints. Whereas a mezzotint cost at least two guineas, you could become the owner of one (or sometimes more than one) of the color prints simply by buying a Christmas supplement or *Pears Annual*, which cost a mere shilling or so. *Cherry Ripe* first appeared in the supplement to the *Graphic* for Christmas 1880. 500,000 copies were printed, and the issue sold out.[25] The familiar *Bubbles* (1885–86, Unilever PLC) also made its debut as a Christmas supplement color print, in the *Illustrated London News* in 1887. As a boy subject, the composition was not expected to do as well as girl subjects had been doing and was printed on a smaller scale than usual; it was one of four color prints, each a quarter the usual size, and the other three were by other artists. What brought *Bubbles* the largest audience of any reproduction after Millais in the artist's own lifetime, and the enormous fame it has enjoyed ever since, was its subsequent commercial use by Pears' Soap (Figure 10.11). For many years reproductions of it featured prolifically in various types and sizes of Pears advertisements and publications, including the same *Pears Annual* as *Cherry Ripe* in 1897.[26]

The first color reproductions after Millais were sweet and ingratiating child subjects of the kind that high-brow audiences since the artist's own time have found hard to take: *Cherry Ripe* and *Bubbles*, along with *Puss-in-Boots* (1877, Dundee Art Gallery), *Cinderella* (1881, Lloyd-Webber Collection), and *Little Miss Muffet* (1884, current location unknown).[27] They were associated with triumphant mass marketing on the part of the magazines and Pears, and clearly aimed at a less sophisticated as well as less affluent audience than the mezzotints. The mezzotints were dignified works of art in their own right; whereas they *reproduced* oil paintings, the early color prints—the magazine prints with their laden, sometimes almost pizza-like surfaces, the *Pears Annual* prints with their textured surfaces intended to suggest brushwork and canvas—were trying to *be* oil paintings.

The use of *Bubbles* to advertise Pears' Soap set a seal on the association of Millais in color with the most blatant commercialism. The chairman of Pears, Thomas Barrett, was very much alive to the rewards of what he called 'artistic advertising.' How many hundreds of thousands of times *Bubbles* was reproduced—in posters, placards, postcards, and magazine advertisements (always in chromolithograph apparently)—is unknown, but Barrett claimed to have spent the huge sum of £30,000 on the total *Bubbles* campaign. One of the finer points of Victorian copyright law was that the owner of

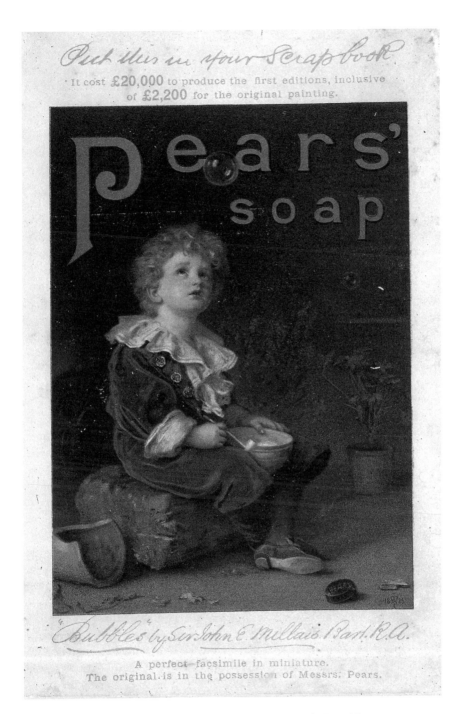

10.11 After John Everett Millais, *Bubbles*, chromolithograph, Pears' Soap
advertisement, c. 1890

a copyright needed the artist's permission to reproduce the work of art in an altered state—with the addition of a bar of Pears' Soap, for instance. So Millais must have approved of the Pears advertisements, despite the claims to the contrary made after his death by his son John Guille, author of the dismally illustrated two-volume biography, and a body called the Society for Checking the Abuses of Public Advertising.

There were a few outbreaks of color reproduction of Millais in the early twentieth century. A small book by Alfred Lys Baldry in the series 'Masterpieces in Colour' appeared in 1908, and a larger one by Arthur Fish was published in New York in 1923. Neither had much impact on the general slump in the artist's reputation following his death. The great revival of Millais and the Pre-Raphaelites in color reproduction went together with the Pre-Raphaelite revival of the 1960s; indeed the two things were inseparable. The present author's own first memories of Millais's work are from a gloriously colorful picture book with text by Keith Roberts, published in 1967 in a part-work called 'The Masters,' and Jeremy Maas's influential *Victorian Painters* of 1969 featured a sumptuous color plate of *Mariana*. Nowadays, like all the Pre-Raphaelites, Millais is well known and well loved in color. *Bubbles* remains popular, but the Millais that is most popular in reproduction today is probably *Ophelia*, the more extravagantly colorful work that he showed at the same Royal Academy exhibition as the *Huguenot* picture, though to lesser acclaim. *Ophelia* is invariably among Tate Britain's best-selling postcards and posters, and usually near the top of the list.

The old association of monochrome and classiness—which lingered on into the 1960s and 1970s in some academic quarters—has worn off. Students and art lovers are now taught about the Pre-Raphaelites from color slides and Power Point images, which play up the raw brilliance of their painting. The bright color image projected on a white screen replicates the Pre-Raphaelite idea of floating colors over a wet white ground to achieve an effect of luminosity. Projected images and other reproductions of close-up details are in common use, and through them we convey the idea of Pre-Raphaelite pictures as yielding their meaning vividly, piece by piece. With every change in reproduction technology there are winners and losers among the artists, and Millais was certainly on the winning side in the color revolution of the 1960s. Before this, color was hardly part of the picture, and when it did come in, with the Christmas supplements and soap advertisements, it promoted him at his weakest artistically. Describing his early painting of *The Return of the Dove to the Ark*, the reviewer of the *Illustrated London News* referred to the accompanying wood-engraving and lamented: 'Our readers can see the sentiment conveyed; we wish they could see the colour—such robes of green and purple and white—so much to admire, and so much to be offended with.'[28] Now the broad audience for reproductions does see the color, in all its admirable, offensive glory.

Notes

1. Walter Benjamin, 'The work of art in the age of mechanical reproduction,' in Benjamin, *Illuminations*, 1936, translated by Harry Zohn and edited with an introduction by Hannah Arendt, New York: Schocken Books 1969, p. 226.

2. *Illustrated London News*, 16, May 11, 1850, 336.

3. *Punch*, 18, 1850, 198. Dickens's comments appeared in *Household Words*, June 15, 1850, 265–6.

4. *Illustrated London News*, 20, May 8, 1852, 368.

5. When he showed *The Order of Release* (1852–53, Tate, London) at the Royal Academy exhibition of the following year, it attracted 'a larger crowd of admirers … than all the Academicians put together,' *Illustrated London News*, 22, May 7, 1853, 350. It was said to be the first painting to require a policeman to keep the crowd moving. John Guille Millais, *The Life and Letters of Sir John Everett Millais, President of the Royal Academy*, 2 vols, London: Methuen & Co., 1899, vol. 1, p. 184. By the time Emilie Isabel Barrington published her article 'Why is Mr Millais our popular painter?,' his popularity was assumed as part of his artistic identity. *Fortnightly Review*, 30 o.s., n.s. 32, July 1, 1882, 60–77.

6. Henry Duff Linton was the younger brother of William James Linton, one of the leading wood-engravers of the period.

7. *John Cassell's Art Treasures Exhibition*, exh. cat., London: W. Kent & Co., 1858, p. 48.

8. For further information on the Sandys parody, see Betty Elzea, *Frederick Sandys 1829–1904: A Catalogue Raisonné*, Woodbridge, Suffolk: Antique Collectors' Club, 2001, pp. 130–33.

9. See John Guille Millais, *Life and Letters*, vol. 1, p. 147.

10. A copy of the contract between Millais and Graves is at the British Library, Add. Ms. 46140, f. 230.

11. *Illustrated London News*, 29, October 25, 1856, 423.

12. See 'The engraved pictures of Sir J.E. Millais, Bart., P.R.A.,' in M.H. Spielmann, *Millais and His Works*, Edinburgh and London: William Blackwood & Sons, 1898, pp. 179–81.

13. See *An Alphabetical List of Engravings Declared at the Office of The Printsellers' Association, London, … Since its Establishment in 1847 to the End of 1885: Compiled by the Secretary, G.W. Friend*, London: Printed for the Printsellers' Association 1886, with supplementary monthly lists.

14. Thomas Lewis Atkinson's mezzotint after *The Black Brunswicker* was published jointly by Graves and Moore, McQueen & Co. in 1863. On the demands of publishers and dealers for compositions like *A Huguenot*, see Millais's letter to his wife, May 17, 1859 in John Guille Millais, *Life and Letters*, vol. 1, p. 348.

15. William Henry Simmons's mezzotint after *The Proscribed Royalist* was published by Ernest Gambart in 1858.

16. See *An Alphabetical List of Engravings*.

17. The current location of the painting *No!* is unknown. *Yes!* is in a private collection.

18. *The Millais Gallery: A Series of the Most Renowned Works of Millais, Reproduced in Heliotype, with a Sketch of the Life and Works of the Artist by E. Brainerd*, Boston: James R. Osgood and Company, 1878.

19. See William Plomer, 'Agnew's as publishers of prints and printsellers,' in Geoffrey Agnew (ed.), *Agnew's, 1817–1967*, London: Bradbury Agnew Press, 1967, p. 65.

20. Thomas Agnew & Sons, stock book, August 7, 1877.

21. On these blockbusters, see, respectively, Jeannie Chapel, *Victorian Taste. The Complete Catalogue of Paintings at the Royal Holloway College*, London: Royal Holloway College, 1982, pp. 87–92, and *Great Victorian Pictures: Their Paths to Fame*, exh. cat., London: Arts Council, 1978, p. 46 (entry by Judith Bronkhurst).

22. The estimates of Millais's income are based on sources too numerous to cite individually; they include the artist's correspondence, both published and unpublished, and the invaluable records contained in Thomas Agnew & Sons' stock books.

23. Agnew's also published prints after Millais's portraits of John Bright (1882) and Cardinal Newman (1884). The Fine Art Society published prints after his portraits of Disraeli (1882), Tennyson (1882), and the Marquis of Salisbury (1887).

24. Otto Leyde's drypoint after Millais's portrait of Hook was published by the British and Foreign Artists' Association in 1884.

25. On the dissemination and popularity of *Cherry Ripe*, see Laurel Bradley, 'From Eden to empire: John Everett Millais's *Cherry Ripe*,' *Victorian Studies*, 34 (2), Winter 1991, 179–203.

26. On *Bubbles* and its use by Pears, see *Great Victorian Pictures*, exh. cat., p. 60 (entry by the present author); and Laurel Bradley, 'Millais's *Bubbles* and the problem of artistic advertising,' in Susan P. Casteras and Alicia Craig Faxon (eds), *Pre-Raphaelite Art in Its European Context*, Madison, NJ: Fairleigh Dickinson University Press and London: Associated University Presses, 1995, pp. 193–209.

27. Prints after *Puss-in-Boots*, *Cinderella*, and *Little Miss Muffet* appeared in the *Illustrated London News* Christmas supplements of 1878, 1882, and 1886 respectively. The only non-child subject to appear in this form was *The North-West Passage* (1874, Tate, London), in the *Illustrated London News* Christmas supplement of 1885.

28. *Illustrated London News*, 18, May 24, 1851, 464.

Bibliography

Primary sources (before 1918)

Allingham, H. and Williams, E.B. (eds), *Letters to William Allingham*, London and New York: Longman, Green & Co., 1911.

An Alphabetical List of Engravings Declared at the Office of The Printsellers' Association, London, … Since its Establishment in 1847 to the End of 1885: Compiled by the Secretary, G.W. Friend, London: Printed for the Printsellers' Association, 1886.

Angeli-Dennis Papers, Special Collections, University of British Columbia Library.

Armstrong, W., *Sir J.E. Millais, Bart, RA: His Life and Work*, London: J.S. Virtue and Co., 1885.

'Art and the Royal Academy,' *Fraser's Magazine*, 46, August 1852, 230.

Atkinson, J.B., 'Contemporary art—poetic and positive: Dante Gabriel Rossetti and Alma-Tadema—Linnell and Lawson,' *Blackwood's Magazine*, 133, March 1883, 392–411.

——, 'The decline of art: Royal Academy and Grosvenor Gallery,' *Blackwood's Magazine*, 138, July 1885, 1–25.

——, 'The state of art in England,' *Blackwood's Magazine*, 131, May 1882, 609–22.

[Austin, Alfred], 'The poetry of the period: Mr Swinburne,' *Temple Bar*, 26, July 1869, 457–75.

Baldry, A., *Sir John Everett Millais*, London: George Bell, 1899.

Barrington, E.I., 'Why is Mr Millais our popular painter?' *Fortnightly Review*, 30 o.s., 32 n.s., July 1, 1882, 60–77.

Bate, P., *The English Pre-Raphaelite Painters, Their Associates and Successors*, London: George Bell and Sons, 1899.

Bayliss, W., *Five Great Painters of the Victorian Era: Leighton, Millais, Burne-Jones, Watts, Holman Hunt*, London: Sampson, Low, Marston, 1902.

Bell, M., *Sir Edward Burne-Jones: A Record and Review*, 1892, rpt, London: George Bell and Sons, 1910.

Benson, A., *Rossetti*, London and New York: Macmillan & Co., 1904.

'The British Institution,' *Athenaeum*, February 14, 1852, 201.

Boyce, G.P., *The Diaries of George Price Boyce*, ed. V. Surtees, Norwich: Real World Publishers, 1980.

Brown, F.M., *The Diary of Ford Madox Brown*, ed. V. Surtees, New Haven and London: Published for the Paul Mellon Centre for Studies in British Art by Yale University Press, 1981.

_____ , *The Exhibition of Work, and Other Paintings, by Ford Madox Brown*, London: McCorquodale and Co., 1865.

Bryden, I. (ed.), *The Pre-Raphaelites: Writings and Sources*, 4 vols, London: Routledge/ Thoemmes Press, 1998.

Burne-Jones, G., *Memorials of Edward Burne-Jones*, 2 vols, London and New York: Macmillan & Co., 1904.

Carlyle, T., *Past and Present*, 1843, rpt, London: Dent and New York: Dutton, 1960.

_____ , *Sartor Resartus*, London: Sanders and Otley, 1838.

Carr, J.C., *Some Eminent Victorians: Personal Recollections in the World of Art and Letters*, London: Duckworth & Co., 1908.

Catalogue of the Exhibition of the National Institution of Fine Arts, London: G. Dewing, 1850.

Catalogue of the Institution for Promoting the Free Exhibition of Modern Art, London: J. Bradley, 1849.

Catalogue of the Works of British Artists in the Gallery of the British Institution, Pall Mall, for Exhibition and Sale, London: W. Nichol, 1847.

Chesneau, E., *The English School of Painting*, trans. L. Etherington, 1884, 4th edn, London: Cassell, 1891.

_____ , *Les nations rivales dans l'art*, Paris: Didier, 1868.

Collins, W., *The Law and the Lady*, 1875, ed. J. Taylor, Oxford: Oxford University Press, 1992.

_____ , 'The Exhibition of the Royal Academy,' *Bentley's Miscellany*, 29 (174), June 1851, 617–27.

Colvin, S., 'English painters and painting in 1867,' *Fortnightly Review*, 8 o.s., 7 n.s., October 1867, 464–76.

Coombs, J.H., Scott, A.M., Landow, G.P. and Sanders, A.A. (eds), *A Pre-Raphaelite Friendship: The Correspondence of William Holman Hunt and John Lucas Tupper*, Ann Arbor, Michigan: UMI Research Press, 1986.

Crane, W., *An Artist's Reminiscences*, London: Methuen, 1907.

Cunningham, A., *Great English Painters: Selected Biographies from Allan Cunningham's 'Lives of Eminent British Painters,'* arranged and edited, with an introduction, by W. Sharp, London: Walter Scott, 1886.

Delacroix, E., *The Journal of Eugene Delacroix*, trans. W. Pach, London: Jonathan Cape, 1938.

'Dudley Gallery Water-Colour Exhibition,' *The Times*, February 14, 1870, 4.

Dumas, F.G. (ed.), *Franco-British Exhibition: Illustrated Review*, London: Chatto and Windus, 1908.

Exhibition of Art Treasures of the United Kingdom held at Manchester in 1857: Report of the Executive Committee, Manchester: George Simms, 1859.

'The Exhibition of the Royal Academy,' *Bentley's Miscellany*, 29, June 1851, 617–27.

'Exhibition of the Royal Academy,' *Illustrated London News*, 20, May 8, 1852, 368–9.

Farrar, F.W. and Mrs Meynell, *William Holman Hunt: His Life and Work*, London: Art Journal Office, 1893.

'Fine Arts General Water-colour Exhibition,' *Illustrated London News*, 56, February 12, 1870, 180–82.

Ford, F.M. [Hueffer, F.M.], *Ford Madox Brown. A Record of his Life and Work*, London and New York: Longmans, Green & Co., 1896.

_____ , *Rossetti: A Critical Essay on his Art*, London: Duckworth, 1902.

The Germ: The Literary Magazine of the Pre-Raphaelites, preface by A. Rose, 1979, rpt, Oxford: Ashmolean Museum, 1992.

Gilchrist, A., *Life of William Blake, 'pictor ignotus': with Selections from his Poems and Other Writings*, London: Macmillan & Co., 1863.

Goethe, J.W. von, 'On realism in art' (1798), in *Essays on Art and Literature*, ed.
J. Gearey and trans. E. von Nardroff and E.H. von Nardroff, Princeton: Princeton
University Press, 1994.

Hake, A., *Regeneration: A Reply to Max Nordau*, London: Archibald Constable, 1896.

Hares-Stryker, C. (ed.), *An Anthology of Pre-Raphaelite Writings*, Sheffield: Sheffield
Academic Press, 1997.

Hogarth Club, *Hogarth Club Rules*, London: private publication, 1860.

Horne, H., *Alessandro Filipepi, Commonly Called Sandro Botticelli, Painter of Florence*,
London: George Bell & Sons, 1908.

_____ , 'Edward Burne-Jones,' *Morning Leader*, August 18, 1900, 4.

Hunt, W.H., *Pre-Raphaelitism and the Pre-Raphaelite Brotherhood*, 2 vols, London and
New York: Macmillan & Co., 1905; 2nd edn London: Chapman and Hall, 1913.

_____ , *William Holman Hunt's Letters to Thomas Seddon*, ed. G.P. Landow, Manchester:
John Rylands Library of Manchester, 1983; reprinted from the *Bulletin of the John
Rylands University Library of Manchester*, 66 (1), Autumn 1983, 139–72.

_____ , 'Painting *The Scapegoat*,' *Contemporary Review*, 52, 1887, 21–38, 206–20.

_____ , 'The Pre-Raphaelite Brotherhood: a fight for art,' *Contemporary Review*, 49, 1886,
471–88, Part II, 737–50, Part III, 820–33.

'The Hyde Park Gallery,' *Art Journal*, 11, April 1, 1849, 133–47.

La Sizeranne, R. de, *English Contemporary Art*, trans. H.M. Poynter, Westminster:
A. Constable, 1898.

_____ , 'In Memoriam: Edward Burne-Jones "Tribute from France",' *Magazine of Art*, 22,
1898, 513–21.

Maitland, T. [Buchanan, R.], 'The fleshly school of poetry: Mr D.G. Rossetti,' *The
Contemporary Review*, 18, October 1871, 334–50.

Marillier, H.C., *Dante Gabriel Rossetti: An Illustrated Memorial of His Art and Life*,
London: George Bell and Sons, 1899.

Maudsley, H., *Responsibility in Mental Disease*, London: Henry S. King and New York:
D. Appleton & Co., 1874.

Meier-Graefe, J., *Modern Art, Being a Contribution to a New System of Aesthetics*, 2 vols,
trans. F. Simmonds and G.W. Chrystal, London: W. Heinemann, 1908.

Millais, E.C.G., *Effie in Venice: Unpublished Letters of Mrs. John Ruskin Written from Venice
between 1849–1852*, London: John Murray, 1965.

*The Millais Gallery: A Series of the Most Renowned Works of Millais, Reproduced in
Heliotype, with a Sketch of the Life and Works of the Artist by E. Brainerd*, Boston: James
R. Osgood and Company, 1878.

Millais, J.G., *The Life and Letters of Sir John Everett Millais, President of the Royal Academy*,
2 vols, London: Methuen & Co., 1899.

Monkhouse, C., *British Contemporary Artists*, London: William Heinemann and New
York: Scribner's, 1899.

Muther, R., *The History of Modern Painting*, 3 vols, trans. A. Hillier, New York:
Macmillan & Co., 1896.

Newman, J.H., *Apologia pro Vita Sua*, London: Longman, Green, Longman, Roberts,
and Green, 1864.

Nordau, M., *Degeneration*, London: William Heinemann and New York: D. Appleton,
1895; translated from the second edition of the German work.

'"Our Critic" among the pictures,' *Punch*, 22, May 22, 1852, 216–17.

'"Our Critic" among the pictures. A cruise about the line,' *Punch*, 22, May 29, 1852,
232–3.

'"Our Critic" among the pictures. Something about some portraits and landscapes,'
Punch, 23, June 26, 1852, 7.

Palgrave, F., *Handbook to the Fine Art Collections in the International Exhibition of 1862*, London and Cambridge: Macmillan & Co., 1862.

Pater, W., *Appreciations: With an Essay on Style*, 1889, library ed., London: Macmillan & Co., 1915.

_____ , *The Renaissance: Studies in Art and Poetry*, London: Macmillan & Co., 1873; 4th edn, London: Macmillan & Co., 1893; rpt, New York: Random House Modern Library, 1961.

_____ , *Selected Writings of Walter Pater*, edited with an introduction and notes by H. Bloom, New York: Columbia University Press, 1974.

'Pathological exhibition at the Royal Academy. (Noticed by our surgical advisor.),' *Punch*, 18, May 18, 1850, 198.

Pennell, J. and Pennell, E., 'John Everett Millais, painter and illustrator,' *Fortnightly Review*, 66 o.s., 60 n.s., September 1896, 443–50.

[Phillips, S.], 'Exhibition of the Royal Academy. Second notice,' *The Times*, 20, May 7, 1851, 8.

Phythian, J.E., *The Pre-Raphaelite Brotherhood*, London: G. Newnes, 1905.

'Punch among the Painters,' *Punch*, 20, May 17, 1851, 219.

Quilter, H., *Giotto*, London: S. Low, Marston, Searle & Rivington, 1880.

_____ , *Preferences in Art, Life and Literature*, London: Swan Sonnenschein, 1892.

Radford, E., *Dante Gabriel Rossetti*, London: George Newnes, 1905.

Redgrave, R. and Redgrave, S., *A Century of Painters of the English School*, 1866, 2nd edn, London: Sampson, Low, Marston, 1890.

Renan, E., *The Life of Jesus*, London: Trübner & Co. and Paris: M. Lévy Frères, 1864.

Ross, R., 'Mr. Holman Hunt at the Leicester Galleries (an inspection),' in *Masques and Phases*, London: A.L. Humphreys, 1909.

Rossetti, C.G., *Poetical Works of Christina Georgina Rossetti*, ed. W.M. Rossetti, London: Macmillan & Co., 1906.

Rossetti, D.G., *The Collected Works of Dante Gabriel Rossetti*, ed. W.M. Rossetti, London: Ellis and Elvey, 1888; revised and enlarged as *The Works of Dante Gabriel Rossetti*, ed. W.M. Rossetti, London: Ellis, 1911.

_____ , *The Correspondence of Dante Gabriel Rossetti*, ed. W.E. Fredeman, 6 vols, Cambridge: D.S. Brewer, 2002–06.

_____ , *Letters of Dante Gabriel Rossetti*, eds O. Doughty and J.R. Wahl, 4 vols, Oxford: Clarendon Press, 1965-67.

_____ , *The Works of Dante Gabriel Rossetti*, ed. W.M. Rossetti, rev edn, London: Ellis, 1911.

Rossetti, W.M., *Dante Gabriel Rossetti as Designer and Writer*, London: Cassell & Co., 1889.

_____ , *The Diary of W.M. Rossetti 1870–1873*, ed. O. Bornand, Oxford: Clarendon Press, 1977.

_____ , *Fine Art, Chiefly Contemporary*, London: Macmillan & Co., 1867, rpt, New York: AMS Press, 1970.

_____ , *The Germ*, 1850, rpt, London: Elliot Stock, 1901.

_____ , *Præ-Raphaelite Diaries and Letters: Papers 1854 to 1862*, London: Hurst and Blackett, 1900.

_____ , *The P.R.B. Journal: William Michael Rossetti's Diary of the Pre-Raphaelite Brotherhood, 1849–1853*, ed. W.E. Fredeman, Oxford: Clarendon Press, 1975.

_____ , *Rossetti Papers, 1862–70: A Compilation*, London: Sands & Co., 1903.

_____ , *Ruskin, Rossetti, Pre-Raphaelitism: Papers 1854–1863*, London: George Allen and New York: Dodd, Mead & Co., 1899.

_____ , *Selected Letters of William Michael Rossetti*, ed. R.W. Peattie, University Park and London: The Pennsylvania State University Press, 1990.

_____ , *Some Reminiscences of William Michael Rossetti*, 2 vols, London: Brown, Langham & Co. and New York: Charles Scribner's Sons, 1906, rpt, New York: AMS Press, 1970.

_____ (ed.), *Dante Gabriel Rossetti: His Family-Letters with a Memoir by William Michael Rossetti*, 2 vols, London: Ellis and Elvey and Boston: Roberts Brothers, 1895.

_____ , 'The abstract and naturalism in art,' *Edinburgh Weekly Review*, February 28, 1857, 3–6.

_____ , 'Art-Exhibitions in London,' *Fine Arts Quarterly Review*, 3, October 1864, 26–55.

_____ , 'Art news from England,' *The Crayon*, 1, May 23, 1855, 327–30.

_____ , 'Art news from London–No. 1,' *The Crayon*, 1, April 25, 1855, 263–5.

_____ , 'The Grosvenor Gallery,' *Academy*, 11, May 5, 1877, 396–7.

_____ , 'The Grosvenor Gallery,' *Academy*, 13, May 18, 1878, 446, and June 1, 1878, 494–5.

_____ , 'Pre-Raffaelitism,' *Edinburgh Weekly Review*, March 7, 1857, 23.

_____ , 'The Pre-Raphaelite Brotherhood,' *Magazine of Art*, 4, 1881, 434–7.

_____ , 'Preraphaelitism: its starting point and sequel,' *Art Monthly Review*, 1, August 31, 1876, 102–5.

_____ , 'Reminiscences of Holman Hunt,' *Contemporary Review*, 98, October 1910, 385–95.

_____ , 'The Royal Academy Exhibition,' *Fraser's Magazine*, 67, June 1863, 783–95.

[Rossetti, W.M.], 'The British Institution,' *The Spectator*, 25, February 28, 1852, 206–7.

_____ , 'Exhibition of the Society of British Artists,' *The Critic*, April 15, 1850, 199–200.

_____ , 'The externals of sacred art,' *Edinburgh Weekly Review*, March 28, 1857, 67–9.

_____ , 'Fine arts section of the Paris exhibition,' *The Spectator*, September 22, 1855, 983–4.

_____ , 'Fine arts section of the Paris exhibition—No. III,' *The Spectator*, October 13, 1855, 1062–3.

_____ , 'Fine arts section of the Paris exhibition—No. IV,' *The Spectator*, October 20, 1855, 1097–8.

_____ , 'Mr. Madox Brown's exhibition, and its place in our school of painting,' *Fraser's Magazine*, 71, May 1865, 598–607.

_____ , 'The National Institution,' *The Critic*, July 1, 1850, 334–5.

_____ , 'Pre-Raphaelitism,' *The Spectator*, 24, October 4, 1851, 955–7.

_____ , 'R.A. Exhibition,' *Fraser's Magazine*, 71, June 1865, 740.

_____ , 'The Royal Academy Exhibition,' *The Critic*, June 1, 1850, 286.

_____ , 'The Royal Academy Exhibition,' *The Critic*, July 15, 1850, 359–61.

_____ , 'The Royal Academy Exhibition,' *The Spectator*, 25, May 8, 1852, 446–7.

_____ , 'Royal Academy Exhibition—second visit,' *The Spectator*, 29, May 24, 1856, 570–71.

_____ and Swinburne, A.C., *Notes on the Royal Academy Exhibition*, London: J.C. Hotten, 1868, facsimile reprint, New York: AMS Press, 1976.

'Royal Academy,' *Athenaeum*, May 8, 1852, 519.

'Royal Academy,' *Athenaeum*, May 22, 1852, 581–3.

'The Royal Academy Exhibition,' *The Examiner*, May 22, 1852, 326.

'The Royal Academy. (Second Notice.),' *Illustrated London News*, 20, May 22, 1852, 407.

Ruskin, J., *The Art Criticism of John Ruskin*, selected, ed. and with an introduction by R.L. Herbert, Garden City, NY: Doubleday and Co., 1964.

_____ , *Praeterita*, Orpington, Kent: George Allen, 1885–89.

_____ , *The Works of John Ruskin*, eds E.T. Cook and A. Wedderburn, 39 vols, London: George Allen and Sons and New York: Longmans, Green & Co., 1903–12.

_____ , 'The Pre-Raffaellites,' Letter to the Editor, *The Times*, May 13, 1851, 8–9.

Sharp, W., *Dante Gabriel Rossetti: a Record and a Study*, London: Macmillan & Co., 1882.

Smiles, S., *Self-Help: With Illustrations of Character and Conduct*, London: John Murray, 1859.

'Society of British Artists,' *Athenaeum*, April 3, 1852, 384.

Spielmann, I. (ed.), *Souvenir of the Fine Art Section, Franco-British Exhibition, 1908, with Illustrations, and an Essay on the Fine Art Section by M.H. Spielmann*, London: Bembrose and Son, 1909.

Spielmann, M.H., *Millais and His Works*, Edinburgh and London: William Blackwood & Sons, 1898.

Stephens, F.G., *Artists at Home*, 2 vols, London: Sampson, Low, Marston, Searle and Rivington, 1884.

——, *Dante Gabriel Rossetti*, London: Seeley & Co. and New York: Macmillan & Co., 1894.

——, *William Holman Hunt and His Works: A Memoir of the Artist's Life, with Descriptions of His Pictures*, London: James Nisbet & Co., 1860.

——, 'The Grosvenor Gallery,' *Athenaeum*, May 15, 1878, 642.

——, 'Obituary of John Everett Millais,' *Athenaeum*, August 15, 1896, 232–3.

[Stephens, F.G.], 'The two Pre-Raphaelitisms; third article,' *The Crayon*, 3, November 1856, 321–4.

Strauss, D.F., *The Life of Jesus, Critically Examined* [1835], ed. P.C. Hodgson, London: SCM Press Ltd, 1973.

Swinburne, A.C., *The Swinburne Letters*, ed. C.Y. Lang, 6 vols, New Haven: Yale University Press and London: Oxford University Press, 1959–62.

——, 'Simeon Solomon: notes on his "Vision of Love" and other studies,' *The Dark Blue*, 1 (5), July 1871, 568–77.

Symonds, J.A., *The Renaissance in Italy: The Fine Arts*, New York: Henry Holt, 1888.

Thompson, H.B., *The Choice of a Profession*, London: Chapman and Hall, 1857.

Wood, E., *Dante Rossetti and the Pre-Raphaelite Movement*, London: Sampson Low, Marston, 1894.

[Wornum, R.N.], 'The Exhibition of the Royal Academy, 1852: the eighty-fourth,' *Art Journal*, o.s. 14, n.s. 4, June 1, 1852, 165–76.

Secondary sources (after 1918)

Adams, S., *The Art of the Pre-Raphaelites*, London: Apple Press and Secaucus, NJ: Cartwell Books, 1988.

Agnew, G. (ed.), *Agnew's, 1817–1967*, London: Bradbury Agnew Press, 1967.

Allen, V.M., '"One strangling golden hair": Dante Gabriel Rossetti's *Lady Lilith*,' *The Art Bulletin*, 66, June 1984, 285–94.

Altholz, J.L. (ed.), *The Mind and Art of Victorian England*, Minneapolis: University of Minnesota Press, 1976.

Altick, R.D., *Punch: The Lively Youth of a British Institution, 1841–1851*, Columbus: Ohio State University Press, 1997.

Amor, A.C., *William Holman Hunt: The True Pre-Raphaelite*, London: Constable, 1989.

Anderson, B., *Imagined Communities: Reflections on the Origin and Spread of Nationalism*, rev. edn, London and New York: Verso, 1991.

Angeli, H.R., *Dante Gabriel Rossetti, His Friends and Enemies*, London: Hamish Hamilton, 1949.

Armstrong, I., *Victorian Scrutinies*, London: Athlone Press, 1972.

Barlow, P., *Time Present and Time Past: The Art of John Everett Millais*, Aldershot, England and Burlington, VT: Ashgate, 2005.

Barnes, J. and Read, B., *Pre-Raphaelite Sculpture: Nature and Imagination in British Sculpture 1848–1914*, London: The Henry Moore Foundation in association with Lund Humphries, 1991.

Barnes, R, *The Pre-Raphaelites and Their World*, London: Tate Gallery Publishing, 1998.

Barr, A., *Cubism and Abstract Art*, New York: Museum of Modern Art, 1936.

Barringer, T., *The Pre-Raphaelites: Reading the Image*, London: Weidenfeld and Nicolson, 1998; published in the US as *Reading the Pre-Raphaelites*, New Haven: Yale University Press, 1999.

Bartram, M., *The Pre-Raphaelite Camera: Aspects of Victorian Photography*, London: Weidenfeld and Nicolson and Boston: Little Brown & Co., 1985.

Baxandall, M., *Patterns of Intention*, New Haven and London: Yale University Press, 1985.

Bell, C., *Landmarks in Nineteenth-Century Painting*, London: Chatto & Windus and New York: Harcourt, Brace, 1927.

Bell, Q., *Bloomsbury*, London: Weidenfeld and Nicolson, 1968 and New York: Basic Books, 1969.

_____ , *A New and Noble School: The Pre-Raphaelites*, London: Macdonald, 1982.

_____ , *Ruskin*, Edinburgh: Oliver and Boyd, 1963; 1st American edn, New York: G. Braziller, 1978.

_____ , *The Schools of Design*, London: Routledge and Kegan Paul, 1963.

_____ , *Victorian Artists*, London: Routledge and Kegan Paul and Cambridge, MA: Harvard University Press, 1967.

_____ , *Virginia Woolf: A Biography*, London: Hogarth Press and New York: Harcourt Brace Jovanovich, 1972.

Bendiner, K., *The Art of Ford Madox Brown*, University Park, PA: Pennsylvania State University Press, 1998.

Benjamin, W., *Illuminations*, 1936, trans. H. Zohn and ed. H. Arendt, New York: Schocken Books, 1969.

_____ , *Walter Benjamin: Selected Writings Volume Three 1935–1938*, trans. E. Jephcott and eds H. Eiland and M.W. Jennings, Cambridge, MA and London: Belknap Press of Harvard University Press, 2002.

Bennett, M., *Artists of the Pre-Raphaelite Circle: The First Generation: Catalogue of Works in the Walker Art Gallery, Lady Lever Art Gallery and Sudley Art Gallery*, London: Published for the National Museums and Galleries on Merseyside by Lund Humphries, 1988.

_____ , 'The Pre-Raphaelites and the Liverpool Prize,' *Apollo*, 77, December 1962, 748–53.

Bentley, D.M.R., 'Rossetti's "Hand and Soul",' *English Studies in Canada*, 3, Winter 1977, 445–57.

Bhabha, H.K., *The Location of Culture*, London and New York: Routledge, 1994.

_____ (ed.), *Nation and Narration*, London and New York: Routledge, 1990.

_____ , '"Race", time and the revision of modernity,' *The Oxford Literature Review*, 13 (1–2), 1991, 193–219.

Bourdieu, P., *Distinction: A Social Critique of the Judgment of Taste*, 1979, trans. R. Nice, London: Routledge and Kegan Paul and Cambridge, MA: Harvard University Press, 1984.

_____ , *The Field of Cultural Production: Essays on Art and Literature*, ed. R. Johnson, Cambridge: Polity Press and New York: Columbia University Press, 1993.

Bowness, A., *Modern Sculpture*, London: Studio Vista, 1965.

_____ (ed.), *The Complete Sculpture of Barbara Hepworth, 1960–69*, London: Lund Humphries, 1971.

_____ and Sylvester, D. (eds.), *Henry Moore: The Complete Sculpture*, 6 vols, London: Lund Humphries, 1944–88.

Bradley, L., 'From Eden to empire: John Everett Millais's *Cherry Ripe*,' *Victorian Studies*, 34 (2), Winter 1991, 179–203.

Brake, L., *Subjugated Knowledges*, Basingstoke and London: Macmillan & Co., 1994.

Bronkhurst, J., *William Holman Hunt: A Catalogue Raisonné*, 2 vols, New Haven, CT and London: Yale University Press, 2006.

Brooks, Chris, *Signs for the Times: Symbolic Realism in the Mid-Victorian World*, London and Boston: Allen & Unwin, 1984.

Brown, M., *Gypsies and Other Bohemians: The Myth of the Artist in Nineteenth Century France*, Ann Arbor, MI: UMI Research Press, 1985.

Brown, S. and Patterson, A. (eds), *Imagining Marketing: Art, Aesthetics and the Avant-Garde*, London and New York: Routledge, 2000.

[Buckle, G.E., Morison, S., McDonald, I., et al.], *The History of The Times, Volume 2: The Tradition Established 1841–1884*, London: The Times, 1939.

Bullen, J.B., *The Pre-Raphaelite Body: Fear and Desire in Painting, Poetry and Criticism*, Oxford: Clarendon Press, 1998.

Bürger, P., *Theory of the Avant-Garde*, trans. M. Shaw, Manchester: Manchester University Press and Minneapolis: University of Minnesota Press, 1984.

Casteras, S.P., *English Pre-Raphaelitism and Its Reception in America in the Nineteenth Century*, Rutherford, NJ: Fairleigh Dickinson University Press and London: Associated University Presses, 1990.

_____ and Faxon, A.C. (eds), *Pre-Raphaelite Art in Its European Context*, Madison, NJ: Fairleigh Dickinson University Press and London: Associated University Presses, 1995.

Chapel, J., *Victorian Taste: The Complete Catalogue of Paintings at the Royal Holloway College*, London: Royal Holloway College, 1982.

Cherry, D., *Beyond the Frame: Feminism and Visual Culture, Britain 1850–1900*, London and New York: Routledge, 2000.

_____ , *Painting Women: Victorian Women Artists*, London and New York: Routledge, 1993.

_____ (ed.), *Art: History: Visual: Culture*, Malden, MA: Blackwell Publishing, 2005.

_____ , 'Elizabeth Eleanor Siddall, 1829-62,' in Elizabeth Prettejohn (ed.), *The Cambridge Companion to the Pre-Raphaelites*, Cambridge: Cambridge University Press, forthcoming.

_____ , 'The Hogarth Club: 1858–1861,' *Burlington Magazine*, 122, 1980, 237–44.

_____ , 'Statues in the square, hauntings at the heart of empire,' *Art History*, 29 (4), September 2006, 660–97.

_____ and Pollock, G., 'Patriarchal power and the Pre-Raphaelites,' *Art History*, 7 (4), December 1984, 480–95.

_____ and _____ , 'Woman as sign in Pre-Raphaelite literature: a study of the representation of Elizabeth Siddall,' *Art History*, 7 (2), June 1984, 206–27.

Christian, J., *The Pre-Raphaelites in Oxford*, Oxford: Ashmolean Museum, 1974.

Clarke, M., *Critical Voices: Women and Art Criticism in Britain, 1880–1905*, Aldershot, England and Burlington, VT: Ashgate, 2005.

Codell, J.F., *The Victorian Artist: Artists' Lifewritings in Britain, ca. 1870–1910*, Cambridge and New York: Cambridge University Press, 2003.

_____ , 'Horne's *Botticelli*: Pre-Raphaelite modernity, historiography and the aesthetic of intensity,' *Journal of Pre-Raphaelite and Aesthetic Studies*, 2, 1989, 27–41.

_____ , 'Righting the Victorian artist: the Redgraves' *A Century of Painters of the English School* and the serialization of art history,' *Oxford Art Journal*, 23 (2), 2000, 95–119.

Colls, R. and Dodd, P. (eds), *Englishness: Politics and Culture, 1880–1920*, London: Broom Helm, 1986.

Cornfield, P.J., *Power and the Professions in Britain 1700–1850*, London and New York: Routledge, 1990.

Davidoff, L., *The Best Circles: Society, Etiquette and the Season*, London: Croom Helm, 1973.

Denis, R.C. and Trodd, C. (eds), *Art and the Academy in the Nineteenth Century*, Manchester: Manchester University Press, 2000.

Denvir, B., *The Late Victorians: Art, Design and Society 1852–1910*, London: Longmans, 1986.

Derrida, J., *Of Grammatology*, 1967, trans. G. Spivak, Baltimore: Johns Hopkins University Press, 1976.

———, *Margins of Philosophy*, trans. A. Bass, Chicago: University of Chicago Press and Brighton: Harvester Press, 1982.

Doughty, O., *Dante Gabriel Rossetti: A Victorian Romantic*, London: Frederick Muller and New Haven: Yale University Press, 1949; 2nd edn, London: Oxford University Press, 1960.

Eaves, M., *The Counter-Arts Conspiracy: Art and Industry in the Age of Blake*, Ithaca: Cornell University Press, 1992.

Elzea, B., *Frederick Sandys 1829–1904: A Catalogue Raisonné*, Woodbridge, Suffolk: Antique Collectors' Club, 2001.

Everett, S. (ed.), *Art Theory and Criticism: An Anthology of Formalist, Avant-Garde, Contextualist and Post-Modernist Thought*, Jefferson and London: McFarland and Co., 1991.

Fawcett, T. and Phillpot, C. (eds), *The Art Press: Two Centuries of Art Magazines*, London: Art Book Company, 1976.

Faxon, A.C., *Dante Gabriel Rossetti*, New York: Abbeville Press, 1989.

Ferber, L.S. and Gerdts, W.H. (eds), *The New Path: Ruskin and the American Pre-Raphaelites*, New York: The Brooklyn Museum, 1985.

Fish, A., *John Everett Millais, 1829–1896*, New York: Funk and Wagnalls, 1923.

Foucault, M., *The Archaeology of Knowledge*, trans. A.M. Sheridan Smith, London: Tavistock Publications and New York: Pantheon, 1972.

———, 'What is an author?' trans. D. Bouchard, *Screen*, 20 (1), Spring 1979, 13–33.

Fredeman, W.E., *Pre-Raphaelitism: A Bibliocritical Study*, Cambridge, MA: Harvard University Press, 1965.

———, 'A shadow of Dante: Rossetti in the final years (extracts from W.M. Rossetti's unpublished diaries, 1876–1882),' *Victorian Poetry*, 20 (3–4), Autumn–Winter 1982, 217–45.

Gellner, E., *Nationalism*, New York: New York University Press, 1997.

Gere, C. and Munn, G.C., *Pre-Raphaelite and Arts and Crafts Jewellery*, Woodbridge: Antique Collectors Club, 1996; originally published as *Artists' Jewellery: Pre-Raphaelite to Arts and Crafts*, 1989.

Gere, J.A., *Pre-Raphaelite Drawings in the British Museum*, London: British Museum Press, 1994.

Giebelhausen, M., *Painting the Bible: Representation and Belief in Mid-Victorian Britain*, Aldershot, England and Burlington, VT: Ashgate Publishing, 2006.

Giles, R., 'The House of Life: a Pre-Raphaelite philosophy?' *The Pre-Raphaelite Review*, 2 (2), May 1982, 100–119.

Gillett, P., *Worlds of Art: Painters in Victorian Society*, New Brunswick, NJ and London: Rutgers University Press, 1990.

Gordon, J.B., 'The imaginary portrait: fin de siècle icon,' *University of Windsor Review*, 5, Fall 1969, 81–104.

Greenhalgh, P., *Ephemeral Vistas: The Expositions Universelles, Great Exhibitions and World's Fairs, 1851–1939*, Manchester: Manchester University Press, 1988.

UNIVERSITY OF MANCHESTER
LIBRARY

Grieve, A., *The Art of Dante Gabriel Rossetti: The Pre-Raphaelite Period, 1848–50*, Hingham, Norfolk, UK: Real World Publications, 1973.
———, 'Rossetti's illustrations for Poe,' *Apollo*, 97, 1973, 142–5.
Grylls, R.G., *Mary Shelley: A Biography*, London and New York: Oxford University Press, 1938.
———, *Portrait of Rossetti*, London: Macdonald and Carbondale: Southern Illinois University Press, 1964.
———, *Trelawny*, London: Constable, 1950.
Hall, C., *Civilising Subjects: Metropole and Colony in the English Imagination, 1830–67*, Chicago: University of Chicago Press and London: Polity Press, 2002.
Harasym, S. (ed.), *The Post Colonial Critic: Interviews, Strategies, Dialogues*, New York and London, Routledge, 1990.
Harding, E. (ed.), *Re-framing the Pre-Raphaelites: Historical and Theoretical Essays*, Aldershot, England: Scolar Press and Brookfield, VT: Ashgate, 1996.
Harrison, C., '"Englishness" and "Modernism" revisited,' *Modernism/Modernity*, 6 (1), January 1999, 75–90.
Harrison, M., *Pre-Raphaelite Paintings and Graphics*, London: Academy Art Editions, 1970.
——— and Waters, B., *Burne-Jones*, London: Barrie and Jenkins, 1973.
Hartnell, R., *Pre-Raphaelite Birmingham*, Studley, Warwickshire: Brewin Books, 1996.
Hawksley, L., *Lizzie Siddal: Tragedy of a Pre-Raphaelite Supermodel*, London: André Deutsch, 2004.
Helsinger, E., 'Constable: the making of a national painter,' *Critical Inquiry*, 15 (2), Winter 1989, 253–79.
Hemingway, A., 'Cultural philanthropy and the invention of the Norwich School,' *Oxford Art Journal*, 11 (2), 1988, 17–39.
Henderson, P., *William Morris: His Life and Friends*, London: Thames and Hudson, 1967.
Hewison, R. (ed.), *Ruskin's Artists*, Aldershot, England and Brookfield, VT: Ashgate, 2000.
Hilton, T., *The Pre-Raphaelites*, London: Thames and Hudson, 1970 and New York: H.N. Abrams, 1971.
Hunt, D.H., *My Grandfather, His Wives and Loves*, London: Hamilton and New York: Norton, 1969.
Ironside, R. and Gere, J., *The Pre-Raphaelite Painters*, London: Phaidon Press, 1948.
Jackson, M., *The Borderland of Imbecility: Medicine, Society and the Fabrication of the Feeble Mind in Late Victorian and Edwardian England*, Manchester: Manchester University Press, 2000.
Jacobi, C., *William Holman Hunt: Painter, Painting, Paint*, Manchester and New York: Manchester University Press, 2006.
Kamuf, P. (ed.), *A Derrida Reader: Between the Blinds*, London: Harvester Wheatsheaf and New York: Columbia University Press, 1991.
Kris, E. and Kurz, O., *Legend, Myth and Magic in the Image of the Artist*, New Haven and London: Yale University Press, 1979.
Kriz, K.D., 'An English arcadia revisited and reassessed: Holman Hunt's *The Hireling Shepherd* and the rural tradition,' *Art History*, 10 (4), December 1987, 476–8.
L'Enfant, J., *William Rossetti's Art Criticism: The Search for Truth in Victorian Art*, Lanham, MD and Oxford: University Press of America, 1999.
———, 'Truth in art: William Michael Rossetti and nineteenth-century realist criticism,' unpublished PhD thesis, University of Minnesota, 1996.
Landow, G.P., *The Aesthetic and Critical Theories of John Ruskin*, Princeton: Princeton University Press, 1971.

_____ , *Victorian Types, Victorian Shadows: Biblical Typology in Victorian Literature, Art and Thought*, Boston and London: Routledge & Kegan Paul, 1980.

_____ , *William Holman Hunt and Typological Symbolism*, New Haven: Published for the Paul Mellon Centre for Studies in British Art by Yale University Press, 1979.

_____ (ed.), *Approaches to Victorian Autobiography*, Athens, Ohio: Ohio University Press, 1979.

_____ , 'William Holman Hunt's "The Shadow of Death",' *Bulletin of the John Rylands Library*, 55 (1972), 197–239.

Latham, D. (ed.), *Haunted Texts: Studies in Pre-Raphaelitism in Honour of William E. Fredeman*, Toronto, Buffalo, London: University of Toronto Press, 2003.

Lejeune, A., *The Gentlemen's Clubs of London*, London: Parkgate, 1984.

Levey, M., 'Botticelli and nineteenth-century England,' *Journal of the Warburg and Courtauld Institutes*, 23, 1960, 291–306.

Lutyens, M. (ed.), *Millais and the Ruskins*, London: John Murray and New York: Vanguard Press, 1967.

_____ , *The Ruskins and the Grays*, London: John Murray, 1972.

Maas, J., *Gambart, Prince of the Victorian Art World*, London: Barrie and Jenkins, 1975.

_____ , *Holman Hunt and* The Light of the World, 2nd edn, Aldershot: Wildwood House, 1987.

MacCarthy, F., *William Morris: A Life for Our Time*, New York: Knopf, 1995.

Macleod, D.S., *Art and the Victorian Middle Class: Money and the Making of Cultural Identity*, Cambridge and New York: Cambridge University Press, 1996.

_____ , 'F.G. Stephens, Pre-Raphaelite critic and art historian,' *Burlington Magazine*, 128, June 1986, 398–406.

Macmillan, J.D., 'Holman Hunt's *Hireling Shepherd*: some reflections on a Victorian pastoral,' *Art Bulletin*, 54, March 1972, 187–97.

Mainardi, P., *Art and Politics of the Second Empire: The Universal Expositions of 1855 and 1867*, New Haven and London: Yale University Press, 1987.

Mancoff, D.N. (ed.), *John Everett Millais: Beyond the Pre-Raphaelite Brotherhood*, New Haven and London: Yale University Press, 2001.

Marchand, L.A., *The Athenaeum: A Mirror of Victorian Culture*, Chapel Hill: University of North Carolina Press, 1941.

Marsh, J., *Christina Rossetti: A Writer's Life*, New York: Viking, 1995.

_____ , *Dante Gabriel Rossetti: Painter and Poet*, London: Weidenfeld and Nicolson, 1999.

_____ , *The Legend of Elizabeth Siddall*, London: Quartet Books, 1989.

_____ , *The Pre-Raphaelite Sisterhood*, London: Quartet Books and New York: St Martin's Press, 1985.

_____ , *Pre-Raphaelite Women: Images of Femininity in Pre-Raphaelite Art*, London, Weidenfeld and Nicolson, 1987.

_____ and Nunn, P.G., *Women Artists and the Pre-Raphaelite Movement*, London: Virago, 1989.

McGann, J.J., *Dante Gabriel Rossetti and the Game that Must be Lost*, New Haven and London: Yale University Press, 2000.

_____ (ed.), *Victorian Connections*, Charlottesville: University of Virginia Press, 1989.

Merck, M. and Townsend, C., *The Art of Tracey Emin*, London and New York: Thames and Hudson, 2002.

Morgan, T. (ed.), *Victorian Sages and Cultural Discourse: Renegotiating Gender and Power*, New Brunswick and London: Rutgers University Press, 1990.

Mort, F., *Dangerous Sexualities: Medico-Moral Politics in England since 1830*, London: Routledge and Kegan Paul, 1987.

Murray, P., *Daniel Maclise (1800–1870) Romancing the Past*, Dublin: Gandon Editions, 2008.

Newman, T. and Watkinson, R., *Ford Madox Brown and the Pre-Raphaelite Circle*, London: Chatto and Windus, 1991.

Nicoll, J., *Dante Gabriel Rossetti*, London: Studio Vista, 1975 and New York: Macmillan & Co., 1976.

——, *The Pre-Raphaelites*, London: Studio Vista, 1970.

O'Doherty, B., *Inside the White Cube: The Ideology of Gallery Space*, 1986, expanded edn, Berkeley: University of California Press, 1999.

Olmsted, J.C., *Victorian Painting: Essays and Reviews, vol. 3, 1861-1880*, New York: Garland Publishing, 1985.

Orr, C.C. (ed.), *Women in the Victorian Art World*, Manchester and New York: Manchester University Press, 1996.

Parris, L. (ed.), *Pre-Raphaelite Papers*, London: Tate Gallery, 1984.

Pasinetti, P.M., *Life for Art's Sake—Studies in the Literary Myth of the Romantic Artist*, New York and London: Garland, 1985.

Pearce, L., *Woman/Image/Text: Readings in Pre-Raphaelite Art and Literature*, New York and London: Harvester Wheatsheaf, 1991.

Peattie, R.W., 'Whistler and W.M. Rossetti: "Always on the easiest & pleasantest terms",' *Journal of Pre-Raphaelite Studies*, n.s. 4, Fall 1995, 77–92.

——, 'William Michael Rossetti's art notices in the periodicals, 1850–1878: an annotated checklist,' *Victorian Periodicals Newsletter*, 8, June 1975, 75–92.

——, 'William Michael Rossetti's contributions to the *Athenaeum*,' *Victorian Periodicals Review*, 23, Winter 1990, 148–55.

——, 'W.M. Rossetti's contributions to the *Edinburgh Weekly Review*,' *Victorian Periodicals Review*, 19 (3), Fall 1986, 108–10.

——, 'William Michael Rossetti as critic and editor, together with a consideration of his life and character,' unpublished PhD thesis, University College, University of London, 1966.

Peterson, L.H., *Victorian Autobiography: The Tradition of Self-Interpretation*, New Haven and London: Yale University Press, 1986.

Pfordresher, J., 'Dante Gabriel Rossetti's "Hand and Soul": sources and significance,' *Studies in Short Fiction*, 19, 1982, 103–32.

Plumb, J.H. (ed.), *Studies in Social History: A Tribute to G.M. Trevelyan*, London and New York: Longmans, Green & Co., 1955.

Pointon, M. (ed.), *Pre-Raphaelites Re-Viewed*, Manchester and New York: Manchester University Press, 1989.

Pollock, G., *Differencing the Canon: Feminist Desire and the Writing of Art's Histories*, London and New York: Routledge, 1999.

——, *Vision and Difference*, London and New York: Routledge, 1988, new edn, 2003.

Prettejohn, E., *The Art of the Pre-Raphaelites*, London: Tate Publishing and Princeton, NJ: Princeton University Press, 2000.

——, *Rossetti and His Circle*, London: Tate Gallery Publishing and New York: Stewart, Tabori & Chang, 1997.

—— (ed.), *After the Pre-Raphaelites: Art and Aestheticism in Victorian England*, Manchester: Manchester University Press and New Brunswick, NJ: Rutgers University Press, 1999.

—— (ed.), *The Cambridge Companion to the Pre-Raphaelites*, Cambridge: Cambridge University Press, forthcoming.

——, 'Aesthetic value and the professionalisation of Victorian art criticism 1837–1878,' *Journal of Victorian Culture*, 2 (1), Spring 1997, 71–94.

Propas, S.W., 'William Michael Rossetti and the *Germ*,' *Journal of Pre-Raphaelite Studies*, 6 (2), May 1986, 29–36.

Rabin, L., *Ford Madox Brown and the Pre-Raphaelite History Picture*, New York: Garland Publishing, 1978.

Radford, E., *Dante Gabriel Rossetti*, London: George Newnes, [1905].

Reitlinger, G., *The Economics of Taste: The Rise and Fall of Picture Prices*, 3 vols, London: Barrie and Rockliff, 1961–70.

Richards, T., *The Commodity Culture of Victorian England: Advertising and Spectacle 1851–1914*, London and New York: Verso, 1990.

Rinalducci, J., 'The 1857–58 American exhibition of British art: critical reactions in the cultural context of New York,' *Athanor*, 20, 2002, 77–83.

Roberts, H. (ed.), *Art History through the Camera's Lens*, Amsterdam: Gordon and Breach, 1995.

_____ , 'Art reviewing in the early nineteenth-century periodicals,' *Victorian Periodicals Newsletter*, 6 (19), 1973, 9–20.

Rose, A., *The Pre-Raphaelites*, Oxford: Phaidon, 1977, rev. edn, 1981.

Rosenthal, M., *Constable: The Painter and his Landscape*, New Haven and London: Yale University Press, 1983.

Russell, D.A. and Winterbottom, M. (eds), *Classical Literary Criticism*, rev. edn, Oxford: Oxford University Press, 1989.

Said, E., *Orientalism*, New York: Pantheon Books, 1978.

Sambrook, J. (ed.), *Pre-Raphaelitism: A Collection of Critical Essays*, Chicago and London: University of Chicago Press, 1974.

Sanders, V., *The Private Lives of Victorian Women: Autobiography in Nineteenth-Century England*, New York: St Martin's Press, 1989.

Scott, W.B., *Autobiographical Notes of the Life of William Bell Scott*, ed. W. Minto, London: Osgood, McIlvaine & Co. and New York: Harper, 1892.

Showalter, E., *The Female Malady: Women, Madness and English Culture 1830–1980*, London: Virago, 1987.

Sloane, J.C., *French Painting Between the Past and the Present: Artists, Critics, and Traditions, from 1848 to 1870*, Princeton: Princeton University Press, 1951.

Sontag, S. (ed.), *A Barthes Reader*, London: Vintage, 1993.

Spivak, G.C., 'Three women's texts and a critique of imperialism,' *Critical Inquiry*, 12 (1), Autumn 1985, 243–61.

Staley, A., *The Pre-Raphaelite Landscape*, Oxford: Clarendon Press, 1973, 2nd edn London and New Haven: Published for the Paul Mellon Centre for Studies in British Art by Yale University Press, 2001.

Stallabrass, J., *High Art Lite: British Art in the 1990s*, London: Verso, 1999.

Surtees, V., *The Paintings and Drawings of Dante Gabriel Rossetti (1828–1882): A Catalogue Raisonné*, 2 vols, Oxford: Clarendon Press, 1971.

Sussman, H.L., *Fact into Figure: Typology in Carlyle, Ruskin, and the Pre-Raphaelite Brotherhood*, Columbus: Ohio State University Press, 1979.

Thompson, E.P., *William Morris: Romantic to Revolutionary*, London: Lawrence & Wishart, 1955, rev. edn, London: Merlin Press [1977].

Thompson, P.R., *The Work of William Morris*, London: Heinemann, 1967.

Tomlinson, J., *Cultural Imperialism*, Baltimore: Johns Hopkins University Press, 1991.

Townsend, J.H., Ridge, J. and Hackney, S. (eds), *Pre-Raphaelite Painting Techniques, 1848–56*, London: Tate Publishing, 2004.

Trodd, C., 'The authority of art: cultural criticism and the idea of the Royal Academy in mid-Victorian Britain,' *Art History*, 20 (1), March 1997, 3–22.

_____ and Barlow, P. (eds), *Governing Cultures: Art Institutions in Victorian London*, Aldershot, England and Burlington, VT: Ashgate, 2000.

Turner, F.M., *John Henry Newman: The Challenge to Evangelical Religion*, New Haven and London: Yale University Press, 2002.

Turpin, J., 'Daniel Maclise and his place in Victorian Art,' *Anglo-Irish Studies*, 1, 1975, 51–69.

Warner, M., Casteras, S.P. et al., *The Pre-Raphaelites in Context*, San Marino, CA: Henry E. Huntington Library and Art Gallery, 1992.

Watkinson, R., *Pre-Raphaelite Art and Design*, London: Studio Vista and Greenwich, CT: New York Graphic Society, 1970.

_____ , *William Morris as Designer*, London: Studio Vista, 1967.

_____ and Newton, T., *Ford Madox Brown and the Pre-Raphaelite Circle*, London: Chatto & Windus, 1991.

Watson, M.F. (ed.), *Collecting the Pre-Raphaelites: The Anglo-American Enchantment*, Aldershot, England and Brookfield, VT: Ashgate, 1997.

Werner, M., *Pre-Raphaelite Painting and Nineteenth-Century Realism*, Cambridge and New York: Cambridge University Press, 2005.

West, S., 'Tom Taylor, William Powell Frith, and the British School of Art,' *Victorian Studies*, 33 (2), Winter 1990, 307–26.

Weston, N., *Daniel Maclise: Irish Artist in Victorian London*, Dublin: Four Courts Press, 2001.

White, H., *Metahistory: The Historical Imagination in Nineteenth-Century Europe*, Baltimore and London: The Johns Hopkins University Press, 1974.

Whiteley, J., *Pre-Raphaelite Paintings and Drawings*, Oxford: Phaidon/Ashmolean Museum, 1989.

Williams, R., *The Country and the City*, Oxford and New York: Oxford University Press, 1973.

_____ , *Culture and Society, 1750–1950*, London: Chatto & Windus and New York: Columbia University Press, 1958.

Wolff, J. and Seed, J. (eds), *The Culture of Capital: Art, Power and the Nineteenth Century Middle Class*, Manchester and New York: Manchester University Press, 1988.

Wood, C., *The Pre-Raphaelites*, London: Weidenfeld and Nicolson, 1981.

Young, G.M. (ed.), *Early Victorian England, 1830–1865*, 2 vols, London: Oxford University Press, 1934.

Exhibition catalogues

The Age of Rossetti, Burne-Jones and Watts: Symbolism in Britain 1860–1910, exh. cat., eds A. Wilton and R. Upstone, London: The Tate Gallery Publishing and Paris and New York: Flammarion, 1997.

British Art and the Modern Movement, 1930–1940, exh. cat., London: Welsh Committee of the Arts Council of Great Britain, 1962.

Burne-Jones: The Paintings, Graphic and Decorative Work of Sir Edward Burne-Jones, 1833–98, exh. cat., London: Hayward Art Gallery in association with the Arts Council of Great Britain, 1975.

Catalogue of the Art Treasures of the United Kingdom Collected at Manchester in 1857, exh. cat., eds G. Scharf and A. Egg, London: Bradbury and Evans, 1857.

Catalogue of an Exhibition of Drawings and Studies by Sir Edward Burne-Jones, exh. cat., introduction by S. Colvin, London: Leicester Galleries in association with Ernest Brown & Phillips, 1904.

Catalogue of the Exhibition of the National Institution of Fine Arts, exh. cat., London: G. Dewing, 1850.

Catalogue of an Exhibition of Pictures, Drawings and Studies for Pictures made by the late Sir J.E. Millais, exh. cat., introduction by J.G. Millais, London: the Fine Art Society, 1901.

Catalogue of the Institution for Promoting the Free Exhibition of Modern Art, exh. cat., London: J. Bradley, 1849.

Catalogue of the Works of British Artists in the Gallery of the British Institution, Pall Mall, For Exhibition and Sale, exh. cat., London: W. Nichol, 1847.

Daniel Maclise 1806–1870, exh. cat., eds R. Ormond and J. Turpin, London: Arts Council of Great Britain in association with the National Portrait Gallery, 1972.

Dante Gabriel Rossetti, exh. cat., eds J. Treuherz, E. Prettejohn, and E. Becker, London: Thames and Hudson, 2003.

Dante Gabriel Rossetti and His Circle: A Loan Exhibition of Paintings, Drawings and Decorative Objects by the Pre-Raphaelites and Their Friends, exh. cat., Lawrence: University of Kansas Museum of Art, 1958.

Dante Gabriel Rossetti, Painter and Poet, exh. cat., London: Royal Academy of Arts, 1973.

Edward Burne-Jones: Victorian Artist-Dreamer, exh. cat., eds S. Wildman and J. Christian, New York: Metropolitan Museum of Art, 1998.

Elizabeth Siddal: Pre-Raphaelite Artist 1829–1862, exh. cat., ed. J. Marsh, Sheffield: The Ruskin Gallery, Collection of the Guild of St George, 1991.

Evelyn De Morgan: Oil Paintings, exh. cat., ed. C. Gordon, London: De Morgan Foundation, 1996.

Exhibition of Art Treasures of the United Kingdom held at Manchester in 1857: Report of the Executive Committee, Manchester: George Simms, 1859.

Exhibition of Drawings and Studies by Sir Edward Burne-Jones, exh. cat., introduction by C. Monkhouse, London: Burlington Fine Arts Club, 1899.

Exhibition of the Works of Sir Edward Burne-Jones, exh. cat., London: New Gallery, 1892.

Exhibition of the Works of Sir Edward Burne-Jones, exh. cat., London: New Gallery, 1898.

Ford Madox Brown 1821–1893, exh. cat., Liverpool: Walker Art Gallery, 1964.

Glorious Nature: British Landscape Painting 1750–1850, exh. cat., catalogue by K. Baetjer and essays by M. Rosenthal, K. Nicholson, R. Quaintance, S. Daniels and T.J. Standring, London: Zwemmer and New York: Hudson Hills Press in association with the Denver Art Museum, 1993.

Great British Paintings from American Collections, exh. cat., eds M. Warner and R. Asleson, New Haven: Yale Center for British Art, 2001.

Great Victorian Pictures: Their Paths to Fame, exh. cat., London: Arts Council, 1978.

A Handbook to the Art Treasures Exhibition—Being a Reprint of Critical Notices Originally Published in the Manchester Guardian, 2 vols, London: Bradbury and Evans, 1857.

Handbook to the Fine Art Collections in the International Exhibition of 1862, ed. F. Palgrave, London and Cambridge: Macmillan & Co., 1862.

Heaven on Earth: The Religion of Beauty in Late Victorian Art, exh. cat., University of Nottingham, 1994.

Holman Hunt and the Pre-Raphaelite Vision, exh. cat., eds K. Lochnan and C. Jacobi, Toronto: The Art Gallery of Ontario, in association with Manchester Art Gallery, Manchester, 2008.

John Cassell's Art Treasures Exhibition, exh. cat., London: W. Kent & Co., 1858.

John Everett Millais, 1829–1896: A Centenary Exhibition, exh. cat., eds C. Donovan and J. Bushnell, Southampton: Southampton Institute, 1996.

John Linnell: A Centennial Exhibition, exh. cat., ed. K. Crouan, Cambridge: Cambridge University Press in association with the Fitzwilliam Museum, 1982.

Love Revealed: Simeon Solomon and the Pre-Raphaelites, exh. cat., ed. C. Cruise, London and New York: Merrell in association with Birmingham Museums and Art Gallery, 2005.

Millais, exh. cat., Liverpool: Walker Art Gallery and London: Royal Academy of Arts, 1967.

Millais, exh. cat., eds J. Rosenfeld and A. Smith, London: Tate Publishing, 2007.

Millais: Portraits, exh. cat., eds M. Warner and P. Funnell, Princeton: Princeton University Press and London: National Portrait Gallery Publishing, 1999.

Morris and Company, exh. cat., ed. C. Menz, Adelaide: Art Gallery Board of South Australia, 1994.

Mulready, exh. cat., ed. M. Pointon, London: Victoria and Albert Museum, 1986.

The New Path: Ruskin and the American Pre-Raphaelites, eds L.S. Ferber and W.H. Gerdts, New York: The Brooklyn Museum in association with Schocken Books, 1985.

A Peep at the Pictures: or, a Catalogue of the Principal Objects of Attraction in the Manchester Art Treasures Exhibition, exh. cat., Manchester: John Heywood, 1857.

Pictures, Drawings, Designs and Studies by the Late Dante Gabriel Rossetti, exh. cat., introduction by H.V. Tebbs, London: Burlington Fine Arts Club, 1883.

Pre-Raphaelite and Other Masters: the Andrew Lloyd Webber Collection, exh. cat., London: Royal Academy of Arts, 2003.

Pre-Raphaelite Paintings from the Manchester City Art Gallery, exh. cat., ed. J. Treuherz, London: Lund Humphries in association with the City of Manchester Art Galleries, 1980.

The Pre-Raphaelites, exh. cat., ed. J. Gere, London: Whitechapel Art Gallery, 1972.

The Pre-Raphaelites, exh. cat., ed. L. Parris, London: The Tate Gallery in association with Allen Lane and Penguin, 1984.

The Pre-Raphaelites and Their Associates in the Whitworth Art Gallery, exh. cat., Manchester, Whitworth Art Gallery, 1972.

The Pre-Raphaelites and Their Circle, exh. cat., ed. R. Ormond, Birmingham: Birmingham Museum and Art Gallery, 1965.

The Pre-Raphaelites on Merseyside, exh. cat., ed. F. Milner, York: Village, 1985.

The Pre-Raphaelites in Oxford, exh. cat., ed. J. Christian, Oxford: Ashmolean Museum, 1974.

Pre-Raphaelites: Painters and Patrons in the North East, exh. cat., Newcastle upon Tyne: Tyne and Wear Museums Service with assistance from the Paul Mellon Centre for Studies in British Art, 1989.

Pre-Raphaelite Women Artists, exh. cat., eds J. Marsh and P.G. Nunn, London and New York: Thames and Hudson, 1998; originally published Manchester: Manchester City Art Galleries, 1997.

Rossetti's Portraits of Elizabeth Siddal: A Catalogue of the Drawings and Watercolours, exh. cat., ed. V. Surtees, Aldershot: Scolar Press in association with the Ashmolean Museum, Oxford, 1991.

The Royal Academy (1837–1901) Revisited: Victorian Paintings from the Forbes Magazine Collection, exh. cat., text by C. Forbes, introduced and edited by A. Staley, New York: Forbes, 1975.

Studies and Drawings by Sir Edward Burne-Jones, London: Fine Art Society, 1896.

Stunners: Paintings and Drawings by the Pre-Raphaelites and Others, exh. cat., London: Maas Gallery, 1974.

Visions of Love and Life: Pre-Raphaelite Art from the Birmingham Collection, England, exh. cat., ed. S. Wildman, Alexandria, VA: Art Services International, 1995.

Waking Dreams: The Art of the Pre-Raphaelites from the Delaware Art Museum, exh. cat., ed. S. Wildman, Alexandria, VA: Art Services International, 2004.

Wilhelm Leibl zum 150. Geburtstag, exh. cat., eds G. Czymmek and C. Lenz, Munich: Neue Pinakothek, 1994.

William Holman Hunt, exh. cat., Liverpool: Walker Art Gallery, 1969.

William Morris, exh. cat., London: Victoria and Albert Museum in association with H.M. Stationery Office, 1958.

William Morris, exh. cat., ed. L. Parry, London: Victoria and Albert Museum in association with Philip Wilson, 1996.

William Morris Today, exh. cat., London: Institute of Contemporary Arts, 1984.

Works by the Old Masters and by Deceased Masters of the British School Including a Special Selection from the Works of J. Linnell and Dante Gabriel Rossetti, exh. cat., London: The Royal Academy of Arts in association with William Clowes and Sons, 1883.

Index

(References to illustrations are in *italics*)

UNIVERSITY OF WINCHESTER
LIBRARY